BELIEVE

The Untold Story Behind
TED LASSO,
the Show That Kicked
Its Way into Our Hearts

BELI

EVE

JEREMY EGNER

DUTTON

DUTTON

An imprint of Penguin Random House LLC
penguinrandomhouse.com

LIBRARY OF CONGRESS CATALOGING-IN-PUBLICATION DATA

Names: Egner, Jeremy, author.
Title: Believe: the untold story behind *Ted Lasso*, the show that kicked its way into our hearts / Jeremy Egner.
Description: New York : Dutton, 2024. | Includes bibliographical references and index.
Identifiers: LCCN 2024021518 (print) | LCCN 2024021519 (ebook) | ISBN 9780593476062 (hardcover) | ISBN 9780593476079 (ebook)
Subjects: LCSH: Ted Lasso (Television program).
Classification: LCC PN1992.77.T38435 E46 2024 (print) | LCC PN1992.77.T38435 (ebook) | DDC 791.4501—dc23/eng/20240522
LC record available at https://lccn.loc.gov/2024021518
LC ebook record available at https://lccn.loc.gov/2024021519

Printed in the United States of America

1st Printing

BOOK DESIGN BY LORIE PAGNOZZI

For Leslie and Jemma, who make it easy to believe

CONTENTS

SECOND HALF 181

STOPPAGE TIME 303

Author's Note

This book was assembled from a number of sources, including interviews I conducted with members of the cast and crew of *Ted Lasso*, TV and advertising executives, members of England's professional soccer community, and assorted real-life Richmonders. Not everyone was available to speak, so I also used archival material, including interviews I did with creators and cast members as an editor and writer at *The New York Times* during the show's run, along with many, many, many (many, many . . .) podcasts; TV appearances; awards panels; and published interviews the stars, writers, and various crew members have done since *Ted Lasso* first charmed the world in 2020. A full list of sources by chapter is in the back. Quotes that appear within quotation marks are exact reproductions of what was said or written by a source. Some interview excerpts in the oral history sections have been edited or condensed for clarity and concision, and I have occasionally used brackets to make the context of a quote clearer.

BELIEVE

WARM-UPS

INTRODUCTION

To hear Brett Goldstein tell it, the creators of *Ted Lasso* knew early on they had something special on their hands. They just didn't think anyone would see it.

It was November 2019 and the show was wrapping up production on its first season. Goldstein had just spent weeks on a muddy pitch in London as Roy Kent, sprinting through one frigid downpour after another—in shorts—as a soccer show tried to figure out on the fly how to film soccer. And yet he was feeling optimistic about *Ted Lasso*. There was a sense that like any number of onscreen underdogs, this humble sports sitcom just might defy the odds and be, you know, *good*.

But even so, neither Goldstein, who would exemplify the series' surprising potential by being hired as a writer and ending up its break-out performer, nor Jason Sudeikis, the show's mastermind and star, thought many people would actually watch it.

"When me and Jason said goodbye, he was like, 'Something happened here, right?'" Goldstein recalled. "And I was like, 'Yeah, something definitely happened here, and even if no one watches it, we got to experience it.'

"That was how it felt," he continued. "It was like we did this magic thing, and no one will ever see it."

The premise of *Ted Lasso* certainly didn't sound like a formula for award-winning television: Take a goofy character from an old TV ad and build an entire show around him; make it about soccer, a sport most Americans don't care about; and fill it with a bunch of actors nobody knows. Then stick it on a subscription service that was less than a year old, with few subscribers, from a company known mostly for smartphones, watches, and laptops. Give it a title that makes it sound like it's about a rodeo clown.

Yet even though *Ted Lasso* had seemingly everything going against it, people did see it, and most of them told their friends after they did. Hit series, like great sports teams, require a fortuitous combination of talent and luck. And while only a narcissistic supervillain like Rupert Mannion would suggest that anything about the coronavirus pandemic was lucky, the fact remains that when *Ted Lasso* arrived in August 2020, much of humanity was housebound—a captive audience—and badly in need of emotional escape and restoration.

It is now blessedly difficult to recall the feeling of August 2020. America was five months into a pandemic that had disrupted the school year, locked most of us inside our homes, and, tragically, killed thousands of our fellow citizens. A vaccine wasn't expected for years, and amid inflamed divisions over face masks and other COVID safety measures, we collectively began to understand that we weren't going to be returning to our normal lives anytime soon. We were beginning to realize there was no end in sight.

At the same time, the country was still grappling with the murder of George Floyd by Minneapolis police and the protests that ensued, and a bruising presidential campaign had Americans steeping in a stew of nasty rhetoric and recriminations, hate speech and high anxiety.

In other words, the world has rarely been as ready for a luxuriously

mustachioed coach full of aphorisms about perseverance and kindness as it was in August 2020. And with very little fanfare, Sudeikis and his magnificent whiskers emerged to give us all what we never knew we needed.

The concept was simple: Take all the antiheroes that had dominated TV for years, from Tony Soprano to Walter White to Larry David, and do basically the opposite. Treat others with kindness. Greet setbacks with grace. Be curious, not judgmental. "I personally didn't want to do the arc of son of a bitch to saint," Sudeikis recalled. "It was like, What about just playing a good guy?"

But there is power in simplicity. And as word spread and more people discovered the show—as the kids began another lost school year, as the vote counting stretched on and wild election conspiracy theories proliferated, as we spent the holidays separated from our families, as we watched the terrible January 6 Capitol riot and yet another round of divisive impeachment hearings—*Ted Lasso* was there for us when we needed it. And in return we showered it with affection, Apple TV+ subscriptions, and Emmys.

Sudeikis, of course, didn't do it alone. The story of *Ted Lasso* is not just a story of unfortunately fortunate timing, of a *Saturday Night Live* veteran's time in the sun, or even of a wondrous mustache. It's a story, appropriately enough, of teamwork, of hidden talent, of a group of friends looking around at the world's increasingly nasty discourse and deciding that, as corny as it sounds, maybe simple decency and a few laughs still had the power to bring people together.

Ted Lasso is a story of actual underdogs playing fictional ones—of Hannah Waddingham, then best known for shouting "Shame!" on

Game of Thrones, emerging as a resilient symbol of modern womanhood; of an unknown comic like Goldstein using the show as a launchpad to international stardom and a spot in the Marvel Cinematic Universe. It's a story of a group of actors, writers, and crew members revealing that they were more than the world realized. It's a story about what happens when you dare to believe.

And it's a story full of questions with fascinating answers. How did Sudeikis's time on *Saturday Night Live* inform *Ted Lasso* themes about fame and ego? How were the cast and writers chosen, and what were the challenges of filming overseas during a pandemic? How did the show's stars adapt to suddenly becoming internationally famous? How did the creators handle the pressure that came from overseeing a story that was not just popular but actively meaningful to millions of people? And how did they feel, after two years of near-universal praise, when a backlash began to build around the show's final season?

My role as the television editor for *The New York Times* provided the ideal perch from which to watch (and cover) *Ted Lasso* as it blossomed from a curiosity into a phenomenon. It also gave me an informed perspective, born of watching way more TV than anyone probably should, on what made it distinctive as a piece of art.

Ted Lasso didn't happen in a TV vacuum. The creators originally based its structure on that of the British *Office*, the instant classic cringe-com. But *Ted Lasso* was part of a pendulum swing in TV comedy away from that and other 2000s series like *Curb Your Enthusiasm*, *Arrested Development*, and *30 Rock*—and before them, *Seinfeld* and *The Larry Sanders Show*—that mined hilarity from often despicable behavior. While fans of choleric comedy still had shows like *Veep* and *It's Always Sunny in Philadelphia* to tide them over, sitcoms have largely trended toward the light in the twenty-first century. The

American *Office* began as a harsh copy of the original but ended nine seasons later as a much warmer, more openhearted show. The heroes of series like *Parks and Recreation* and *Modern Family* were mostly trying to be better people—*The Good Place* was based entirely on that concept—and by the end of its run, *Schitt's Creek*, the Emmys' favorite comedy right before *Ted Lasso*, was a warm, inclusive hug.

So, in this sense, *Ted Lasso* was a kind of apotheosis rather than a bolt of decency from the blue. But in other ways, it is remarkably singular. It is rare for a sitcom to offer potent life lessons and influence people's lives not just as fans, but as human beings. As the first season took off in America, it became common for famous and unfamous converts to urge people to "be more like Ted Lasso." People approached Sudeikis to say the show had inspired them to be nicer at work or, more poignantly, to hang a BELIEVE sign in a relative's hospital room. When the Biden administration wanted to announce a mental health initiative in 2023, it invited the cast of the show to come to the White House to help do it.

The story of how Ted traveled from an NBC soccer ad to the Oval Office is as fascinating as the show itself. This book, a mix of behind-the-scenes oral history and deep critical appraisal of the episodes and themes, is designed to help fans see the series in new ways, with new context. Read it all the way through or read it out of order. Use it as a rewatch guide or use it as a coaster. Give it to your dad or regift it to your mother-in-law. While it might not technically be *The Richmond Way*, much like Trent Crimm, I just really want you to like it and use it however works best for you.

I wrote it as a TV professional, but I also had a unique personal perspective on *Ted Lasso*, one that came from being an early, rather public victim of the COVID pandemic. I was fit and healthy until I

caught and then nearly died from the disease in those terrifying, confusing days of March 2020, and while lying in a hospital bed, I tapped out a *New York Times* dispatch on my phone to warn people about the seriousness and unpredictability of the epidemic. I eventually emerged thrilled to still be alive but changed by the experience, with diminished lungs but a more open heart, and it broke as the country, confronted with the pandemic's existential threat, collapsed into a morass of acrimony and accusations.

So I needed *Ted Lasso* as much as any fan, and I understand as much as anyone what it meant to America and beyond. The show was heartwarming and frequently hilarious, but it also showed people a better way to be. Its lessons were obvious—be kind to other people, be kind to yourself, understand that though the world can seem designed specifically to knock you down or piss you off, you get to decide how you respond to it. But sometimes the most obvious messages are the easiest to ignore until a story comes along to sneak them through a side door to your soul.

That's something art can do: slip through all your usual emotional defenses. As a jaded journalist, I could sometimes almost physically feel the show working on me. It circumvented my native cynicism, sinking in even when I instinctively resisted its earnestness, and I doubt I'm alone. None of us ever really is—that's another *Ted Lasso* lesson.

Another thing about simple, powerful values is that they are timeless. Though *Ted Lasso* is inextricably linked with the pandemic, with its arrival in 2020 as an emotional balm, it was conceived years earlier as a response to a society that increasingly indulges and rewards humanity's worst impulses. "You could argue these things were always there, regardless of the pandemic," Goldstein said. "It's mad that this was normal, people being fucking horrible to each other.

"It felt revolutionary to see someone being nice," he added. "And it shouldn't have."

While the pandemic thankfully has mostly ended, toxic cultural tendencies, alas, have not. Which is to say, whatever the future of the franchise—whether there ends up being a sequel series or five sequels or no sequels—*Ted Lasso* will be there *whenever* you need it. This book will be there, too.

THE BIRTH OF TED

"Everybody who saw it liked it and laughed at it."

The foundational joke of Ted Lasso, *the engine of its fish-out-of-water central premise, is that a man who knows nothing about soccer is hired to coach a team that competes at the pinnacle of the sport: England's Premier League.*

In the series, the explanation for this patently absurd turn of events is that Rebecca Welton, played by Hannah Waddingham, wants to get revenge upon her vile ex-husband, Rupert Mannion (Anthony Head), by destroying his favorite thing: his beloved Premier League club, AFC Richmond, which she acquired in their divorce.

It is a concept borrowed from the 1989 baseball comedy Major League, *in which the viperous widow of the owner of the Cleveland Indians fills the team with losers in order to tank it, so she can move the franchise via an escape clause tied to attendance. (Scheming*

fictional sports owners take note: the secret self-sabotage ploy never seems to work.)

But the original reason Ted was sent to England was to (1) make Americans feel OK about not knowing anything about soccer, and (2) amuse them into considering watching it anyway. The character was born in 2013 in an ad for NBC Sports, which had just purchased the American broadcast rights to the Premier League. The network's promotional campaign initially primarily targeted America's relatively small but fervent core audience of dedicated soccer fans. But unlike the previous rights holder, Fox Sports, NBC planned to broadcast every game for free—the tagline was "Every match. Every week. Every team."—and needed to expand the audience in order to make its purchase worthwhile.

And unlike the rest of the world, American sports fans would take some convincing to watch soccer. "We weren't just selling NBC Sports; we were selling soccer," said Bill Bergofin, who was the head of marketing for NBC Sports at the time and one of the architects of the Ted Lasso spots.

They decided the best way to do that was to create a comic link between America's favorite sport and the one that captivated fans nearly everywhere else, two abiding obsessions that happened to share one name: football.

John Miller, then chief marketing officer for NBC Sports: The Premier League had been on Fox for a while, and they didn't show all that many games. We were going to show every game, because we had multiple channels in which to do it, and we were going to show them for free. So for a soccer fan to be able to see every Premier League game free—it didn't stay free for long, but at that point it was—was a big selling point.

But 50 percent of all regular soccer viewers were in just five

markets. So we can get them, but it became, OK, well how do we grow it beyond those five markets? Because we knew that if we got the people who are regular fans of the Premier League and who have been watching it on Fox Sports, it's just not going to be as big as we need to make it, considering the rights that we just paid for.

Bill Bergofin, the then newish head of marketing for NBC Sports: I was still sort of proving myself within NBC, so I tried to convince John to bring someone in from the outside. I had been working with Guy Barnett for probably five years at that point, and he had become a dear friend. He's one of the greats, in terms of advertising creativity, and being a Brit who had spent the greater part of his adult life in the US, he was uniquely qualified. And he had always said to me, "If you ever get the Premier League, you have to bring me in."

So one day I brought Guy in and said, "Look, I think we really need someone who authentically has lived this life and is a die-hard fan but also understands American culture equally." And we started having a conversation and halfway through the conversation, John pointed to a campaign for New Era. Someone he knew had said it was one of the best-performing campaigns, based on research, that he had done.

The campaign for the sports cap company featured celebrity fans trading insults about rival teams. Alec Baldwin, a New York Yankees fan, squared off with John Krasinski, a Boston Red Sox diehard. The dueling Chicagoans Nick Offerman and Craig Robinson bickered about the Cubs and White Sox. "Your infield has more holes than a Swiss cheese doughnut," Offerman said. Robinson: "The last Cub to throw a no-hitter was your pitching machine."

Bill Bergofin: John asked if Guy knew it. And Guy said, "Well of course: I wrote it."

John Miller: We said, "Well, is there something that we can do that would help explain the game but make a lot of noise? A long-form comedy video?"

Bill Bergofin: We know who we are and who the core fan is. But how do we create that tipping point for soccer in America? And a lot of it was you had to educate people, and we needed to do it in a way that took the piss out of it so that it wasn't intimidating.

Guy Barnett, founder of the Brooklyn Brothers ad agency: We wanted to explain the game in an entertaining manner. Not in a superficial or supercilious manner as it had been done by lots of people, but really from an American perspective: What is this game about?

John Miller: We thought, Let's take the most popular sport in America, which is football, and see if we can make some comparisons to football. Or at least have the idea of somebody with a different American focus look at the game and see if we can help explain it, but do it in a fun way.

Bill Bergofin: So we started thinking, What would be the right way to do it? Who's the right fish out of water? And are they here? An American in England? An English coach in America? You know, which is the right way to go?

John Miller: We originally went after John Oliver, who was then at *The Daily Show,* and he was sort of intrigued. It would have taken a different tack: a Brit helps explain the game in a fun way. But at that time, Jon Stewart was going to direct a film and so all of a sudden, John Oliver is going to take over *The Daily Show* all summer long. So he was out. Then we went to Chris Pratt, because we thought that he would be sort of interesting and fun. And he's a guy from *Parks and Recreation,* an NBC connection. So we asked him but he was in the middle of *Jurassic [World]* and *Guardians of the Galaxy* and going off on a film career, and wasn't interested.

We briefly toyed with Ricky Gervais and thought, Maybe that's not the best idea. We also talked with Seth Meyers, because he was a real Premier League fan, but he was not quite as big as we wanted then.

Bill Bergofin: So we're all kind of scratching our heads. We had a talent wrangler and they said, "You know, Jason Sudeikis, I'm not sure he's a soccer fan, but he's coming off *SNL* and I don't believe he has any projects lined up."

Sudeikis wasn't the world's biggest soccer fan, but sports had been central to both his life and his career. Growing up in the Kansas City suburb of Overland Park, Kansas, he was a point guard on his high school basketball team and went on to play briefly in community college. He eventually gave up that dream and pursued another: comedy.

A move to Chicago in the late 1990s put him in the orbit of the famed Second City comedy theater, where Sudeikis's famous uncle, George Wendt (best known as "Norm!" in Cheers*), got his start in the 1970s. Sudeikis eventually joined the theater, performing improv with future stars and* Saturday Night Live *colleagues like Tina Fey, Rachel Dratch, and Horatio Sanz. He went on to perform improv at Boom Chicago, an American-style comedy theater in Amsterdam. There he worked with Joe Kelly and Brendan Hunt, the future Coach Beard himself, who became close friends, comedy partners, and eventually co-creators of* Ted Lasso.

They all had met previously doing comedy in Chicago: Hunt was an Illinois native and theater major who decided early on to dedicate himself to Chicago improv, studying at Second City before heading to Europe to become a Boom Chicago legend. Kelly grew up in Georgia and also did improv in Chicago before moving to Amsterdam. He would later work with Sudeikis as a writer at Saturday Night Live. *Kelly also created the Comedy Central series* Detroiters *with Zach*

Kanin and the stars Sam Richardson, who would later win an Emmy as the nutjob oligarch Edwin Akufo in Ted Lasso; and Tim Robinson, who would later win an Emmy for I Think You Should Leave with Tim Robinson, the most acclaimed sketch comedy series of the past decade.

But Amsterdam is where Sudeikis, Hunt, and Kelly all bonded, fortuitously so. In fact, Sudeikis and Hunt's sessions playing the video game FIFA before and after their Boom Chicago shows was partly what sparked both men's interest in professional soccer (Hunt's passionately so).

Sudeikis's big break came in 2003, when he was hired as a writer on Saturday Night Live. It would be two more years before he was promoted to the main cast. He credits a parody he cowrote of "The Super Bowl Shuffle," the legendary cringe-rap performed by the 1985 Chicago Bears, as the key to his promotion: while rehearsing the bit with the host Tom Brady and others, Sudeikis, in the background, did a version of the goofy Running Man dance he would perform later in Ted Lasso, inspiring hysterics on set.

"I had been doing that dancing since I was on basketball teams in the early nineties," he said on the Fly on the Wall podcast in 2023. "It was the same thing that made my fifteen-year-old friends laugh." Two weeks later, he was added to the cast.

Over ten years on SNL, Sudeikis was a reliable utility player who could also carry sketches as the star. His most notable roles included then vice president Joe Biden, Mitt Romney, a cop who ran an ill-advised "scared straight" program, and a self-involved douchebag who paired with Kristen Wiig in the aptly named recurring sketch "Two A-Holes." He also stood out as a tracksuited, tight-Afroed dancer in the exuberantly absurd "What Up with That?" extravaganzas, in which his signature move was yet another version of the Running Man.

But it was a 2011 riff on collegiate sports sex-abuse scandals that formed an unlikely blueprint for historical TV acclaim. In a sketch titled "Coach Bert," cowritten by Kelly, Sudeikis played a college basketball coach—sans mustache but with a recognizably strident yet obtuse diction—giving a press conference in which he throws his harmless but off-putting assistant coach, played by Steve Buscemi, under the bus for "having all the tell-tale signs of a sexual predator."

"He's antisocial, lives with his mom, he's never had a girlfriend," Sudeikis continues. "I mean, he's a genius with the X's and O's but an absolute zero when it comes to human interaction."

Sudeikis formally announced he was leaving Saturday Night Live *in a July 2013 appearance on* Late Show with David Letterman, *not long after shooting the first Ted Lasso ad. "You have a giant mustache," Letterman marveled, little suspecting that years later those whiskers would become an international symbol of kindness and decency.*

John Miller: Somebody suggested Jason Sudeikis, because he had done a character on *SNL* as a coach.

Guy Barnett: Wouldn't it be funny, I thought, if this American coach was put in charge of an English football team? Not as a pedophile, obviously, but as a fish-out-of-water character. Through his ignorance we could shine a light on the sport our client NBC had just paid $250 million to air. And thus, the idea for *Ted Lasso* was born.

Bill Bergofin: It came back that Jason was very interested but he wanted to see a few other directions and ideas, and Guy put those together. We were kind of sweating a little bit time-wise, and then Jason came back and agreed to do it.

Jason Sudeikis, creator, Ted Lasso, seasons 1–3: When we were first doing the commercial, because it has this international flavor, I was immediately like, "Oh, Joe and Brendan." There were no other two people that I was going to pick at that point in my life. It was

because we had the opportunity to work in a place called Boom Chicago in Amsterdam; it was started by three Americans from Northwestern University in the middle of Amsterdam, and it took off.

Brendan Hunt, creator, Coach Beard, seasons 1–3: I got a call from Jason: "Hey, NBC Sports wants me to do a soccer thing." He and I both became soccer fans, to different degrees, at around the same time living in Amsterdam. Neither one of us was into soccer as kids in the Midwest, but we moved to Europe and caught the bug.

So he called me and said, "This is a soccer thing, and if we do it, we get to go to England for three whole days. Then they've got to fly us out to go see a Premier League game later when the season starts." This is the best gig ever! It will never get better than three days in London and one soccer game!

Jason Sudeikis: It truly was us wanting to get to be flown out to go see a Premier League game, specifically an Arsenal game because Brendan's the biggest fan out of me, Brendan, and Joe. And we hit that bull's-eye!

Brendan Hunt: This ad agency came to Jason and said, "Hey, here's, like, three different ideas of, like, you know, kind of like a coach thing." And Jason's like, "Uh-huh. This one where he coaches a Premier League team, but he doesn't know anything about it—I'm gonna push that around a little bit. And I'm bringing in my buddy Joe Kelly and my buddy Brendan." And they were like, "Oh, OK. Oh, great."

Jason Sudeikis: Originally, the ad agency, Brooklyn Brothers, had envisioned the character as more of a hair-dryer-type coach: somebody who yells and screams, like a Bobby Knight or your stereotypical NFL coach. I wanted to do a softer version of that—just yelling and screaming didn't feel as fun and also felt derivative of things that I'd played. And it shifted into less of a hair dryer and more like this

bumpkin guy. I dressed like Mike Ditka—you know, the polyester shorts, the orange glasses, and the mustache, which I had. He chewed gum.

The campaign had its star, but it also needed a Premier League club that was willing to let an American comedian clown around on its pitch. After being turned down by nearly every other team in the league, Bergofin found a willing partner in Tottenham Hotspur Football Club.

The script was tweaked and Sudeikis named the character Ted Lasso. ("I just like the idea of a single-word first name, you know, Tom, Ted, Tim, whatever," he told Virgin Radio in 2023. "And then a noun specifically. I just thought that was funny.") Hunt was tapped to be an assistant coach who actually understood the game, a rough blueprint for his role as Coach Beard in the series. The production went overseas in July 2013 to shoot the ad at Tottenham's training ground in Enfield in North London.

Donna-Maria Cullen, executive director of Tottenham Hotspur: We were and we still are, to a certain extent, a challenger brand. NBC were going to be taking Premier League coverage from behind the paywall that Fox had, and that's an opportunity for bigger audiences, for us to catch fans that didn't have a Premier League club affinity already and also just to show ourselves to more fans on the other side of the pond.

John Miller: Bill had a relationship with Tottenham Hotspur. He was able to get them and they had the free time, and allowed us to come in as they were doing their training.

Donna-Maria Cullen: I said to Bill, "We won't be able to do it exactly as you have it in your head, but we will accommodate it so you won't see the difference." If you look at the ads, you can see that sometimes Jason's on the touchline [the out-of-bounds line] as opposed to actually being in the middle of the pitch. So it meant that

our coach could do the preseason coaching uninterrupted, and Jason could still interact on the side.

Jason Sudeikis: It was my inclination—I think it's my parents' influence—that we went in there quiet and gentlemanly on the first day. The second day is when we started hollering at them.

John Miller: To be honest, I'm not sure if any of the players knew what the heck was going on with Jason doing some of this.

Donna-Maria Cullen: If you look at the ad, we have players like Aaron Lennon and Gareth Bale there, and you can see that they cannot stop themselves laughing as they're coming off that pitch, even though they've not necessarily had a one-on-one interaction with him. He just exuded humor.

Jason Sudeikis: Especially for the training team: When we got to the younger guys, they were cracking up quite a bit. I really gave it to that young fellow, Jon Miles, who I yelled at a lot—a lot of it ended up on the cutting-room floor, but he got an earful and then he just smoked me in *FIFA*.

The Coach Lasso of the first ad is much more buffoonish and blustery than what the character would ultimately become, berating and mocking the players as his ignorance of the game is played for laughs. "Will you explain to me how that was offside?!" he erupts at a referee. "No, I'm asking you. Seriously. Explain offside to me, it makes no sense!"

The most obvious seeds of the show lie in the relationship between Lasso and Hunt's then nameless assistant—he teaches his boss various rules and uses flash cards to explain other Premier League clubs—and in a press conference that includes jokes that would return years later in the series. "They're going to play hard for all four quarters," Lasso tells assembled reporters. ("Two halves!" someone corrects.) "We're gonna play until there's a winner and there's a loser." ("Or a tie!") There's also silly physical comedy, as when Lasso stops using his hands "out of

*respect towards the game," and a running talking-head interview that
provides the final punch line when Lasso, moments after avowing, "I'm
here to stay. You can guarantee that!" receives word that he has been
fired. NBC's closing tagline reads: "It's football. Just not as we know it."*

*Much of the comedy was planned in advance, but not all of it.
While there was a working script, Sudeikis's improv and sketch instincts
quickly took over once filming started.*

Guy Barnett: Most of the jokes for the ads were written at writers'
sessions with Joe Kelly, Brendan Hunt, and Jason, most of which I
attended. Let's be clear, though: Those guys are fucking funny peo-
ple. Better comedy writers than me, for sure. But I feel I upped my
game enough to earn the credit I take as cowriter.

John Miller: Most of it was scripted. But you have improv players
like Jason Sudeikis and Brendan Hunt, so there is plenty of improvi-
sation that went in as well.

Brendan Hunt: We basically riffed for a few days. I mean, they
hired a professional crew of professional people who are used to hav-
ing a script every day, and we never had even the tiniest thought of
furnishing one of those. And we just had the biggest blast doing it.

Guy Barnett: I've seen a lot of great actors up close in that pro-
cess. Alec Baldwin, everything has to be scripted. Krasinski is a bit
more spontaneous. But Sudeikis was just a tour de force of spontane-
ity and fun and reactions. We wrote scenes, but his ability through
SNL to just create a character and let it go was really remarkable to
watch—eight hours, ten hours a day, just riffing on this character. It
was a remarkable performance.

Donna-Maria Cullen: I was absolutely astounded by the impro-
visations that Jason was able to bring to that. I mean, what a natural,
what a star. He deserves everything he has achieved with it. Just
the way he looked—I mean, the tight shorts. Even down to the bit

where it's no hands in our sport, so he tries driving the buggy with no hands.

Bill Bergofin: I think what was masterful is yes, there was a ton of improv and he was an absolute pro and a machine. But there was that balance. We had a goal here: This was an ad; it was a communication. But it's got to be entertaining even to someone who isn't a fan, and he was able to balance that.

John Miller: It explained the game to people through Jason's eyes, as his character was learning the game.

Jason Sudeikis: Our whole goal was making it so that American football fans will get the correlation, but also so that soccer fans enjoyed it as well.

Bill Bergofin: Jason did a great job of helping string the whole thing together. The ad-libbing. The foil that Coach Beard was— obviously you look at how that chemistry became so critical in the show. It was all the right pieces. It was a magical time.

The first ad, produced on a tight timeline, was just over four minutes, forty seconds long. It would eventually be broken into shorter segments to run on television and in movie theaters, but first NBC wanted to get the video out ahead of the Premier League season, in mid-August. So they posted it on the NBC Sports YouTube account on August 3, 2013, with the title "An American Coach in London: NBC Sports Premier League Film Featuring Jason Sudeikis."

Bill Bergofin: We wanted to get it out as soon as we could. We put it on YouTube and this is ten years ago; viral video and social media was, by volume, not what it is today, right? We put no paid advertising support behind it. We just sort of put it out there organically, and I went to sleep and woke up in the morning to emails like, "Hey, are you watching this thing?" And I clicked on it. And we'd had over a million hits in less than twenty-four hours.

It had impact. So much so that we heard from people in England, our contemporaries at the networks that carried the Premier League there, that they were jealous. They were flummoxed that Americans understood the sport and the nuance of it as well as we did. It was as funny, if not funnier, over there that we made fun of ourselves in such a way.

Donna-Maria Cullen: It immediately went viral. It was all anybody in the football world was talking about. Other clubs were kicking themselves that they hadn't done it.

Jason Sudeikis: Me and a buddy were at the US Open in Queens. I looked down and I see Thierry Henry and Tony Parker, both legends. They're like, "Hey!" waving at me. I'm like, What are they . . . ? I don't know what's going on here. Like maybe they've seen *Hall Pass* a bunch of times or something? And then after the match, they come up and they're gushing in their lovely French accents: "Ted Lasso! Oh my gosh, Ted Lasso!" Steve Nash was another guy who I'm a huge fan of and he's just terrific, huge soccer fan, big Tottenham supporter. At a Jay-Z concert in L.A., he came up to me. I was like, This thing's got reach in ways that I had no way to anticipate.

John Miller: Everybody who saw it liked it and laughed at it. And it respected the game, because he was sort of trying to make it work. We weren't making fun of the game, we were explaining the game— the whole thing about four quarters, two halves and all that. So it made it memorable and put it on the map. We won awards for the overall effort, and the Lasso campaign was the brightest and shiniest piece of it.

The Ted Lasso spot received three million views in its first week, and as of early 2024 it has been viewed nearly twenty-two million times on the NBC Sports YouTube page. The network's Premier League campaign would win a Clio and an Effie and be nominated for a Grand

Effie, the most prestigious award in advertising and marketing. Beyond the accolades, there was also evidence that it had worked: from the first week of the season, viewership of Premier League matches was three times higher on NBC Sports than it had been on Fox Sports.

In advertising as in Hollywood, such success leads only to one thing: a sequel. So the next year the various players reunited to create a spot for the beginning of the 2014 Premier League season. In "The Return of Coach Lasso," Ted, like countless fired coaches before and since, has become a TV analyst. Though still somewhat clueless about the game, he is now a veritable Anglophile, creating a shrine to British culture in his apartment when not interacting fecklessly with his NBC Sports colleagues: soccer presenter Rebecca Lowe and announcer Arlo White, who would eventually be a game commentator in Ted Lasso. *Ted is also coaching a girls' youth team, another subplot that will turn up in the series.*

In a bit of inadvertent foreshadowing, the spot ends with Ted being invited back to the Premier League, to coach Leicester City. In the real world, while the second spot didn't make the same splash as its predecessor, it was what convinced all involved that the character could be the anchor of a series.

But some of Ted Lasso's creators would have to let him go in order for it to happen.

Bill Bergofin: We always said, "You know, this should be a show." That was the feedback even from fans. One of the greatest things about YouTube and social media is they're like an instant focus group, and when you go back and look at the original comments, they were like, "Make this a show."

It was just talk after the first one. But with the second one it was like, "No, we *should* make this a show." Streaming was in its early days—Netflix was the eight-hundred-plus-pound gorilla. They

wanted it to be on Netflix. From my vantage point, we owned the IP and shouldn't NBC continue to benefit from this? With NBC Sports? I'm thinking, Well, OK, ESPN has *SportsCenter,* you know. Can we be comedic entertainment?

John Miller: Bill had got the rights to possibly do it as a half-hour sitcom, but we had no real place to put it. We could put it on the NBC Sports Network, but it would really be a fish out of water there. It really wasn't a sports show, per se. It was going to be a comedy, and as it ended up, it was far more about humanity than it was about soccer.

Bill Bergofin: We actually got the show greenlit for NBC Sports Network, Thursday nights. And at the same time, I had been put in touch with BBC for their streaming platform—we entered into a co-production agreement and they were going to provide a lot of funding. We actually started embarking on that with Jason and team, and actually at one point I was over in London with them talking to potential showrunners and things. We had this thing greenlit. And then, you know, I think Jason had other things going on, I can't really speak to that. But whether it was because where it was going to air or because he had other stuff going and it wasn't his top thing, it just sort of fizzled out. And I was pretty sad. I put a lot of time and energy into that.

Sudeikis would continue to develop the Ted Lasso *concept with Hunt and Kelly, before letting it go dormant for several years. When it eventually emerged as an unlikely hit for Apple TV+ in 2020, going on to net a record twenty Emmy nominations for its first season, there were few signs of its ad origins aside from the "Based on pre-existing format/ characters from NBC Sports" in the opening credits of each episode. A few jokes from the spot made it into the pilot; a rival player in a season two episode was named Barnett.*

The admen who were there at the beginning joke about waiting for their checks from Apple. But more earnestly, they express pride at their role in birthing a phenomenon.

John Miller: We own the character, and we are sort of the inspiration behind it. And we got a royalty for every season. We really didn't have much to do with it after the launch of the show, but we were instrumental in starting it off. After it got all the Emmys the first time, I sort of felt like a sperm donor at a beauty pageant. Who knew? Who knew I would create that?

Guy Barnett: The seeds are definitely there, which is why we still talk about it as somewhat ours. I tip my hat to them and what they've created. There are layers to that show that definitely aren't in the ads. I think Jason saw a warmth in this character that I didn't see. We did our job well, but we've also become the fathers of something so much bigger.

Bill Bergofin: Every time I turn on Apple TV, there's an ad for *Ted Lasso* on it. To have created something that has such impact, it's astounding. To see the vision really come full circle at the scale that it did, it's humbling.

Donna-Maria Cullen: I'm glad they kept it alive. I'm glad they kept looking for something else to carry on and do with it.

Bill Bergofin: Maybe it would have done amazingly on BBC; maybe it would have done great at NBC Sports. But there were going to be limitations to where the character could go. Timing-wise, 2015 or 2016 is when we had the show greenlit internally. You think about all the pieces, the audience and the product and all of that—it didn't have that alchemy culturally that it did when it finally came out. When people needed hope, people needed something to grab hold of, people were stuck in their houses. And this character provided that release that the world needed at the time.

John Miller: We said this could be a show and it turned out to be a show. So I have a significant amount of pride in it. Every episode says "Inspired by the character in a promo from NBC Sports." That was good enough for me.

Bill Bergofin: I was skiing in Park City with my daughter, who was a college student. And we get on the shuttle bus to go back to the hotel and the driver closes the door and he goes, "Hey, is anyone watching *Ted Lasso*?" And I look at my daughter, and she's looking at me like I'm a god, and she goes, "Tell them! Tell them!" And I'm like, "No, just looking at you, I got everything I need out of this."

John Miller: It's one of those unexpected things that happens in your job sometimes. My job was to get people to watch the Premier League and let people know that it was now part of NBC Sports, and that was accomplished. The fact that anything else came with it was just a joy.

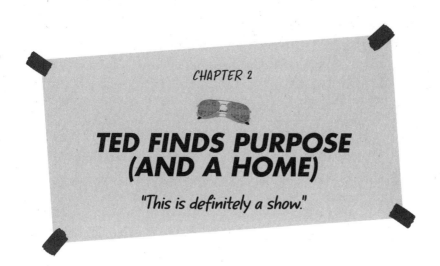

TED FINDS PURPOSE (AND A HOME)

"This is definitely a show."

Though the initial plans to make Ted Lasso the star of his own series fizzled out, Sudeikis never stopped thinking about the man in the mustache.

After SNL, Sudeikis had carved out a steady acting career in middling R-rated comedies like Horrible Bosses and Hall Pass, indie films, and guest-star stints in series like 30 Rock and The Last Man on Earth. But after shooting the second (and final) Ted Lasso commercial in 2014, the character stuck in his head as a kind of obsession of uncertain significance.

That began to change when Olivia Wilde, the actor and filmmaker who was Sudeikis's partner at the time (they would have a highly public split a few months after Ted Lasso premiered), suggested that he figure out something more to do with it.

Jason Sudeikis, creator, Ted Lasso, seasons 1–3: The commercial did well and was well liked by people in the UK and the US. So then we got to do the second one, and doing the second one really unlocked this element of the character that was his enthusiasm and optimism. Because the story of the first commercial was that he got hired and fired to coach Tottenham Hotspur in three days. So then he came back a year later and he loved it! He fell in love with soccer; he fell in love with London. And it was just a fun character to play, and it was a fun double act for Brendan and me as Ted and his assistant coach, who we then very cleverly named Coach Beard.

That growth between the first and second and that idea of extending the character's universe or mythology or whatever you want to say, that had to be realized. It was fun improvising this character; it was easy to create content. But what can we do with it? The theme and tone of it was just bouncing around in my head.

Then me and my ex-partner Olivia were at dinner somewhere, probably in Brooklyn, and she knew that Brendan, Joe, and I had a ball doing it, and that it was well liked. And she said, "You should do something more with that." It's not like that idea hadn't crossed our minds. But it's one of those things where it takes someone outside of you to get your baggage—the part of me that's like, That only exists in that medium and people don't want this—out of the way of your intuition. And the second she said it, I started just riffing: "OK, but why? Why would he do that? Because I'm, at that point, almost forty—he must have a kid. Why would he leave? Maybe things aren't going well at home." So that stuff marinated.

Brendan Hunt, creator, Coach Beard, seasons 1–3: The three of us had an awareness that Jason sort of verbalized first, like, this is fun. This character is fun. The three of us getting to hang together

making this thing is fun. But we weren't sure if it's gonna be another commercial or a movie or TV show.

Jason Sudeikis: Brendan and Joe came out to Brooklyn for a week and we kept spilling out stories. We'd get up every morning, drink coffee, go down to the basement, play pinball, and come upstairs and just riff on ideas. It was a very prolific week, because we came up with so many ideas for episodes and things that are in the show. You know, Ted seeing Rebecca cry in episode four. It was always at a gala—we knew we were going to show why this woman was hiring this guy to fail. Ted's panic attack in episode seven was always going to be surrounded within a karaoke situation—it wasn't until we were fortunate enough to meet and then hire Hannah Waddingham that it was going to be sprung by her. But all those things happened in that week.

Brendan Hunt: We wrote the pilot and were like, "OK, well, let's see what happens here." And then nothing happened. Nothing happened for a very long time.

Jason Sudeikis: It just sat dormant for three years. Olivia and I had kids; Joe created a series with friends of ours called *Detroiters*. Brendan was working, acting and everything.

Brendan Hunt: Jason kept having babies. Jason and Joe, their careers were going great. I was still waiting tables at a club.

Jason Sudeikis: Then the universe brought Bill Lawrence into the mix, and he actually made the son of a gun happen!

Sudeikis, Hunt, and Joe Kelly could hardly have found a more suitable partner than Bill Lawrence. A Connecticut native, he came to Hollywood in the 1990s and quickly became the Nate Shelley of TV: a "wonder kid." At twenty-seven, he cocreated the hit Michael J. Fox sitcom Spin City *in 1996 before moving on to create the hospital comedy*

Scrubs in 2001. That show, which ran for nine seasons, mashed up heart and silliness in a way that would be familiar to most Ted Lasso *fans. Lawrence's follow-up,* Cougar Town, *eventually moved past its original focus on middle-age lust to become one of television's most easygoing portraits of adult friendship, another future* Lasso *hallmark.*

When he and Sudeikis connected, in 2017, Lawrence was amid a streak of series that either had short runs (Ground Floor, Undateable) or didn't even make it to air (Spaced Out, which starred a then unknown Brett Goldstein). Lawrence and Sudeikis occasionally played in the same pickup basketball games in Los Angeles, and they had been looking for something to develop together.

Bill Lawrence, creator: I wanted to work with Jason Sudeikis; he just cracks me up. I thought he was awesome on *SNL*. Whenever he shows up in a movie I'm immediately into it, and he seems like that dude you want to hang with.

Jason Sudeikis: We were chatting about another thing, and that didn't quite work out. But our respect and rapport did, and he asked me at the end of it, "Do you have anything else?" And I was like, "We have this thing," and as that old saying goes, Bill's forgotten more about television than we'll ever know. We were like, "We don't know if this is worth a damn," and he's like, "Oh yeah, this is great! This is definitely a show."

Bill Lawrence: I'd seen those sketches, the promotional videos for the Premier League, back when he did them. I thought they were so funny, and he said, "What if we made that character three-dimensional and really rounded him out?"

If Jason had pitched the first video, I'm not sure I would have been as into it. I thought what these guys did was really funny, but he was a bombastic, yelling . . . I wouldn't say angry, but certainly a more aggressive Ted Lasso. And from the start, Jason was really clear that

this was about a dude living in the world of not only curiosity but kindness and empathy and forgiveness.

Jason Sudeikis: So then the four of us all sat down and rewrote the pilot together. I knew we had to work backward. At that point I'm forty-three, I have a child of my own, so we knew he was going to be married. But then why does he take this job? Well, things must not be great at home. We added the kid once we connected with Bill.

I personally didn't want to do the arc of son of a bitch to saint. It had already been crushed by Ricky Gervais as David Brent and Michael Scott by Steve Carell, and the idea of playing an antihero dramatically had been done so well: Don Draper, Tony Soprano, *Breaking Bad*, et cetera. So it was like, What about just playing a good guy?

Bill Lawrence: I was sitting with a writer, Bill Wrubel, talking about the show and asking him to come meet Jason and hopefully get to write on it, and he said, "What about the show appeals so much?" And I said that I'd reached a point in my life that if I were to meet Ted Lasso for real, I would go, "Now I'll just wait for two weeks for this guy to reveal that he's just an asshole like everybody else." And then two weeks later, when he doesn't reveal that and he turns out to be an empathetic, forgiving, kind person, you have to take a look at yourself.

Jason Sudeikis: Bill and I went around and pitched it. A thing we talked about was this antidote or antithesis of the shitty cocktail of a human man being ignorant and arrogant. Which, lo and behold, a Batman-villain version of it became president of the United States right around the same time.

Bill Lawrence: I had just been living in the Czech Republic, because this show I was doing was shooting in Prague. And the perception of Americans outside America is not the same as we remember. So to do a show about how we want to believe Americans would

behave overseas and how we want to think Americans would be thought of by the people within that country meant a lot to me. It's not the Ugly American abroad.

Jason Sudeikis: What if you played an ignorant guy who was actually curious? And when someone used a big word like *vernacular,* he didn't act like he knew it? We all know that comedy move where it's like, "Oh right, yeah, *vernacular,* exactly." But he just stops the meeting, like, "Question: What does that mean?"

And that idea of saying please and thank you. I remember holding doors for people when I first got hired at *SNL,* walking out of 30 Rock and people stopping, thinking I'm going to hit them in the butt if they walk through it. It was always really funny to me. So it was based on all those observations about what was going on with society and discourse online and in person and lack of manners, et cetera. It was all that rolled into one.

Doozer Productions, Lawrence's company, had a contract with Warner Bros. Television, which would become the producing studio for Ted Lasso. *But the creators needed someone to actually air it. Sudeikis and Lawrence pitched the show around Hollywood and found little interest until they talked to program executives at Apple TV+, which hadn't actually launched at the time. Whatever misgivings they had about the unproven platform was offset by its parent company's global dominance and deep pockets. "Evidently they do more than just television," Sudeikis cracked.*

They sold the show to Apple in 2018 and were given a green light to production in early 2019, then the creators assembled a writers' room to help Sudeikis, Hunt, Kelly, and Lawrence build out the world of Ted Lasso. *Brett Goldstein and Phoebe Walsh were British writer-performers who would also act in the series (as Roy Kent and Jane*

Payne, Beard's tempestuous girlfriend). Jane Becker had been a writer mostly for irreverent animated series like Rick and Morty, SuperMansion, and Harley Quinn. Leann Bowen had come up through Upright Citizens Brigade and written for Funny or Die and series like the Netflix comedy Dear White People. Jamie Lee was a touring comic and talk-show panelist who got her big break on Last Comic Standing. She also wrote for shows like Ridiculousness and Crashing. Finally, Bill Wrubel was a veteran writer and producer for hit sitcoms like Modern Family, Ugly Betty, Will & Grace, and Sports Night.

Some of them were familiar with the Ted Lasso ads, but they quickly learned that the series would have little to do with coaching bombast or, for that matter, soccer.

Bill Wrubel, writer, seasons 1–3: They pitched it but people didn't want it because often they were reacting to the promos—like, "I don't know, the promos seem goofy; the promos seem broad." I know for a fact certain well-known streamers passed on it for that exact reason. But when I read the script it was actually kind of melancholy. And then little by little, as we worked on the show—because it was often my job to kind of drill down with Jason on what we wanted the show to be—I was like, Oh, this is going to be entirely different. There's a handful of jokes from the promos we're going to steal, but this is its own brand-new thing.

Joe Kelly, creator: We went into filming feeling like the underdogs that Richmond were. We weren't coming on the heels of a bidding war. We weren't coming on the heels of like, Here we go with this monster show. And it felt like it helped the process, the tone, the feeling, the vibe, everything.

Jane Becker, writer, seasons 1–3: The line that drew me to the show in the original pilot was, "If we see each other in our dreams,

let's goof around and pretend we don't know each other." That was the weirdest, stupidest thing, but I thought, You got me. These people fucking get it.

Bill Lawrence: I remember in the interviews of writers, which is before you've outlined or written any of these shows, that Jason was asking each writer who the mentor was in their life that gave them a little push, a head start into the world. It's rare that you know so early in conception that that's the stuff you're going to try and hit on.

Bill Wrubel: One of the first questions he asked me was, "Have you ever had a mentor in your life? I want you to tell me a little bit about him or her." And that speaks to what Jason's vision was for the show, which is, he didn't want it to be a goofy coach. He wanted it to be about a human being who could have an impact on the lives of a bunch of other human beings.

Jason Sudeikis: I've always felt that if you ask someone who their heroes are—and I don't mean, like, famous people but just actually people that encouraged them—you can learn a lot about someone.

Brett Goldstein, writer, Roy Kent, seasons 1–3: At the beginning, all there was was the pilot script that Jason, Joe, Brendan, and Bill had written and the original commercials. All the characters were there in the pilot script, in their basic form, and then we just started filling up the boards. It's got more and more specific as it's gone on, but there were end points that Jason had.

Jane Becker: Jason had thoughts for every character, what they're going to be doing for three seasons. I think Nate, as far as I know, is the one who has stayed true to his vision. But for everyone else, it was fun to see them change and grow when you put that character into the writers' room. You know, shake it up and see what comes out.

Jason Sudeikis: I make the joke about: fund the arts, don't give all the money to the [pharmaceutical companies]. Because there is a

way to exercise and exorcize your demons when you get to work in the arts. There's a little part of me in every character, and I have definitely taken stories from my life and philosophies about life and have given them all to Ted. And things in life that I messed up that I want to retry, redo. You get the opportunity to do that when you are fortunate enough to work in the arts.

Brett Goldstein: Being in that writers' room—we're in there however many hours a day around the table all together. It is this weird sort of half group therapy, where we tell each other everything and people cry and hug. When you think about it, it probably looks very odd. It's a beautiful thing. It's really quite amazing.

Jason Sudeikis: I know the vulnerability and honesty that our writers' room goes about sharing, both in their execution of those drafts but also just in the regular banter that occurs in those sessions. Ted, specifically, his reference level is that of everybody in that room.

Brendan Hunt: So much of Ted comes from at least part of Jason. It is a growth—like a cyst or a goiter—that comes from DNA that has actually happened in Jason's life. Ted is a manifestation of coaches he's had and teachers he's had, and the Midwestern kindness and thoughtfulness with which he was raised. We still watch soccer games, but I have to explain the offside rule to him at least once, sometimes multiple times. Like, "We've gone over this, man."

Jason Sudeikis: Early on, we didn't have series regulars as being the players. That was something that, as we were breaking the story and certainly as the Roy-Jamie-Keeley love triangle became paramount, was fodder for a great, fun story, romantically, comedically, and dramatically. A guy kisses your girl and then you have to pass to that guy or not, those micro-stories that let you get to know those characters. You're going to care about whether that pass happens or not, and that's theater, baby!

Brendan Hunt: I was not privy to the hiring process at all. I can say that the results were fantastic. They were looking to have a healthy female presence in the room, especially because this is a show that's going to take place a lot in locker rooms. And also, there is a fair amount of people who don't much care about sports, be they male or female. And Bill Lawrence, from early on, was very fond of saying loudly, "It's not a soccer show! It is an ensemble comedy, it is a workplace comedy. Not a soccer show!" And I'm like, "All right, man, stop looking directly at me."

Jason Sudeikis: The way I would pitch it is, "This show is as much about soccer as *Rocky* is about boxing."

Brendan Hunt: We pushed it away from being too much about soccer—very wisely, I say, as the resident soccer nut of the group. But because it's a sports [TV show], that was always going to be a part of the structure of it in terms of finding the emotional hearts and crescendos that sports and sports movies do. So it was always going to be available to us in that way, but as something that would serve the story.

Jason Sudeikis: It's family, it's a workplace, it's both chosen family in some instances and also the families that we're born into. Sports can carry all those stories, and you can Trojan horse a whole bunch of interesting things into those worlds. I still believe you can learn a lot about watching someone play a game and seeing how they go about, yes, winning and losing but also just how they go about playing it. They're fantastic playgrounds, and whatever you want to tell in those stories, you can do it.

Brendan Hunt: One thing about the soccer-as-life metaphor is the way that figures into our improv backgrounds and the way we see the world, improv-wise. Because soccer is the least structured of the big sports, it requires the most improvisation and quick thinking,

and the goal is to find flow with your colleagues. The best improv shows are doing that, too, and if you can find flow in your life then you're firing on all cylinders. I don't know where the big, sweaty Scotsmen who come and kick you in the shins fit into that metaphor, but it's all of a piece.

Jason Sudeikis: I'm going to butcher the Mark Twain quote: Every person's life is a comedy, drama, and a tragedy. So we had to honor those other two elements, because the comedy was baked into the high-concept premise of the fish-out-of-water, bungling-idiot-who-doesn't-know-what-he's-doing situation. And the mustache, obviously.

So that's why I find it to be not too indulgent for the show to be called *Ted Lasso* and be named after a character, much less a character that I play. Because *Ted Lasso* is a vibe; it's not just a show and a character. And that vibe trickled down into the story and into the other characters.

FIRST HALF

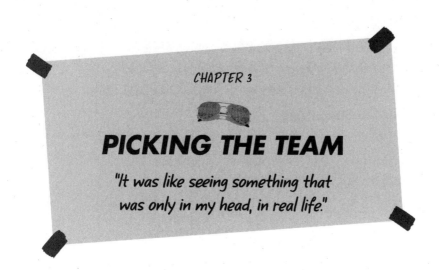

CHAPTER 3

PICKING THE TEAM

*"It was like seeing something that
was only in my head, in real life."*

The creators had a deal to air the show, a writing staff, scripts, and the beginnings of a three-season plan to take a group of footballers and their handlers and friends on a journey toward their better selves. They had a vibe. What they needed was a bunch of talented folks to bring it all to life on-screen.

Two characters were set: Ted Lasso and Coach Beard, the lone carryovers from the original ad. Jason Sudeikis was thinking about the indie darling Juno Temple for the role of Keeley Jones, and he also had Anthony Head, the veteran screen and stage actor, in mind for the irredeemably caddish ex-husband, Rupert Mannion. But everyone else was up for grabs.

Theo Park, casting director, seasons 1–3: When the script came to me, Jason was obviously on board to play Ted Lasso and Brendan

Hunt was on board to play Coach Beard. But apart from that, we have to cast everybody else.

Bill Lawrence, creator: You always have to start with Jason. Because it's like having an answer key to a final exam if you have the lead of your show already cast, and you're kind of picking the planets that circle around him.

Theo Park: Jason was really clear about what he wanted for each character. He'd been thinking about people for each and every character and where they're going as well in the arc of the character.

Bill Lawrence: It was a huge effort for Theo. Because not only was she doing all the work hunting actors and actresses down, but she was doing it in a vacuum, because we wanted everybody other than Jason and Brendan Hunt to be British and to be cast from over there.

Theo Park: It was really exciting, because these guys didn't really know anybody. I had free rein and it was fantastic. I just got my favorite comedy actors in and they're not actually all that well known, some of them.

Jason Sudeikis, creator, Ted Lasso, seasons 1–3: It was important to have people read. The people that do "offers only"—I don't subscribe to that as an individual. I'd rather audition for it, meet with the person doing it, and get the job and earn it versus get fired two days later. That's just me. But, you know, to each their own.

Bill Lawrence: And we lost some high-profile actresses and actors that were interested in certain parts that I bet are kicking themselves now, because Jason just made the edict of no one's getting any of these big parts without auditioning and showing that you want it.

Theo Park: They got me early on to really focus on Rebecca Welton, the female lead. She's a complicated creature, so she had to have a lot of range, many different facets.

The first role cast was Rebecca Welton, the female lead of the show.

A divorcée who received a Premier League club in the split, she was the character who set the entire show into motion by bringing over what seemed to be a goofy doofus to run her ex-husband's beloved AFC Richmond into the ground to spite him. Whoever played her would have to be formidable enough to present as an icy villainess in the early going and supple enough of a performer to make Rebecca's eventual pivot to decency and remorse seem credible.

Jason Sudeikis: We had a couple people in mind, like, you know, big fish. Apple could probably pay them enough to make things interesting. Unfortunately, no one cared about us or knew what we were doing, and a lot of folks were also already busy. So we couldn't get one of those "big fish," and then we opened it up to auditions.

Theo Park: For Rebecca, Jason had a really clear idea that she was older, in her forties, and had come from money but had sort of turned away from money to try and make it herself. Maybe she was working as a waitress at a private members' bar and then met this fantastic man and had this fantastic love affair.

Jason Sudeikis: We had anywhere between ten to twenty women audition, and some were just absolutely fantastic. Brendan and I went to do chemistry reads with them in London, and I came back pretty confident in some people. Then our writers' room, which was filled with our producers as well, didn't respond in the same realm. Sometimes when you're in the room with someone, it's a different energy than when you're watching them on television. Nobody really responded.

So then Brendan was chatting about something totally different with a buddy of ours named Todd Stashwick. "How are things going?" "Oh, doing this show, trying to find this character." "What's she like?" Brendan gives, like, a two-line description. And Todd just goes, "Hannah Waddingham. That's who you want to play this part." And

it was kind of like, "OK . . ." So then we looked her up and, wow, she definitely looks the part. She didn't when she was the "Shame" gal.

The "Shame" gal. That amounted to what most people knew about Hannah Waddingham going into Ted Lasso, *though they might not have known they knew it. As the sinister nun Septa Unella, Wadding-ham was part of one of the most memorable scenes of the global mega-hit* Game of Thrones. *Her character accompanies Cersei Lannister (Lena Headey) on a nude walk of shame through the streets of King's Landing while ringing a bell and chanting an instantly meme-able re-frain: "Shame! Shame!" But the Waddingham of* Game of Thrones *was so unrecognizable compared to the Waddingham of* Ted Lasso, *many fans were gobsmacked to learn they were the same person.*

"Thankfully, everyone's shocked," Waddingham told Jimmy Kim-mel in 2021.

But even before Lasso, *Waddingham was far more than the "Shame" gal. The daughter of an English National Opera singer, Melodie Kelly, she is an exquisite singer herself and has been a fixture on British stages for decades, with acclaimed roles in blockbuster shows like* Spamalot, Into the Woods, *and* Kiss Me, Kate. *"I am, at heart, an old-school the-ater girl now, because that's where I was for twenty years," she told* Backstage *in 2021.*

She also has appeared in other acclaimed series, including 12 Monkeys, *the Netflix hit* Sex Education, *and a new adaptation of* Tom Jones. *But a traumatic experience during filming of the science-fiction series* Krypton *left her reevaluating her career. While she was shooting in Belfast one night, her young daughter back home in London became suddenly, seriously ill with a mysterious affliction that was later revealed to be Henoch-Schonlein purpura, an inflam-mation of blood vessels that causes a rash and digestive distress and can lead to lasting kidney damage. With no more flights to London*

available that night, Waddingham experienced the parental nightmare of being separated from one's child while she is in the midst of a medical crisis.

"*I couldn't get back,*" *she said on the* White Wine Question Time *podcast in 2021.* "*I tried to charter a helicopter. The producers tried to get me on some boats over there, and I couldn't get back.*"

She made it to London early the next morning and her daughter eventually made a full recovery. But the experience left Waddingham rattled and determined to remain close to home, whatever the cost to her career.

Hannah Waddingham, Rebecca Welton, seasons 1–3: To my management both here and in L.A. on a conference call that day, I said, "This is not happening again. Whether that means that I have to dumb down what I'm doing or be less committed to work that might have a possibility of taking me abroad or whatever, I'm perfectly happy to be here doing bits and pieces. I'll do concerts, I'll do voice-overs." That would be brilliant for any actor, but where they were wanting to take me and where they felt I was moving into—the phone went silent. And I said, "Look, I get it. I don't want it this way either. But I'm first and foremost a mum and more importantly a single mum, and I'm happy with that decision."

A month later when my girl was getting better, I stood outside in my garden, and I looked up at the skies and I went, "Thank you so much for pulling her through this. I'm really grateful. Is there any way you could give me something that will just fill our lives and let me do things with her as a single mum and will keep us, financially? And also, can I be so cheeky as to say, could it be something that shows everything that I can do and things that I don't feel like I've been able to do yet? And is there any way it could be here, maybe around the corner?" And I'm not joking: in two months, the audition

came in for *Ted Lasso,* which shoots forty minutes away from my house. Completely mental. Ask the universe, people, it works!

Theo Park: Hannah taped with us in London, and then they flew her out to L.A. to meet Jason so they were able to read opposite each other.

Hannah Waddingham: I just thought, Oh, this will go to, as I call them, one of the "famouses." I'm a jobbing actress, to a greater or lesser extent, and that's it and that's fine for me. Because I feel like if I let any la-di-da stuff in, the quality of my work will suffer, and that's the honest truth. So no, not for me, the whole famous-y thing, celebrity thing.

Jason Sudeikis: She auditioned, then I can't remember how quick it was after that but she's now in L.A., you know, jet-lagged as hell. We do a chemistry read like we had done with the women in London. And it was just evident to me: The minute or the second I saw her, it was like seeing something that was only in my head, in real life. You're meeting and shaking hands and it's like, Oh, yeah. And then our conversations before the audition, during the audition, post-audition only cemented that notion.

Hannah Waddingham: On a very basic level, Jason and I just got on. And he obviously liked what I did.

Theo Park: It was a slam dunk.

Hannah Waddingham: Jason and I had a really nice immediate shorthand, and I was in there for two hours. Bill Wrubel was there and put me at ease. At the end of the meeting he went, "I must just say that I loved you in *Spamalot* on Broadway." And then the casting director, as we walked down the corridor, said, "God, it's such a pity that Rebecca doesn't sing." And under his breath Jason went, "She does now."

Jason Sudeikis: Then it went up the chains at Apple, went up the chains at Warner Bros. A fellow named Peter Roth, who was in charge

of Warner Bros. Television at that time, was like, "I love her." A guy that had done so many shows just immediately snapped on to it. That really helped. But for me, it was right from the first, like, OK, Rebecca. Done.

Hannah Waddingham: When I came home, I didn't hear anything for ages and I just thought, OK, well that was that. I know I couldn't have done any better with the material. I felt the character really rippled through my bloodstream and I thought, OK, well they've gone for a famouser, and that's fine. But apparently no, Jason had gone, "I knew it was her when she walked in the room." And he didn't care that I was taller than him in heels either.

Jason Sudeikis: It's one of those neat things where sometimes the right thing shows up at the right time, and you're ready for it and they're ready for you. And off we went.

If the hunt for the right Rebecca was long and involved, the search for Keeley Jones, who arrives as the model girlfriend of the star footballer Jamie Tartt but has much bigger things awaiting her, was nonexistent. The creators met with a number of actresses, but Sudeikis from early on had a particular performer in mind: Juno Temple, who had worked with his then partner Olivia Wilde in the short-lived HBO series Vinyl. *His interest surprised Temple more than anyone.*

The daughter of producer Amanda Pirie and Julien Temple, an experimental filmmaker, Temple has been a professional actor since she was a child. She won the BAFTA Rising Star Award in 2013 and has stood out in both intimate award-winning dramas like Notes on a Scandal *and* Atonement *and Hollywood blockbusters including* The Dark Knight Rises *and* Maleficent. *But she was not exactly known as a comic actor. "I've played, like, lesbian werewolves," she said on* The Tonight Show *in 2022. "I've spent quite a lot of time in trailer parks going through some shit."*

So she was confused when Sudeikis texted her about the job.

Theo Park: Juno was Jason's idea. We saw a lot of people in London and in America, lots of good actors, but no one was quite right. And Jason had thought of Juno because Olivia had worked with her and he'd met her. And he said, "What about Juno?" And I'm like, "Yeah, but would she ever do it?" And he just talked to her and he has amazing powers of persuasion, and she said yes.

Juno Temple, Keeley Jones, seasons 1–3: Jason texted me out of the blue. I'd been back in L.A. from shooting this show called *Little Birds*, inspired by Anaïs Nin's short stories. So I'd just spent six months playing this repressed girl in the 1950s who was on diet pills and valium at the same time. I go back to L.A., and before my luggage had even made it back, I get texts from Jason saying, like, "Yo, yo, Jason here, curious if you want to read this pilot." I genuinely thought it was a mistake. I was like, Oh no, he thinks I'm a different actress, because I am not known for comedy.

Brett Goldstein, writer, Roy Kent, seasons 1–3: I thought, Wow, that's a left-field choice. Because of all that darkness.

Jason Sudeikis: I just knew the authenticity of what that role needed to be. It needed to be someone that was nonjudgmental of the role.

Theo Park: She's such a chameleon anyway—that's her thing, Juno. In everything she does, she's different.

Juno Temple: I had to go to a friend's thirtieth birthday and Jason asked me to come and meet him for a drink later that evening, so I was really dressed up. I went to meet him in a local bar in an outfit that, actually, now I look at it, is an outfit Keeley would wear, so I may have done myself a favor. He was in board shorts, sneakers, and a T-shirt. I suddenly thought, He's gonna think I'm trying really hard! We had a real giggle about that.

Nick Mohammed, Nathan Shelley, seasons 1–3: Juno's a ray of sunshine. Whenever she comes into the room, it lights up.

Brett Goldstein: She's fucking amazing. She's fucking pure light.

Juno Temple: Jason told me a little bit about the plan for Keeley's journey from the start to the end of the season. Not in any crazy detail—that's always kept quite close to his chest—but he described the show he wanted to make in terms of the British *Office* meets *Friday Night Lights*. I thought, If he can pull that off, that's some kind of wizardry.

He has this ability with a lot of people that were cast in the show to see something in all of us that we didn't necessarily think we had in us at all. That being said, a lot of the times I'm telling jokes on *Ted Lasso*, I don't know they're a joke.

Keeley began the show as a spin on a so-called WAG—British slang for footballers' "wives and girlfriends"—but would ultimately go on to run publicity for AFC Richmond before leaving to pursue her own business ventures. The character was loosely inspired by Keeley Hazell, a longtime friend (and briefly romantic partner) of Sudeikis's who is better known to Ted Lasso fans as Bex, the young woman Rupert marries after leaving Rebecca. A model turned actor and author, Hazell became a writer on the show in season three.

Despite her trepidation over tackling comedy, Temple was won over by the character's relationship with Waddingham's Rebecca, a mentor who helps Keeley realize that she has more to offer the world than just a pretty face.

Juno Temple: The thing that really turned me on about the conversation I had with Jason was the relationship Keeley would have with Rebecca. We don't see female friendships like that often enough. I think those relationships need to be shown as much as humanly

possible because they're the relationships in my life—Juno's life—
that, my god, I would be dead without them.

*Brett Goldstein was one of the earliest additions to Team Ted
Lasso, but he didn't actually make it into the cast until months later.
That's because he was hired first and foremost as a writer, with a possi-
ble chance to play Higgins, AFC Richmond's mild-mannered commu-
nications director. But that went out the window after Jeremy Swift's
outstanding audition. So instead, the amiable, somewhat soft-spoken
Goldstein did something no one expected: he put himself up for the role
of the rageful team captain, Roy Kent.*

*A veteran comic performer in Britain, Goldstein had written and
appeared in films, series, plays, and stand-up gigs, stringing together
enough jobs to make a decent living and enough credits for a respect-
able career. But the seeds of his spot in Ted Lasso were planted a few
years earlier in something that didn't work out: a failed sitcom pilot.
And the seeds of what he did with it were planted in the previous years
and decades in London's theater and comedy scene becoming the kind
of actor who could turn a fading soccer player into one of TV's most
instantly indelible characters.*

Bill Lawrence: One of the fun things about TV, before stream-
ing became like the feature film business, was you're always trying to
discover cool people. The world I lived in for a long time was stand-
ups who maybe hadn't been widely known as actors or actresses.

I knew a couple of people who had seen Brett do stand-up, and I
was able to get some tape of him on a pilot he did that did not work
and did not go on TV. He was funny and good, so I met with him and
liked him and cast him in the lead of a network show. It was called
Spaced Out; it was kind of a dysfunctional family workplace comedy
set in a SpaceX-type place. On that pilot, he jumped in and helped to

make the character funnier, helped to write other jokes. We just really connected. But it was a massively failed project.

Brett Goldstein: I don't know if this is a good thing or a bad thing, but I think my brain works better when there's twenty things happening at once, rather than one. And that's always been that way. I have always been a full workaholic. Even when I was doing stuff that no one was watching, I was always working. I was always writing two things at once and doing gigs at night and making shorts. Either I'm mentally unwell or genuinely this is the thing that gives me purpose and makes me happy.

Bill Lawrence: I liked him as a comedic voice. I thought he would be a great comedy writer. And when Jason and I were staffing up the first season of *Ted Lasso*, we knew it was really important to get a couple Brits on the show.

Brett Goldstein: Bill Lawrence called me up and said, "I think you'd be right for this show, *Ted Lasso*." And I knew Ted Lasso because the original sketches were at Tottenham, which is my team. And he said, "Do you want to come and do this? You'd have to be in L.A. in a week." And I said, "I've got some stand-up shows booked." And he was like, "You're fucking mad if you turn this down for some stand-up gigs."

He said, "You'll have to talk to Jason first, see if you get on." Me and Jason did a FaceTime at, like, one in the morning my time, and we talked for an hour and a half. At the end of it I was like, "I think we're in love."

Jason Sudeikis: Bill had worked with him on a show. At that stage of the game, I was meeting with various people. It was mostly just a vibe check to kind of articulate the tone of what we were hoping the show would be and some of the references. I immediately liked

him. We had the same level of affection for, you know, the British *Office* and that whole notion of having characters and getting to know each of them to encourage the storytelling. There was just a common language there and an appreciation of work gone by.

Brett Goldstein: Then, like, on a Saturday I was told, "Get on a plane tomorrow and be here on Monday," and I did. For the forty people who were coming to that stand-up gig, I can only apologize. But I don't regret it.

Bill Lawrence: The other thing is we got to know Brett better—you know, his family is buried in the Premier League. His dad is one of those psychotic fans. So it really helped us fill out the staff. But he was originally hired as a writer, not a performer.

Brett Goldstein: I was there as a writer on the show. Then I was secretly thinking I could be Roy. I remember the exact moment I wanted to play him: It was around the time we were writing episode five. It was the scene in the car park where Roy scares Keeley and she goes, "You snuck up on a girl in the middle of the night, well done." I thought, I really get Roy; I understand him.

But I also knew no one was thinking of me for Roy, so right at the end of the writers' room I put myself on tape. And I emailed it to Bill Lawrence and I said, "If this is shit, we never need to speak of it again. Like, pretend you never got it—I will never ask. But I've been thinking I could be Roy, and I made you a tape."

Bill Lawrence: "If you don't like this, please don't speak of it and we don't have to be uncomfortable." It was adorable. Everything Brett does is adorable.

Brendan Hunt, creator, Coach Beard, seasons 1–3: Roy is based on this guy Roy Keane, this legendary hardscrabble midfielder from Ireland, and we were seeing guys in that sort of macho vein. On his way out the door, Brett filmed himself doing the Roy audition scenes

and he sent it to Bill Lawrence with the most, like, humble, typically Brett apologetic email. They watched them that day before I got there, and when I got in, there was a buzz about the place. I was like, "What's happening?" "Brett filmed himself as Roy." And it was so clear right away, like, Oh, Brett's Roy, this is great.

Jason Sudeikis: It was a no-brainer.

Brett Goldstein: And then I flew back to London, and when I landed, I got an email saying, "This is fucking brilliant."

Brendan Hunt: The voice was not yet as gravelly as it would become, but he had the timing, he had the pain, he had the comedy. He's a very, very talented man and he just happens to have finally found the exact right part to bring that out to the world.

Brett Goldstein: When I look back on it, I hate to sound like it was like a calling. But I felt it very, very strong. I felt like I have nothing to lose here because maybe two other times in my life, I've had that feeling where it's like, This feels very important to do this. So I better do it.

With her beauty, modeling, and chic wardrobe, Keeley injects a note of glamour into Ted Lasso *from the moment she walks on-screen. With his glower and endless f-bombs, Roy immediately infuses the show with grit. Nathan Shelley initially contributes the inverse of both qualities.*

In the script for the pilot episode, the future Nate the Great is described like this: "30s, put-upon clubhouse attendant, he's got a lot to offer, but has no belief in himself." That certainly sums up the Nate we meet in the beginning of Ted Lasso. *But the man who would eventually play him worried that he came across in his audition as too much the opposite: arrogant and self-involved.*

At the time Ted Lasso *was casting, Nick Mohammed was in the thick of production on* Intelligence, *a workplace comedy he created set*

in a UK spy agency that starred David Schwimmer, Ross himself, as a brash American agent and Mohammed as his awkward computer analyst sidekick. It was the biggest break yet for Mohammed, who had by then been working steadily on British stages and screens, primarily television, for more than a decade. But his workload on Intelligence *was such that after he lost out on his first* Ted Lasso *audition, he wasn't sure he wanted to do the one that led to his biggest break of all.*

Nick Mohammed: I initially went out for Higgins. I obviously didn't get that because Jeremy was too good. Quite rightly didn't get that. About a month later, they asked me to tape for Nate.

Bill Lawrence: He did read for it, but was very casual because he had his own show going and wasn't sure what he was doing.

Nick Mohammed: They sent me the pilot and then maybe, like, three choice scenes from later on in season one. I only submitted one when they asked me to do three, which must have come across as very arrogant at the time.

Brendan Hunt: Nick did only one of the three scenes, but I was actually already a fan of Nick because I had seen his one-man show in Edinburgh in 2007, I believe. So when I saw his name come across, I was predisposed to be like, "We have to pay very close attention to whatever this guy's gonna do, because I got a good feeling."

Nick Mohammed: I had to do it on my lunch break.

Theo Park: And it was totally perfect in every way, mic drop.

Brendan Hunt: He only did one scene. It was clearly in his dressing room. It was clearly hastily done. But Nick doesn't know how to do comedy badly.

Brett Goldstein: Nick is so good. He's such a good actor. My god.

Bill Lawrence: So we had to get in the game and sucker him into doing this one, too.

Nick Mohammed: I count my lucky stars it was enough to get the part. Once I'd gotten it, I remember Jason and Bill explaining that Nate is going places.

Mohammed wasn't the only Ted Lasso *cast member who initially hoped to play Leslie Higgins. At least two other stars of the show originally had their eyes on the part of the somewhat bumbling but kind-hearted communications director. But Jeremy Swift was so perfect for the role, all involved say he'd locked it down before his audition was even over. "It was one of those auditions that just hit the ball out of the park," Hunt said.*

Swift has been acting professionally since the 1980s, spending most of that decade on the stage. Since the 1990s, he has worked steadily in British television and film, displaying a particular knack for playing servants to England's upper classes, experience that prepared him well to do Rebecca Welton's bidding in Ted Lasso. *He was a footman in* Gosford Park, *a manservant in* The Durrells, *a butler to Maggie Smith's dowager countess in* Downton Abbey. *It was this last role in the international hit that led to his audition for* Ted Lasso.

Jeremy Swift, Leslie Higgins, seasons 1–3: I met a casting director, the lovely Theo Park, and went in there and did some scenes and waited to hear. Initially I thought, I'm not quite sure what to do with him. And I said that to my agent, and she said, "Swift it." I sort of thought, I don't even know what that means. So I did that.

Theo Park: For Higgins, I saw a dozen really great people who all came in differently. But of course, Jeremy Swift totally nailed it.

Jeremy Swift: Loads of people went up for Higgins—including Phil Dunster, who plays Jamie Tartt!

Nick Mohammed: I can't believe Phil went up for Higgins.

Brett Goldstein: I was originally brought on as a writer with the

promise from Bill Lawrence of, "Maybe you'll play this Higgins character." And I knew I'd lost that gig the second we in the writers' room saw Jeremy's casting tape.

Brendan Hunt: Jeremy's audition came in pretty early as we were looking at a bunch of Higginses, and it was one of those where everyone in the writers' room goes, like, "Oh. Well that's the guy."

Jeremy Swift: I just turned up with my take on it. I do like to smooth the waters on things. I think I'm a little bit more proactive than Higgins, but you just have to think, What would it be like if I just was a bit more confused than I already am? I'm winging it a bit because that's what he has to do.

Jason Sudeikis: It became an audition that we watched over and over as we were casting other people. When we were questioning other parts, we'd go, "Throw Swifty back on!"

Jeremy Swift: I'd wanted to be in an American comedy for a long time. I go up for a lot of things so I didn't think about it too much because it was going to be so upsetting when I didn't get it. But then I heard I was in the running along with a couple other people. Then the possibility of upset became even higher. I just thought it looked like tremendous fun. Getting it was amazing.

If Swift was the veteran of the ensemble, Toheeb Jimoh was at the other end of the experience spectrum: when he got the audition for Ted Lasso, he had been out of drama school for only about a year.

Born in London to Nigerian immigrants, Jimoh moved with his family back to Nigeria as a baby and stayed there until he was seven. When he returned to Brixton, in South London, his Nigerian accent made him a target for bullies, which made the fact that his breakout role came as a Nigerian footballer all the more satisfying. "I'm getting paid and I'm doing the work and my career's great for the same accent

that I was bullied for as a kid," he told the Peanut Butter and Biscuits *podcast in 2022.*

Jimoh found a haven in acting, performing at his secondary school and in a youth theater program put on by the Young Vic, and he went on to study at London's Guildhall School of Music and Drama. (Other alumni include Damian Lewis, Daniel Craig, Hayley Atwell, and Ewan McGregor.) Jimoh graduated in 2018, and from there things moved quickly: He got a small part in Wes Anderson's The French Dispatch, *and lead roles in the BBC film* Anthony *and the Amazon series* The Power. *And of course, he won the part of the upbeat, principled Sam Obisanya, which would turn him into a global celebrity. But even though Jimoh brought little experience to his 2019 audition, he was already confident enough to make the role his own before he walked into the casting room.*

Toheeb Jimoh, Sam Obisanya, seasons 1–3: My audition was the scene in episode two of season one, where he's feeling really down and he's super homesick, and they bring me all these foods from back home. So I got the script, and the character was originally Sam Abara, a Ghanaian footballer. And for whatever reason I decided to just change everything and make it Nigerian—I still can't remember why and I don't remember it being a big deal when I did it.

Brendan Hunt: We called him Sam because we were giving a shout-out to our buddy Sam Richardson, who is Ghanaian. [Richardson would play the mercurial African oligarch Edwin Akufo.]

Toheeb Jimoh: I thought, If I wanted to play this role and make it more authentic for myself, he should be Nigerian, and I didn't see any reason why he had to be specifically Ghanaian. I was like, If they want me to do this, then he should be a Nigerian, because that's something that I understand, that I can relate to more authentically.

So I changed some of the lines and made various Ghanaian foods [into] Nigerian foods, you know? Wrote some Yoruba lines, like "thank you" in Yoruba, stuff like that.

Brendan Hunt: It's kind of a ballsy move for an actor to do: "This guy's French? Fuck it, I say he's from Luxembourg!"

Theo Park: We probably saw a dozen people, but there's something about his aura. He is just gorgeous in every way, inside and out. I think for the role of Sam, we definitely wanted a bright-eyed optimism almost on a par with Ted.

Toheeb Jimoh: I actually read the scene, and I didn't know the show was a comedy. So I took it pretty seriously. I was like, Ah, this poor kid's missing home, and this is a really poignant, touching moment and it could even get a little emotional. And I went into the audition and I did my first take, and the casting director was like, "They actually want it to be really funny, so could you do it again and make it funny?" And I was like, "OK, cool." So I threw everything in the bin and just winged it.

Theo Park: Toheeb just came in, smiled, and lit up the room, and it had to be him.

Phil Dunster, Jamie Tartt, seasons 1–3: He has that effortless charm that just means everyone loves him.

Brett Goldstein: Working with Toheeb is like what it must have been like working with George Clooney on *ER*. It's like, You're doing a good job, but you're not George Clooney. This guy's going to be Batman.

Toheeb Jimoh: It's a really fulfilling arc for me, because a Nigerian accent is how I grew up speaking. To go back to that professionally is super poetic.

While casting Sam was relatively easy, thanks to Jimoh's undeniable charm, finding Sam's season one tormentor, Jamie Tartt, was the

60

opposite. Which is surprising, because the man who ended up getting it seems so perfect for the part.

With his chiseled good looks, athletic physique, sporty chic wardrobe, and vaguely ridiculous hair, Phil Dunster as Jamie is the platonic ideal of a cocky English footballer. But originally the creators had something completely different in mind for Richmond's preeminent prima donna, envisioning the character as a flashy Latin American player. Dunster, however, convinced them to go in a different direction.

Born into a military family, Dunster planned to follow his father and brother into the British Army but quickly realized it wasn't for him. "I think I'm far too much of a wallflower or maybe a fragile flower to be in the military," he told People *magazine in 2021. He studied acting instead at the Bristol Old Vic Theatre School. After the requisite small plays and restaurant jobs, he got a part in the British gangster film* The Rise of the Krays *and never looked back, taking roles in British series like* Catastrophe, Strike Back, *and others before nailing the* Ted Lasso *role.*

But it wasn't easy. Park said the casting team read Dunster the most of anyone in the main cast, partly "because we tried different accents." The Mancunian brogue they landed on became one of the show's most memorable elements.

Phil Dunster: I first came to it not knowing a huge amount about the show other than I'd watched the commercials. I wasn't sure how it would work. I love, love, love football. It's what I spend my life doing. I auditioned for it a few times. Jamie was originally called Dani Rojas, and it was a very open casting bracket in terms of who they were looking for.

Theo Park: I did fight quite hard for Phil Dunster, because we went on this wild-goose chase trying to find a South American to play Tartt's arrogance.

Phil Dunster: Originally they were looking for somebody who

was a Latino player or maybe Italian, someone from countries that had a lot of flair when they play football. I did a Spanish accent for it and it was like, "You're good. Your Spanish accent isn't."

I did my best to make a fairly bold choice of who he was. It was a pretty broad brushstroke: a fame-hungry young man with a warped idea of celebrity who thinks longevity in this industry is to be as ostentatious as he can be.

Kola Bokinni, Isaac McAdoo, seasons 1–3: He's so good at playing Jamie Tartt that people don't actually know that he's probably one of the nicest people you'll ever meet. He's so nice that he makes me be like, Am I a little bit of a dickhead?

Phil Dunster: My lawyer would tell me that I have to say it's an amalgam: Jamie's based on people like Jack Grealish, the sartorial style. Cristiano Ronaldo, he would love to believe that he's got a bit of his swagger. Bernardo Silva. There's a bit of Neymar in there. But you know, any elite footballer has to have a sort of undying self-belief. There's plenty of footballers out there whom you can take inspiration from.

Theo Park: I kept saying, "Everybody, no one is as funny as Phil." Everyone agreed in the end.

Phil Dunster: The note was, find an accent that would represent footballers in the UK that doesn't sound like me. Maybe from an area where someone's got to hustle a lot in order to get to where they need to be. A lot of my girlfriend's family are from Manchester. I know a lot of pop culture from Manchester, and there's a sort of attitude to the place that just really lent itself to, like, a bit of flair, a bit of show-off, a bit of passion. It's an inner-city accent. It has to be quick. It's very different to mine.

Tom Marshall, director, season 1: I remember Phil Dunster's audition very clearly. I can't think of what was scripted, but put it this way: We auditioned a guy who did an Italian accent. And then Phil

came in, and Phil was the one who says, "So I've sort of been trying it in a Manchester accent." And I remember talking afterward to Bill and Jason, like, That is so bang on. It has such great connotations: Oasis; there's a whole music scene from Manchester, the Madchester scene, that is basically about being cocky and being from Manchester. So, you know, Jamie Tartt with that accent completely aligned for me.

Phil Dunster: So yeah, we've managed to veer away from the Spanish accent enough so that I could get the part, thankfully.

Theo Park: Phil was so brilliant. He was the funniest person we saw for the part, and we said, "Well, come on, let's just make him British for God's sake." Then, in that search, we found this fabulous Mexican actor, Cristo Fernández. He wasn't quite right for that part as written, the arrogant star player. But when the writers saw his tape, they said, "OK, we're going to write a part for him, and let's let Phil just do his thing."

Cristo Fernández began playing soccer professionally in Mexico when he was a teenager, but a knee injury eventually forced him to seek another path. He discovered a love of acting in college and eventually moved to London to pursue it.

He had only limited experience in small indie films, but his audition for Ted Lasso *was so magnetic, the creators turned another character they'd planned to add later, who was going to be Icelandic, into the ebullient Mexican footballer Dani Rojas. They also gave him an instantly memorable catchphrase, taken directly from Fernández's audition.*

Bill Lawrence: The way we changed the role, it really came down to who Cristo was as a human in between takes when he sent his audition tape. He had this exuberance and this "I'm so happy to be reading for you! This is the best thing that's ever happened!" Kind of like a puppy dog.

Theo Park: He came up with "Football is life!"

Bill Lawrence: He said "Football is life!" in one of his auditions. It might have just been when he was talking about himself as a football player.

Cristo Fernández, Dani Rojas, seasons 1–3: We were in a panel, and Bill Lawrence said in the Q&A, "By the way, 'Football is life' is all Cristo." And I was like, "What?" And he told me, "Go and take a look at your self-tapes." And yeah, I did the scenes and then at the end, we had to talk about our experience in football, and then I say, "Hola, my name is Cristo Fernández, and well, to me football is life because blah, blah, blah . . ."

Bill Lawrence: And then in the writers' room, we said, "That guy's gonna say that constantly, it's gonna be the greatest thing in the world."

Brendan Hunt: By the time we got his tape, we were going to do this other thing. But the audition was so pure and so positive and so energetic. We watched it and we're all like, "What do we do?" And to his credit, Bill Lawrence said, "I'm casting that guy! I'm casting that guy, and we are figuring it out!"

Cristo Fernández: Sometimes we don't understand why certain things happen. Whether you believe in God or the universe or Mother Nature or whatever you believe, there's a bigger purpose. For me, it's with God, and I'm grateful my family and friends were always there to help me find new passions.

Jason Sudeikis: It's similar, what you're hearing about three of the auditions. Brett having an understanding of the role, and being like, "I'm going to go for it." That's one way. "Swift it up," meaning be yourself, but also being open to having representation that encourages you to be yourself. Then there's also the power of someone just being themselves, like Cristo.

KEY INFLUENCES

THE SURPRISING INGREDIENTS OF A SURPRISE HIT

From a market perspective, the birth of *Ted Lasso* was a good news–bad news kind of deal. The good: as a sitcom built around a character first introduced in an ad, it was based on existing intellectual property, one of Hollywood's favorite things. The bad: ask the GEICO cavemen how well sitcoms based on ads usually work out. (Or don't, if you'd rather be spared a sad story that will only get sadder, given the fate of all cavemen.)

Besides, while the iconography—a Scrabblicious culture-crit term for, in this case, a big mustache and some tinted sunglasses—was familiar, *Ted Lasso* almost immediately veered away from any expectations set by the buffoonish NBC Sports spots. The creators instead mashed up cornball humor, character comedy, emotional trauma, intense soccer drama, subverted sports-flick tropes, and a

warm humanism in a way that felt strikingly unique to many viewers, even or perhaps especially those who knew the commercials.

That idiosyncratic combination, however, was based on an expansive playlist of things that came before it—the creators of *Ted Lasso* wore their influences and obsessions on the sleeves of their AFC Richmond jumpers. Sitcoms, rom-coms, sports movies, space movies, Scorsese movies, movie musicals, musical musicals—all showed up in *Ted Lasso*, sometimes in the form of tossed-off tributes, sometimes as structural bedrock, sometimes as conceits the show went on to undercut. The show is nothing if not hyper-referential, with lines, scenes, and occasionally entire episodes directly quoting earlier works, and part of the fun of watching it is the scavenger-hunt dimension of deciphering the various nods and allusions.

The creators' fan worship goes back to the very beginning: Jason Sudeikis, Brendan Hunt, and Joe Kelly have been open about the fact that when they first started sketching out the show, they based its structure on that of the British *Office*, the instantly legendary mockumentary sitcom, created by Ricky Gervais and Stephen Merchant, that revolved around another quotable leader with signature facial hair (Gervais's goateed David Brent). "We banged out an arc structure for a couple of seasons and a special, you know, the same model as the original UK *Office*," Hunt said on the podcast *The Rich Eisen Show* in 2023. "We were thinking, we'll do an English version of this because that's kind of the hook: we'll honor the English comedies we love so much."

At a glance, this three-part narrative structure would seem to be the only thing the two series have in common. (Of course, *Ted Lasso* ended up having many more episodes within that structure.) *The Office*, which premiered on BBC Two in 2001, became a foundational text in the emergence of cringe comedy, deriving much of its humor

from the deep discomfort of social embarrassment and spurring laughs that are partly reactions to the humor and partly a way for viewers to physically cope with the painful awkwardness on-screen. It is not, in other words, the first thing that comes to mind when you think of *Ted Lasso*, defined by its silliness and warmth. But there is more correspondence between *Ted Lasso* and *The Office* than initially appears.

They are both character studies, for one thing, with the comedy (and drama) based in the clash and interaction of recognizable human qualities. See Tim's sardonic self-pity and yearning, Dawn's self-doubt, or Brent's sweaty desperation to be liked and admired. *The Office* is also, like *Ted Lasso*, a comedy that is ultimately about growth. Tim and Dawn finally come together, Gareth gets a promotion, and Brent eventually finds enough fulfillment and self-worth to symbolically reject Chris Finch, the boorish colleague he once idolized.

"At the end of the day," Sudeikis told me in 2023, "those fourteen episodes are about him telling Finchy to fuck off, and how satisfying that was as an audience member to see him finally happy, whether you're aware of that or not."

Ted Lasso never told anyone to fuck off, as far as I can recall. But when he effectively tells Midwestern reserve to fuck off by acknowledging his pain and facing emotions he's avoided for decades, it's just as satisfying. (He also told his mom "fuck you" a bunch one time as part of this process, which sort of counts.)

"LOTS OF SPORTS-MOVIE ARCHETYPES"

When Sudeikis first pitched *Ted Lasso* to Juno Temple, one of two cast members he handpicked rather than auditioned (Anthony Head

was the other), he pitched the show as the British *Office* meets *Friday Night Lights,* another clear antecedent. Like *Ted Lasso,* the poignant drama was a football show that was less about football than about the struggles of selfhood and the power of family, mentors, and other supportive relationships, with a specific sense of place. (As someone who grew up watching and playing high school football in a small Texas town, I can attest that the show's re-creation of the buzz of Football Fridays was dead-on.)

Friday *Night Lights* was hardly the only sports story to influence *Ted Lasso,* of course. The creators leaned into their sports-movie fandom throughout the development and production of the show. Sudeikis evoked *Rocky* when he pitched *Ted Lasso* around Hollywood; another Sylvester Stallone movie, the 1981 World War II soccer drama *Victory,* was subtly referenced in the show itself, when the names of the players on Coach Beard's whiteboard (in the seventh episode of season one) were of players from the film. Sudeikis had Temple watch *Bull Durham* to prepare to play Keeley Jones—"I must have watched that film a hundred times," Temple said in a 2023 SAG-AFTRA interview. This is presumably because Keeley's season one romantic arc, in which she dumps the vapid, preternaturally talented young star in favor of the charming, broken-down veteran, is basically the plot of 1988's *Bull Durham.*

But the big one, at least from a structural standpoint, was, like *Lasso,* an underdog sports comedy: the 1989 baseball farce *Major League.* It is a minor masterpiece—OK, a *very* minor masterpiece— though like many eighties comedies, it shows its age in various ways, beginning with the fact that it is about the since-renamed Cleveland Indians. If you have somehow managed to miss *Major League,* the concept is this: A gold-digging former showgirl who has inherited the team after her rich husband's death seeks to ruin it, so attendance

will drop and she can move it to Miami via an escape clause. Her plan is to bring in enough deadbeat players (played by Charlie Sheen, Tom Berenger, Wesley Snipes, and Corbin Bernsen, among others) to destroy the club, but wouldn't you know it? They end up being pretty good and—thirty-five-year-old spoiler alert—go on to win the pennant.

While *Ted Lasso* borrows the movie's framing device, it complicates it similarly to the way it complicates most of the sports-movie tropes it plays with: by infusing a stereotype with humanity. The allusion functions as both a tribute to a film that informed the creators' original conception of the show and as a generator of tension around whether and when Rebecca will finally come clean about hiring Ted to fail. "We drew from many sports movies of our youth," Hunt said. He continued:

> *Major League* was a great starting-off point because in *Major League,* that character just wants the team to tank. OK, but why is she like that? There has to be a reason. And once you start getting into the why, that opens up a whole thing for us of, we're going to bring in lots of sports-movie archetypes and maybe even tropes. But we can go deeper in each of them. Go deeper in the pretty-boy-punk superstar, and go deeper in the aging legend. Find out the why instead of the what, and then the whole world and every character becomes richer and therefore, hopefully, the comedy does, too.

There were other references to *Major League* sprinkled throughout the series, alongside hat tips to many other sports movies. The dialogue references films like *Field of Dreams, Miracle, Bend It like*

Beckham, and *Hoosiers.* ("Why the fuck is it called *Hoosiers?*" Roy wonders in season two. It's a reasonable question for a Brit to ask.)

Actual sports figures and events are also important reference points. Donnie Campbell, Sudeikis's high school basketball coach, was a model for Ted Lasso, and much of Ted's wisdom was drawn from coaching sages like John Wooden. The football action is inspired by actual professional soccer matches, thanks to Hunt's encyclopedic knowledge of the sport.

Meanwhile, the show's most idiosyncratic upcycling of a sports cliché was based not on a movie or TV show but on real life: NBA star Allen Iverson's famous "Practice?" monologue, from a 2002 press conference. Iverson's incredulous response to questions about his missing team practices—"I'm supposed to be the franchise player, and we in here talkin' about practice"—has been endlessly cited, quoted, mixed into dance and hip-hop tracks, and misunderstood. (Iverson goes on to say he's upset over the death of a friend, which almost never makes it into the clip.) *Ted Lasso* turned it into dialogue in a season one episode, Ted quoting the jag almost word for word as he harangues his arrogant star player, Jamie Tartt, for faking an injury in order to skip practice. ("You're supposed to be the franchise player, and yet here we are talkin' about you missing practice.")

In a 2021 interview with IndieWire, Sudeikis said he originally planned to use it comically in a press conference, like Iverson. But not long before filming the confrontation scene with Tartt, he said, "It just hit me where it's like, oh, the Iverson speech . . . and it's gonna be in protest, not comedy." He added that his use of it was informed—to stack an allusion atop another allusion—by Monty Python films like *Life of Brian* and *The Holy Grail.*

"If you know those references, religion or Knights of the Round Table, they score on that level—we do those with soccer jokes all the

time," he said. But even if you don't know the references, "they're just funny. It's just good wordplay, great acting, great ensembles."

Given the particularly esoteric nature of the "practice" reference, Bill Lawrence wondered if they should have a character say, "Isn't that the Iverson speech?" or otherwise make the connection for the audience. "I was like, no," Sudeikis recalled. "If they get it, they get it, and if they don't, they don't."

"I AM YOUR FATHER."

Of course, it's not only sports movies that animate the themes and vernacular of *Ted Lasso*. Indeed, the whole thing can be read as a whiskery riff on *The Wizard of Oz*, with our hero arriving in a strange land and helping a band of colorful characters achieve self-actualization before heading home to Kansas. (I guess Beard is Toto in this formulation, which . . . tracks?) Dialogue references to this classic abound, too.

Among the most explicit influences is the film that gives one episode its title: *After Hours*, the inspiration for the divisive "Beard After Hours" from season two. One of Martin Scorsese's least known and appreciated films, the 1985 dark comedy follows a high-strung Manhattan yuppie, played by Griffin Dunne, who goes out to meet a woman (played by Rosanna Arquette) and then finds himself trapped in a seedy 1980s SoHo, trying to get back home uptown but thwarted by a series of bizarre interactions and occurrences. "Beard After Hours" borrows the film's creeping sense of eerie fantasy as Beard flees various predicaments, and it is emblematic of the show's delight in playing with different aesthetics and tones. (See also: the Christmas special, "Carol of the Bells," from earlier in season two.)

Another Scorsese film provided one of the show's most personal

reference points, for one of its most instantly iconic scenes. Ted's season one pub darts match with the wealthy cad Rupert Mannion, played by Anthony Head, was a mini sports movie in its own right, as the underdog vanquishes the villain before a crowd fueled by the tension and release of dramatic competition. It is the source of the show's "Be curious, not judgmental" motto, and it revealed new layers of Ted, who initially led Rupert to believe he was bad at darts. Ted's hustling of the judgmental Rupert was partly inspired by Sudeikis's love for a film about hustlers of a different stripe: *The Color of Money*, Scorsese's 1986 sequel to the 1961 neo-noir classic *The Hustler*. It stars Paul Newman reprising his role as "Fast Eddie" Felson, now a faded shark taking on a hothead prodigy played by Tom Cruise. "I liked *The Color of Money* growing up because it was one of those movies I saw with my dad," Sudeikis told Brett Goldstein, Roy Kent himself, in 2023 on Goldstein's movie podcast *Films to Be Buried With*. "I loved going to play pool with my dad, which really was usually me playing pool next to him and sort of what the darts speech is based on, although it was billiards. My dad would play with friends, and I'd play on the table next to him and just get plowed on Cherry Cokes and potato skins."

The film, which was based on a Walter Tevis novel and won Newman what was somehow his only Oscar, for best actor, was a touchstone for Sudeikis, and its themes and interpersonal dynamics had a big influence on *Ted Lasso*. "So much of our show is rooted in my love and growing understanding of *The Color of Money*," he said. "It's all about just male mentoring, about father-and-son relationships" and "the way we treat and hurt people whether accidentally or just by being ourselves."

Few would guess the centrality of *The Color of Money* to *Ted Lasso*, but other father-and-son, male-mentoring influences are less

subtle. OK, one in particular: *The Empire Strikes Back*, the film that turned bad-dadding into the anchor of an entertainment, er, empire and one of the most quoted lines in American history. ("I am your father." I literally just quoted it and will do it again later in this book.)

The second, most emotionally convulsive movie in the original Star Wars trilogy, it was the overarching inspiration for the second, most emotionally convulsive season of *Ted Lasso*, which ended with Nate the Formerly Great's turn to the Dark Side. "With Nate, it was very Star Wars–ian," *Ted Lasso* writer Jane Becker told *Script* magazine in 2022. Nate's fall from grace was closely related to his unresolved bitterness toward his father, but he hardly had that particular market cornered. Daddy issues run throughout *Ted Lasso*, affecting Ted himself, Jamie, Rebecca—it is the painful inverse of the positive mentoring the show is obsessed with.

While Sudeikis called the second season of *Ted Lasso* the *Empire Strikes Back* season, strictly speaking the more direct analogue, at least as far as Nate is concerned, is *Revenge of the Sith*, the final film in the *second* trilogy (though it is Episode III in Star Wars order, because of course it is). That's the movie in which Anakin Skywalker's rage leads him to cross over to become Darth Vader. But as Sudeikis told me in 2021, *Empire Strikes Back* was also "the one that started in the cold and ended with questions versus answers, and that's a little bit of what we're dealing with" in season two. So . . . fair enough.

ROM-COMMUNISM

But enough about the Dark Side. One of the most obvious *Ted Lasso* influences is also the most joyous: romantic comedies. Beginning with its setting—the lovely, Richard Curtis red-phone-box fantasia that is Richmond—*Ted Lasso* unfolds in a rom-com version of Britain

in which attractive people with interesting jobs bond, bicker, and occasionally make out. Its resident therapist, Dr. Sharon Fieldstone, is named after the radio host in *Sleepless in Seattle*, Dr. Marcia Fieldstone. Its players have informed opinions about Renee Zellweger's Bridget Jones accent and "the three Kates" (Beckinsale, Hudson, and Winslet).

While there have been some legitimately romantic sports movies— *Bull Durham*, again, comes to mind—it's hard to think of another sports story that is more indebted to the rom-com genre. The interesting thing is that by and large, the romantic subplots in *Ted Lasso* tend to focus more on the challenges of staying together than of getting together, and the relationships between men and women generally are more complex and more realistic than in the average rom-com— the most profound one, between Ted and Rebecca, was not romantic at all despite many fans' most fervent wishes.

So the influence is not so much thematic as formal and philosophical. "I believe in communism . . . *rom*-communism," Ted tells his team in the episode "Rainbow," from season two. "Gentlemen, believing in rom-communism is all about believing that everything is going to work out in the end." But then he adds some shades of gray: "Now, it may not work out how you think it will, or how you hope it does. But believe me, it will all work out exactly as it's supposed to."

This sounds a lot like fate, a lesson from a genre that relies heavily on certain couples and other outcomes that are Meant to Be. But then Ted gives it a twist, turning it into a statement more about getting out of your own way and *letting* things be: "Our job is to have zero expectations and just let go." This is a helpful idea for a struggling team—as Richmond was at the time—and it aligns with Ted's general vibe. It also flies in the face of most sports messaging, which appeals to players' competitive instincts and tends to be about rising

to the moment, asserting your dominance over your opponent, and taking decisive action in pursuit of victory. Roy Kent, the hard-nosed former player who used to run like he was angry at the grass, as Nate tells him at one point, is the embodiment of this sensibility.

Which is why it's significant that Ted's speech comes in "Rainbow," the show's most straightforward tribute to rom-coms. Full of direct references to *Sleepless in Seattle*, *When Harry Met Sally*, and other classics of the genre, the episode follows Ted's urging Roy to leave his TV job, the bad-match relationship that inevitably gets tossed aside in a rom-com, and coach with him instead. When Roy eventually does, arriving on the sideline mid-game, it marries the two halves of the show's ethos—sports movie and rom-com—and seals it with a pitch-perfect *Jerry Maguire* reference: "You had me at 'coach.'"

While Broadway musicals are not quite as prominent a reference point as rom-coms, they are undeniably core to the *Ted Lasso* experience, whether it's Zava dominating to the strains of *Jesus Christ Superstar*, lines of dialogue based in *Hamilton* couplets, or an entire season three episode named after *La Cage aux Folles*. (Or Nate channeling *The King and I* in a press conference, or Ted quoting *Chicago* in an Amsterdam burger barn, or . . .) The show's idiosyncratic mash-up of sports comedy and musical theater comedy directly reflects Sudeikis's formative roots as an ace basketball player who grew up in a family that valued performance and the arts. (His mother's brother, remember, is the actor George Wendt.) It also is the product of the show's "beautiful balance of traditionally masculine sport energy and traditionally feminine energy," said Adam Colborne, who, as a self-described theater kid who played the pub lad Baz in *Ted Lasso* (and personally cares little about soccer), knows something about striking that balance.

Ted Lasso is also structurally similar to musicals in that while it is

based in real feelings and actions with real consequences, occasionally someone will break into song—sometimes literally, sometimes via an equally improbable act—and as a viewer you just have to go with it. Season two amped up this element of unreality, particularly in the add-on episodes, "Carol of the Bells" and "Beard After Hours." But even in season one, the series gave us a professional soccer team arranging itself on the practice pitch to spell out "Hi boss!" for the owner. Sudeikis, a lifelong fan of musicals, has talked about his admiration for how they can seamlessly blend comedy and poignance, often within the same scene. "Musicals have the ability to have a really funny scene and then go right into a song," he said in an interview with GoldDerby in 2021. "Something like *La Cage aux Folles*, that's *The Birdcage* with kick-ass Jerry Herman tunes.

"They can break your heart, and they can make you laugh at the same time," he added.

Sound familiar?

CHAPTER 4

GOING TO RICHMOND

"They saw that they had something fairly special on their hands."

It was sometime in late spring 2019 when Sue Lewis received word that a film crew was interested in shooting in her town. "It was nothing out of the ordinary," she recalled. "We issued the permits."

As the film officer for Richmond-upon-Thames, a lovely borough in southwest London, Lewis is used to such requests. Richmond, the primary town in the borough, is the picturesque platonic ideal of a British hamlet, with a broad, pleasant green and charm to spare. Tidy streets like the tiny, cobblestoned Paved Court, lined with quaint shops, galleries, and the occasional empanada joint, offer delightful strolls and scenery. Nearby is the Prince's Head, a three-hundred-year-old pub fronted by picnic tables and a stone plaza dotted with benches and two classic red British call boxes. It's all catnip for filmmakers of every stripe—the pub appeared in the Idris Elba crime thriller *Luther;* the magisterial Old Town Hall played a tuberculosis hospital in the 1960s

cad classic Alfie. *"There is this rich history of filmmaking throughout the borough," said Gareth Roberts, leader of the borough council.*

What Richmond's leaders didn't realize at the time was that this request was different, that it would put their little town on the global map as the home of a fictional football club coached by an earnest American optimist with a push broom on his upper lip. Paved Court is now familiar to millions as the lane where Ted Lasso lives, the pub as the Crown & Anchor, the AFC Richmond fan hub overseen by the wise den mother Mae Green.

But while Ted Lasso now signifies all sorts of things to all sorts of people, it didn't mean much to anyone beyond its creators when filming started in June 2019. "We made the first season in a bubble," Jason Sudeikis said.

Said bubble would ultimately pop out a massive hit and make stars of many largely unknown performers. But in the beginning, the primary significance was that six years after the first ad and after months of crafting characters and spinning out story in a writers' room in Los Angeles, Sudeikis and Co. were finally going to see it all come to life in England.

Brendan Hunt, creator, Coach Beard, seasons 1–3: No one thought it was practical to do [the show] in the UK, and there are certain people signing checks who would have loved it if we would have just green-screened Trafalgar Square. But we felt like it was artistically important, because this is, among other things, a love letter to England. The best way to get that right is to be there.

Sue Lewis, film officer for Richmond-upon-Thames: They'd been to see a couple towns. And I think in the end they decided upon Richmond because it's so picturesque.

Gareth Roberts, leader of the Richmond Council: The film crew came to us and said, "We've got an idea for a show. We'd like to

do some filming around Richmond, would it be possible?" And of course we said yes, we were delighted to. We're used to managing film crews, and Richmond residents tend to be quite respectful of them when filming is going on—they don't crowd around and point, slack-jawed in amazement that the talking pictures are coming to town.

Sue Lewis: There were no crowds; nobody took an interest. It was just another production.

Gareth Roberts: More than anything else, the residents like to bask in the reflected glory of seeing Richmond being shown on people's television screens.

Declan Lowney, director, seasons 1–3: The production saw Richmond and saw how charming it was. It didn't have a football stadium, so the stadium was Crystal Palace and we pretended it was in Richmond. We changed the name to Nelson Road in the show.

Lola Dauda, script supervisor, season 1: We shot it all in West London [Film] Studios, which isn't a huge studio so we more or less had it to ourselves, which was nice. And a lot of the football at Hayes & Yeading, which is a very small West London football club and their pitch is basically behind the studio. We used the pitch for the practice sessions.

Tom Marshall, director, season 1, including the pilot: When I got on board, it was already sort of planted there. I'd heard through Bill Lawrence that there had been an intention to do more of a working-class setting and football club. My initial gut would have been to do that, because I've lived in London for ten years and Richmond has very different connotations to other places you might pick. But once I got there and really started looking around with the director's hat on, you start to think of Richard Curtis and how well all those films played in the US. The cobbled streets, that pub and the

phone box—you're like, Oh yeah, there is totally a world where this would work.

Gareth Roberts: We had no idea it was going to be the phenomenon it would develop into and neither did they. But very soon they saw that they had something fairly special on their hands, the combination of the beautiful backdrop and the cast.

Tom Marshall: It's obviously Jason's baby. I was asking him as many questions as the cast were asking me. Me, him, and Brendan would go and watch some football together on Saturdays, and then you end up having little crossover chats there.

Lola Dauda: We set rehearsals with Jason and Brendan and some stuff with Brett and Hannah, as well, where they basically rehearsed with the director who was doing the first episodes, Tom. And they'd read through and cut scenes and make adjustments, that kind of thing. I think Jason was doing a lot of rewriting and editing during the time.

Tom Marshall: I'd worked with Brett on a show called *Drifters* in, like, 2014, got on really well with him. He's so nice that when I found out he'd be Roy, I was a bit like, Really? Luckily, my first shot of Brett was when Ted comes into the locker room and he's scanning around, and then I got a shot of Brett gliding by almost looking at the camera as if it was Ted, staring him out. As soon as he did that, I was like, All right, that'll work. Nick Mohammed I'd worked with before and I thought, That'll work. Hannah, there was a distinct moment in rehearsal that I think, because she was in a comedy, she might have thought she had to match some of the comedic energies that were floating around in the room. And then the more we just sort of played it straight and real, the more it worked.

I come from a world of all-out comedies: be as funny as you can in the twenty-four minutes we're on-screen. It did take a bit of feeling

out: In this one, not every scene is going to be funny and we are leaning into the drama at some moments. It took a while to align with that. But once we did, you could feel really confident in the drama scenes knowing that after this, we're gonna go back to comedy, but for now we can just play it real and go for the emotion. And because you've got Hannah Waddingham in that role, it works because she can pull it off so well.

Brendan Hunt: I was immediately a fan of all of them. We'd been writing these characters for a while and then you cast them, but they're in another country. So you're not fully meeting them yet. And then once we got to England and started watching people work, it was like, Oh, all of them are amazing.

Brett Goldstein, writer, Roy Kent, seasons 1–3: Everyone is amazing. And once we knew each other and we were seeing everyone work, we started writing to them. Juno, in particular, is an interesting one. The way Keeley was funny is different from how we originally started it, because Juno was funny in a very specific way and it was like, Oh, that's great. We'll write to that. And I think that's true of everyone.

Juno Temple, Keeley Jones, seasons 1–3: The writing is genius in the sense that the minute it's about to get too corny, it turns a corner. And the minute it's about to get too funny, it turns a corner. And the minute it's about to get too serious, it turns a corner. It doesn't ever quite go too far in one direction.

Brendan Hunt: They have that English-actor ability to bring reality to the comedy and to easily change lanes from comedy to anything that might be a little more weighty. As we became more fans of the cast and had a better recognition of what their qualities were, it became even more of a goal to write to their strengths and to their quirks.

Bill Lawrence, creator: In the pilot episode, the characters belong to the writer because you invented them and you're bringing people in to try and realize them. But in the most successful TV shows, that ownership shifts. And the pace with which it shifts, that the characters become owned by the actors and actresses, is a good benchmark of how successful a show is. On *Ted Lasso*, all of the actors and actresses have more ownership than the writers, and are the policemen and policewomen of what their characters would do and say and how they would act in certain scenarios. And you can either, as a writer, fight that and be resistant to it, or you can enjoy it and then take credit for it even though you had nothing to do with it. I like the latter.

While writing the first season, the writers had mined their experiences and anxieties to craft ten episodes that, if they were successful and lucky enough to get a chance to make more, would serve as the first of a three-season arc Sudeikis had had in mind, in rough form at least, basically from the beginning.

So there was an elaborate blueprint. But once everyone got on set, not only were the characters and storylines evolving in response to the actors' performances, there were constant reminders that the original brain trust—Sudeikis, Hunt, and Joe Kelly—first bonded over and inside the world of improv comedy. "The best idea wins, that's an old improv philosophy," Sudeikis said. "So someone comes in with an idea, and it just vibrates up to its highest level."

Nick Mohammed, Nathan Shelley, seasons 1–3: I used to get caught in the firing line because there were a lot of scenes on the sidelines between Brendan, Jason, and me, and I was in the middle. And because they're so good at improv and just bounce off each other, they would just change the ending to the scene every single take. And I'd usually ruin it by laughing, you know, every time.

Brett Goldstein: The writing is always carrying on and Jason's always rewriting and doing a final polish on set. I've learned a lot from this—I do think it keeps everything fresh. I think it affects performances, affects everything. We're never filming something that's stale, that's been around forever. It's always regenerating.

Annette Badland, Mae Green, seasons 1–3: I'd never worked with a writers' room before—that is a very lively experience. Because Jason likes to rewrite, they're coming in with pieces very late. One lunch hour I got a big scene with the guys coming into the pub, which I wasn't doing in the morning. It makes it very immediate and very alive, which is wonderful.

Anthony Head, Rupert Mannion, seasons 1–3: Definitely a novel experience was to have voices, often Brendan or Joe but mainly Jason, tickling my ear with ideas. Sometimes lines being changed but largely ideas about existing lines—sometimes what had created them, sometimes the drive of them. I love letting thoughts come into my head and just playing the emotion that they conjure. It was vibrant. Jason and I developed this bond—he could see how much I enjoyed it.

Kola Bokinni, Isaac McAdoo, seasons 1–3: That's very hard to find, you know, a set with that kind of buzz and that kind of magic, where your creative juices flow and you can come up with stuff. They'll whisper something to you: "Or try this . . ." And that's how you get all these magical scenes.

Brett Goldstein: I think what we do—certainly what Jason and me and Joe Kelly and Brendan and any writer who's on set will do—is almost, like, pre-improvising. As in, we have this bit and we'll talk before we shoot: "What about this, this, this, this, this, this . . . ?" And then that becomes the thing that we shoot.

Phil Dunster, Jamie Tartt, seasons 1–3: Working with Jason was

an absolute treat. He knew the fabric of the piece from start to finish, but he would never micromanage. You'd be going through the scene that you've got coming up and he would be like, "Great, you've got it, but we can always massage it so it feels natural to you." A lot of writers on a big show, they would be nervous to do that because they've mulled over everything. It's just a mark of the man to be like, "Look, I trust you. That's why we've got you on this."

Nick Mohammed: They're very collaborative once we get to set. They'll tweak things to put in our own accents, and occasionally they'll ask me to tweak lines and stuff.

Jason Sudeikis, creator, Ted Lasso, seasons 1–3: We allow the actors the space to Anglicize my English. You know, "Oh, we wouldn't say it this way." Like, my being a kid from Kansas, Higgins said "ma'am" all throughout the pilot. Then the second we hear Jeremy Swift say "ma'am" and it sounds like "mom," I was like, "Oh, no, no, no. He's going to call her Miss Welton."

Hannah Waddingham, Rebecca Welton, seasons 1–3: The one thing I always get involved with is Anglicizing Rebecca to death. There'll be things like, "Oh I don't know, I guess . . ." And I just think, Absolutely not. She doesn't talk like that, for god's sake. I think they've learned now to just go, "Yeah, just do what you want with it."

Jason Sudeikis: The one that Juno does that I love in [episode seven], when we go on our away game in Liverpool, I just had her say, "I'm gonna go to the bathroom." You know, "go to the toilet" is what they say over there. And she's like, "My grandma used to say, 'I'm going to go spend a penny.'" I was like, "Yeah, that's fucking great, go spend that penny." Which I assume had something to do with pay toilets.

Annette Badland: Jason had a three-series arc in his head; he

told me that at the beginning. So he knew what he wanted from the story, but he's very responsive. So if people give him ideas, he will investigate them and incorporate it if he thinks it's OK.

Hannah Waddingham: I'll say to Jason, "Do you not think because this happened in episode one then . . . ?" And you know, rubbing the 'stache of truth, sometimes he'll go, "Oh, yeah, OK." But most of the time he just goes, "No," and carries on. I just think, OK, pick your moments.

Sara Romanelli, assistant script supervisor and script supervisor, seasons 1–3: In season one, Jason was there with us a lot even when he wasn't Ted. I think he was there mainly for the actors, because obviously it was the first time the actors were impersonating those characters, so you want to make sure they got the characters the right way. He's the creator, he's the mind, he's everything behind *Ted Lasso*. There's the director and obviously you have the other producers and stuff, but in the end, Jason was the person that knew all the details.

Declan Lowney: He comes so well informed, and you'd be crazy not to listen to him. You could say, "I don't want to do it, I want to do *this* . . ." But the guy is giving you a gift of an idea, so you'd be mad not to take that.

Lola Dauda: Jason and/or Brendan were always on hand. Sometimes something wasn't working, then they'd rewrite. There was an element of finding their way and saying, "OK, this doesn't work so we're going to do something different." So it was really hard work. But they made it fun.

Brendan Hunt: Coach Beard, he's so much of a be-in-the-background-and-observe-and-be-ready kind of cat. I guess there was an element to that in my off-set world. Because we would get off set finishing an episode, if we finish at the same time—which we often

did because we're often in scenes together—and get in the car and go over what we've got to do tomorrow. "What does that script need? Probably needs this, probably needs this . . ." And if I'm home for the night, I'm still absolutely ready for a call from Jason to go over whatever we've got to go over tomorrow. So I guess to some degree, being the support system did become ingrained.

Lola Dauda: The scenes in the locker room were always really funny to shoot because the lads were just so funny together. Brendan and Jason did a really good job of creating this sense of team camaraderie with them.

Bill Lawrence: My favorite one, I remember calling Brett and saying, "Let's come up with something to riff on the field when Ted is talking about a new play in the third episode." And Brett and Jason came up with, "That's the funniest thing I've seen since *Step Brothers*" and "That's when art and whatever combine." That's my favorite thing because it never existed for me until I watched dailies.

Jeremy Swift, Leslie Higgins, seasons 1–3: I love when Ted says, "That's when sports and art combine." I actually punch the air every time I see that.

Lola Dauda: I quite liked the scenes in the pub as well.

The Crown & Anchor was its own little world within Ted Lasso. *Overseen by Mae and almost invariably inhabited by the rabid Richmond fans Baz (played by Adam Colborne), Jeremy (Bronson Webb), and Paul (Kevin Garry), the pub was a font of sage wisdom, comic relief, and on match days, flying ale, with the show's camera operators shooting from behind a clear plastic sheet so the equipment could stay dry. "Jumping up and down, beer raining on us, great joy," Badland recalled.*

Annette Badland: It was a different entity, this different energy and a place mainly for Jason and Brendan to come into and find out

what they thought and get some advice from Mae, maybe. Jason always said I was the sort of matriarch.

Adam Colborne, Baz Primrose, seasons 1–3: Many fans of the show were like, "Why aren't they at the games? They love the team so much." Yeah, we love the team, but we love the pub, too.

Bronson Webb, Jeremy Blumenthal, seasons 1–3: We shoot our stuff stand-alone. They shoot a lot of the episode, and then they do a lot of the Crown & Anchor stuff and the lad stuff. We've filmed that pretty quick, it's over a couple of days. We're always in that same spot. They're like, "Where do you want to stand this time 'round?"

Adam Colborne: There's a lot more swearing in season one than there is in seasons two and three. There was a pullback on that, and the characters moved from being aggressive and funny to funny and a bit aggressive. We were these sort of respite moments, like a break away, funny line, punch line, boom. In season one, you see a lot of my neck and slowly I like to think that kind of goes out.

Annette Badland: My three lads, the guys in the pub, I used to joke with them because I'm short and they'd be in front of the bar. They'd be jumping up and down and I'd say, "I can never get on camera!" They were a lovely group of guys to work with.

Bronson Webb: We've got, like, a little family between us four. We've got a WhatsApp group going, the Crown & Anchor group. It's always been just kind of us four bouncing off each other.

Annette Badland: Mae longed desperately to get into that locker room and never did. What I did enjoy was my connections that were made—mostly with Jason and Brendan, and other characters that came in, like Juno coming into the pub that time. Mae always had a strong connection with the people that she did encounter.

Bronson Webb: We spoke about this with a lot of [the cast]. A lot of people, when they first read the script from the first audition,

couldn't see how it would be going. The concept of an American coach coming over and all of that seemed a bit silly. But it ended up being a lot more amazing than I think people anticipated, you know, just the hidden meanings and the "Believe."

Brett Goldstein: You can't make *Ted Lasso* and not think like it. It's how we make the show. If we're stuck on set, it's almost—not quite this, but close to it—well, what would Ted do? What's the best, kindest, most inclusive solution to this problem that we have?

Jason Sudeikis: Every time a joke would come up that was rooted in sarcasm, or cynicism, or apathy toward someone else's story, just cut it out. I mean, you try not to say no in the writers' room—some of them would get in there. I remember there being a joke at Higgins's expense and it got as far as a script, and we're doing rehearsal and it was just like, What is that? Then we cut it.

Toheeb Jimoh, Sam Obisanya, seasons 1–3: Everyone on every TV show's like, "Oh my god, we love each other." But we genuinely do just, like, vibe. *Ted Lasso* is such a heartwarming, good-natured show, it would kind of be weird if we didn't have good-natured, heartwarming people on the show. One of the best things we've done with casting is we don't have any dickheads on set. Everybody's really nice, and that's kind of all you can ask for.

But even on a show as apparently blessed as Ted Lasso, *not everything was magic.*

Hannah Waddingham: [The biscuits], man they are dry. Oh my god. They are, like, making your gums become your top lip. They are better [in later seasons] because I've complained so globally about them.

Jeremy Swift: Hannah thinks the biscuits have improved on this series. I had my first one for a bit of PR and I was like, "These are fine." She's like, "Yeah, but in the first season they were terrible!"

Hannah Waddingham: They didn't expect me to go at them like a truffle hound—I decided that Rebecca should be an emotional eater. At the end of the day, they were like, "Do you want a spit bucket?" And I just thought no, that's very inelegant.

Lola Dauda: With the BELIEVE sign, we did so many versions of it. I remember the arguments in the art department and Jason and the guys just over the look of it, how big it should be, what colors it should be. It's that sort of detail-oriented thing that becomes so important and the source of many email discussions. "How should the sign look? No, we're not happy with that one." And you're thinking at the time, God, this is so ridiculous. But it ended up being a linchpin of the whole show.

Annette Badland: There are a couple Mae scenes that Jason says he wishes were still in there but they're not. One because it had the c-word—it was actually very funny. It's Mae going, "What's the problem, you Americans, with the c-word?" And she gave different examples of getting a ticket and the person's a real C, and then on down to your friends give you a birthday party and you say, "Oh you wonderful C's . . ." It made the crew laugh, anyway.

Tom Marshall: Episode ones of any show are notoriously hard. It's where you're doing the heavy lifting and no one knows exactly what you're making. We're seeing all these big sets getting built but we're like, Is it going to be good? And then on top of that, there are all those nitty-gritty practical problems. Like, we'd started filming when we realized the set for the changing room, the floor made this sound every time someone stepped, a really loud sort of sticky, suctiony sound. So we lost half a day because we had to sort that out.

But there's actually a run of scenes in episode one where even when I was shooting them—and that was, like, the first week—I thought, OK, this could be good. At the press conference scene, I

really felt like, Oh, this is like a movie: it's funny but it's got stakes, and it feels really unique. And Jason's obviously knocking it out of the park. To this day, it's one of the best scenes I've ever done. So even though it was hard, you got little tasters like, Oh, actually this could be really worth the hard work.

The first episode set up the premise and included the most explicit links to Ted Lasso's origins, with the press conference and other scenes even borrowing a few lines from the original ad. ("How many countries are in this country?") The next couple broadened the story and revealed more about Rebecca's plans, borrowed from Major League, to use the seemingly incompetent Ted to destroy AFC Richmond.

We also started to get revealing peeks behind the stereotypes, as with the reserved Higgins's delightfully unbridled dancing with a piece of cake at Sam's locker room birthday party in the second episode. "Zach Braff directed that episode and he just wanted to keep shooting, and I kept having to eat very, very sugary cake—I'm in the process of going toothless," Jeremy Swift told the Peanut Butter and Biscuits *podcast in 2022. "But I loved doing that.*

"You can see that Jason is laughing as Jason Sudeikis in it, which is great," he added. "I love to make somebody who's that talented laugh."

Other characters that seemed minor ended up becoming more prominent, as suggested by the title of the third episode, "Trent Crimm: The Independent."

Bill Lawrence: We want even the minor one-line characters to be accomplished actors and actresses. We are looking at anywhere from five to ten people for one-line roles and then they would often become, like Trent Crimm, for instance, much bigger parts.

James Lance, Trent Crimm, seasons 1–3: There was an email from my manager and it said this script came, *Ted Lasso,* and he said,

"I think there could be a role in this for you, maybe the role of Higgins." And I read it, and I saw this name "Trent Crimm," double *m*, and I thought, Who is Trent Crimm? And I read that little scene and I wrote back to my manager and said, "I won't get Higgins but let them know I'd love to play Trent Crimm. I'm sure it's just going to be a day. But I'd love to do it."

Bill Lawrence: He made a huge impression in the pilot. It's been a fun experience for me with people who might think they're getting into it for nothing and then have a big ol' role.

James Lance: Six months later, the audition comes in and I was talking to my agent about it. I was like, "I think there's only one episode." But she's like, "Well, who knows?" Anyway, I went, I auditioned, I got offered the role and then it's turned into an amazing ride.

"PILOT"

Season 1, Episode 1
Written by: Jason Sudeikis and Bill Lawrence
Directed by: Tom Marshall

Ted Lasso is a fascinating show to rewatch. (I'm going to assume that if you've made it this far into a book about *Ted Lasso*, you've seen the show at least once already.)

Most shows are fun to review with the benefit of hindsight, of course, when we see how the writers planted the seeds of what the story would become. But that sensation is enhanced, in the case of *Ted Lasso*, by the fact that most of us probably went into it with pretty modest expectations. It was, after all, a show based on a TV ad starring a former *Saturday Night Live* cast member in a funny mustache. Even if it was better than every other sitcom based on a commercial, probably the most any viewer was hoping for were a few laughs about an American ass on British turf, literally and figuratively. But one of

the show's best tricks is not just to subvert expectations but to actively use them against the expecters. "Be curious, not judgmental," the show's de facto motto—uttered by Ted in the instantly famous darts scene a few episodes later but embodied by nearly every other character at some point—is another way of saying, you can't always trust your first impressions.

In its opening episode, *Ted Lasso* cleverly invites viewers to make snap judgments by loading the show with stereotypes we know well. Not just the bewhiskered cornball that is Ted but also most of the other main characters we meet in the efficient thirty-minute pilot: The ballbusting powerful woman (Rebecca). The sniveling corporate stooge (Higgins). The surly, jaded alpha male (Roy). The arrogant prima donna (Jamie). The skittish toady (Nate). Even the pretty pinup (Keeley, or, more specifically, the topless photo of her in Jamie's locker). In inviting us to indulge our assumptions about such characters, the show sets us up to be surprised and moved by their complexities and eventual evolutions. Just like you might be with the people you encounter in your actual life, if you set your judgments aside and let yourself be open to the possibility.

Then there's the title bumpkin, Ted himself, by all appearances a two-dimensional "Ronald fucking McDonald," as Roy memorably puts it. The pilot leans into the fish-out-of-water aspects of the comedy, from Ted's general cluelessness about all things soccer to his distaste for tea. "I've got a feeling we're not in Kansas anymore," he tells Coach Beard as they check out London's Tower Bridge during their trip from the airport to the Richmond facility. "Hey, I've never actually said that when not in Kansas before!" But it quickly becomes clear that there's more behind that mustache than a few folksy aphorisms. As soon as Ted gets to Richmond, he starts displaying the

charms and flaws that will come to complicate and define him over the next three seasons.

In the win column are the chummy supportive traits that will become synonymous with the character. Upon meeting Nate on the pitch, Ted treats the overlooked kitman with a basic decency that he has rarely experienced, based on his incredulous response. (Nate is shocked when Ted remembers his name mere minutes after he told him.) Ted is similarly solicitous toward Rebecca as she shows him around the facility, producing the episode's only brief thawing of her icy exterior when he asks her how she's doing after her divorce. "It hasn't been the easiest year," she acknowledges.

There are also clear signs that Ted has his own issues. These include early indications that his cheerful demeanor is at least partly a tool for keeping reality at arm's length, as when during his first call home from England—where he has moved to give his wife, Michelle, some space, remember—he is immediately trying to get her to come visit. And with the benefit of hindsight, the chaotic press conference scene is more than just a comic set piece and the pilot's most explicit link to the original ad, with its recycled football culture-clash jokes about quarters, halves, and ties. It's actually our first look at one of Ted's panic attacks, or the beginning of one, anyway. As the reporters' shouts combine into a pitched cacophony, Ted begins to stammer and the high-pitched whine climbs in the soundtrack until Rebecca steps in to save him by chastising the journalists and cutting the conference short. Of course, minutes later, after Higgins voices cautious support for Ted, we get a glimpse of Rebecca's own inner demons.

"He's an absolute wanker," she says. "I hope he fails miserably. See, my ex-husband truly loved only one thing his entire life: this club. And Ted Lasso is going to help me burn it to the ground."

Careful viewers of *Ted Lasso* will note that each season opens and closes on shots of the character whose journey will most define the narrative over the next ten or twelve episodes.

In season one it is Rebecca, whose emergence from the fog of quiet rage to embrace the "Lasso way" is, more than anything Ted does, the spine of the story. Season two begins with Nate, whose heel turn provides that chapter's most dramatic emotional arc. Season three begins with Ted himself, who triggers the endgame with his realization that, true to his Kansas roots, there really is no place like home.

"For me, season one was all about Rebecca," Jason Sudeikis said on *The Jess Cagle Podcast with Julia Cunningham* in March 2023. He continued:

> I didn't invent that, you know, first shot–last shot. The director George Roy Hill talked about in *Butch Cassidy and the Sundance Kid*, at that point no one knew who Robert Redford was. Everyone knew who Paul Newman was, but he was like, I'm gonna leave this camera on Robert Redford. So as much as the show is called *Ted Lasso*, this is Rebecca Welton, and this is Hannah Waddingham playing Rebecca Welton. We wanted to have that sort of symmetry, if you will, those bookends.

Which is why the opening sequence of *Ted Lasso* actually has little to do with Ted Lasso. Over the kicky strains of the Sex Pistols' "God Save the Queen," we see a montage of AFC Richmond players putting on a show of sublime football skill—the actors, clearly ringers,

are not recognizable members of the cast—until the camera pans up and away from the field and the music warps and we land on Rebecca, the new owner of the team, who couldn't care less about any of it. She is instead pondering a valuable artwork (by David Hockney, Higgins points out) that she and her reptilian ex-husband, Rupert, once bought to celebrate a marriage that is now over thanks to his serial philandering. She is composed but seething underneath, consumed with bitterness over her betrayal and silently plotting revenge.

The team-sabotaging scheme *Ted Lasso* borrowed from *Major League* will ultimately be subverted, when Rebecca finally comes clean. But her awakening won't happen for a while; the woman we meet is in an angry, retributive headspace. Which isn't to say it's not fun to watch. Her pithy firing of Coach Cartrick, his boorish misogyny made flesh by his carelessly exposed testicles—thankfully viewers are spared the sight of Liam and Noel, as Rebecca calls them—was the show's first dismantling of toxic masculinity, which would become a theme. Her rejoinder to Higgins's reservations over hanging Ted out to dry revealed both her sharp wit and her perspicaciousness born of a lifetime of being disregarded, despite her smarts and statuesque beauty.

"I know that there'll be elements to this little adventure that will weigh on you a bit," she tells him, after giving him a promotion to buy his cooperation. "But I'm sure it won't be harder than it was to sneak all Rupert's women in and out behind my back all those years."

This role could have gone wrong in many ways. Played too harshly, Rebecca becomes a caricature; too sympathetically and her eventual pivot becomes meaningless. The writers deserve credit, of course, but Waddingham from the beginning telegraphed the wounded vulnerability beneath the artfully composed appearance.

"I felt a huge responsibility for men and women of a certain age

who are lost," Waddingham said in a 2022 panel discussion. She continued:

> The ones that try and present a strong exterior are often the ones that have had their hearts smashed on the floor, and I wanted to honor that most. I take it very seriously, because the most response I get is men and women coming up and saying, "Thank you for highlighting that." That you can be presenting one thing and go home and be desperately lonely and have to pick yourself up the next day. That's why I'm an absolute stickler—her appearance, all the things on her desk—that she's a bit precise about things. Because it adds a layer of granite that nobody can penetrate, because if they do she'll not be able to cope.

Waddingham is equally effective at showing those cracks as they appear and then widen over the course of the season, as people like Ted and Keeley push through, helping her to begin healing. Rebecca comes to understand that no one should define herself by the worst thing that ever happened to her. And her emergence, and the emergence of all the other characters who break through their own self-imposed confinements, is ultimately the point of *Ted Lasso*.

If you were to put this book down and start accosting (or maybe just politely calling) *Ted Lasso* fans to ask them what the show was about, a few things might come up over and over: Culture clashes. Underdogs. Dad jokes. The timeless comic power of a silly mustache. Most likely you'd get some version of the conventional wisdom that has followed the series since it came out within a particularly acrimonious and despairing moment in America: *Ted Lasso* is about the importance of kindness and decency.

These are all respectable and at least partially correct answers. But what *Ted Lasso* is really about, more than anything else, is personal transformation—or more precisely, the potential we all have, through our choices and actions, to become more humane versions of ourselves at any point in our lives, generally with the help of others. The show wasn't *about* kindness and decency as much as it was a case for how those qualities can unlock human potential, and in turn proliferate by helping people become more supportive, empathetic, and self-actualized.

The first episode presents us with a soccer team full of stuck people, including its resentful owner and perhaps the most stuck of all, its Ronald fucking McDonald of a new coach. The story of the next three seasons is how they all help one another start moving freely through the world and their lives again.

WHO WON THE EPISODE?

Rebecca, who successfully hatched her team-scuttling plan while putting various men in their places, including Higgins, the surly reporters, and most memorably, the loathsome Coach Cartrick when he asks why he is being fired:

> I suppose I could go for any number of reasons, really. Your casual misogyny, for one. I know it's a big word. Ask one of your daughters what it means. Or perhaps it's your performance, having led this team through yet another remarkably average season. Or maybe it's because you insist on wearing those tiny shorts that force me to see one of your testicles . . . and there's the other one. Liam and Noel, though perhaps not an oasis. Still, if I'm being completely

honest, George, you're fired because I'm the owner now and I don't like you. Now do piss off, you fat twat.

BEST ASSIST

Keeley, who late in the episode arrives in the locker room to find Ted, by then trending under a number of nasty hashtags thanks to the disastrous press conference, and helps him adjust the crookedly hung BELIEVE sign. She leaves the sign just as askew as it had been, a glimpse of her playful personality, and is the first person Ted meets in London who shows him any real warmth and support. The scene introduces Keeley as in many ways the show's animating spirit, the person who as much as or perhaps even more than Ted helps the people around her find their better selves.

BEST SAVE

Rebecca, who rescues Ted from said press conference and manages to slip a knife between Rupert's ribs in the process: "There is not a single person in this room who has seen Richmond play more than I have. And in all those years under the stewardship of the previous owner, I've witnessed nothing but profound mediocrity. Am I wrong?"

BEST LINE

Ted, in response to Rebecca asking if he believes in ghosts: "I do. But more importantly, I think they need to believe in themselves."

RANDOM STATS

- On the plane to London, Coach Beard is of course reading the seminal soccer book *Inverting the Pyramid: The History of Football Tactics*. But Ted is reading *The Dharma Bums*, Jack Kerouac's follow-up to *On the Road*. There are certainly Zen elements within Ted's teachings about letting go of the things dragging you down ("be a goldfish") and pursuing your best self. But a clearer narrative parallel comes in the novel's final section, in which the Kerouac stand-in travels to a remote, unfamiliar place (in his case, Desolation Peak in Washington) to try to make sense of what his life has become.

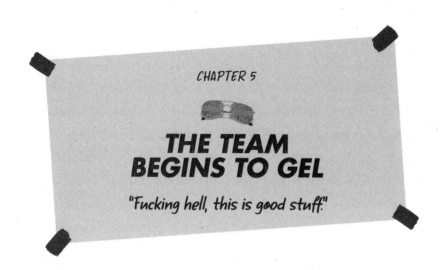

CHAPTER 5

THE TEAM BEGINS TO GEL

"Fucking hell, this is good stuff."

From the early days of the production, there were reasons to be optimistic about Ted Lasso. *"I always remember when we did the first read-through, and we got to that final scene in episode one where Ted calls his now ex-wife,"* Toheeb Jimoh recalled on Q with Tom Power *in 2023. "I think everyone was kind of like, All right, cool. Like, this isn't just this zany American thirty-minute-episode comedy show for Apple TV+. There's a heart to it."*

But many involved point to the fourth episode of season one as the one in which the show's potential really started to become clear. The episode, titled "For the Children," was the first to take the main characters away from the AFC Richmond pitch, offices, and locker rooms and begin to suggest an entire complex world full of Greyhounds and Greyhound-adjacent folks trying to sort out their lives. Unfolding largely at a charity gala hosted by an anxious Rebecca, it brought all of the

major players together and introduced a new one: Rupert Mannion, Rebecca's ex-husband and the former owner of AFC Richmond, a wealthy cad who almost immediately preyed upon Rebecca's insecurities. The show's villain, he was played by Anthony Head, ironically best known before Ted Lasso *for playing a sympathetic mentor and father figure in the series* Buffy the Vampire Slayer.

Anthony Head, Rupert Mannion, seasons 1–3: I actually didn't meet any of the creators until my first day, at AFC Richmond's charity ball. I was quite nervous making my first entrance, as Rupert, in front of absolutely everybody, who'd all been working together for a bit. But filming the whole thing turned out to be wonderful—everyone was lovely and throughout my onstage speech, various members of the writing team came up and whispered alternative joke lines in my ear. Such fun to play ideas as they come. No one told me how they perceived Rupert—it was pretty much there on the page just waiting to be interpreted. Definitely a narcissist.

Jason Sudeikis, creator, Ted Lasso, seasons 1–3: Anthony Head coming in in that white dinner jacket was just badass. That's just like bad Rick from *Casablanca*, like if Rick was a bad guy.

Brett Goldstein, writer, Roy Kent, seasons 1–3: In my head, episode four of season one is when it all started. I remember that read-through it felt like, This is cooking. Everyone is now comfortable in their parts and we are all gelling, and the chemistry is great. It may have been there before, but I think everyone's confidence started to come in episode four.

Jason Sudeikis: It was the first time there were multiple stories going on with emotional undercurrents. It's something about being on a field trip or at camp. We were at *Ted Lasso* camp, and it was unusual.

Tom Marshall, director, season 1, including episode 4: The gala

episode was good for the ensemble properly coming together. When you saw, like, Brett and Phil interacting as Roy and Jamie you were like, All right, even though Jason's obviously leading the charge, I can see a world where everyone cares just as much about all these other characters as well. Seeing them interacting is really working and it feels like there's a lot to build on.

Jason Sudeikis: Some folks were concerned about that episode because we were setting up the locker room, and now we're already out in a different place and nobody's in the same clothes. And I love that, because it just accelerates community in real life. For me, that's where you get to see people outside of their elements, like watching them play board games or seeing them dance. You see them where they could be uncomfortable.

Tom Marshall: There's a scene with Phil and Brett at the bar where they're competing, they're sort of like rutting stags going at each other. But also you can sense that emotional depth to it, but then it's sort of funny—all that was going on in that episode. Episode one felt like a little scaled-down sports movie with Jason at the center whereas this, I'm starting to see season two, season three . . .

Jason Sudeikis: I was holding a lot of these stories in these arcs in my head. I remember that was the first time that I sat down with Nick and explained to him what was going to be going on there.

Nick Mohammed, Nathan Shelley, seasons 1–3: I remember we were filming the gala episode, because I sat next to Jason for a lot of it. And in the camera breaks and when they were doing different setups and stuff, we would just be chatting.

Jason Sudeikis: I told him, "You don't get up and dance, though. You just sit back and watch because you don't think you can dance. But you're seeing, like, 'Wow, this guy, like, how can I affect people the way he affects people?'" And that obviously turns in season two

where [Ted] doesn't affect Nate the way he did at that moment. So if you watch that episode again, you see Nick just sitting at that table in that suit that Ted bought him, literally, you know, surrounded by it.

Nick Mohammed: And even though we hadn't got the green-light on seasons two and three at that point, Jason outlined exactly where Nate goes in season two and where it goes in season three as well. As a trilogy, I guess. I would have done the show regardless of whether that character was going on an arc or not, because of the level of talent involved and being a huge fan of Bill Lawrence and Jason and so on. But it's nice that virtually every member of the cast has a little journey, and often it's not the case in those minor parts.

Juno Temple, Keeley Jones, seasons 1–3: I loved the moment with Keeley and Rebecca, when Keeley gives her advice on how to stand at the red carpet. A little tiny moment that I thought was just really special.

Tom Marshall: It's a bit like the A-Team or something. [Rebecca's] out in the alley crying because she's seen the ex at the gala. Then you're cutting back inside and Jamie's complaining about spilling shit on his nipple because he's not wearing a shirt. It's people passing the ball to each other and running with it in different directions, but it's working together as a play.

Anthony Head: I felt a remarkable energy on the floor and in the building. Then there was the story about the loss of Robbie Williams performing at the event and Ted asking a busker he'd seen playing locally to replace him—and Jason actually inviting Cam Cole to perform, a real, amazing busker whom he had seen playing at Piccadilly Circus. Cam took to the stage and was unbelievable, and the whole dance sequence that followed. It all told me that this show had heart, had drive, had soul that you rarely see, unfolding before your very eyes.

If the fourth episode expanded the world Ted Lasso *was creating, the eighth, "The Diamond Dogs," gave it its thesis statement. It came in one of the show's most beloved and widely referenced scenes, in which Rupert challenges Ted to an impromptu darts duel before the Richmond faithful at the Crown & Anchor pub.*

Rupert has just told Rebecca that he is engaged to the younger woman he left Rebecca for, Bex, played by Keeley Hazell. He has also announced that he has helped Bex become a minority owner of AFC Richmond, and that he plans to sit in the owner's box at every match and make Rebecca's life miserable. So when Ted accepts the challenge, on the condition that if he wins Rupert must stay away, the scene is at once a milestone in Ted and Rebecca's relationship, a big step toward Ted's winning over the Richmond supporters, and a statement of purpose for the show itself.

"You know, Rupert, guys have underestimated me my entire life," Ted begins. "And for years I never understood why, it used to really bother me. But then one day I was driving my little boy to school and I saw this quote by Walt Whitman, it was painted on the wall there. It said, 'Be curious, not judgmental.'"

Setting aside that it probably wasn't really Whitman who said it, the quote is a succinct encapsulation of the show's world view—one the cast and creators often invoke in interviews—and reveals the elegant philosophical underpinnings of Ted's seemingly happy-go-lucky approach to life, even as the scene itself makes clear that Ted is no pushover.

Anthony Head: The darts match when Ted Lasso beats Rupert— Jason's writing was sublime, and the whole scene kind of summed up where the show's heart was.

Nick Mohammed: "Be curious, not judgmental." It will take three seasons for all the characters to be curious about something and

not judge and work things out for themselves, but I think that's a very strong message. I think all the characters do go through that in different ways.

Annette Badland, Mae Green, seasons 1–3: The darts moment was wonderful. You smell when things are important, I guess. It touches a nerve in you and the other actors. You just know it's a good, quality scene that should hit home.

Hannah Waddingham, Rebecca Welton, seasons 1–3: I didn't have to say anything, really. I could just sit back and feel Ted and Jason. That scene didn't look or sound like that until very shortly before the cameras turned over—he was tweaking and tweaking that monologue.

Annette Badland: The dartboard scene I sort of take into my life. Because I am quite a little policewoman. I will go, Why are they doing that? This shouldn't happen! You know? And I now think, No, be curious. . . . That just hit home, really.

Hannah Waddingham: When I've watched it back, there are moments when I look at it and I can see me just luxuriating in Jason, and then other moments where Rebecca is feeling her guilt that she is putting this human being who is such a good man through the wringer.

The shoe that has been dangling over the entire season—when is Rebecca going to admit her vengeful true motives for hiring Ted?— finally drops in the following episode, fittingly titled "All Apologies." In it, Rebecca tearfully comes clean about hiring Ted to fail and working against him since he arrived, and Ted shocks her by embracing one of the show's other core themes: the power of forgiveness. In turn he inspires Rebecca to make amends with Higgins, whom she fired because he would no longer go along with her scheme.

Jason Sudeikis: We didn't have these words up [that said] "This

is what the show is about: Grace. Forgiveness." It's just when the choices come for characters to make, this is just where they would gravitate.

Brett Goldstein: You know what my favorite scene is, maybe? I've got loads. But it's when Rebecca confesses to Ted. I was hidden in the room next to them, and I saw it from the run-through. I was just like, "Fucking hell, this is good stuff." And I like the message of that. I like that it almost plays like a twist, that it's just instant forgiveness. I just love that.

Jason Sudeikis: Episode nine, it didn't seem to me to be a plot point that Ted was gonna forgive Rebecca. It's like, Let's just get that out of the way. It's about her. Ted hadn't done anything wrong to her. It's about her forgiving Higgins, who used to sneak Rupert's girls in because he was scared about losing his job. He has a family of six that he loves—he doesn't want to lose his gig. And so he had to play the game, and he hates himself for it. Go forgive that dude. Take what Ted did and let yourself off the hook.

Jeremy Swift, Leslie Higgins, seasons 1–3: It's a really attractive bit of human interaction. She takes Ted's forgiveness and hopes that Higgins will do the same, and she's open enough for him to do that.

Rebecca's apology to Higgins was sincere and Waddingham's performance was moving—this was the episode she submitted for Emmy consideration, successfully—but the scene stands as a prime example of the show's rare ability to blend drama and comedy. Because when Rebecca goes to Higgins's home to apologize, she finds the former uptight company man sporting a Van Dyke beard and soulfully plucking an upright bass.

Jason Sudeikis: Higgins playing the bass, that's me knowing that he was into jazz and finding that out when we were shooting episode

three. It's like, Oh, Higgins is going to find his inner jazz man. I knew where he was going, I just didn't know how he was going to get there.

Jeremy Swift: It came about on a lunch break. I said to Jason, "When does he appear again?" And he said, "Rebecca's gonna go to his house." And I said, "Maybe he could have a really long beard by then—how long has it been?" And he said, "Well, he could have a jazz goatee." And I went—crowbarring it in—"Well I like jazz and I play the double bass and the piano and stuff." That's how that came to be.

Jason Sudeikis: The part of him that was missing under the influence of Rupert, the thing that he loved about himself, was missing. So in the absence of doing that job, he would go to his passion—he'd grow back his goatee and play the bass. That's from a brief conversation.

That happens with all of us, and that's a by-product of something I learned and saw as a fan at Second City when someone like Jeff Richmond—who did all the music for *30 Rock*, him and Tina Fey, husband and wife—would direct shows. I'd always heard during the process, he would ask people, "What are your tricks, what can you do?" And then he would use those tricks in the show.

"MAKE REBECCA GREAT AGAIN"

Season 1, Episode 7
Written by: Jason Sudeikis
Directed by: Declan Lowney

Crazy things happen on the road. Away from the familiar structures and obligations of home, we can become a bit unmoored physically, emotionally, spiritually, morally. The result might be a revelatory night out or tears on your hotel pillow. An improbable win or a shattering loss. New romance or old love gone bad. Hurt feelings, hookups, breakups, breakdowns, broken furniture . . . or just an ill-advised warbling of "Wonderwall" in some random karaoke bar.

The very eventful seventh installment of *Ted Lasso*, which follows AFC Richmond's trip to Liverpool for a match against Everton, crams all of the above and then some into its thirty minutes or so of action. One of the show's best episodes, it lives up to the promise of its title—"Make Rebecca Great Again"—in multiple ways, but that's only the beginning. Elsewhere Ted finally confronts his new reality;

Nate finds his emerging, caustic confidence; Keeley and Rebecca solidify their friendship; and Keeley and Roy kiss for the first time.

Keeley and Roy are among several new couplings in the episode, which also sees Ted find serendipitous companionship with Sassy, and Rebecca with a nameless waiter. We also get a bit of foreshadowing between Rebecca and Sam, who share a quick moment in the karaoke bar. (Rewatching the first season reveals multiple hints about their season two affair.)

But this episode is defined not by new relationships but by two that have ended: Ted's and Rebecca's marriages, the twin shambles that form the brokenhearted foundation of *Ted Lasso*. It opens with nods to both of their breakups. Ted is talking to his son in a video chat when his wife, Michelle, drops in to ask him to sign his walking papers. (That's not what she says, but it is effectively what they are.) Meanwhile in her own office, Rebecca is getting email reminders from florists about her upcoming anniversary, the first since Rupert left her. Ted and Rebecca both could stand to blow off some steam, in other words, and eventually will. But they will take dramatically different paths to get there, their respective emotional arcs fueling the episode until they come together in one of the show's most memorable scenes.

For Ted, the trip to Liverpool brings wild swings between his usual good cheer and despair—bad Beatles jokes in one scene, drunken self-pity in the next. His interactions with the team are typically agreeable as he urges them to turn their Everton frowns upside down—they dread playing the club because Richmond hasn't beaten it in sixty years—and emotionally prepares them for the match with a screening of *The Iron Giant*.

"Keep an eye on these guys," he tells Beard as he heads up to his room. "Because around the seventy-four-minute mark, there's gonna be a roomful of grown men crying." (Beard: "I'll be one of them.")

There will be tears for Ted, too, but for different reasons. Drinking whiskey in his room, his normally tidy Ted 'do all askew, he scowls at his divorce papers and then lashes out at Nate when the kitman tries to slip some thoughts about the team under his door. While Ted will rebound the following day to help Nate finally claim some authority (by having him tell the team what he thinks of them) and to lead Richmond to a galvanizing (off-screen) victory, his struggle is far from over.

For Rebecca, the trip north is both cushier—private jet, presidential suite—and less intensely upsetting. She is not in the throes of her breakup but in the long, fumbling period of readjustment to life on her own, when painful milestones like your first postdivorce anniversary sneak up on you. She also has more support in the form of an exciting new friend, Keeley, and a treasured old one, Sassy. Together they represent the promise of what Rebecca sacrificed when she gave herself over to Rupert, the kinds of nurturing relationships she can let back into her life as she gradually reclaims who she really is.

"That's not Rebecca," Sassy tells Keeley when Rebecca is in the loo. "The real Rebecca is silly. Strong, yeah, but not cold. Have you ever heard her sing?"

Foreshadowing alert! Eventually everyone will hear her sing and it will be glorious for us all, even Ted, though the power of the song and the specter of letting things go will send him spiraling. But it will also begin to bring the two of them together in a way that helps them both to heal.

Women, amirite?

Men, who needs 'em?

The battle of the sexes, the received wisdom about mutual need confounded by fundamental misunderstanding, is ingrained within American pop culture practically to the point of invisibility. Even as the twenty-first century has brought an overdue influx of shows and movies based on same-sex relationships and introduced a more kaleidoscopic understanding of gender, Girls vs. Boys—and the yin to its yang, Girls + Boys—remains a central conflict in most of the stories we tell ourselves. It's the engine of sitcom marriages, of rom-coms, of love songs. It's the frisson that animates odd-couple pairings of cops, doctors, and lawyers. It's Ross and Rachel, Sam and Diane, Meredith and McDreamy.

While *Ted Lasso* has received plenty of praise for its generally hopeful, aspirational ideas about how humans should treat one another, less attention has been paid to the nuanced ways it depicts male-female relationships. But from Ted and Rebecca on down, the show consistently finds ways to render the bonds between men and women that are surprising in a TV show but happen to align more closely with the real world.

The first season of *Ted Lasso* is in many ways a divorce story, told from the perspectives of the dumped. It was Ted's separation from Michelle that sent him to England and Rebecca's abandonment by Rupert that led her to hire Ted in an act of revenge. The first episode ends with Ted's half of a conversation with Michelle, which in a few gutting lines reveals his motivation, gives the show emotional subtext, and announces that it isn't going to be the zany fish-out-of-water sports comedy we might have expected. Rebecca, meanwhile, is so consumed by her own pain that she is willing to inflict it upon everyone else in the name of making Rupert feel some for a change. The casualties include Ted, of course, but also Keeley, set up when Rebecca hires a photographer to incriminate her and Ted; Jamie, sent

back to Manchester City to handicap Richmond; and Higgins, who is fired when he refuses to play along with Rebecca's scheme anymore. When she finally repents and comes clean near the end of the season, Ted forgives her and explains his generosity in simple terms: "Divorce is hard."

The bond they form out of that understanding is profound, demonstrating that while it may be true that hurt people hurt people, healing ones can help others heal, too. But Ted and Rebecca's friendship is also recognizable—most of us have worked with, admired, or befriended someone of the opposite sex without falling in love or into bed with them. (In the non-TV world, that's actually more typical than the alternative.) And because the relationship at the center of the show is at once commonplace, powerful, and uncomplicated by romance or lust, it sends a message about the ability we all have to bring meaning and comfort into one another's lives.

None of which stopped viewers from wanting Ted and Rebecca to end up together. Many *Ted Lasso* fans *desperately* wanted this—entire podcasts and countless tweets and Reddit comments were devoted to it. Even some people on the show wanted it.

"I'd love to see Rebecca and Ted get together," Nick Mohammed told me in 2021. "I don't know if it will happen, but that'd be nice."

It's easy to see why viewers would want two beloved, attractive, mutually affectionate characters to pair off, and a hundred-plus years' worth of movies and TV—and centuries more of plays, novels, and operas—have trained us to expect it, particularly when the characters in question must overcome initial antagonism, impossible circumstances, or some other obstacle to make it happen. Hollywood's preferred truce for any battle of the sexes is a big kiss.

Ted Lasso teases its 'shipping fans in the final episode, showing Ted waking up at Rebecca's house and sharing an awkward moment

with her before it is revealed that he stayed over only because there was a gas leak in his neighborhood. After dashing fans' hopes of seeing their dreams come true, *Ted Lasso* threw in something nobody hoped to see: a shot of Beard in a thong. In a Reddit AMA interview after the finale, a presumably more clothed Brendan Hunt—though we can't know for sure—was asked if the writers had ever considered putting Ted and Rebecca together.

"Out of professional responsibility, yes," he responded. "But never with enthusiasm."

But in ultimately denying viewers TedBecca (apologies), the show gave us something rarer than a wish-fulfilled will-they-or-won't-they: a layered depiction of a mature, rewarding, deeply emotional but platonic male-female friendship on TV. When called upon to answer for their crimes against romantic inevitability, Jason Sudeikis and Hannah Waddingham have hit similar notes. "People say, 'Are they ever gonna get together?' They *are* together," Sudeikis told Sky Sports in 2023. "That's part of the fun of the show, is these people that you meet and how you respond to them. Do you fall in love with them? Is that love necessarily romantic love? Is it just, like, soulmates?"

Actually, it's "devoted soulmates," Waddingham said in a 2023 panel discussion. "Sometimes you can have a relationship with somebody that is so deep that it goes beyond.

"A leading woman and a leading man in a show can find a depth of love and companionship that is not purely sexual," she continued. "And I felt it the minute Jason and I met, and it was effortless from day one, and we still have it today. We will have each other's backs forever, and I'm glad that we got to portray that on-screen."

Ted Lasso was also surprising—and surprisingly real—in how it handled its relationships that *were* romantic. Its love triangle between Keeley, Roy, and Jamie was authentically messy from start to finish.

The story of season one was Keeley leaving behind the narcissistic Jamie in favor of the more noble Roy, with hiccups and backslides. Then once Roy and Keeley were together, the show dug in on the day-to-day care and feeding of a relationship, and the petty jealousies and annoyances that can entail.

Over time Jamie matured and Roy's less flattering attributes came to light—when an embarrassing private video of Keeley leaked in season three, it was Jamie who was the more supportive one. As time went on, the romantic rivals became friends—with the occasional fistfight—and in the end, nobody got the girl. The girl chose herself, and based on the finale, everyone decided they were all important enough to each other to remain in one another's lives.

Ted Lasso also upended expectations by inverting the usual May–December routine. Sure, the wealthy cad Rupert married a much younger woman and then cheated on her with an even younger one. But Rebecca's season two affair with the twenty-one-year-old Sam shocked viewers, and then Sam ultimately surprised *her* by deciding to put himself first. (One weird blind spot is the show's blasé attitude about the power imbalances inherent in dating the boss, not just with Sam and Rebecca but also with Keeley and Jack in season three. Apparently there are no HR departments in Richmond.)

The story's most enviable partnership in *Ted Lasso* is the most stolid one: the Higginses' decades-long marriage. It was also the show's most realistic relationship, in a literal sense: the actors who play the couple, Jeremy Swift and Mary Roscoe, have been married for more than thirty years. "Bill Lawrence came up to me one day and said, 'Have you worked with your wife before?'" Swift told *60 Minutes* in 2022. "I went, 'Yeah, I have actually a couple of times.' He went, 'Do you get on when you work together?' And I went, 'Yeah.' And he said, 'Because we're thinking of bringing her in

for your wife.' He's very cool, Bill. So I went, 'OK, yeah, right,' inside thinking, Woo!"

But it was another real-world couple that shadowed the relationships in the show, particularly Ted's disintegrating one: Sudeikis and his partner, the actor and filmmaker Olivia Wilde. The couple, who had been together for a decade and share two children, broke up after the first season of *Ted Lasso*, and their split remained a tabloid and social media fixation. Some of the details were lurid: Wilde struck up a romance with pop star Harry Styles, the star of her movie *Don't Worry Darling*. She was later served custody papers onstage during an event to promote the film. (Sudeikis released a statement saying that he had not known the service company would ambush Wilde then and did not condone the action. When *Variety* asked Wilde about it, she replied, "Sadly, it was not something that was entirely surprising to me. I mean, there's a reason I left that relationship.") In 2022, the couple's former nanny gave an interview to the *Daily Mail* that included scenes of Sudeikis lying down in front of Wilde's car to keep her from meeting Styles and bemoaning the fact that she was sharing her "special dressing" with the singer, a detail that went viral. (Wilde even participated, in a way, posting a photo on Instagram of a page from Nora Ephron's novel *Heartburn* that included the salad dressing recipe.) Sudeikis and Wilde together released a statement calling the claims "false and scurrilous."

This symmetry of Sudeikis traveling to England to tell the story of his character traveling to England in the wake of a collapsing marriage is hard to ignore. While the first season was shot and aired before Sudeikis's split with Wilde, it was natural to wonder whether he was working through his own personal issues with *Ted Lasso*, and to what extent the ongoing real-world story informed the ongoing TV

one in later seasons. Sudeikis grasped the inclination. "I understand people conflating the two," he told the *Fly on the Wall* podcast in 2023. "Literally the second I started thinking about it in the long form of a television show, I knew that [Ted's rough conversation with his wife] was the ending of the pilot. So none of that was autobiographical. Then as life sort of marched on, the only thing in my life that helped inform the playing of things and maybe even the notion of a story point was being a father."

But even that was not a direct analogue, he explained, because unlike Ted, who was painfully separated from his son, Sudeikis and Wilde's custody arrangement allowed him to have his children with him in London during filming of seasons two and three. Of the breakup itself, Sudeikis told *GQ* in 2021, "You take some responsibility for it, hold yourself accountable for what you do, but then also endeavor to learn something beyond the obvious from it.

"Anything I've gone through, other people have gone through," he said. "That's one of the nice things, right? So it's humbling in that way."

The creators always knew Ted was going to have his first major panic attack in the seventh episode. "We had always had a karaoke scene where Ted loses it," Sudeikis said in a 2023 panel discussion. "Whether it's gonna be Ted singing 'Friends in Low Places,' whatever, it was always episode seven."

But early in the shoot things actually weren't going according to plan, Declan Lowney, the episode's director, told me. Lowney directed more *Ted Lasso* episodes than anyone else, but "Make Rebecca Great

Again" was his first. "I think that might have been my second or third day shooting, and boy, it was a big day for Jason because he had the panic attack," he recalled.

> I remember that morning, he turned up and I showed him around the location we picked for the karaoke club, and he just said, "Sorry, everything you're showing me is wrong. This doesn't feel like a karaoke club." And he's right: It wasn't a karaoke club, because the London karaoke clubs hold maybe twenty people but we have forty actors; all the team are there with girlfriends. So we've gotten into a much bigger space, which wasn't properly a karaoke bar. So we spent a couple hours re-dressing the room, pulling furniture in from another place and just tweaking stuff until he felt better about it. I think it was a tough day for him because he had a lot on, and it freaked him out that it just didn't feel right. Now in the finished show, it's perfectly a karaoke club.

The karaoke bar was crucial because it would be the setting of the event that would start to solidify Ted and Rebecca's bond: her showstopping rendition of the *Frozen* anthem, "Let It Go," which both symbolizes her reembracing herself as she moves past her divorce and sends Ted through the fire of his own emotions. As the Greyhounds stare agape at Rebecca's performance, Ted flees in the throes of a panic attack, and is left shuddering in the street until Rebecca arrives to help him come out of it. "Jason's work on his anxiety attack, I think, is absolutely beautiful and could be so easily over-baked or under-baked, for that matter," Waddingham told *Entertainment Weekly* in 2022. "But it was really . . . delicately thought out."

The scene doubled as a showcase for Waddingham's world-class

pipes. "We knew she was a West End star," Lowney recalled. "But when you're live in the room and she's singing, those reactions are fucking real for people, you know? And what a difficult song to sing."

Waddingham was all too aware of the challenges presented by that particular number, originally performed by the musical theater superstar Idina Menzel. The song was inescapable in the years following the release of *Frozen* and remains so for any parent of a toddler.

"I didn't want to sing 'Let It Go,'" Waddingham told the *White Wine Question Time* podcast in 2021. "As a professional singer, I've avoided that song ever since it came out—if there's a concert where they've asked me to sing it, I go, 'No, I'm not doing that one.' Because it's been sung so brilliantly and sung to death by everyone else since." When she told Sudeikis that she didn't want to sing "Let It Go," he replied that if she could come up with a better song for the scene, she could sing it instead.

> He went, "OK, go off into your dressing room and see if you can find me a better song that's the perfect Venn diagram moment for your character, for my character, for your goddaughter being reintroduced, the song that you and she would have sung together when she was younger, all of that." I was like, "Fine, I *will* find something better." I went into my trailer and I was thinking, and then I was just like, God, he found the perfect song. And then I sang it for about ten hours in that karaoke place. Like, "Please tell me one of those takes was nice."

Most if not all of them were, according to the people on set. The scene remains one of the best in the show and the cast knew it was

exceptional even at the time. "It's pretty fucking special," Brett Gold-stein told me. "And it was special when we filmed it."

The episode ends with Rebecca returning for the waiter she flirted with earlier and Ted receiving a late-night visit from Sassy. But first he faces the end of his marriage, signing the divorce papers, sending them to the lawyer, and then giving himself a flicker of a smile in the mirror as if to acknowledge that he has gone through something terrible and he is still here. The episode ends on one more memorable musical interlude, a lengthy play of the melancholy soul ballad "Strange" by Celeste. "Sometimes a show gets the rights to part of a song, but I believe that's the entire song," Hunt told *The Rich Eisen Show* in 2021. "It just brings the whole thing together, and makes it more than the sum of its parts."

With its poetic exploration of the way people connect and come apart, the song aligns with *Ted Lasso* in suggesting that the mysteries and rewards of human interaction are no less magical for happening again and again, every day, all over the world. "Isn't it strange?" the chorus begins over a fragile piano melody. "How people can change / From strangers to friends / Friends into lovers / And strangers again?"

In other words, it pretty much says it all.

WHO WON THE EPISODE?

While Rebecca is the clear choice here, for how she triumphantly flipped the script on her fraught anniversary, the spirit of the episode demands that we call it a tie between her and Ted. Ted had a hard time, drunkenly berating poor Nate and later collapsing in a heap outside a karaoke bar. But in the end, he does what he knew he needed to do. Just before signing the divorce papers, he rights the upended army man on his desk—the latest in the show's series of

totemic plastic soldiers. By then, he has more than earned the symbolism of the gesture.

BEST ASSIST

Sassy, who, despite being neglected by Rebecca during her marriage to Rupert, shows up unannounced to help her through her anniversary weekend. She also gives her some sage tough-love advice about personal responsibility.

"God, that man took so much from me," Rebecca laments at one point, but Sassy isn't having it.

"No," she responds. "Rupert is a horrible man who built an ivory tower he kept you captive in, but you climbed every single step of that tower on your own. You're the one who stopped coming home, stopped calling. You made a six-year-old girl wonder what she'd done wrong. I'll always be your biggest defender but you have to own up to the part that you played."

BEST SAVE

Rebecca. A big step in reclaiming her humanity postdivorce comes when she helps a flailing, bewildered Ted recover from his panic attack. So in that way she sort of saves herself as well as him.

BEST LINE

"Rojas, you say that football is life, right? Well then your defense is death." That's one of many merciless bon mots in Nate's profane pregame roast of the team. ("Tough but fair," Rojas responds.) The speech, which both showcases Nate's tactical smarts and previews his

cruel streak, results in Roy flipping over a bolted-down bench and spurs the Greyhounds to victory.

RANDOM STATS

- The editors originally considered using "Strange" in the fifth episode, when Michelle visits Ted in London and admits her feelings for him have faded.

- More music trivia: "Let It Go" wasn't the only song Waddingham sang in the karaoke bar. "We had to shoot another song as well just in case we couldn't use the Disney song," Lowney said. "We shot Gloria Gaynor's 'I Will Survive.' So Hannah had a lot of pressure on; she had to sing two songs in that time."

- Disney actually did initially reject the show's request to use "Let It Go." But Tony Von Pervieux, one of the show's music supervisors, convinced the studio's reps to change their mind by showing them footage of the scene and Waddingham's performance.

- One memorable mini-moment during "Let It Go" comes when we see Roy mouthing the lyrics, clearly familiar with the song. "We learn later his niece obviously loves the movie, and that's why he's seen the movie multiple times," Lowney said.

- It is Sam who sings "Wonderwall." It goes about as well as you'd expect.

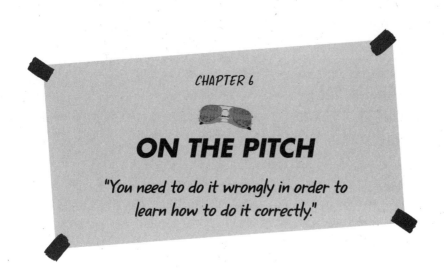

ON THE PITCH

"You need to do it wrongly in order to learn how to do it correctly."

People involved with Ted Lasso are quick to tell you that the show isn't really about soccer. But because it was a series set in the Premier League, centered on a professional soccer team and its coach and its owner, and filled with dozens of soccer players and hundreds of soccer fans, somebody was going to have to kick a ball at some point.

While the creators didn't have any illusions that they would be able to re-create a Premier League–level match—and their task was made easier by the fact that AFC Richmond was not supposed to be a particularly good team in the beginning—they did want the soccer action to be convincing. Or at least convincing enough that it wouldn't detract from all the relationships, conflicts, and emotional awakenings that made up what the show really was about.

Brendan Hunt, creator, Coach Beard, seasons 1–3: We're not

trying to make fun of soccer. We love all this stuff. For the main player roles, everyone got asked at their audition if they could play.

Theo Park, casting director, seasons 1–3: They had to do normal scenes acting, and then they had to show us their football skills on tape as well.

Brendan Hunt: Except we sort of forgot to ask Brett Goldstein. We all just kind of assumed, from the sound of his voice, that he knew how to kick a ball around. Anyway, special effects are a wonderful thing and stunt doubles are great.

Jason Sudeikis, creator, Ted Lasso, seasons 1–3: Michael J. Fox didn't know how to skateboard. There's buttons on keyboards to make all that jazz happen.

Chris Powell, soccer coach, played himself as a commentator, seasons 1–3: The guys are OK. Obviously not the standard of Premier League players; you don't expect them to be. But they were OK. Moe Hashim, who played Bumbercatch, he played at a decent level. Kola Bokinni—the captain, Isaac—and Phil Dunster are pretty decent. Toheeb was OK. We had to film one scene about twenty times, but he nailed it in the end.

Toheeb Jimoh, Sam Obisanya, seasons 1–3: Moe Hashim is hands down the best footballer on the team. Cristo's good. Phil's really good at football, as well. Kola's really good.

Kola Bokinni, Isaac McAdoo, seasons 1–3: I'm gonna exclude myself from this—saying who I think is the best footballer and then saying myself is not Ted Lasso–like. So I say Moe. And then Cristo is pretty good. Toheeb's pretty good. And Phil is pretty good.

Jason Sudeikis: [In Britain] they refer to background actors or extras as supporting artists, or SAs, and a lot of the SAs did have high-level soccer skills. Higher level than me, at least.

Phil Dunster, Jamie Tartt, seasons 1–3: The guys who were on

the team were genuinely lovely blokes who were all much better at football than we were at Brighton High. It was just a really lovely atmosphere to turn up and play.

Hunt, who became a soccer fan during his time living in Amsterdam in the 2000s, is knowledgeable about the sport and was heavily involved in the soccer scenes. But he and the other creators wanted to bring in an actual professional to coach the on-screen players and make the action on the pitch look authentic.

They hired Chris Powell, a well-known player, manager, and pundit in England, as soccer guru. Powell eventually was also cast as one of the show's TV soccer commentators, alongside Arlo White. (White, a former announcer for NBC Sports, appeared in the second Ted Lasso commercial, making him the show's only cast member besides Sudeikis and Hunt who also appeared in the ad campaign.)

Chris Powell: I had a call from a guy who works for a sports marketing company. We've had dealings in the past in football, and he just called me out of the blue and said, "A script has landed on my desk about a show made by Apple TV about an American taking over a Premier League team." And I said, "I don't think that'll work." [*Laughs.*]

Brendan Hunt: Chris Powell was a fullback who spent most of his career with a London club called Charlton. He is awesome and he was such a good guy, and he was so good for all our football-playing cast.

Chris Powell: I was told they need someone to coach the actors and extras so it looks realistic. I had left my previous job in Holland, so I wasn't doing anything, and I said fine. The guys were great. They all loved football and obviously they knew my career, they'd seen me playing and managing. Then while I was there, I got a job at Tottenham and I got a job with the England national team.

Jason Sudeikis: To have someone that had that kind of résumé and was just a natural leader and inherent coach was great.

Chris Powell: I was called upon two or three times a week. They would ask me, "We've got a scene where the guys are in the background—if they did this drill would it look right?" A producer would give me a heads-up when they were looking to do an attacking scene or a possession scene, and I'll say, "What were the numbers?" And they'd tell me they want two teams, and I would set it up and if it worked for the camera and the angles, they would do it.

Brendan, especially, he's got extensive football knowledge—he really understood what he wanted to see. I would sort of talk to him and it worked well. Hopefully I was helpful to them.

Brendan Hunt: Chris was a dream. He was fantastic. And then to have him doing the announcing with Arlo was just doubling that up.

Chris Powell: I've always done some TV punditry for games on Sky. I believe someone from the production team saw me one evening, and when I came in they said, "You were seen on TV last night and it looked really good. We've got a commentator, Arlo White—would you like to be his co-commentator?" I said, "You know, I'm not an actor." And they said they didn't want an actor; they wanted someone who has been involved in the game to give it a bit more realism. And I said, "Yeah, great," and it's just gone from there.

It's been crazy, the life they gave me. Because football shows rarely work. The ball gets passed differently so you can't repeatedly do a scene the same. It's very hard to shoot football scenes, notoriously hard. So what they did was use it sometimes, but then other times they almost left it to your imagination.

Declan Lowney, director, seasons 1–3: In season one, they kept

pushing the football because they weren't sure how the hell they were going to do it.

For AFC Richmond's home ground, Nelson Road, the producers chose Selhurst Park, a small, relatively ramshackle stadium in South London that is the home of Crystal Palace F.C., a storied club that has never won a Premier League title. In doing so, the producers were intentionally reaffirming Richmond's identity as a squad of Davids facing off with Goliaths like Manchester City and Chelsea. As a practical matter, Crystal Palace's red-and-blue color scheme set the template for Richmond's look. (Visit the Crystal Palace website and for a second it feels like you're a Greyhounds fan checking in on your team.)

Bill Lawrence, creator: We had to find a Premier League team that would let us use their facilities and [would be] what we would base our team on: a local, community team as opposed to any of the big juggernauts. What's a team stadium that still feels like it's part of the community and localized? Not only did Crystal Palace fit the bill, but Bill Wrubel, who's one of the executive producers and writers on the show, his uncle is one of the ownership partners of Crystal Palace, so we had a connection to go in and talk to their management group. We told those folks what we were looking to do and said, "Look, our team will be an imaginary team and if we shoot in your stadium, Crystal Palace will kick our butts in the first game."

Paul Cripps, production designer, seasons 1–3: That kind of led to the color scheme for the team: Because Crystal Palace play in red and blue, they have a lot of red and blue seats in their stadium. So we felt it was best to link to their colors with the Richmond team in order to have less work to do, in terms of using the stadium, so we could fit in.

Jacky Levy, costume designer, seasons 1–3: Because we were

going to use the Crystal Palace stadium, we used the same colors for the uniform. We designed our own logos and badges.

Ted Lasso *kept its promise: In the show's first match, in episode two, Richmond loses to Crystal Palace 4–1. However, the production wasn't allowed to shoot the actual gameplay on the club's pitch.*

Lola Dauda, script supervisor, season 1: We shot bits of it at Crystal Palace, at Selhurst Park. And then the matches where we had to sort of go into the pitch and shoot the actual action, it was at this place in Eton, that private school where the toffs go, like Prince William and stuff. They have a huge football pitch—I think it's a rugby pitch, but we converted it into a football pitch. So we did the actual matches at the end of the shoot in November, on this freezing-cold pitch in Eton. We did them as a block over a week of night shooting.

Declan Lowney: All the games in season one were nighttime games, and that's a fucker because it's really hard shooting at night. You know, it gets dark before five o'clock in London at that time. They did it at the end—it was November and it fucking rained for a whole week. So that's why those games are very, very wet.

Sara Romanelli, assistant script supervisor and script supervisor, seasons 1–3: Basically we shot it under rain the whole time, thunderstorms. And during the night as well, so I remember it being very, very hard to shoot—obviously for the cast more than for us, because they had to be on the pitch running around with rain.

Chris Powell: Especially season one, we filmed quite a few scenes at night in front of a stand full of support actors and the production team. It was nerve-racking, I've got to say!

Declan Lowney: Everybody had had enough—they just never wanted to play a football game again. So in season two we said, "Let's make them all daytime games, that makes it so much easier, and let's

be smarter about how we do it." You need to do it wrongly in order to learn how to do it correctly.

The volume and ambition of the football action in Ted Lasso *increased each season. A big part of what made that possible was that beginning in season two, the creators charged a second-unit director named Pedro Romhanyi with overseeing the football blocks, or the chunks of production that were dedicated to filming the matches. They also hired Kasali Casal, a former professional player, to help choreograph the action.*

Declan Lowney: The big thing we did in season two was to take the football away from the episode directors and give it to a football director, Pedro. So while we were halfway through the season, six episodes in, we took a week and shot football for those six. And then at the end of next six, we took a break and shot football for all the second six.

Pedro Romhanyi, second-unit and soccer director, seasons 2–3: If you get the sport wrong, it's almost like the suspension of disbelief for the viewer gets ruptured. So, you can no longer participate as a dramatic piece. So it was important for us to try and make it easy on the eyes, credible.

Declan Lowney: So Pedro oversaw all the football-action shooting. But if there was dialogue happening on the pitch, then the director for that episode would just shoot the close-ups of the dialogue on Saturday.

Sara Romanelli: It will be a collaboration between Pedro and, say, Declan, for example, because the football will also have drama in it. And those sequences become quite tricky to shoot because you have to make sure you have the football, but you also have all the story beats that you need. Because it's very easy, when you shoot football, to get carried away and forget that you actually need the story. That's why we are there.

Pedro Romhanyi: The football is giving you a physical externalization of a character's inner issues. So, it's not a football match. It's not just, "Oh, he did a good tackle," and so on.

James MacLachlan, on-set visual effects supervisor, seasons 2–3: Pedro always had great references from Brendan.

Hunt, Team Lasso's resident soccer savant, continued to be the primary source of the vision behind the on-field action. It was often inspired or informed by his memories of actual matches from various professional leagues. "He was the guru," Romanelli told me.

Brendan Hunt: I got into soccer pretty late—like, not until I moved to Amsterdam in 1999. And I felt like I'd been lied to when I discovered soccer, because you hear it's dumb, it's divey, it's slow, it's low scoring. And I was like, It's the most dramatic thing since opera! So I went in full catch-up mode—I went full sponge and that basically has never stopped. Among Americans, I'm definitely your friend who knows a bunch about soccer. But then here comes Brett [a dedicated football fan] in the writers' room, like, Oh boy, OK, we have a Brit in here. . . . And it was one of those weird confidence moments when Brett kept deferring to me on soccer stuff.

Brett Goldstein, writer, Roy Kent, seasons 1–3: I know Premier League. [Hunt] knows the world. He's watched *every* football league.

Phil Dunster: Brendan's football reference knowledge is unreal, like, it's unprecedented. It's verging on concerning. He is the sage with that stuff.

James MacLachlan: Anything he doesn't know about football isn't really worth knowing.

Jason Sudeikis: Brendan, with every bit of football stuff, it was like, What normally happens here? And what does that matter in Kansas? Like, you know, regular folks. And we would twiddle the knobs on those things. Many of the stories are rooted in things that

have happened at different points in history or different countries, different leagues. It becomes a little like templates or archetypes.

Kasali Casal, soccer choreographer, seasons 2–3: Brendan was very clear in what he wanted, so we wanted to make sure we did Brendan proud.

Declan Lowney: The football sequences, in particular, are quite complicated in how the shooting is structured. Each of the elements—the football action, the coaches' dugout, the directors' box, the crowd cutaways, commentators Arlo and Chris—are all in different locations, and shot at different times.

James MacLachlan: Different times, different stages, different weather conditions. And then all of the crowds as well, which we shot separately as its own unit.

Sara Romanelli: The most difficult thing was obviously you have to have the action correct and the people to be more or less in the right position, from a continuity point of view. But you also have to have the right geography, because we shot every single part of those sequences separately. It seems really natural when you watch it, but when you're there trying to figure out, OK, which way are they facing on the pitch today? And what's happening now? And where is Rebecca compared to Ted? It can get very complicated.

James MacLachlan: It's not super straightforward, because often the director of photography wants to structure everything around the nicest light. So sometimes we'd have to flip and flop stadiums; sometimes we'd have to rotate them. So it wasn't necessarily as simple as, "OK, well, that's the south end and that's the north end." There was a lot of working out beforehand [of] where we were on the pitch, what was happening, eyelines.

Sara Romanelli: It's such a big deal with the eyelines. Because you have the pitch, the dugout, the press, the owner box. And there

very particular about that. Then there are also rights issues shooting in certain stadiums and timing issues of production versus when they're having matches and how ready the stadium is to even host people.

Vanessa Whyte: It was a bit of a nightmare. But the amazing CGI team helped us out with all that stuff.

Because the production was generally not allowed to shoot matches in actual stadiums, it filmed the football action on the Hayes & Yeading F.C. pitch near its West London Film Studios home base. Then teams of effects artists used green screens, rotoscoping, 3D volumetric capture, and other kinds of technical wizardry to place the matches within enormous stadiums churning with clamorous fans.

Cory Jamieson: All of the football action was filmed on the practice field, and then we would add in the stadium around it.

David Rom: They lidar-scanned all the stadiums and they piecemealed it together from CGI fans as well as real fans. [Lidar, an acronym for "light detection and ranging," is a remote scanning method for creating 3D models of physical spaces.]

Cory Jamieson: We would go and we would do a scan. And we would use that as not only a basis for the CG model that we were building, so we could make sure all the dimensions were correct and we would know where all the seats are, but then we would use that when we're putting the crowd in. We create what's called a particle array, and each particle will represent where a person would be. So in a lidar we can create a particle array to place around the stadium, the virtual space, and have it exactly match up with what they filmed.

David Rom: There are so many elements that go into just building those stadiums before even the content we shoot. It's quite a process.

Cory Jamieson: One of the earlier decisions that we made on the

show was not putting a huge green screen around the whole field. We decided that for two main reasons: One, that much green screen will be hugely expensive. You'd have to have a lot of crew to put it up; you'd need a lot of lead time to put it in. It probably can't stand up in the weather. So it's a huge pain in the ass, and expensive. The second thing it does is it makes it really hard to light it properly. So from a cinematography and filmmaker standpoint, you're sort of putting this giant shadow around your whole stadium in a way that isn't really reflective of what reality would be.

James MacLachlan: So we decided to green up to the advertising hoarding [the strip of ad space that encircles the field] so that we had green around the players' legs mostly, because of the movement of the legs.

David Rom: There are very small green screens around the bottom area and occasionally behind goals where you need, just for the net, a bit more detail. Then, incredibly, they managed to cut them all out and put them into the stadiums.

James MacLachlan: It was really important that we caught the emotion in the moments. Because with football grounds, as anybody knows who's been to one, the crowd is riding the emotion. They don't just sit there waving their arms and yelling and screaming the whole time. So we had to formulate a plan where we could make sure that emotion followed the arc of what was happening in the edit, you know, six months later.

Declan Lowney: We shot hundreds of people against a green screen doing a set routine of stuff. It's, like, three hundred people or whatever, and then they're replicated in the thousands and thousands. But they are real people.

The thousands of cheering, screaming, cursing, booing fans that filled the stands in the matches were assembled by combining shots of

dozens or hundreds of extras, filmed acting crowdlike in a given stadi-um's seats, with three different types of digital soccer supporter.

Most common are sprites, or video performances of people filmed in front of green screens that are turned into discrete, digital objects that can be assigned to the points within the stadium scans and ma-nipulated as needed for a given shot. They are ideal for filling thou-sands of seats, but seen too closely or at oblique angles, "it starts to give away the gag," Jamieson said. More supple are computer-generated digi doubles, which "are like fully realized three-dimensional people" that artists can tweak infinitely—relight them, change clothing or behav-iors, whatever—though visually they lack the photographic realism of the sprites. Finally, there is volumetric capture, which combines ele-ments of the other two—they are actors filmed from all sides on a green screen stage.

"It's like a three-dimensional video of someone," Jamieson said.

Barnstorm VFX brought in groups of extras and gave them cues for a range of reactions to portray: elation, disappointment, rage, nervous-ness, frustration, any flavor of feeling one might find in the crowd at a professional soccer match. They cheered and booed and yelled, all while cameras captured their performances in 3D. "So they're sitting there, they're jumping, they're cheering, they're clapping, they're disap-pointed, they're angry, they're happy," Jamieson said. "All that stuff in a loop, and now we have this in three dimensions."

The array of tactics and digital people allowed effects artists to be-lievably fill entire stadiums and dial up whichever emotions were re-quired for a given shot or sequence, no matter whether the camera was far away or closeup, static or sweeping around the field.

James MacLachlan: We shot all the additional material that was more narrative-based rather than football-based in those scenes with a few hundred extras in the crowd. And then it was a case of putting

it all together, which is handing it over to the amazing team at Barnstorm VFX. We were putting stadiums around, we were putting dugouts in, we were having to cover all of the crowd, all of the extra bits and bobs that you get, like photographers and linesmen, stewards and all that, and it was a case of stitching it all together. We shot in up to five different locations that were put into one, because we had crowd shoots, we had Hayes & Yeading shoots, we had dugout shoots, and we had to ensure that it all felt seamless. That all the eyelines were right, that all the action was happening in the right place. So it was a fairly mammoth task.

Cory Jamieson: I talk to people and I say, "Oh, we do the VFX work for *Ted Lasso*," and they're like, "What are you talking about?" Which on one hand is flattering, because it means it's going by kind of unnoticed. But on the other hand, it's a show that gets produced in a way that's not like a "visual effects show." Which means that the timetables are shorter, the expectations are different. And that's a hard thing when you have a lot of shots. That's a bit of a challenge.

Declan Lowney: The postproduction on that show is massive.

The net result was tense, exciting, at least somewhat realistic matches happening in some of the most famous grounds in England, like Chelsea's Stamford Bridge and Manchester City's Etihad Stadium. Even more pro soccer verisimilitude was made possible by a licensing deal Apple made with the Premier League ahead of production on season three, which enabled Ted Lasso *to use the official uniforms and logos of clubs like West Ham United F.C., purchased in the show by Rupert Mannion and coached by Nate during his less great phase. A separate deal with Nike put the Greyhounds in more premium uniforms and allowed the sportswear giant to sell a new line of AFC Richmond gear.*

"Apple managed to get the rights to use a Nike kit for AFC

Richmond, then the proper kits of all the teams they are playing against," Powell said. "It just added a touch of realism and authenticity."

The Premier League access came with the occasional hiccup. Chelsea fans were outraged when a banner honoring the late team legend Ray Wilkins that reads, "They don't make them like Ray anymore" was digitally edited to read, "They don't make them like Roy anymore" in an episode when Roy Kent, a former Chelsea star, returns to the stadium as a Richmond coach. But on balance, England's pro soccer community embraced Ted Lasso, with legends like Thierry Henry, Gary Lineker, and Chris Kamara making cameos and others openly expressing their affection for the series.

Chris Powell: It's gone down a storm. I think they recognize that it could have gone really, really wrong. The scenes, the language—they've been true to the Premier League and the Championship, when they got relegated.

Donna-Maria Cullen, executive director of Tottenham Hotspur F.C.: We all love it. It shows humor around the whole league itself. It humanizes certain aspects of it. It allows us to almost recognize some characters we might see around in our league. It's just great fun whilst also tackling serious issues, such as mental health.

Jürgen Klopp, legendary former manager of Liverpool F.C.: *Ted Lasso* mentioned me. That's better than getting the trophy for the best manager—unbelievable.

Mikel Arteta, manager of Arsenal F.C.: *Ted Lasso*, just looking at my profession, our industry, from a different angle, different perception, and in a different way, I think it was great.

Chris Powell: They use referees that have been in the Premier League. They used Thierry Henry, Jeff Stelling the presenter. They used some really well-known people.

Toheeb Jimoh: Meeting Thierry Henry was one of the only times

I've ever been completely awestruck. I was like, "This is Mr. Va Va Voom himself! This is Titi."

David Elsendoorn, Jan Maas, seasons 2–3: Meeting football legends like Thierry Henry in the makeup trailer, that was really cool. We would see American football matches with Harry Kane in the Tottenham Hotspur stadium, that was really cool.

Donna-Maria Cullen: It's entered our language. If we have someone who doesn't know the rules of football, then it's a "Ted Lasso comment," or we call them Ted.

Chris Powell: Unfortunately, for someone like Jesse Marsch—he came over at Leeds, you know—if he loses a game or he says something that doesn't fit right, they'll say that. [Marsch, an American coach, was the manager at Leeds United F.C. from 2022 to 2023.] Which I think is quite sad, because Jesse's actually managed in America, England, Germany, Austria and done very well. Someone like him and future American coaches shouldn't really be labeled as [Ted Lasso], because it's a lighthearted show. It's nothing to do with his quality.

Jesse Marsch, former manager of Leeds United F.C.: I think there's probably a stigma [against American coaches in the Premier League]. I'm not sure *Ted Lasso* helped. I haven't watched the show, but I get it.

Jason Sudeikis: I haven't had the opportunity to apologize or explain myself yet, with Jesse Marsch. I think it's a little lazy of anybody to correlate the two. That's never our intention, to make things more difficult. I think the things that Ted is teaching is stuff any of us would probably encourage our sons and daughters to live up to or at least strive for. Ultimately, if American coaches came into this league and won a whole bunch of games, that would probably go away.

Jesse Marsch: All I can say is, the only way I know how to do

things is to go all in, to give everything I have, to believe in who I am, to believe in the people that I work with, and to try to maximize what we are every day. And I find if you can do that effectively, that you can be incredibly surprised with the human spirit and what you can achieve.

So . . . that sounds like Ted Lasso, I think, from what I've heard.

The show's starriest football cameo came when Pep Guardiola, the manager of Manchester City F.C. and widely recognized as perhaps the best coach in the sport, appeared in the penultimate episode of the series. After Richmond improbably beats the mighty Man City, Guardiola shares Ted's own defining theory with him. "Don't worry about wins or losses," he tells Ted. "Just help these guys be the best version of themselves on and off the pitch. This, at the end, is the most important thing."

"I couldn't agree more, Coach," Ted replies.

While some critics balked at the notion of such wholesome Ted-speak coming from one of professional soccer's fiercest competitors and most committed winners, the cameo amounted to the ultimate Premier League endorsement of Ted Lasso.

Pep Guardiola, manager of Manchester City F.C.: As a family, my little daughter, Valentina, and my wife, we enjoy the show. We are big fans, especially the first season, and when they come and offered me to make a cameo, I said, "Why not?" and I could meet the actors.

Brendan Hunt: The football world has really opened up to us. It's funny to me when we see the odd social media troll complaining about a football fact we got wrong. Like, "Oh yeah? You know who doesn't mind? Jürgen fucking Klopp, man, Mikel fucking Arteta. They see what we're doing here—why don't you take a look?"

However, as rewarding as it was to earn the embrace of the real

professional soccer community, perhaps the most profound honor the show received, at least to those who play the show's footballers, came from an ersatz soccer enterprise. In September 2022, between the second and third seasons, EA Sports released FIFA 23, *the latest iteration of its blockbuster soccer video game. The new version integrated Ted, Beard, the rest of the AFC Richmond stars, and even the club's home ground, Nelson Road, into the game, allowing Lassoheads (and Lasso stars) to play as their favorite footballers.*

FIFA *had an outsize role within the life and development of* Ted Lasso, *going back decades before the show even existed. So for Ted and everyone else to end up inside the game itself was an incredible through-the-looking-glass experience for all involved.*

Jason Sudeikis: *FIFA* was part of the origin story of the show, with Brendan and I playing *FIFA* back in 2000 in Amsterdam, and him having just recently fallen in love with football and explaining it to me using, like, the nineties Bulls as a metaphor as we play Man U versus Arsenal.

Then during COVID, after we had all worked together at the end of 2019, I would say anywhere between eight to twelve of us were playing *FIFA Pro Clubs* [the online social mode of the game]. We created the Richmond team on there—we built our own characters, we named them after our own things. We had Nate as one of the characters; Rebecca Welton was in there. I played as Roy Kent, but I built an early 2000s version where he looked more like Oasis than the Roy Kent we now know. We were all playing and it became a way for us all to hang out.

Brendan Hunt: We can do it over headset, so we're socializing together even with these guys who are in London or Mexico. That's been a really cool way to sort of stay in touch.

Jason Sudeikis: I also always had a notebook open. When funny

lines came up or story ideas—whether they were articulated or we just happened upon them as we're playing—I'd write them all down. A lot of jokes and story have come out of it. It's, like, me, Brendan, Joe, Toheeb. Cristo. Brett Goldstein plays. Paul Cripps, our production designer.

Toheeb Jimoh: We would just be having conversations. "So um, what's going on and how's the writers' room going?" I got little pieces of information about season two. "We're gonna venture into Sam's politics." "There might be a romantic storyline," but I didn't know it was gonna be with Hannah. That came out while we were playing *FIFA*, which is really cool.

Jason Sudeikis: Then once the show hit, it wasn't just Ted as a coach on the sideline or even just doing a commercial. It was like, "No, we want to put him in the game." Then lo and behold, we got the whole kit and caboodle where they're like, "We want to put the team on there. We wanna scan the players."

Kola Bokinni: It's actually us. We have all of our characters. I play Isaac McAdoo in the *FIFA* team.

Jason Sudeikis: So it was a blast. I got an early copy of it. I remember inviting everybody over and we played Richmond versus Richmond, home kits and away kits, for basically eight straight hours. Winner would stay on, like, three games in a row and then people would rotate out. My little boy, Otis, was playing. It's just nuts. Everybody was flipping out.

Cristo Fernández, Dani Rojas, seasons 1–3: I'm fulfilling dreams as a football player because we're in *FIFA*. When you're a kid and you want to play football, that's the dream. Forget about anything else—just to play *FIFA* and play yourself.

Jason Sudeikis: I mean, look, we've had a real fortunate run with the reception to this show. Winning Emmys and awards and people

digging the show has been lovely. But I don't think anything created such a ruckus among the footballers as being immortalized on *FIFA*.

But back in November 2019, as the production struggled to finish its first season in the London rain, Ted Lasso *was still a long way from immortality. No one involved knew that their soccer show would eventually become the darling of TV fans, critics, awards presenters, Premier League pros, and e-sports gamers. They barely knew how to shoot the soccer itself.*

"By season three, we had our system," Romanelli told me. "But season one was a bit like, What are we doing?"

Even amid less than ideal conditions on an unproven production, however, there were reasons for optimism as well as a growing sense that whatever the future held for Ted Lasso, *the struggle would be worth it.*

Declan Lowney: Everyone's wet and fucking miserable, and it's "Let's just do two takes and move on." So there were days like that. The weather is not our friend shooting outside in November in the UK.

Jason Sudeikis: It was brutal. It was freezing.

Brett Goldstein: I always get annoyed when actors complain. Like when they made *The Revenant*, and they were like, "It was so hard. It was so cold." I always think, You were paid, and you're fucking happy. What are you moaning about? And then we did two weeks in shorts, in winter, in torrential rain, and I thought, This is worse than *The Revenant*.

Declan Lowney: It's a tough show to shoot. It's a big show to shoot, and there are a lot of elements. But our production was superb. We had fantastic people running the whole thing.

Lola Dauda: It had been raining pretty steadily for the last couple weeks. Obviously between setups in between shots, we had to

keep the actors dry, so we had this big tent to keep them sort of warm and dry. When we did the last shot, we all sort of piled in there and there was a big sort of emotional goodbye—this is pre-COVID, so a hundred people under a giant tent was fine then.

With the benefit of hindsight, you can't say people were thinking, Oh, this is going to be a huge success. But there was definitely a feeling that people would find it funny and it would find an audience. They obviously didn't realize quite *how much* of an audience and *how much* of a success it would actually be. But yeah, there was definitely a feeling that we'd created something good.

Bill Lawrence: Part of the thing that made the show work was how collaborative it was and how therapeutic it was for everybody to work on it. None of us knew if the show was going to work, but we knew we were all having a great experience writing it, producing it, making it in a way that no one would have regretted anything if the show just came and went.

Brett Goldstein: On the last day of season one, when we said goodbye, me and Jason, there was a moment of, "Thank you, this was amazing. . . ." And he was like, "Something happened here, right?" And I was like, "Yeah, something definitely happened here. And if no one watches it, we got to experience it." That was how it felt: it was like we did this magic thing and no one will ever see it.

Anyway, people did turn up.

KEY EPISODE

"THE HOPE THAT KILLS YOU"

Season 1, Episode 10
Written by: Brendan Hunt
Directed by: MJ Delaney

Dani Rojas is right: football is, in fact, life.

All sports are—it's one reason they're so globally popular both as spectator events and as fodder for TV and film. Sports are life distilled into intense simulacra of its most dramatic aspects: successes, failures, rivalries, close bonds. The deep satisfaction that comes from giving yourself over to a higher cause. The despair of confronting your own mortality.

It is this last one that gives the first-season finale of *Ted Lasso* its emotional resonance. Sure, there is the drama of whether AFC Richmond will be relegated, and whether the team's prodigal striker, Jamie Tartt, will be the one to "put the final nail in the ashes," one of several expressions we hear him mangle in a TV interview. (He also mentions "instant caramel," which sounds like a Ben & Jerry's tribute to John Lennon.) There is the question of whether Ted's head will

roll if the team fails, which by this point is no longer much of a question. And whether Nate's will swell after his new promotion to assistant coach, which definitely will happen, but not until next season.

But the star of the episode is the man who almost immediately becomes the breakout star of *Ted Lasso*: Roy Kent, the surly but secretly tenderhearted midfielder, played by Brett Goldstein, who at the beginning of the show is a lion in winter loudly lamenting his fate of finishing a stellar career playing for "Ronald fucking McDonald," as he put it in the pilot.

Ted being Ted, he eventually wins Roy over with a steady diet of support and platitudes, even as he convinces Roy to put himself on the bench. "This is why it's so hard to love you," Roy tells Ted as they dicker over who will become the new team captain. Which, as Beard notes, means that Roy has come to love him. (Isaac gets the captain gig by throwing a chair through the TV playing Jamie's interview.)

Roy's biggest battle, however, is not with cornball American optimism but with Father Time. It comes for us all eventually, and for none so mercilessly or undeniably as professional athletes. The rest of us can pursue at least a delusion of youth with turmeric shots, facelifts, or red convertibles, but for sports stars there is no escape from the moment when your body simply is no longer able to do what is required for you to remain employed. Sometime in your twenties or thirties or, for a lucky few, forties, life as you know it will be over.

It's what makes the fading athlete such a potent symbol of our ultimately doomed struggle against the dark. It's why movies like *Bull Durham* and *The Natural* still make grown men cry. The end is inevitable, these stories remind us. The only question is: How are you going to meet it?

Roy's end as a player, looming all season, finally arrives in this episode, and he meets it with the mettle and honor the previous nine

have taught us to expect from both him and this show. But it is still thrilling to watch Roy's heroic final moments as a professional footballer, as he comes off the bench to chase down and thwart Jamie's charge toward a certain goal and final nail in the ashes of Richmond's hopes. (Of course, Jamie *does* set up the brutal deciding goal a bit later.) Roy injures his knee on the play, and as he leaves the field one last time, he is serenaded with his signature song—"Roy Kent! Roy Kent! He's here, he's there, he's everyfuckingwhere"—and then limps off toward the rest of his life.

Ted Lasso is an underdog story told largely by underdogs.

Hannah Waddingham was an accomplished stage performer and singer whose on-screen reputation consisted of one word—"Shame!"—said over and over in *Game of Thrones*. Brendan Hunt was a world-class improviser who was still waiting tables when *Ted Lasso* began to take shape. Toheeb Jimoh was a year out of drama school when he was hired to play Sam Obisanya.

But no one embodied the show's power to turn around a life like Goldstein. A performer and writer of wide-ranging interests and abilities, Goldstein had carved out a solid perch in Britain's comedy scene over nearly two decades of steady work. He was and still is a prolific stand-up comic and the host of a popular film podcast, *Films to Be Buried With*, in which he excavates the lives of other comics and actors through conversations about their favorite films. He had appeared in series like *Derek*, Ricky Gervais's maudlin senior-care comedy, and written and acted in multiple small British films, including his own indie about a melancholy superhero, called *SuperBob*.

Along the way he bumped into future *Lasso* castmates like

Nick Mohammed. "We started doing the London comedy circuit around the same time, so we've gigged together a lot and we've been in sitcoms together," Mohammed told me in 2021. Phil Dunster first met Goldstein about a decade before becoming Jamie Tartt, when he acted in a small play Goldstein had written. "He was perfectly congenial and charming, and such great eyebrows," Dunster recalled.

Goldstein was known in London and beyond as a reliably sharp, funny writer and performer. "He's very well known in the comedy circuit in the UK," Dunster told me for a 2023 profile of Goldstein in *The New York Times*. "He's always been the sexy, hunky dude in, like, really tiny comedic circles." By his late thirties, however, Goldstein had made peace with never breaking out in a major way.

"I had a sort of epiphany of, I've missed my window," he said in the same profile. "Then a couple of weeks later, I got the *Ted Lasso* call."

Hired as a writer, Goldstein landed the role of Roy Kent through an audacious act of moxie, putting himself on tape for the role even though no one was considering him for it. The show's breakout as a pandemic hit meant that Goldstein went into quarantine a gigging comic and came out a celebrity.

"It's all mad and surreal," he said. "We came out of lockdown and suddenly when I walked down the street, people recognized me."

Roy Kent remained a fan favorite throughout the show's run, as he transitioned into being first a hilariously profane soccer commentator and then an assistant coach to Ted. Goldstein won Emmys for best supporting actor in a comedy for the first two seasons of *Ted Lasso*, channeling Roy's profane charm in his f-bomb-laden acceptance speeches.

The show and Roy have been a remarkable career boost for Goldstein as well. After the second season of *Ted Lasso*, he created the

breezy grief-com *Shrinking* with Bill Lawrence and star Jason Segel. Goldstein got to cast his childhood hero Harrison Ford as a character based partly on his own father. He also shocked and thrilled *Ted Lasso* fans—and colleagues—when he showed up as Hercules in a post-credits scene in the 2022 Marvel hit *Thor: Love and Thunder*.

"It's so mad that my sweet, dear friend is a Greek god," Dunster told me. "It's such a clear indication of the impact that he's had as [Roy Kent]."

The fact that Goldstein found such success playing the flinty Roy, that he felt so deeply connected to such an angry character, is all the more remarkable when you encounter him in the wild. His actual demeanor is friendly and solicitous, closer to the warm, curious conversationalist listeners hear on his podcast. Of course, actors are not their characters—Goldstein based Roy's gruff demeanor partly on that of Bill Sikes, the *Oliver Twist* villain—but in this case the divergence is so pronounced, his *Lasso* compatriots frequently mention it.

"I mean, Brett is an absolute sweetheart," Mohammed said.

"Of all the shows that I've done, Brett is one of the top two people in terms of how different he is from his character," Lawrence told me for the *New York Times* profile. "People approach him thinking he's this gruff, terse, kind of cold, insensitive dude, and he is the most sensitive, lovely, vulnerable man." (For the record: Ken Jenkins, who played the churlish Dr. Kelso in *Scrubs*, is the other.)

"Even if you just boil it down to his voice, you know?" Jason Sudeikis told me in 2023. "His speaking voice is very different, much less his temperament."

Goldstein said the clipped growl he uses for Roy is meant to be interpreted as a kind of cork keeping all the character's painful, repressed feelings from spilling out into the open. And despite appearances to

the contrary, he said, he is familiar with the darkness that Roy strives to keep bottled up. "I repress it, but it's all in me. I just control it better in real life," Goldstein said in the *Times*. "And I very much relate to the anger. I used to be very, very miserable and had a quite dark brain, and I've worked very hard at changing that. But it's there."

He's not alone. "I think that everybody has darkness and anger inside of them; Brett is just really good at utilizing that and efficiently talking about it," Dunster said. He continued:

> The great thing about Roy Kent is that I think a lot of men
> watch and go, "I think that's like me, really. I don't really
> understand how to convey how I feel, or even accept that I
> am sad, or coming to the end of my career, or aging." The
> reason Roy Kent is so affecting is because Brett tussles with
> that and is so good at externalizing that. In order for Roy
> Kent to work in a way that he does, you have to have an
> incredibly emotionally vulnerable actor who has access to
> that, like Brett does.

Nowhere over the course of *Ted Lasso* did Roy tussle with it so movingly as in the Richmond locker room after his last game. The Roy at the end of season one still has a ways to go—his relationship with Keeley will grow complicated and eventually splinter, thanks partly to his own emotional self-sabotage. He won't seek professional help for his issues until the very end of the series, when we see him in Dr. Sharon's office.

But even among career-ending injuries and catastrophic losses, *Ted Lasso* reminds us that while Father Time may be undefeated, we all still get to choose how we play the match.

Roy Kent is based loosely on Roy Keane, the legendary Irish footballer and current TV commentator. ("I'm a lot nicer than him," Keane said when asked about the resemblance on Sky Sports in 2023.) Chris Powell laughed when I asked him about the comparison. "There are some parts of Roy Keane in it but not a lot," he said. "Obviously, the anger."

Given Powell's long career as a player and coach, Goldstein asked him early on about how great athletes handle the inevitable. "He was just asking about how players are when they're coming to the end of their careers, and everyone else can see it but they can't," Powell said. "Coming to the end of time and accepting that can be very hard for a lot of sportsmen and -women."

Goldstein played Roy more darkly in the beginning than most people realized. "I grew up around a lot of footballers, and I've always had sympathy for them," he told *Vulture* in 2020. "There's no way when you're young you can understand that inevitability. You just think you're invincible. I bet if you asked Roy at twenty 'What's the plan?,' he'd say, 'I'll play football until I can't and then I'll kill myself.' There was no post-football for Roy. There's a real tragedy to him, I think."

We get a glimpse of this Roy in the silence of the empty locker room, after he's left the pitch for the last time. He is crying on the bench, and when Keeley approaches he shouts at her, telling her to go away and leave him to his misery. One distinct quality about *Ted Lasso* is that all the main characters, not just the leads, undergo a transformation over the course of the show. They confront challenges and personal demons and work through them on the way toward "the best versions of themselves on and off the field," as Ted would put it,

generally with assistance and support from the people close to them. As Higgins tells Roy in the series finale, "The best we can do is to keep asking for help and accepting it when you can."

Roy's personal journey revolves around the end of his playing career and resultant need to redefine himself: What comes next? What is he if he's not a footballer? The evolution forces him to confront emotions he's avoided for his entire life, a process that's helped along by Ted and, most profoundly, his relationship with Keeley.

So Keeley doesn't leave him alone in the locker room. And as she puts her arm around him and helps him acknowledge and finally reveal his own vulnerability, we see that there might be a post-football life for Roy after all.

Sudeikis based the end of Roy's football career partly on the final stretch of his own decade-long run on *Saturday Night Live*. "Roy's final moments as a player are emblematic of my final episodes at *SNL*," he told me in 2021. "I'm mapping my personal journey there, you know what I mean?" He has said that the locker room scene between Roy and Keeley is one of his favorite moments of the entire series. "Certain scenes come up that I get emotional describing," he said on *The Jess Cagle Podcast with Julia Cunningham* in 2023. "That final shot, when she puts her arm around him and he just gives over to it. But the whole time she's walking to him it's 'Get out, fuck off, leave me alone. You're not allowed back here. Don't. Stop. Get away, get away.' And she just . . . Ah, I love it."

The scene marks a milestone in the dramatic evolution of a character whose entire arc is about opening up. It was a more explicit turn toward the version of Roy only glimpsed in earlier moments when, as Mohammed put it, "the mask slipped and we realized he was just a good old sweetie at heart." This came in earlier scenes with Keeley,

in a speech in which Roy tells Rebecca not to settle for a dud boyfriend because "you deserve to be with someone who makes you feel like you've been struck by fucking lightning," or particularly in moments with his niece, Phoebe, played by Elodie Blomfield.

It also puts a final emotional button on a tremendous season-long performance that turned Goldstein from a journeyman comic into a Hollywood upstart with global fame, awards, lucrative development deals, and a spot in the Marvel Cinematic Universe.

WHO WON THE EPISODE?

As if I'm not going to put Roy here after going on and on about his emotional growth and valiant final moments on the pitch. But while this feels a bit blasphemous to note in a Roy-focused chapter, Jamie had objectively the strongest episode of anyone, backing up his big talk in the TV interview by knocking the team that dumped him out of the Premier League. And he did so by passing to another player for the winning goal, perhaps the first unselfish act of his football career.

BEST SAVE

Also Roy. For one last time, as Jamie breaks away with the ball, he's everyfuckingwhere.

BEST ASSIST

Again, you could go with Jamie here for his actual game-winning assist, the extra pass Ted kept asking for only to see it crush his dreams. (It's the hope that kills you, Ted, just like everyone said.) Of course

Ted being Ted, he still sends Jamie an attaboy note with a toy army man to protect him from his dire drunk dad, who earlier ruined Jamie's triumphant moment.

But I'm going to go with Keeley, for enabling Roy's biggest step yet toward accepting his own vulnerability and showing him the possibility of a life after football.

BEST LINE

Ted, trying to understand England's various football leagues: "So if you come in last place in the Premier League, you get to play in the Championship?"

Coach Beard: "They also invented irony."

RANDOM STATS

- The season opened with Rebecca's face, so it closes with it as well. This time it's soaking wet, doused in the sparkling water Ted has spat all over her. Similarly, it ends with one last homage to *Major League*, when Ted lays out a plan that also, in a meta touch, outlines the show's three-season blueprint. Next year, Richmond will get promoted back to the Premier League, Ted says, and "then we'll do something no one believes we could ever do: win the whole fucking thing."

- Roy's gimpy knee finally ends his career but the episode's most serious injury is a real-life one, when Ted jumps gleefully through Rebecca's office doorway after she gives him the idea to use trickery against Man City. Sudeikis did not intend to smack his head on the top of the doorjamb but did, hard, and then it started bleeding enough to bring the production briefly to a stop. But he decided it looked good in the scene, so they left it in.

- Ms. Shipley, Ted's unseen upstairs neighbor, is named for Sudeikis's

high school speech teacher, Sally Shipley. Shipley has been name-checked on *Saturday Night Live* and elsewhere by another famous former student: Paul Rudd.

- The episode opens with Nate's being promoted to coach after briefly being tricked into thinking he's been fired. It is a happy scene, but it also includes a glimpse of the bitter Nate to come before he realizes what is going on, in both his vicious treatment of Will, the new kitman, and his attack on Rebecca. "You shrew, you did this, didn't you?" he spits. "Why so hostile, Nathan?" she responds. They ain't seen nothing yet.

- There's a lighter bit of sneaky foreshadowing in the final locker room scene, as Ted tells his team to be sad together after the defeat and then let it go and move on. What should everyone do? he asks Sam. Be goldfish, Sam says. And who's that sitting next to him in front of his locker? Why, it's Rebecca, who may or may not recall this moment when they pair off next season.

- For the record, studies have shown that goldfish can actually remember things for months.

SOMETHING LIKE A PHENOMENON

"The hero we need right now."

Over its three seasons, Ted Lasso *racked up impressive numbers as it became one of the most decorated series of the twenty-first century, winning a Peabody, thirteen Emmy Awards (out of sixty-one nominations), seven Critics Choice Awards, three Screen Actors Guild Awards, and two Golden Globes, among dozens of other plaudits and honors. It established Apple TV+ as a player in the streaming wars, becoming TV's most popular streaming original series in its third (and possibly final) season, with viewers collectively watching an estimated 16.9 billion minutes of* Ted Lasso *in 2023 alone.*

But ahead of its debut a few years earlier, Ted Lasso *was defined by a more modest figure: 0. As in, 0 percent of the human race would have predicted such success for a soccer sitcom based on an ad campaign most people had forgotten about. And for some, that was actually a*

smidge too high. "My expectations are always below zero," Brett Goldstein said.

What Goldstein and Team Lasso didn't yet understand—to say nothing of the rest of humanity—was the degree to which the world was primed for the show's agreeably addictive mix of laughs, vibes, and decency. By the time Ted Lasso came out on Apple TV+, on August 14, 2020, much of the globe had been in quarantine lockdown for five months and the scale of the pandemic losses was becoming increasingly incomprehensible—the front page of that day's New York Times said an estimated two hundred thousand Americans (and counting) had died of COVID so far. The US was also deep into a convulsive summer of protests and crackdowns after the murder of George Floyd by a Minneapolis police officer, the latest in a string of indefensible police killings of Black citizens. A bruising presidential campaign was entering its caustic final stretch, which would end up lasting far longer than voters or anyone else anticipated.

So as word spread about the surprising fact that this soccer ad spinoff was not just OK but heartwarming and actually pretty great, as celebrities sang its praises and Twitter began to overflow with hosannas and Ted memes, and as we all kept staying home and the world outside kept being more or less terrible, a narrative began to take hold: Ted Lasso is the show we all need right now. And Ted Lasso would ride it to global popularity and awards glory as it became a pop culture phenomenon.

But when the series rolled out with little fanfare in August 2020, with media attention amounting to a few articles and Jason Sudeikis appearing on his pal Seth Meyers's late-night talk show via video chat, there were few indications that viewers would need it any more than any other random streaming sitcom. And nobody, least of all the people who made the show, knew if anyone ever would.

Brett Goldstein, writer, Roy Kent, seasons 1–3: The week

before your thing comes out is terrifying, because you kind of make these things in private. You spend so much time and you're making this baby, and then suddenly you're putting the baby out in the world. And it's like, "Oh my god, everyone's going to attack the baby! What are we doing? We shouldn't let this out!" That's always scary.

Jeremy Swift, Leslie Higgins, seasons 1–3: I've been in things before where I've thought, This is great! And then the reviews come out and you go, Oh, they hate it!

Brett Goldstein: I truly didn't think anyone would watch. No one knew how to get Apple TV, let alone whether they'd want to watch it. My expectation is, No one's going to see this and if they do, they're going to fucking hate it, and I'm dead. I've always existed in this way, and I don't know if it's the healthiest way or not. But it's served me OK.

Jeremy Swift: You never really know how the public is going to be. Then there were a couple of slightly stinky reviews, initially.

The Guardian *described* Ted Lasso *as a "middling new transatlantic sitcom" that "isn't unwatchably bad but isn't really much of anything, an in-the-background time-waster ill-suited to a time when there are so many other better things to be watching." The New York Times, in its initial review, called it "the dad pants of sitcoms" and said Lasso himself was "a character who makes no sense except as an avatar of a mythical Midwestern good-heartedness." (Times critic Mike Hale did astutely identify the show's potential as emotional counterprogramming: "It's as if Sudeikis et al. foresaw the chaos and terror of the summer of 2020 and wanted to prove that America could do something right.")*

Even Trent Crimm's Independent said, "The series is less sharp than the original promos," though it did go on to give it a mild thumbs-up: "Ted Lasso ropes you in, even if it's more by likability than laughter."

But the show got an early enthusiastic vote of confidence from

Entertainment Weekly. *From its opening line—*"Ted Lasso *has no right to be this funny"—the review was an unqualified rave that specifically praised most of the main cast and described the show overall as "a wonderfully amusing, surprisingly thoughtful sports sitcom that is, of course, not really about sports at all."*

Brendan Hunt, creator, Coach Beard, seasons 1–3: We started to realize that the show might be successful when we got an A from *Entertainment Weekly*—that was a really lovely piece. Like, Oh, hold on, that's a magazine that I actually trust and they're saying awfully nice things. OK! There were obviously a few more good reviews after that, but that was the first one that kind of put us at ease, or at least put me at ease.

Brett Goldstein: It's true. Nick Mohammed actually sent me that review. Because I was like, I'm not going to look at any of these; I don't wanna know. And then I got a text from Nick and he said, "I know you said you didn't want to look, but have a look at this." And I was like, Fuck, this is nice.

Jason Sudeikis, creator, Ted Lasso, seasons 1–3: They roll those episodes out, you know, one at a time. And I was sitting in here, you know, playing video games or something, I forget, on a Saturday or Sunday morning. And Olivia comes in with her phone and she goes, "Hey, you're trending on Twitter." I'm not on Twitter actively in that way. And so immediately it was like, "Wait, why?"

Bill Lawrence, creator: I'm like anybody involved with a TV show, I was searching for *Ted Lasso* on social media. And my favorite thing, when you talk about the start of the show, was finding all of these posts where people had said, "I can't believe this show is actually good!" Or "This show actually doesn't suck!" I would respond and say, "Me, too! I can't believe it wasn't horrible!"

Brendan Hunt: Welcome to the Bill Lawrence Museum of Low Expectations!

Jason Sudeikis: We don't get metrics—there's no Nielsen ratings or box office dollars or anything like that. But when we released the thing on Friday, then Bill and I get on the phone on Monday with folks from Apple and they were like, "Hey, we're going to pick you up for a second season," that was also a pretty good indicator that it must have struck a nerve!

Brendan Hunt: And then almost by the end of that call it's like, "OK bye . . . oh wait, wait, wait, also season three!"

Bill Lawrence: The only thing I take great pains to remind people of is, I don't think it's like a normal show with word of mouth. We've all seen shows that start and then slowly build. The difference with this one that people sometimes forget is when we were first making it, Apple didn't have television shows on anywhere. So my kids were like, "How am I going to watch this?" I'm like, "I don't know, but I'm sure it'll be somehow accessible." I had a sense that what these guys had all done was working just from people picking up on the things we wanted them to pick up on, even though it was a small snowball rolling downhill.

Jason Sudeikis: The whole second half of the first season was edited in quarantine. Then the show came out while in quarantine. So I think the first time I heard anything about it from the outside world was when I was taking the garbage out at our place in Silver Lake, and a guy driving by stopped and goes, "Hey, I like your show!" And I was like, "Oh, all right, thank you!" It was six feet away, hollering out of a car window to a man with the garbage in his hand—or recycling, which is probably better for my brand if you don't mind me saying recycling instead.

Jeremy Swift: Then the public, on social media, just went crazy for it.

Jason Sudeikis: Slowly but surely people on the internet, people on Twitter, and then folks like Brené Brown and Patton Oswalt, the blue-checkmark culture, started hyping it up.

In the pre–Elon Musk era of Twitter, blue checkmarks denoted verified accounts that tended to belong to well-known or otherwise culturally influential figures, many of whom did in fact become Ted Lasso *cheerleaders. "I am just now discovering* Ted Lasso *on Apple TV and oh my God did I need this show," Oswalt tweeted in October 2020. "Heartfelt, hilarious, defiantly optimistic." Brown, the researcher, bestselling author, and apostle of vulnerability, was also an early fan. She wrote about the show in her newsletter and mentioned it often on Twitter, to the delight of Team Lasso, who had referred to her work in the writers' room.*

"In a five-minute period of one episode, you make fifty connections that are so deeply human," Brown told Sudeikis and Hunt on her podcast in October. "I think there's something really important here."

She, Oswalt, and other famous tweeting fans, like Sarah Silverman and Ron Howard, were prominent stand-ins for the legion of viewers discovering and falling in love with Ted Lasso *throughout the fall of 2020 and into the New Year. But thanks to the gradual build of the audience and the fact that the second season began filming in January 2021 under COVID quarantine restrictions in London, the people who actually made the show were removed from its evolution into something like a phenomenon. "I'm just aware of it from Twitter, frankly," Goldstein told* Esquire *in February 2021, six months after the show's premiere. "Every day there seems to be someone amazing suddenly going, 'I love* Ted Lasso, *why did nobody tell me about this?' And you go, 'Alright. OK, cool, cool.'"*

Jason Sudeikis: After the holidays it felt like folks watched it with their families or the second time through or something, because that really felt like an exponential growth.

Nick Mohammed, Nathan Shelley, seasons 1–3: We couldn't travel because of the pandemic. Even though it was obviously gaining quite a lot of momentum in the States, there was no real way of experiencing that. It felt quite detached. It almost felt alien to me that it was doing well in this other place.

Brendan Hunt: There was an *Esquire* piece about the show, and Sarah Silverman was asked about it. I've got huge respect for Sarah Silverman, and she was talking about how we are doing comedy and something a little bit, wait . . . I believe her exact quote is "They're walking a tightrope, and it's fucking fantastic." Or something along those lines. [The quote was: "It feels absolutely effortless, but make no mistake: they're walking a fucking tightrope here, and it's perfect."] That was a feather in the cap. I slept well that day.

Jason Sudeikis: But again, once we got to London we were in lockdown and we were only on set. I would say it's only after coming back to Brooklyn, and going to a Nets game with my son, Otis, and walking to the Barclays Center and walking home and people being like, "Yo, love the show!" Or they put me up on the Jumbotron, much to Otis's surprise, and they showed a clip of Ted slapping the BELIEVE poster in the third quarter before a rally. And it was like, Oh, OK, yeah, people have seen this show.

Juno Temple, Keeley Jones, seasons 1–3: Suddenly it was like, Whoa, this is a fucking hit. . . . Suddenly it happens like, boom! Because it had been out for a little while.

Sara Romanelli, assistant script supervisor and script supervisor, seasons 1–3: Usually if I tell my family in Italy, "Oh, I'm working on this show . . ." they never know what it is. Whereas with *Ted Lasso,*

I really started to feel like everybody that I knew either watched it or had heard of it. Obviously you see things on the internet, but I think the internet sometimes gives you a false perspective. But the people around me—not only in the UK and in the film industry but even my mom in Italy who does not watch television—started to be like, "Oh, I heard about *Ted Lasso*." My mom got Apple TV just so she could watch it. That makes you feel like, OK, this is going to be bigger than we thought.

Annette Badland, Mae Green, seasons 1–3: On social media was where I noticed—people trying to be in touch about how much it meant to them. Later I had a cab driver who said, "During COVID, *Ted* was my family. It was my group, because I'd just moved and I wasn't near my friends. I was in a small flat; I knew no one; I couldn't do anything. And *Ted* became my family every week." That was terribly important.

Anthony Head, Rupert Mannion, seasons 1–3: The power of social media, especially in lockdown when it was first released. People singing out about its positivity, its heart, its drive into helping mental stability, and its heartwarming humor—all so apt and so helpful at such a difficult time for everyone.

Nick Mohammed: Just the fact that a show can have such far-reaching impacts in such a positive way. It's just really, really lovely.

Declan Lowney, director, seasons 1–3: When the show started going out, the fact that this happened just as we were all locked down—it was a huge part of the show's success. Had it come out in regular times, I don't know if we'd have cut through—there's so much other stuff out there. But you Americans love a weighted blanket and that's what it was like, wasn't it? It was the perfect thing in the perfect time.

Toheeb Jimoh, Sam Obisanya, seasons 1–3: No one could see

their parents or hug each other. It came at a really important time for the world. But we couldn't have known that when we were making it. There was just some universe magic dust sprinkled over it.

Brett Goldstein: I think everything has its time. There's magic to it.

Anthony Head: It felt like it was meant to be.

Chris Powell, soccer coach, played himself as a commentator, seasons 1–3: The timing of the show was perfect for what it was about. It touched people in different ways: relationships, football teams, love, parenting—everything was in it. The football is sort of the vehicle to get that across, and people just found it very heartwarming.

Lola Dauda, script supervisor, season 1: Everyone was really scared and wondering what's going to happen. It's a ton of real fear and uncertainty, and then this show comes out and it doesn't try to be too clever or anything like that. It was just about a really lovely guy trying to do something really, really nice against the cynicism of the world. And I think that's just what people really needed.

Tom Marshall, director, season 1: People wanted their minds off what was happening, wanted to laugh, but also they were feeling more emotional because of what was happening. So at the same time, they wanted to have that fed as well. It's so fucking cliché and corny, but I do think they wanted to laugh *and* cry at that time. *Ted Lasso* did that for people.

From the beginning, the show's potential to soothe and comfort frayed nerves and frightened hearts was touted as the key to its appeal. "We're in this dark time," Conan O'Brien told Sudeikis during a September 2020 (remote) late-night interview. "The show is really funny, but also the character of Ted Lasso is so optimistic that I sort of feel like he's the hero we need right now.

"That's the guy who I think can get me through COVID," he added.

This sense only grew alongside the popularity of Ted Lasso. *And it's hard to deny the emotional alchemy watching it produced as the pandemic stretched on and mutated into new variants, as the death toll climbed, as historically awful things kept happening. "All it took to get me to appreciate* Ted Lasso *was an assault on American democracy," began a February 2021 piece by TV critic James Poniewozik in* The New York Times. *He wrote about watching the show in January, after "the once-rote transfer of power became a white-knuckle ride" thanks to then President Trump's lies about voter fraud, which culminated in his supporters' January 6 attack on the US Capitol in an effort to disrupt certification of the election results.*

Ted Lasso *was "sweet. It was nice," Poniewozik wrote. "And God, did I need that."*

While the show's creators were careful to honor the relief it brought viewers, they also gently pushed back against the ubiquitous narrative of Ted Lasso *being "the show we all need right now," given that it had been conceived years earlier primarily in response to the increasingly toxic state of human interaction. "It was the culture we were living in," Sudeikis told* The Guardian. *"I'm not terribly active online and it even affected me. Then you have Donald Trump coming down the escalator. I was like, 'OK, this is silly,' and then what he unlocked in people . . . I hated how people weren't listening to one another."*

Or as he replied to O'Brien in that 2020 interview: "There's an argument to be made that maybe we could have used this guy, you know, four or five years ago."

Bill Lawrence: There's always the danger of sounding like, "We were so lucky that the pandemic hit." The truth is, Joe, Brendan, and Jason were all talking about this stuff long before this. This is the

response to the toxic and cynical culture out there, especially if you look at social media and what young people have to deal with right now—just political discourse and how they watch people speak to each other.

Brett Goldstein: You could argue these things were always there, regardless of the pandemic. It's mad that this was normal, people being fucking horrible to each other. So it came in a time where it felt revolutionary to see someone being nice. And it shouldn't have. It says more about the world than it says about our show that it felt so, "Wow, look at this person being decent."

Bill Lawrence: And I don't think the need for that has gone away, and I don't think that's quarantine-related. I still watch the news and can only stomach it for twenty or twenty-five minutes before I hear something that makes your stomach turn, man. So that's why I think *Ted Lasso* hit a chord—even more so, believe it or not, than the quarantine.

Jason Sudeikis: If anything, the quarantine removed all the noise of other options people had in their lives. "I can only watch *Queen's Gambit* so many times, I guess I'll watch this stupid-ass soccer show."

Brendan Hunt: That was the slogan for a little while: *"Ted Lasso*: Because *Queen's Gambit* eventually ends!"

Bill Lawrence: I also was curious about the fact that *Ted Lasso*— in a nice way—was labeled as, like, "Oh my god, it's a video hug! It's a sunshine enema through your television set!" Because it's a show that has so much dark pathos underneath it.

It's a dude whose wife isn't into him, who's away from his kid, who's suffering from massive panic attacks. An older player whose career is ending, and he doesn't want it to end. A diva player with an emotionally abusive father. A woman who is emotionally abused by her husband and left to rot. A young woman who is filled with a little

self-hatred, if not self-doubt, because she knows she's on a path that she doesn't want to stay on forever. And then the narrative became, "It's the cheeriest show you'll ever see in your life."

Nick Mohammed: If it was sweet for the sake of it, that would start to grate a bit. I think it's really important that for as much as Ted represents "Be curious, not judgmental" and this hope and this optimism, he's not just a beacon of light. He has his demons. He is flawed as a character, undoubtedly. When it came out at the time it came out, there was certainly an appetite for the positive themes and to just be like, "This is what we need, this is what we need." But it's definitely more layered than that.

Jason Sudeikis: One of the themes of the show is that evil exists. Bullies, toxic masculinity, malignant narcissists, et cetera—we can't get rid of them. It's all about how you deal with those things.

Maybe that's where the positivity and the heartwarming element and some of the lessons come from: It's not about the elimination of those things; it is about what we have control over. It's not the reception of the show but the way by which we make it—with intentionality, with being ladies and gentlemen to each other both as artists and as coworkers, as human beings. I think that's one of the elements that people are consciously or unconsciously picking up and that we're trying to intentionally do, both in front of the camera and behind it.

Nick Mohammed: I think kindness is the new cool. I hope the message is that there are nice human beings, and we can all be nice to each other, and good things happen as a result of kindness. We can all benefit from being a bit more like Ted, I guess.

As the show's profile grew throughout 2021, there were increasingly public signs that many people wanted to be like Ted, even beyond the famous tweeters. References to the fictional soccer comedy began showing up in the real world of professional sports. The soccer star Alex

Morgan did a Ted Lasso–inspired dance after she scored a goal in a match. (The US Women's National Team later brought on Sudeikis and Hunt, in character, to announce the members of the 2021 Olympic team.) Utah Jazz coach Quin Snyder cited Ted Lasso *in a postgame press conference and said the show "should be required watching for coaches." Later, Premier League managers like Jürgen Klopp would express their affection for the series.*

"Each time is surprising to us," Sudeikis told me in 2021. "At no point has anyone that works on the show been like, 'Hey, did you notice the press conference last night where we didn't get name-checked?'"

In the summer of 2021 Apple began selling shirts, hoodies, and mugs with Ted Lasso *and AFC Richmond branding, giving fans the chance to literally wear their devotion on their sleeve. For the stars of the show, the growing prominence and celebration of all things* Lasso *meant they emerged from their pandemic lockdowns to find they had become famous.*

Brett Goldstein: On the road I live on, I came out of my house and the man from across the street ran across and said, "I'm the biggest fan of your show! I've watched six episodes of it. I just love *Ted Blasso*." And I was like, I don't know how big a fan you are. I feel like you need to do a little more research into the title of the show you love.

Nick Mohammed: I was at London Zoo with the kids and it was quite a hot summer's day. I had a baseball cap on and my glasses and a mask on, so you can't really see me at all. And we were going to go see the butterflies or something, and the lady who was working there said, "Oh, Nate the Great!" And both me and my wife thought she said, "Nature is great," because she's working at the zoo. And we were like, "Oh yeah, no, it is. It's all good." And she kept saying, "Nate the Great, can I have a photo?" And we didn't work it out for

ages that she was saying "Nate the Great"—it just became this really weird thing until I was like, "Oh, you watched *Ted Lasso?*"

Kola Bokinni, Isaac McAdoo, seasons 1–3: [At the supermarket], this guy was like, "Oh my god, oh my god!" I always like to go, "Calm down, I'm just a person. Isaac is the guy on the show. I'm just Kola, you know, I'm not that impressive." And then he's all, "Can we take a picture?" Cool, and I took a picture. Then he kind of glanced down and started looking in my basket, and I was like, No, don't look in there, don't judge me for what I'm buying right now. It was like nine p.m. on Saturday night—I want to get some munchies and watch a film or whatever. And he looked in my basket and was like, "Hmm." I was like, Aww this guy's gonna judge me for the rest of his life now. Just loads of snacks, man.

Juno Temple: Up until *Ted Lasso* came out, people would stop me at a grocery store and be like, "Hey, did we go to school together?" "No." Then they suddenly realize, like, "I've seen your tits in a movie, I don't know where to look now. . . ." It's this panic moment while I'm grabbing an oat milk or whatever. But yeah, I don't know [how I feel about] the idea of being someone that kind of can't be invisible when you want to be invisible.

Toheeb Jimoh: I run into people in real life and they're like, "Oh my god, you're Sam in *Ted Lasso!*" And they're almost expecting me to *be* Sam. I'm like, Yo, I'm on the Tube. I'm tired.

Hannah Waddingham, Rebecca Welton, seasons 1–3: The lovely things that are happening, nominations and the show doing brilliantly and more people stopping me in the street, does it make me a different person? No, because I walk through my front door and I'm still a single mom looking after my girl, and it could absolutely all end tomorrow. I'm mindful of that always. Finding more notoriety later in your career, I think, is perhaps no bad thing. And I certainly

don't think I would have been able to play this part of Rebecca Welton when I was younger and hadn't been through heartache and that kind of thing. So I do think things plop into your life when they're meant to.

Brendan Hunt: One slightly awkward moment was [at the 2021 Emmy Awards], I ran into Barry Jenkins—director of *Moonlight* and *Underground Railroad*, and an early Twitter advocate of the show.

But when I meet him in the hall, I'm, like, 99.9 percent sure it's Barry Jenkins. And people are watching us talk and I'm not going to take this swing and be wrong if it's *not* Barry Jenkins. So it's, like, small talk, small talk, small talk. And at the end of it he goes, "Well, great. Love the show. Good luck tonight, Brett."

While Ted would discount the value of arbitrary awards as a measure of personal worth, Hollywood long ago decided that they were the best available scorecard, after profits, and thus a very important metric of artistic quality. If there were any lingering doubts that Ted Lasso *had completed its arc from underdog to cultural juggernaut, they were undone by the laurels heaped upon it throughout 2021.*

The show's first taste of awards glory came at the Golden Globes in February, when Sudeikis was named best actor in a musical or comedy. The internet being what it is, the bulk of the chatter focused less on the win than on the somewhat addled appearance of the winner, who showed up via video like everyone else but was noticeably dressed down by comparison, wearing a tie-dyed hoodie and seeming somewhat foggy.

The attention was no doubt enhanced by the very public dissolution of Sudeikis's relationship with Olivia Wilde during the time of his greatest professional success, with salacious tabloid reports about their split sharing internet space with celebratory Ted Lasso *coverage. The hoodie brought the two narratives together. "Twitter Wonders if Jason*

Sudeikis Was High for Golden Globes Award Speech," read a New York Post headline that night. Sudeikis later explained with some exasperation that the sweatshirt was promoting his sister's dance and workout studio and that it had been in the middle of the night in London, where he was working on season two. "I was neither high nor heartbroken," he told GQ.

The honors kept coming: The show won three Critics Choice Awards, two Writers Guild awards, two Screen Actors Guild Awards. In June it was presented with a Peabody Award, one of the nation's highest honors for electronic media, for "offering the perfect counter to the enduring prevalence of toxic masculinity, both on-screen and off, in a moment when the nation truly needs inspiring models of kindness."

The show followed that up in July by receiving twenty Emmy nominations, the most received by any first-year comedy in TV history. (Glee also received twenty for its first season, in 2010.) The ceremony in September made it official: Ted Lasso was TV's top sitcom, winning the Emmy for outstanding comedy series. It was the biggest of the seven total awards it took home. The individual honors included Sudeikis being named best actor in a comedy—this time he wore a sleek blue velvet tuxedo—and Waddingham and Goldstein winning supporting acting trophies in the first two awards handed out that night. (Goldstein gave a profanely Roy-worthy acceptance speech.) On the technical side, Theo Park won for casting and the show also earned wins for editing and sound mixing.

Held under COVID restrictions in an indoor-outdoor event space, the Emmy ceremony amounted to an ecstatic Ted Lasso reunion, with most of the UK cast flying over to celebrate all the wins and one another. "We don't get to see each other very often," Waddingham told Entertainment Tonight that evening. "So yeah, it's gonna get messy."

Hannah Waddingham: The thing I love is that myself and the

glorious Juno Temple were nominated in the same category. I don't know who was more shocked, me or her. I was certainly more pleased for her and for Jeremy Swift, because they are the most unassuming, lovely, joyous souls I've met in recent times. Juno and I were each other's second phone call. I rang my parents and then I rang her, and she was calling me. And she went, "Will you be my date?" And I went, "Obviously!"

Juno Temple: I got to go with Hannah, who is one of my best friends in the entire world.

Brett Goldstein: I had never been to such a thing. We were stuck in a queue with lots of famous people and we were like, Oh, famous people have to queue as well.

Juno Temple: I found it a little nerve-racking. It was interesting, too, because it was in a parking lot somewhere under a big tent. I dipped out for a cigarette but I was also waiting for Hannah, and we ended up running a bit late so we missed the whole red carpet at the beginning, which I was actually grateful for. I get really nervous whenever I do photo shoots—normally the feedback I get is, "Could you look a little less frightened?" I'm better in a moving picture.

Brett Goldstein: Suddenly we were told, "You don't have time to do a red carpet. You've gotta come because the show's started."

Jason Sudeikis: Our table was front and center—I mean, it was in the round but we were like *right there*, and then my seat was literally right up in the front, which has never been my move. I'm much more of a back of the classroom, you know, whisper and passing notes, doing shenanigans. It felt a little like I was mayor.

Brett Goldstein: We sat down, and then suddenly it started. [The host] Cedric the Entertainer and a load of people started singing and dancing toward us, and everyone stood up and all I was thinking was, Oh fuck, have I got to dance? What is this? I couldn't see where

the cameras were, and I was thinking, Please don't make me a meme. I was just so embarrassed. No one told me there'd be dancing.

Jason Sudeikis: We had no idea. Brett's already reticent because he's British and a writer. But then to ask him to be at his first fancy thing like that, and now here we are around a bunch of fancy folks and they want us to dance right away . . .

Juno Temple: We got rushed in and our category was the first up. So, like, we sat down, I got to eat chocolate and Hannah had a sip of a glass of champagne, and then there was this extraordinary moment where she won and I was like, Oh my god! Because we had no time.

Hannah Waddingham: My butt cheeks had barely touched the chair and then I was up again. They said my name and I literally thought I was going to black out. I got grabbed on the shoulders by various people and honestly, I genuinely have not prepared a word because I thought, There are so many glorious women in this category, just go along and have a very nice time.

Juno Temple: And then she gave such a beautiful speech.

In her charmingly off-the-cuff speech, Waddingham thanked Sudeikis for changing her and her daughter's lives, celebrated the show's writers, and urged Hollywood to give West End musical performers more work in movies and television. She also paid special tribute to Temple, saying, "There's no Rebecca without Keeley."

Hannah Waddingham: [Goldstein] had said to me the whole time, "You need to prepare something," and I was just adamant that I wasn't going to . . . evidently, [considering] the nonsense that fell out of my face.

Brett Goldstein: Then I won an Emmy, the whole time thinking, Thank God I didn't have to dance.

"I was very, very specifically told I'm not allowed to swear," Goldstein began after taking the stage. "So this speech is going to be fucking

short." He went on to say being on Ted Lasso had been "one of the greatest honors, privileges, and privileges—I just said that twice. But it's a double privilege, it's the most privileged privilege and pleasure of my life. And this is the fucking icing on the cake. I'm so sorry. Please have me back. . . ."

Brett Goldstein: A few people said, "If you win, don't swear." And I was like, "Why are you saying this? Now I'm gonna do it twice." If they had kept saying it, the speech would have just been "fuck fuck fuck. . . ."

Juno Temple: It was such a wild, wild evening in the sense that *Ted Lasso* did so well, and just watching these brilliant people that you've worked with.

Brendan Hunt: Really the most important one for me, to be honest, was for Jason to win. Because he's done such good work, and we're friends from way back. Once Jason won, then it was officially a good night for me no matter what. In fact, I probably cared more than Jason did.

In his best-actor acceptance speech, Sudeikis connected the themes of Ted Lasso *to his own life. "So, yeah, heck of a year," he began. "This show's about family, this show is about mentors and teachers, this show is about teammates. And I wouldn't be here without those three things in my life."*

He went on to thank people from each of those categories, including his fellow Lasso *creators and the cast and crew. "I'm only as good as you guys make me look. So really, it means the world to me to be up here and just be a mirror of what you guys give to me and then we reflect back and forth on each other. So, thank you so much."*

Sudeikis was right: it had been a heck of a year. The Emmys amounted to a coronation for Ted Lasso, *an outcome not even a committed optimist like Ted would have predicted when the show first snuck*

onto television a little over a year earlier. Sudeikis followed the awards haul by going back in October to where it all began: Saturday Night Live, *where eight years earlier he'd done a blustery coach character that fortuitously inspired some ad executives looking for someone to star in a soccer spot. It was a triumphant return, the former writer and cast member back as host, and in his monologue he joked about the unlikeliness of the rise of Ted.*

"I've been working on this Apple TV show called Ted Lasso," *he said, to raucous applause. "We somehow became a hit. You know, it's truly shocking to me, because it's built around two things Americans hate: soccer and kindness."*

Jason Sudeikis: I just at this point in my life don't expect anybody, when you make something, to respond to it in the exact way you had hoped. I mean, I think that's so neat.

Brendan Hunt: There's been talk about how we've sort of constructed this character of Ted specifically to be this good person in this dark world. There's some truth to that. But also, in terms of what's surprising about the reaction, we kind of made what we think is a pretty normal guy just in normal Midwestern terms. He's certainly, to some degree, the best of us, but he was never thought of as a superhero. And it's just interesting that nowadays that person seems more unique and out-there than Batman.

Jason Sudeikis: The fact that families are watching it together is nuts. Because that's how we grew up watching TV, everybody around one television. So the fact that we became a show like that is lovely.

Annette Badland: I think people responded so well because it was created without cynicism. It wasn't Jason thinking, "Oh, this is a great product and if I get A, B, and C in it, this will sell and that's fantastic. . . ." It came out of his humanity, and his joy and his intellect and in knowing how we operate, how we are as human beings,

and I think an audience can smell that. They knew it was from a very genuine place, however comedic or not. They responded because it's not designed as, Let's make a hit show! It's, Let's tell this story, and let's hope it can help and enlighten and bring joy to people.

Nick Mohammed: I think it's probably a little dangerous to set out hoping to get any kind of accolade. You just have to make the thing you want to make and make it the best that it can possibly be, and hope that it finds its audience. And *Ted Lasso* is an example of a show that absolutely managed to do that.

SECOND HALF

CHAPTER 8

A SOCIALLY DISTANCED HIT

"We weren't allowed to touch each other."

Season two of Ted Lasso *was already mostly written when the show began to take off. Although the series premiered in August 2020, fans were still discovering it when the cast and crew began production on the second season, in January 2021. So the story it tells was conceived and planned without any regard for the hit the show had become, simply because it hadn't become much of anything when the season was written.*

But there was one enormous difference between shooting season one and two: the coronavirus pandemic. The first season was shot before most people had ever heard of COVID-19, but in January 2021, the world was experiencing not just the lingering presence of the pandemic but also a new surge in cases. Which meant that the motto for the second season of Ted Lasso *was "Be curious, not judgmental . . . but keep your distance."*

Chris Powell, soccer coach, played himself as a commentator,

seasons 1–3: No one was sure if there would be another one after season one, but of course it just exploded. When they sent me season two, I thought, It must be popular.

Nick Mohammed, Nathan Shelley, seasons 1–3: Season two coming off the back of the success of season one was strange, because there was then suddenly a lot of attention on the show and almost a responsibility for us to deliver, I think. We started filming season two in January. Earlier on it started to get awards recognition with the Golden Globes and Critics Choice and so on. There was this sort of, Well, that's kind of cool, but Jason and everyone was very humble about it. It was just, We got a job to do. Let's just keep going. We got even more work to do, in a way, because the audience will be anticipating some good stuff out of season two. We've got a duty of care here because there was a growing fan base for the show. But that's a real privilege to be in that position.

Declan Lowney, director, seasons 1–3: There's definitely a confidence that comes, and I think that happened with season two. I mean, Jason, it's all in his head—he had plotted out his three-season arc. But I think that gave them confidence to go further with season two, and Apple threw in two more episodes as well.

Brendan Hunt, creator, Coach Beard, seasons 1–3: It's really cool that we were getting all these responses about how the show is found to be inspirational and meaningful to people and stuff. But our only intention was to make a comedy, and we still have to do that. It does happen to be about a guy who's a leader, and he likes to inspire people, but we have to be focused pretty heavily on it's a comedy, it's a comedy, it's a comedy. If we get out there trying to be inspirational, then we probably won't be.

Jason Sudeikis, creator, Ted Lasso, seasons 1–3: I think the first day—definitely the first week—I said in the writers' room that this

was our *Empire Strikes Back* season. Now, not being the biggest *Star Wars* fanatic but certainly growing up with the original trilogy, that was the one that started in the cold and ended with questions versus answers, and that's a little bit of what we're dealing with. And it sort of follows the theme, the philosophy that occasionally the best way to help others is to help yourself.

Brendan Hunt: This season has a sports therapist. That's something we talk a lot about in the room—because we're writers, almost all of us have therapists—just how damn important therapy is.

Jason Sudeikis: Dr. Sharon Fieldstone is her name, and that's because of Dr. Marcia Fieldstone from *Sleepless in Seattle*. Dr. Sharon, we chose that because it was one of our writers' therapist's name.

Brendan Hunt: There are still stigmas about it in the Midwest and definitely in England, to the point where Prince William has a campaign of trying to help people with it. I think I wouldn't be sitting here if I hadn't started getting therapy at a couple key points in my life, and it's insane to me that people still think that getting therapy is some sign of weakness. And so as a room we drew a lot from our own experiences of therapy in putting together some of the things that happen in that vein this season.

Jason Sudeikis: So that's the notion, that the characters that we spend three-hundred-plus minutes with in that first season, that we know a little bit more now, they turn inward and find out how to define what is going on with them. And similar to the sport of soccer, they may win those battles, they may lose those battles, and very often in life as we know, as grown men, you tie. But it's about the endeavor of trying, and I think that's where comedy and drama are fun to watch. We like to see action. So it lives in that space.

Declan Lowney: There was a huge concern that we don't change a thing. Literally: Don't fucking change anything. This works.

Brendan Hunt: [The pandemic] impacted the writers' room for season two. The writers' room was all Zoom and we got a lot of work done, but it's not quite as nice as being able to look around a table and see people you're hanging out with.

Jason Sudeikis: Humans are made to be connected. There's power in human beings being in the same room.

Bill Lawrence, creator: I think anybody involved in any production would lie if they said that it wasn't challenging, because part of the thing that made the show work was how collaborative it was and how therapeutic it was for everybody to work on it. None of us knew if the show was going to work, but we knew we were all having a great experience writing it, producing it, making it. I think the biggest strength of this show is, it was very important to Jason, to all of us, to keep the same group together.

Jason Sudeikis: We didn't lose any writers between the first and second season, and we added a badass writer in Ashley Nicole Black.

Bill Lawrence: So top to bottom, department to department, having continuity among people that really enjoy spending time with each other made the process painless, even though it was Zoom.

Brett Goldstein, writer, Roy Kent, seasons 1–3: The first two weeks were tricky. The first two weeks we were like, Oh, fuck, how is this going to work? You couldn't throw in a little joke because people would go, "What??" You know, there's twelve of us on this screen.

Bill Lawrence: I think the only way that these things work, and it's a philosophy that Jason and I both have together, is if they're a meritocracy, if no one feels like, Oh, I'm not supposed to talk right now. The fact that everybody is able to contribute and no one gets punished or judged for trying to put their two cents in, I think creates an environment, even on Zoom, that people aren't just sitting on their hands being quiet. So we jammed through it.

Brett Goldstein: We got used to it. Bill is very good at doing a half an hour of fun at the top. We all do half an hour of bits, and it's like we sat around a table together. You have pockets of just, like, Let's just fuck about, you know?

Bill Lawrence: If you can't create that environment, it becomes so antiseptic that it's undoable, espccially with comedy. But I'm lucky there are so many talented young men and women on this show that we're able to still pull it off. And we also have Jason Sudeikis on set to be a real-time monitor of if something doesn't work, to change it immediately with whoever happens to be around or available. It's a quality-control thing that keeps the world's situation from crushing us.

Jason Sudeikis: That's the neat thing about us circus folks: we solve problems every single day. You solve a problem if an actor has a pimple; you solve a problem if someone won't come out of their trailer, or whatever the case may be.

Nick Mohammed: Because we were filming during COVID, everyone was obviously really grateful to be working. But it's a really strange time to be working because there was no socializing at all. Everyone's wearing masks. You could only really properly talk to each other during scenes, and even then you were meant to be filming.

Jeremy Swift, Leslie Higgins, seasons 1–3: We did have a big chat from Warner Bros. about COVID before we started. And I got a little emotional and said, "Look, I want it to be really great and how are we going to do that now?" But once we got over the fact that we had to wear masks all the time, apart from acting or eating, and it became the norm, we still found the scenes, we found the reality, we found the fun stuff. And so, yeah, we just got on with the job, really, and just trying to make every moment work.

Annette Badland, Mae Green, seasons 1–3: You get on with it,

but it is tricky because acting is about looking at someone else's face. The rehearsals are important and how you connect with one another, so leaving the mask on until the take is really hard. Also for the cameramen and voice sound, knowing what's happening. So it was tricky, but we were all very well behaved and did what we should do.

Bronson Webb, Jeremy Blumenthal, seasons 1–3: A lot of people were just grateful to get out the house. So when people come in to work in the morning, it wasn't just about coming to film *Ted Lasso*, which ended up being amazing, it was just about being out and being able to do something.

Sara Romanelli, assistant script supervisor and script supervisor, seasons 1–3: We were divided into different zones, so we were like different little islands. It was more difficult to block the scenes sometimes. They obviously didn't want to do the thing the other shows did where you always keep the actors one meter apart, because it just looks unreal. But it was definitely more difficult. For example, it can always happen that the actors need the lines, so we'll try to be close to them. But that wasn't possible because less people were allowed to be on set.

Toheeb Jimoh, Sam Obisanya, seasons 1–3: We weren't allowed to touch each other—we weren't allowed to hug, we weren't really allowed to eat lunch together and stuff. We were sometimes trying to get as close to each other as possible. The vibe that we found in the first season—we're all very tactile. Especially for us, the players, we're in a locker room surrounded by each other. So trying to do that while being distanced was a bit difficult.

Phil Dunster, Jamie Tartt, seasons 1–3: It's special because it's set at a club. Obviously, the football players don't see a lot of the backroom staff or the head honchos of the club. But a lot of the scenes happen on the same set, so you do get to see a lot of each other. That

was one of the difficult things, over COVID, is the consistency of seeing people.

Sara Romanelli: And then you obviously had all the COVID people. They were great and very supportive, but it also made it way more difficult because, especially with the locker rooms, we have so many people on set at the same time. Then having also the COVID marshals coming in every time the scene would cut to give them masks and visors. And bless them, a lot of them were maybe not the most experienced people. I remember moments where the director hadn't said "Cut" yet and then you have people starting to shout, "Masks!" It's like, Oh, the scene hasn't ended yet! Please!

Annette Badland: Later on, the COVID team got COVID.

Bronson Webb: We were taking so many tests. We were taking COVID tests the night before, COVID tests in the morning when we got there, in case we had caught it somehow overnight, and then COVID tests in the afternoon. They must have done thousands of COVID tests over the time.

Sara Romanelli: The good thing was because it's such a nice crew and cast in general, nobody made it more difficult than it was supposed to be. There was nobody that was unreasonable or didn't want to do the things that we're supposed to do. The difficult part was when things started to open up, obviously a lot of people will get COVID. And that means a lot of the crew had to stay home and other people had to isolate and stuff like that. But I think we were quite lucky: I don't remember anybody from the core cast having to step away for a long time. I remember maybe Jason's driver had COVID but I think it was only a case of having to isolate a little bit.

Annette Badland: One morning I got a call saying, "Annette we've got some very bad news for you." And I thought, Gulp, I've got COVID. They said, "Your driver has tested positive, you have to

self-isolate for ten days." And people did come to the door to check I was here—not *Ted* but the governing bodies. I was really cheesed off; I was perfectly all right. I said, "He didn't touch me, there was a plastic between!" "Nope, you have to stay home." When I got back to *Ted* someone said, "Oh that driver took a lot of people out."

There was the occasional advantage to shooting in a pandemic. "A lot of the time the residents weren't around because filming was allowed to happen during lockdown," recalled Sue Lewis, the film officer for Richmond-upon-Thames. "So it was, in a way, easier because there was nobody sort of watching." And as reports of the show's growing popularity reached the set, it buoyed spirits as the production worked on the next batch of episodes.

"I just remember everyone was sort of going about with this spring in their step because we were just so excited about the audience seeing season two, knowing that most of season one resonated with lots of people," Mohammed said.

The second season brought more of the same Ted Lasso *fun and games—more cornball jokes, more biscuits—even as it was true to Sudeikis's* Empire Strikes Back *intentions. There would be beloved relationships torn asunder, shocking betrayals, emotional distress, much of it stemming from the more interior journeys the writers devised for the characters. The Sherpa for many of these journeys was the most notable addition to the cast in season two: AFC Richmond's new therapist, Dr. Sharon Fieldstone, played by Sarah Niles. A longtime theater actor, Niles had also appeared in British TV comedies like* Beautiful People *and* Catastrophe. *But she didn't know the first thing about* Ted Lasso.

Sarah Niles, Dr. Sharon Fieldstone, seasons 2–3: I got an email just to say, "There's a casting for this show." I didn't know anything about the show. We were in lockdown, so I got a friend to self-tape

with me and he's like, "Have you not watched the show?" No, I haven't. So I did the self-tape, sent it off, and then I started watching bits of the show, and was like, "Wow, this is really good. There's something honest about this and there's a lot of heart. Oh my god, I need to get this job!" Well, it's too late—I've already sent the tape. I keep getting these messages: "You're in the mix." And I was like, Oh, come on, come on, just say yes. Then, yeah, I got the job.

I think [Dr. Sharon and Ted] teach each other that it's OK to be vulnerable. I think vulnerability is such a powerful thing—we were always told not to be sensitive, to always be strong, to be about success, success. She's probably had to work hard to be successful.

Niles had to work extra hard at one aspect of Dr. Sharon: her preferred mode of transportation. The therapist was a dedicated cyclist, and the actor was . . . not. Niles actually had to learn how to ride a bicycle for the part. And while she managed just fine, she did end up in the hospital—in character—after Dr. Sharon gets hit by a car while riding. Ted has to pick her up.

Sarah Niles: I'm really good at football and really shit at cycling.

Brett Goldstein: She never went down! The day I watched Sarah, it was one of my favorite things because she's very, very good, and she's very, very serious in it. In the scene where she first arrives on the bike, that was a lot of takes. And sometimes she was just in the background on the bike being very serious.

Jason Sudeikis: Every shot you see of Sarah riding a bike on that show is movie magic. It is more incredible than Elliot's bike flying in *E.T.*

Sarah Niles: The hospital scene. I loved how vulnerable she was and how awkward it was. And plus, behind the scenes, Jason was just making me laugh. He's goofing around; he's just so funny. And once he knows there's an opening—your guard is down, you're

laughing—he'll just keep on going. And it was really hard for me to shoot without collapsing.

Ted Lasso *also added another Greyhound to the team, one who reflected the show's prehistory in the Amsterdam improv scene. David Elsendoorn, a young Dutch actor, was cast as Jan Maas, a center back whose characteristically Dutch candor is played for laughs. He is named for Saskia Maas, who helped oversee Boom Chicago, the Amsterdam improv club where Sudeikis, Hunt, and Joe Kelly worked.*

David Elsendoorn, Jan Maas, seasons 2–3: I hadn't figured out yet that they had lived in Amsterdam and that they knew so much about Dutch culture. I was just flabbergasted by how funny the scene was that they wrote for the audition, because it was so accurate about the clash between, in this case, an American coach and the Dutch guy. I just thought it was really, really funny.

They would tell me to really accentuate the bluntness, but without any bad intentions about it. That was a fine line. There was naturally so much comedy in the difference between the Dutch and the English culture, because Jan was mainly surrounded by English guys, who tend to be polite and very well-mannered. They say England took over half the world by saying yes, please, and thank you, whereas with the Dutch, it's more like you want to know where you stand. You want to know what someone thinks of you.

This was my first international show, and walking into the locker room is like you've stepped into a dream, because you knew that locker room but you don't see the stuff around it. And I was just kind of a fanboy for everyone—I caught myself calling Phil "Jamie" and Toheeb "Sam." They were all super, super nice.

The new season brought the beginning of the Ted Lasso *run-time creep. Scripts got longer, which meant the episodes and shooting time*

did, too. "A thirty-minute episode should be, in script form, about thirty-five to thirty-seven pages, but the scripts are coming in forty, forty-two, forty-five pages," Lowney recalled. "Apple, in its wisdom, I guess they said it doesn't really matter how long it is—just give us something funny and charming for approximately half an hour. I think season two we were getting up toward forty minutes, so that meant more content and that means you have to shoot for longer."

The season opened with a moment that signaled both its theme of characters turning inward and its slightly darker tone (while also being hilarious, I'm somewhat ashamed to say): the penalty-kick killing of the team's mascot, Earl the Greyhound, by the happy-go-lucky Dani Rojas. Rojas's resulting emotional tailspin spurred the team to bring in Dr. Sharon as sports therapist.

Brendan Hunt: We really felt it was important to start things off by killing a dog. Because we had become the feel-good show, the show that's like a hug. It's like, I don't know, we're kind of a sitcom, guys. Just to remind everybody what's up here, we're going to kill a dog right away.

Cristo Fernández, Dani Rojas, seasons 1–3: I'm very, very happy and grateful that there were new ways to explore who Dani was, because we saw in season one the positive energy and charisma. But life cannot be all the time like that. Life brings us surprises and that will mean some sad moments. For me, it was nice to explore that and make Dani feel more of a real human being. And I think that's why "Football is life, football is death" works.

For the newly coupled-up Keeley and Roy, theirs would be a shared journey of discovery as they negotiated life together and what it revealed about each other.

Juno Temple, Keeley Jones, seasons 1–3: Someone used the

example of *Beauty and the Beast,* and it kind of fits: the angry, beautiful, mysterious man and the bouncy, sweet, kind girl. Finally she cracks through, and underneath is a Prince Charming.

Brett Goldstein: He's a slightly more progressive beast in that he does let her in and out of his house.

Juno Temple: The courtship has been done. So you're just existing in a relationship, and relationships are fucking hard. It doesn't mean they're not amazing, but they're hard. And it was really cool to get to see what it is to live in a relationship with somebody and the ups and downs of that, and also how important communicating is.

Sam Obisanya's season two journey involves a crisis of conscience that leads to a political awakening. In the third episode of the season, "Do the Right-est Thing," he is tapped to be a spokesman for Dubai Air, the team's sponsor, and is thrilled until he is upbraided by his father because the airline is owned by an oil company that has wrought environmental devastation in Sam's native Nigeria. Sam ultimately leads a protest of the airline by taping over its logo on his uniform, and the rest of the team follows suit in solidarity. In the post-match press conference, Ted cedes his usual spot to Sam so he can more fully explain his protest.

"Filming it, everybody knew what the significance was for me," Jimoh told the Los Angeles Times in 2022. "Jason was there even though he had shot his part of the scene; he still stood there and was with me, the same way Ted was there for Sam."

For Sam, the protest inspires a growing social conscience that will last throughout the series, his political statements and the scorn they inspire in some circles reflecting the experiences of real professional athletes. In season three, a conservative politician will tell him to "shut up and dribble" in response to his comments about immigration policy, a direct quote of what the Fox News host Laura Ingraham directed at LeBron James for daring to share political thoughts in an interview.

Other models include Colin Kaepernick in the US, who was attacked and effectively barred from the NFL for kneeling during the national anthem to protest police brutality and racial inequality, and Marcus Rashford in England, who faced blowback for his activism regarding providing meals for underprivileged children.

Toheeb Jimoh: Marcus Rashford was just trying to make sure that kids get fed, and people were like, "Why are you, a footballer, the person who needs to make this point?" And it was like, "Well, I'm a footballer or a basketball player or an American football player, but I'm also just a human being, right? I'm one of the leaders of my community and I'm just trying to help people with the platform I have."

Brendan Hunt: We wanted to find a way that wasn't forcing it that would reflect the current mood, where athletes are using their voices more.

Jimoh saw parallels between Sam's evolution and his own political awareness.

Toheeb Jimoh: This is partly why we want to be in these positions, to have these followings so that we can use this platform to help people, especially people who come from the same place that we come from. And at the time Nigeria [was] going through massive protests. And it felt like a time when I was coming to terms with what it meant to use this platform properly. Look how many people are going to watch this show now, and I get to go, "Yeah, by the way, the Nigerian government isn't doing enough for its people." Which is true, and which I stand by.

That's the message that Sam sends out; that's the message the team sends out. And the amount of Nigerians that were messaging when season two came out, just being like, "Yo, I feel seen, thanks for pulling up." And so yeah, I felt massively privileged to have that episode and to have that opportunity to look somebody in the eye and

go, "Yes, I am accusing them of corruption because somebody has to say it." I loved that scene so much.

Of course, not all of the Empire Strikes Back *season was so weighty. The fourth episode, "Carol of the Bells," was sweeter than a sugarplum dipped in chocolate inside a rock-candy shell. Essentially a Christmas special—even though it first aired in August 2021—it had almost nothing to do with the show's larger narrative because it was one of two episodes added, at Apple's behest, after the season was mostly conceived. As a result, it and the other bonus, the wildly eccentric "Beard After Hours," the ninth episode of the season, are essentially stand-alone stories.*

Jason Sudeikis: We had ten episodes the first season, then the second season got picked up. They asked for two more episodes for our second season. We had already known what the story was for season two, and then all the writers chatted about it, pitched ideas. The Christmas episode was the one that won out, and then [the one] where Beard's out all night.

Declan Lowney: Rather than fuck with the story structure, they said, "Let's do two episodes that we could take out and it wouldn't really matter." So no major plot points happen in episode four, the Christmas one, and Beard's night out.

In "Carol of the Bells," Ted is sad to be spending the holiday away from home, and Rebecca takes him out to give presents to local children while the rest of the team goes to Chateau Higgins for Christmas dinner. Roy and Keeley take Roy's niece, Phoebe, around the neighborhood to find a dentist to diagnose her bad breath (the culprit is her antihistamine). And that's pretty much it, along with some carols, Phoebe's re-creation of the poster board scene in Love Actually, *and a big Nerf-gun fight among the players and Higgins's kids that is treated with the over-the-top portentousness of a war movie.*

But the big Christmas gathering of the diverse array of players,

with their favorite dishes from home and the actors' actual hometowns listed off by Higgins, is a reminder of the many different cultures welcomed into the Ted Lasso *tent, showcased by an elegant shot tracking down the Higginses' long, improvised holiday table. "To the family we're born with, and to the family we make along the way," Higgins toasts.*

Declan Lowney: [Sudeikis] is like a one-man film school. The Christmas episode does that shot when they run out of space—the team has come out to Higgins's house and they can't cope with the numbers. They end up having to put the table, and then a surfboard, and then a billiard table and put them all together to make space for everybody. Jason showed me a clip one day, he said, "I want to start on Jeremy but then I want to just keep going and going and going and discovering more and more faces." He showed me a clip from a 1920s silent movie called *Wings*, where they did something like that. He absolutely knew what he wanted, where it had come from and why, and that's something we would never have found on our own.

Jeremy Swift: Doing that episode with [his wife] Mary was just so great. There were scenes where we were in the background just cutting up carrots or something like that whilst, you know, the kids or Toheeb was doing a scene, and I just thought, Wow, this is just like being at home but with a camera crew. We would just sort of chat as we would at home, so that was a unique bit of fun.

Moe Jeudy-Lamour, Thierry Zoreaux, seasons 1–3: [The Nerf-gun fight] is one of my favorite scenes of all time. I had no lines, and Joe Kelly, he's the one who wrote this episode, he was like, "Just improv whatever you want." He just nudged me in the right direction. I was like, "Oh, OK, I got it," and then boom, boom, boom, I just started riffing.

Juno Temple: The whole group of boys that are on the football team is so great. It was such a great thing in the Christmas episode to see all of them in Higgins's house, and they're playing games and everyone's just having a great time.

Joe Kelly, creator: Writing for *Ted Lasso* means writing conflict without one-dimensional villains who show up to do horrible things because they're evil and want to rule the world or whatever. The only "villain" in this episode is depression, which really is a powerful villain in real life. The idea that Rebecca swoops in and helps defeat that for Ted for a moment is so sweet, especially after everything that happened between them in season one.

The fifth episode of the season, "Rainbow," is an extended riff on rom-coms, one of the show's foundational pillars, as Ted woos Roy, trying to convince him to leave his job as an increasingly grumpy football commentator and join the Richmond coaching staff. In the episode's set piece, Roy realizes where his heart wants him to be—with Ted coaching football and being part of a team, his life's true passion—and makes a mad, Nora Ephron–worthy dash from the TV studio through the streets of London to Nelson Road, Richmond's stadium. The sequence, which includes a brief cutaway to Higgins and his wife meeting and embracing in the stadium concourse, is set to the Rolling Stones' objectively delightful piano-and-mellotron-fueled hippie anthem, "She's a Rainbow."

"Hello, Coach," Ted says when Roy arrives on the sideline. "I'm really glad you decided—" But Roy cuts him off.

"Shut up, just shut up," he says. "You had me at 'coach.'"

Melissa McCoy, editor, seasons 1–3: When Roy goes to run—you know, romantic comedy—and he runs to "She's a Rainbow," that song plays on the screen for, like, five minutes, and it's a three-minute song. [The US single version is technically 4:10.]

[To the music editor, Richard David Brown] I was like, "Look, I have these little bits, and then when he stops to talk to all these different people, you can't have the lyrics under all of that." Sometimes newer songs, you can get an instrumental of it where you don't have any lyrics so you can kind of blend it. But older songs, they don't do that. So there was no instrumental. I was like, "The important bits are when Higgins sees his wife, you hear 'She's all in blue. . . .'"

Jeremy Swift: We were still in pandemic mode. The director said, "Oh, you two can actually touch and kiss." And I said, "Well, we could if you like. . . ."

Tony Von Pervieux, music supervisor, seasons 1–3: As an Easter egg, we also went back in episode 203 and used ["She's a Rainbow"] for another quick use of Higgins's ringtone, prior to the big use in 205.

Melissa McCoy: Also there's "She's all in gold . . ." and Keeley's all in gold, and our music editor made that hit. And every time I made changes, I would send it back to him and he would hit all my important things. For us to get that song, our music supervisor had to take that scene to the Rolling Stones and they had to bless it. So they were like, "We approve this, but if you make any [more] changes, it's not approved anymore."

From the show's zippy opening moments, set to the Sex Pistols' "God Save the Queen," to the emotional closing ones, with Cat Stevens's "Father and Son" bleeding into the Flaming Lips' "Fight Test," music is a crucial component of the Ted Lasso *experience.*

It is used to score big set pieces like Roy's "Rainbow" sprint, sure. But it also underscores meaningful personal moments both epic—like when the pub lads cavort on the Richmond pitch to Queen's "We Are the Champions"—and intimate, as when Ted signs his divorce papers to the poignant strains of Celeste's "Strange." It lends verisimilitude in ways both literal—as in all the versions of "Blue Moon," related to Man

City and its supporters—and referential, as when a montage tribute to You've Got Mail is set to the Cranberries' "Dreams," just like in the movie. It fuels scripted singalongs both joyful—"Hey Jude" outside the pub and "Three Little Birds" on the team bus, both in season three—and affecting, like the counterintuitive deployment of Rick Astley's "Never Gonna Give You Up" in the season two funeral episode. Such recontextualizing is another of the show's musical moves—see also: Marcus Mumford's stirring rendition of "You'll Never Walk Alone," from Carousel, at the end of season one; or Brandi Carlile's cover of "Home," from The Wiz, to signal Ted's departure near the end of the series.

The show's inclusion of pricey legends like the Beatles, the Rolling Stones, Bob Dylan, Beyoncé, Queen, Bob Marley, David Bowie, Édith Piaf, Leonard Cohen, A Tribe Called Quest, and Radiohead—as well as the Walt Disney and classic Broadway songbooks—is also a periodic reminder that it is produced by the wealthiest company in the history of humankind. Apple leverages its synergy by releasing Ted Lasso playlists on its Apple Music service—not only the soundtracks and songs from each season but also themed playlists like "Ted's Breakup Mix," "Roy Is Sorry for Not Understanding Keeley," and "Sam Obisanya's Afrobeats for Ola's."

Before the show could commence incorporating dozens of legendary acts into its soundtrack, however, it had to have a theme song and score. For that, Sudeikis and Lawrence each turned to a trusted maestro, and then paired them off: Sudeikis brought on Marcus Mumford, lead singer of the folk-rock band Mumford & Sons; and Lawrence called Tom Howe, who had scored an earlier Lawrence series. Together, the two Brits would create the sound of Ted Lasso and receive an Emmy nomination for their efforts. But first they had to meet.

Tom Howe, composer, seasons 1–3: I did a show called Whiskey

Cavalier, which Bill Lawrence did. He called me on *Ted,* and we met and talked about it, and he said, "I want you to be involved." And I said, "Great."

Marcus Mumford, composer and vocalist, seasons 1–3: I met Jason Sudeikis doing *SNL.* We did a Beatles sketch together, then we stayed in touch. I knew about his bits as Lasso, that he did his ads early on. Then he told me he's doing a show, and then he left me, like, four hundred hours' worth of voice memos.

Tom Howe: Jason was very good friends with Marcus and expressed an interest in Marcus doing the music, and Bill had said, "Well, Marcus hasn't done something to picture. Why don't they get together and see if they get on, and then do it together?" So [Mumford] and I met for breakfast in L.A., and then he invited me and my four kids to his concert in Anaheim. And I then flew to England and went to his house for ten days, which is quite unusual when you don't know someone that well. We were in a studio together from basically nine in the morning 'til five late each night, just putting down ideas. We didn't have a picture at that point—what we had was conversations with Jason and some of the editors. We started with the title track.

Marcus Mumford: Tom and I, when we were together in the studio, we listened to a lot of transatlantic references. So we're listening to, like, Gerry and the Pacemakers at the same time as Creedence Clearwater Revival, because it felt like quite a transatlantic show. As Brits doing the music for this show that was being run by Americans, it felt like a good place to start with somewhere between the UK and the US.

Tom Howe: The song came very quickly, we kind of had the idea within a couple of hours. That particular lyric was something Marcus [created]. When you're writing a song, often you are kind of

mumbling lyrics around, and that was something that he came up with on the spot and kept going back to, and then that sort of became the hook.

Marcus Mumford: I think I was at an advantage, because I've had a really good, quite long-lasting relationship with Jason before we started working on the show together. And we talked a lot about the character of Ted Lasso, and what he was trying to achieve, and what kind of person he was, and the story arc that he was going to experience through season one. So we were sort of in the head of Ted before we started.

Tom Howe: It was a great hook and it worked really well, and that really set us on the kind of path of what the music for the show was going to be about. And we were able to take the theme from that and then put that into cues moving forward. So it was incredibly helpful.

The other important things to get right were the sporting moments. It's very easy to lean into cheese without meaning to; you want to play the action but not overplay it. The sporting moments and the odd comedy cue were the things that we spent a lot of time with initially. I think the emotional things are a bit easier, because the acting and the storylines were just so good.

Marcus Mumford: The process of scoring a show to picture is a lot like making a record, in that by the end of it, you're completely sick of it. But it's also really fulfilling. There are a lot more people behind the scenes and a lot more opinions, so you have to get your creative partnerships and your collaborative chops down early. Making music with Tom was a really enlightening experience for me, and a fulfilling one.

Declan Lowney: We're also blessed to have had such brilliant music supervisors. All the music choices in the show are just spot on. *The music supervisors, Christa Miller and Tony Von Pervieux, also*

received Emmy nominations for their work on the show. Von Pervieux was the person primarily responsible for securing the rights to use desired songs, derived from specific mentions in scripts, from Von Pervieux's own ideas for certain scenes, and from suggestions by writers, editors, or, most often, Sudeikis, the final word on the matter.

Brendan Hunt: You try not to get too attached to a song for a particular moment in a script. We have a really good conveyor belt of people with good opinions of music that these things go through.

Jason Sudeikis: It's a team. I'll [be] sort of the final yes or no.

A.J. Catoline, editor, seasons 1–3: Jason always says that he knows it when he hears it.

Tony Von Pervieux: Jason has somewhat of a clear vision, especially certain songs that he scripts or the writers script into the episode. Obviously we go after those first, and then the editors do an amazing job to cut it in and if it works, great. Then that's what we go for. If not, then that's when we start diving in as to which songs fit better.

A.J. Catoline: For example, the ending song of episode ten [in season one], we were trying different things and we'd keep auditioning things and Jason was like, "No, no." When he knows that he's not finding it, he'll think about it, and he ended up selecting "Non, je ne regrette rien," Édith Piaf. Oh my god, it's the perfect *Ted Lasso* anthem: "Regret nothing, bc goldfish." So when we had that fit at the end, that was just like a piece of the puzzle and I remember how excited we were, and Tony had to chase that down.

Tony Von Pervieux: After you select all the songs and everyone's on board and has approved what's being used in the show, then you have to go out and clear the songs that you're using. So that process can take from a few days to weeks or even a month.

It's a job that got somewhat easier once the show became a

sensation. Normally reticent acts like the Stones and Beyoncé became more receptive.

Tony Von Pervieux: We have gotten artists that are typically notoriously known for taking forever to respond. For example, the Beyoncé song at the end of the first episode of season three ["Ring the Alarm"], that song was not my choice. That was chosen by the producers, because they wanted something that was going to take us out in a big way.

Brendan Hunt: It was actually one of Joe Kelly's notes, I can't remember what song was in there before. We tried it and it worked great.

Tony Von Pervieux: I just told them, "Okay, well, Beyoncé is not easy. She's clearable, but it can take quite a long time sometimes to respond, and, of course, you know it may be a little pricey." But they obviously wanted to go for it, and I totally understood why. So when I send out a request, sometimes you just kind of mentally prepare yourself that you're gonna be waiting and following up for a few days or a week or two weeks. And I literally got Beyoncé's approval back in two hours.

Brendan Hunt: Beyoncé, I owe you yet again.

Tony Von Pervieux: I got to use Radiohead ["Karma Police," in season two], and that was really exciting. There was potential to use a song at the end [of the episode "Midnight Train to Royston"]. I was like, "Oh, this is a really good chance to use Radiohead," for the emotion behind it, and I sent it off to the editor. Of course, she's a Radiohead fan, too, and we got to use it, and Jason loved it, so sometimes it just works out like that.

Jason Sudeikis: Apple has always been amenable, unlike other streamers [who] don't give a shit about the exit song. Filmmakers really care about that song, so much so that Radiohead has "Exit

Music (for a Film)," it's like an idea. And streamers are just like, "Don't leave! Here's the next episode!" As opposed to letting you land. Apple has let us land. We've had to pay a big chunk of change for some of our final songs that are maybe only five, six, seven seconds, and Apple's always been cool with it, and Warner Bros. has been cool with it.

Artists who are more accustomed to renting out their hits, meanwhile, were pleased to see the creative ways in which Ted Lasso *used them.*

Tony Von Pervieux: Some artists lean into the lives their songs have taken on. When we used Rick Astley [in season two], he leans into it. He understands, like, "OK, look, I understand the Rickroll, I don't necessarily like it, but . . ." type thing, and so Jason was great with the creative vision on how to utilize a Rickroll at the end of that episode in a very different way, that Rick Astley had never seen. I got to talk to Rick and his wife, who manages him, and they're like, "It was one of the best uses we've ever had of our song." Because no one's ever used it for a eulogy.

There were good reasons for artists to want their songs in Ted Lasso. *In 2021,* Billboard *reported that Phil Collins and Philip Bailey's "Easy Lover" received 300 percent more downloads after a brief appearance in the funeral episode. Downloads of "She's a Rainbow" were up by nearly 2,000 percent after Roy's big sprint. For "Hello," the dance hit by Martin Solveig and Dragonette, downloads spiked by more than 11,000 percent after Beard ecstatically danced and Hula-Hooped to the track in "Beard After Hours."*

But some songs remained difficult to clear. For example, Disney initially rejected the show's use of "Let It Go" in Hannah Waddingham's pivotal karaoke scene in season one.

Tony Von Pervieux: I did initially get a denial on that song because the catalog is very particular about uses, and initially when

you're sending in a scene description—because you've not shot it yet—they don't know exactly what it is. The hope was that we would send them the scene and be like, "Look, we told you, she's an amazing singer. This is actually a really good scene. We're not denigrating the song in any way. There's no derogatory use. This is a legit use for the song." And they ended up reversing the denial, so we got the approval on it, and it was a perfect fit.

A.J. Catoline: Adriano Celentano's . . . I can't even pronounce it. ["Prisencolinensinainciusol," a gibberish song used to score a Zava montage in season three.] It also became a challenge to get that.

Tony Von Perviaux: It was quite a challenging song to get, I have to say, because Mr. Celentano is still alive, living somewhere in Italy probably, in his eighties. The song was not over four minutes long, I think it was probably two to maybe three minutes long, and we're like, "OK, well, we would like to use this for over four minutes." So for me it was the battle of trying to get them to agree that this is a good use for the artist, like, this is a really good use, you guys will be very happy with it, and then just figuring out how we get Mr. Celentano to actually say yes.

A.J. Catoline: Jason actually wrote a letter to Adriano Celentano that he showed me. He had to get personal permission from the artist.

Tony Von Perviaux: The Christmas episode [in season two] was a doozy. We had about sixteen songs in that episode and Christmas music tends to be a bit pricier since it's cyclical. But the "Beard After Hours" episode was Goliath. We had around twenty-one [songs], most of them well-known, so that episode definitely took first place using "wall-to-wall" music.

"Beard After Hours" included a version of the show's theme song by Wilco maestro Jeff Tweedy—some of the show's most memorable musical moments came from songs it commissioned. Mumford's cover of

"You'll Never Walk Alone" threaded multiple Ted Lasso needles: it was one of the show's composers performing a song of support and togetherness that originated as a Broadway show tune but, thanks to a 1960s cover by Gerry and the Pacemakers, had also become the anthem for Liverpool F.C. fans. (Other club songs the show employed included "Blue Moon," Man City's anthem, and "Three Little Birds," beloved by Ajax fans.)

Eurovision star Sam Ryder wrote and recorded a new song, "Fought & Lost," which appeared in the penultimate episode of season three, with Howe and Jamie Hartman. (Brian May, of Queen, lent an unmistakable guitar solo.) Pop star Ed Sheeran contributed "A Beautiful Game," which scored one of the final scenes in the final episode (for now, at least), when the team watched Beard's emotionally gutting video in the locker room. The song won one of the two Emmys Ted Lasso received for season three. (The other was for Sam Richardson's guest appearance as Edwin Akufo.)

However, the most momentous song in the finale was a borrowed one: "Father and Son" by Cat Stevens, now known as Yusuf Islam. It's hard to think of a more fitting tune to close out Ted Lasso, given the show's themes, and Sudeikis had long had it in mind. It scored the final montage and took Ted home to Kansas, among other happy endings. "Father and Son" was followed by the Flaming Lips' "Fight Test," as the credits song, partly because they flow seamlessly into each other, thanks to their similar sonic qualities. A bit too similar, as it turns out: back in 2003, the year after "Fight Test" came out, Islam's publishing company sued the Flaming Lips for copyright infringement, and as part of the settlement, Islam now gets part of the song's royalties. So the Ted Lasso finale gave him a nice little double-dip.

A.J. Catoline: That Cat Stevens "Father and Son" song, Jason had that idea from a long time back.

Declan Lowney: Jason wanted to put the two songs back to back because they do sound really similar when you hear one right after the other.

A.J. Catoline: I tried to put "Father and Son" in [episode] 208 when Jamie has a fight with his dad. It's just a temp: when we do the editors' cut, we try to take a stab at what the music should be. I put that in just to be like, It feels like we had a father and son scene, and I was always very attuned to the show's reference of father and sons. So anyway, I use "Father and Son" and Jason sent a text to me, and he's like, "Please don't use that Cat Stevens song. It's spoken for." And I was like, OK, so I'm curious where that's going to go. But then when I read 312, I thought, I bet he's gonna end with that. So it was a beautiful song to end with.

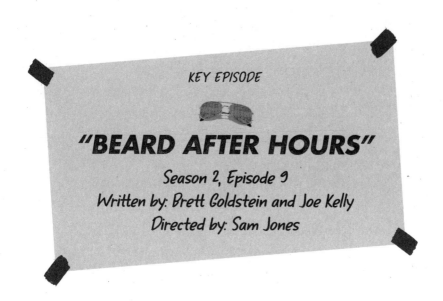

"BEARD AFTER HOURS"

Season 2, Episode 9
Written by: Brett Goldstein and Joe Kelly
Directed by: Sam Jones

Ted Lasso had a few notably polarizing episodes. The Christmas special. The Amsterdam one. Nate's return home.

But none split viewers like "Beard After Hours," the ninth episode of season two, which was, like the Christmas one, a stand-alone bonus installment added to the season when Apple asked for more episodes. A forty-three-minute riff on Martin Scorsese's *After Hours*, among many other movies, the episode follows Brendan Hunt's gnomic Coach Beard as he alternately stumbles, drinks, sprints, fights, leaps, rides, dances, and Hula-Hoops his way through the London night while trying to shake off Richmond's bruising loss to Man City from the previous episode, and make sense of his romantic life (and life in general).

I have encountered as many people who loved "Beard After Hours" as despised it, and critics were as divided as anyone. *Vulture*

called it "a fun departure"; TV Fanatic said it was "wonderfully strange"; *Rolling Stone* had "mixed feelings"; *The New York Times* found it "frankly bizarre"; the *AV Club* thought it was "a waste of time." A *New Republic* writer called it "genuinely one of the worst episodes of TV I think I've ever seen." Comments sections across the internet were even more disharmonious than usual. I liked it fine. My wife, on the other side of the couch, most definitely did not.

The timing of the episode was a factor in the antipathy—or at least confusion—that many felt when it premiered in September 2021. Coming right after the eventful "Man City," in which Jamie punches his dad, Roy hugs Jamie, Rebecca pairs off with Sam, Dr. Sharon crashes her bike, and Ted reveals his father's suicide, most viewers expected the show to deal with the aftermath of at least some of all that. Instead we got the character who rarely speaks as a sparkly-pantsed Dante negotiating nine circles of an increasingly hellish night, until he finds salvation in the holy trinity of a dance club, his tempestuous girlfriend, and a Hula-Hoop.

In story time, "Beard After Hours" picks up moments after Ted's revelation to Dr. Sharon about his father's suicide, flipping the point of view to that of Ted's sidekick as he ventures out into the night. Professional coaches talk about the almost physical pain of losing, about how the elation of victory pales in comparison to the despair of defeat. We can see the weight of it upon Beard as he rides the Tube after the match, as he trudges stoop-shouldered toward home. An enormous blue moon follows him everywhere, haunting him along with the different versions of the matching Man City anthem, "Blue Moon," that play throughout the episode. The hallucinations start when he gets home, as the soccer commentators on Beard's TV, Gary Lineker and Thierry Henry, go from criticizing his team's loss to criticizing him, his coaching, his personal choices, even his furniture.

("Does anything say 'sad single man' more than a chessboard coffee table?") Thus do the pain and guilt of Beard's self-perceived failings at his job metastasize, as such emotional agonies tend to do, into a more general miasma of self-recrimination. So he does what many of us do in such circumstances: pounds a beer and goes out in search of distraction.

And he finds it! What follows is a wild journey through the highs and lows of Bearddom, with plenty of drinking, philosophical musing, heartsick wallowing, odd charm, quick extemporaneous thinking, and even quicker flights from harm, not all of them successful. Beers at the Crown & Anchor lead to sneaking into a luxe private club (with the douche-chic name Bones & Honey) with the Richmond fanboys Baz, Jeremy, and Paul, where Beard pretends to be an Irish former Oxford professor in order to trick a trio of arrogant toffs. How did you know all that stuff about Oxford? Jeremy asks later. Beard: "Dated a professor at Oxford, and I listen more than I talk."

It's as succinct a summation of Beard as the show has offered, and whatever the rampant criticism, "Beard After Hours" does fit within the general tenor of the second season, when many of the key players turn inward. In this it aligns Beard, a mostly inscrutable if highly enjoyable sidekick to that point in the show's run, with the other Richmonders working toward becoming better selves. It deepens the character and casts what we had seen of him in a new light, suggesting a churning world of emotions beneath the placid surface. While his relationship with the aptly named Jane Payne (played by Phoebe Walsh, one of the show's writers) had to that point been mostly a punch line, the episode reframed it as a possible key to if not Beard's salvation, then perhaps some comfort with himself and his place in the world.

More than most *Ted Lasso* episodes, "Beard After Hours" benefits

from a rewatch, when the swerve it represented within the season feels less pronounced and you can view it on its own terms. Because however much it did or didn't apply to the larger narrative, the episode is probably best understood as a showcase for a man who has been waiting for one for decades. "I personally had always wanted to do a Coach Beard *After Hours* kind of thing where we were with him," Jason Sudeikis said in a panel discussion in 2022. "Part of that truly just comes from knowing Brendan really well and being a fan of his even before I was friends with him.

"It was really just, 'Wait, how do we exploit all of the fun, neat, silly, crazy, weird talents that Brendon Hunt, as a human man and artist, has?'" Sudeikis added. "We just kind of start from there and root it in the character, and try to find the overlap."

By his own admission, Hunt was "rotting on the vine" before *Ted Lasso* came along. He was working at a restaurant in L.A. and "considering a career return to dinner theater," Hunt told *The Dan Patrick Show* in 2023. "Then at the last minute a couple years ago, Jason was like, 'Oh, I'm having lunch with Bill Lawrence tomorrow, we'll see what happens.'" One thing that ended up happening was a *Ted Lasso*–worthy redemption arc for someone many famous people consider to be one of the best comic performers of his generation.

Hunt grew up in Chicago with a sister and single mother and caught the theater bug in junior high. But seeing an improv show at Second City "blew my lid," he told NPR in 2023. Eventually Hunt would become part of Chicago's legendary improv and sketch scene himself. But it was an improv club in Amsterdam, of all places, that

would be his most fruitful creative home and sow the seeds of *Ted Lasso* and, by extension, his own future success.

In 1993, two Chicago improv performers, Andrew Moskos and Pep Rosenfeld, opened Boom Chicago in the Dutch capital with Saskia Maas, a Netherlands native. Hunt was part of the cast from 1999 to 2005, plus some shorter follow-up stints, and Amsterdam was where he found himself as a performer and discovered his abiding love for soccer and—of particular relevance to "Beard After Hours"— dancing. It's also where he cemented his friendship with Sudeikis and Joe Kelly, Boom castmates. And it's where the origin story of *Ted Lasso* began, with Hunt and Sudeikis playing *FIFA* on a PlayStation and bonding between shows.

Boom Chicago would become a remarkably fertile incubator of American comedy talent. Other alumni include Seth Meyers, Jordan Peele, Amber Ruffin, Ike Barinholtz, Colton Dunn, and Kay Cannon. But even amid such a starry roster of alumni, "Brendan's the best performer that's ever come through Boom," Barinholtz said in *Boom Chicago Presents: The 30 Most Important Years in Dutch History*, a fascinating oral history of the club, from 2023.

"I've been trying to make Brendan Hunt a household name for years," Cannon, a writer and director behind films like *Pitch Perfect* and *Blockers*, said in the same book. (Cannon was also married to Sudeikis for several years in the 2000s.)

Hunt has said that Amsterdam helped him shake off the Catholic guilt he grew up with, but that it came back once he returned to America. He wrote and performed several idiosyncratic, award-winning theater pieces and made one-off appearances in shows like *Community* and *How I Met Your Mother*, and in Boom Chicago–adjacent projects like *Key & Peele*, Sudeikis's *Horrible Bosses 2*, and

Cannon's *Girlboss*. But he was mostly treading water professionally. Then, in 2013, Sudeikis was approached about starring in a soccer ad set in Europe, and he decided his old Amsterdam comrades, Hunt and Kelly, were the people to help him do it. The popularity and fun of the Ted Lasso spots spurred them to develop them into a show concept that then sat around for years—with Sudeikis and Kelly continuing successful careers and Hunt returning to bit parts and scraping by—until Sudeikis's lunch with Lawrence got the soccer ball rolling.

"*Ted Lasso* was just this great reminder that I'm capable of contributing to something in a material way," Hunt said in *Boom Chicago*. "We're not playing space aliens; we're doing versions of ourselves."

Hunt's improv background informed his approach to the laconic Beard. "I'm a blabbermouth," he told NPR. "I'm way opposite Coach Beard, but it's another improv and sketch maxim that he represents." He continued:

There's a school of thought that you should be watching the scene that your partners are in in the show and ask yourself, What does this scene need? And it may or may not need you to enter that scene. But that's Beard's whole thing: What does this life of ours need? It does not need talking—Ted's got that part handled. It does need someone to learn the rules of soccer on a ten-hour flight as quickly as possible. So yeah, he just waits to see what is happening before he acts and tries to fill in the gaps. I think that's an essential part of a team.

But when it was time for a starring role, Hunt was ready. For his former Amsterdam cohorts, "Beard After Hours" was both a

recognizable embodiment of Hunt's spirit and the kind of global showcase they'd long wanted to see for him. "It's basically a solo Brendan Hunt jam session," Rosenfeld said in *Boom Chicago*. "Finally, the world got to see Brendan really dance his ass off."

Beard did dance. But first he had to run a gauntlet of snooty hostesses, angry bouncers, paranoid hotel clerks, football hooligans, and a jealous muscle-bound boyfriend named Darren.

The movie *After Hours* follows Griffin Dunne's uptight yuppie, who goes out to meet a woman and then finds himself run through a series of odd and menacing trials and tribulations in a very dicey downtown Manhattan. (It was the 1980s, trigger warning for any real-estate-obsessed New Yorkers reading this.) While "Beard After Hours" borrows the overarching concept and some specific elements, like the recurring significance of keys, it inverts the movie's outdated sexual politics. The young, gorgeous woman Beard spots in Bones & Honey doesn't actually want him, just his pants. But that's enough to put Darren in hot pursuit.

One persistent knock against *Ted Lasso* as it went on was that for all its fun, kindness, and nuanced ideas about human nature and behavior, it lacks the conflict required for satisfying drama. (The saccharine Christmas episode, in particular, fueled this complaint, but then again, as my wife is quick to point out, it was a Christmas episode.)

"Beard After Hours" is almost nonstop conflict. But it also reflects the fact that the series as a whole is generally more interested in inner conflict, in how our experiences, relationships, and personal programming shape our perspectives in ways that can both help and

harm us. "Beard After Hours" has plenty of that, too. Beard's own particular brand of self-loathing is exemplified by the moment when, as he flees Darren, he literally throws himself into the garbage. Later he runs into James Tartt, Jaime's rotten father, who is feeling extra spiteful because Beard had kicked him out of the Richmond locker room earlier that evening. We see the drunk and his droogs backlit in an alley like a scene out of *A Clockwork Orange,* and it's as if Beard's inner demons have been externalized. His refusal to let his resulting beating end starts to feel like a form of self-punishment until Darren improbably saves his bacon.

We learn later in *Ted Lasso* that Willis Beard had a rough past that included addiction, criminality, jail time, and general dirtbag behavior. But he is more vague about his issues when, in a church near the end of "Beard After Hours," he opens his heart in a prayer that begins: "Are you there God? It's me, Margaret's little boy."

"There's this woman, Jane," he says. "I'm under no illusions that she could solve what ails me, but when I'm with her the world just feels more interesting." Then his prayer is answered by thumping bass, which he follows to discover the club he's been seeking all night, as well as Jane and a Hula-Hoop.

Hunt didn't write "Beard After Hours" and didn't weigh in on it as much as he would a typical episode, as one of the show's creators. "He was in our hands, as it were," Brett Goldstein, who wrote the episode with Joe Kelly, said in a 2022 panel discussion. So it wasn't a form of autobiography. Still, it's hard to watch Beard move from despair in the church to ecstasy in the club without thinking about a guy who felt like he was rotting away in his late forties, and then suddenly found himself at the center of one of the most beloved TV shows in the world.

When the episode first aired, some writers and viewers wondered

if Beard's brilliant Hula-Hooping on the dance floor was real or CGI. It was 100 percent authentic—one of the fun, neat, silly, crazy, weird talents Sudeikis wanted to show off and something Hunt has incorporated into performances over the years. (In one he played an abject, adult version of Pig-Pen, from *Peanuts*, and represented the character's signature dust cloud by Hula-Hooping throughout the show.)

"I would say, as someone involved in the writing of 'Beard After Hours,' you think to yourself, Can we ever get bored of watching Brendan Hunt dance and Hula-Hoop?" Goldstein said in a 2022 interview. "And the answer is no, never ever. And if anything, there wasn't enough of it."

Love the episode or hate it—on that point, at least, I think we can all agree.

WHO WON THE EPISODE?

Baz, Jeremy, and Paul. Not only did the trio of Greyhound super-supporters get to drink on Beard's dime, party in Bones & Honey, run the pool table on the Oxford fancy lads, cruise in a limo, and cavort on the pitch at Nelson Road to the strains of "We Are the Champions," but they (and we) finally received proof that they are actual people and not just fanboy spirits cursed to haunt the Crown & Anchor for eternity.

But seriously, folks: Beard won, with Hula-Hoop aficionados coming in a close second.

BEST SAVE

Darren, the self-actualized muscleman, for taking out James Tartt before he could put out Beard's lights with a lead pipe. The episode

marked the elder Tartt's last appearance in *Ted Lasso* outside of re-hab, where we glimpse him at the end of the series, including in a scene in the final montage rekindling his relationship with Jamie. I like to think it was Darren's knockout punch that finally convinced him to get his life together.

BEST ASSIST

OK, yes, the charming and definitely corporeal Baz, Jeremy, and Paul. The actors who play them—Adam Colborne, Bronson Webb, and Kevin Garry, respectively—had "no inkling" they were going to get their own big episode, Webb told me. "Jason and Brendan come on with Joe Kelly, and they were like, 'Lads, how about you're gonna go with Beard on a night out?'" The episode marked the first time the trio were seen outside the Crown & Anchor.

"When we heard that we were going to be leaving the pub, we were all very confused and shocked," Adam Colborne said. "What the hell would we do outside of the pub?" What followed was "two crazy weeks of us just being silly," Webb said, culminating with the triumphant nighttime frolic on the Hayes & Yeading pitch, where the show filmed its practice scenes. "The director's like, 'Just go around and, you know, do whatever lads do,'" Colborne, who is not a soccer player or fan, recalled. "I'm like, 'What does that mean? Kick a ball?' But they've done some amazing edits, where it looks like I've sunk the ball in the back of the net and all this stuff.

"It was a really special moment for me, Bronson, and KG," he said. "They just sort of sat with me after we finished the episode and we were like, 'This is big, guys, well done.' It was really nice."

BEST LINE

Beard on Vegas: "One night is good. Two nights is perfect. Three is too many." Correct!

RANDOM STATS:

- The pub lads are routinely seen outside the pub at Richmond practices in season three. Webb said they had actually shot some scenes earlier in the series, before "Beard After Hours," in which they were kicked out of the Crown & Anchor for being obnoxious and resorted to watching matches through the pub's windows, but they weren't used in the end.

- By the way, Webb really did hit that no-look pool shot in Bones & Honey. Kelly, one of the episode writers, bet him £50 that he couldn't hit it, but he did on the third try. "It was just, like, epic, and behind the camera everyone just jumps up crazy," Webb said. "So it's all natural." (He said he never got the fifty quid, though.)

- Bones & Honey is a riff on Milk & Honey, the influential Manhattan bar credited with sparking the speakeasy and craft cocktail trends. It later opened a London location that was a private members' club, but it closed during the pandemic.

- When Beard impersonates the Irish former Oxford prof, he introduces himself as Declan Patrick Aloysius MacManus. That's the given name of Elvis Costello.

- In "Beard After Hours," we get a pensive version of the show's theme song from Jeff Tweedy, of Wilco. Sam Jones, the episode director, is best known for the Wilco documentary *I Am Trying to Break Your Heart*.

- Beard tells the lads: "Ted is a man, just a man," a *Jesus Christ Superstar* allusion. Other reference points include *Fight Club* during the elevator ride to the club and, with all the "Blue Moon," *An American Werewolf in London*, another Griffin Dunne flick.

- There was also a funny, tossed-off joke when the imaginary version of Gary Lineker described Richmond's loss as "a real David-versus-Goliath match, but where Goliath just curb-stomped David in the back of the skull like in that Ed Norton movie." Thierry Henry: "*Moonrise Kingdom*?" Lineker: "I think that's it, yeah."

- (For the record, the movie he was thinking of was *American History X*.)

- "Shut up, Thierry Henry!" gets funnier every time Beard says it.

- James Tartt's beatdown of the coach also strikes a note of ambiguity about soccer fandom, specifically the caustic, violent side that Jamie's dad represents. "I tell you what, lads, why don't we teach Coach here, in his magic trousers, exactly what football is all about?" he tells his buddies. "Because it doesn't happen on the pitch—it happens on the street." They then proceed to batter Beard to a moody rendition of "Blue Moon," the Man City anthem we hear throughout the episode.

- Give Tartt one thing: those glittery, star-spangled trousers *were* pretty magical.

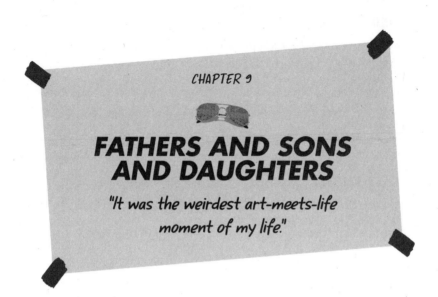

CHAPTER 9

FATHERS AND SONS AND DAUGHTERS

"It was the weirdest art-meets-life moment of my life."

For all its silliness and sports-movie uplift, Ted Lasso *is focused heavily on the external and internal patterns of abuse that keep people stuck and unhappy, and the various ways in which these patterns can be broken. The elemental, cyclical ways in which children are molded by their parents is suggested by the Philip Larkin poem Mae recites in season three, "This Be the Verse." The opening could be a subtitle for the show:*

> They fuck you up, your mum and dad.
> They may not mean to, but they do.

The Empire Strikes Back *season, fittingly, is particularly focused on the fraught ties between parents and their kids. (As Darth Tartt might put it: "Jamie, I am your drunk, mean father.") The back half of season two, in particular, contains some of the show's most powerful moments and scenes, beginning with Ted's panic attack on the sideline*

in the sixth episode, "The Signal." Inspired by his unresolved anxiety around his father's suicide and his own separation from his son, Ted's flight from the field reverberates throughout the season and beyond as the engine of Nate's betrayal of his own father figure, Ted, and the rest of AFC Richmond. But for the members of the team, the episode is most memorable for an improbable act of football heroism on set: Jamie Tartt scoring on an impossibly long free kick in a match. The heroic part is that Phil Dunster actually nailed the goal himself.

Phil Dunster, Jamie Tartt, seasons 1–3: You might be able to see me squeezing my eyes and praying whilst I do it. It was one of those moments where I was like, God, that was a good time to have a fluke.

Moe Jeudy-Lamour, Thierry Zoreaux, seasons 1–3: I'm supposed to be in the goal but, you know, movie magic—if we're filming it this way and I'm behind the camera, I'm probably in my trailer sleeping. But this time I was on the pitch and I was like, OK, let me see if he's actually going to hit this. So I was standing at the monitors and I could see it live, and he just does the whole thing, backs up. And I was like, Yeah, we'll see.

Phil Dunster: For anyone who is familiar with the Cristiano Ronaldo free-kick canon, there is his famous free kick from about forty-five yards out in the semifinal of the Champions League. It is one of the biggest domestic football competitions, so you don't want to take too many chances, but Ronaldo took it upon himself to go, "No, I'll probably score this if I hit it as hard as I can." So I want to channel that, but obviously to actually do that you need to be Cristiano Ronaldo, and I am not. Hence the praying and the shutting of the eyes.

Pedro Romhanyi, soccer director, seasons 2–3: I never thought it would go anywhere near the goal.

Moe Jeudy-Lamour: He hit it on his first try, and I couldn't believe it.

Toheeb Jimoh, Sam Obisanya, seasons 1–3: That was the one time none of us had to act. It went in, and we were screaming.

Hannah Waddingham, Rebecca Welton, seasons 1–3: In shock.

Toheeb Jimoh: All of us running and mobbing him, none of us are acting—I didn't have a Nigerian accent. That was for real.

Brendan Hunt, creator, Coach Beard, seasons 1–3: Suddenly, they didn't have to act at all. Like, everyone was losing their fucking shit.

Kola Bokinni, Isaac McAdoo, seasons 1–3: I was ecstatic. Because the Man Citys and the Tottenhams that we play are made up of a bunch of semiprofessional footballers. They've all got their opinions about us actors playing football. So they were giving Phil a bit of lip as he was going to take the shot. Even the goalkeeper was like, "Yeah, I'm just gonna go fetch the ball out the bushes," or whatever. And then he did it, and their faces were just priceless.

Phil Dunster: There was a lot of, "Wait, did Phil do that? No, surely Phil didn't do that."

Pedro Romhanyi: I mean, it shouldn't have gone in.

Brendan Hunt: Sure, the goalie is not exactly doing his best there, but, I mean, it's just fucking impressive.

Some on set advocated for the episode to include the uncut long shot of Dunster's instantly legendary kick, but the creators ultimately went with an edited sequence seen from multiple angles. But Hunt documented the kick for history, filming a monitor screen of the take with his phone and posting it on Twitter.

Brendan Hunt: I just knew it had to be recorded for posterity.

Phil Dunster: I don't let anybody forget it. I forced Brendan to put that on Twitter. I said, "People need to know, man, people need to know."

Brendan Hunt: Not a lot of guys can do that, especially someone

who does not have to do that because he's just an actor. But he's not just an actor. He's also a damn fine footballer, and it was one of the coolest moments of the season.

Dunster was also at the center of the eighth episode, "Man City," though for far less triumphant reasons. The episode saw AFC Richmond play at Wembley Stadium in an FA Cup semifinal against fearsome Manchester City, the club Jamie Tartt previously left partly to get away from his abusive father, a rabid fan of the team. Though Jamie supplies tickets for his father and his drunken mates to see the match, the elder James Tartt, played by Kieran O'Brien, still comes down to the Richmond locker room to gloat after the Man City victory.

Toxic masculinity and the powerful, occasionally destructive bonds between fathers and sons are key themes of Ted Lasso, with Ted, Nate, and Jamie, among others, shaped harshly by their relationships with their dads. "Fathers and sons, so tricky," Higgins says in the episode—which, again, is titled "Man City"—when Jamie asks him for match tickets. "They should really write songs about it." ("Think they do," Jamie replies.)

We initially hear about Jamie's dad in the first season, when Jamie mentions that he wanted to avoid emulating him. In the season one finale, we glimpse him berating Jamie for making an extra pass, that Ted obsession, to set up the winning goal. (James and Ted are the devil and angel on Jamie's shoulders.) So when Jamie's dad comes down to mock his son and the team in season two, the only thing left to do is what Jamie does: punch him in the face. But however satisfying it was for viewers to watch the elder Tartt hit the deck and then get bounced by Beard, it is less so for Jamie, who collapses crying into Roy's arms, revealing the depth of his torment.

Brendan Hunt: We had a lot of looks at mental health this season, but we were kind of setting that up before, even if we didn't

always know that for sure. And there's a lot of stuff about bad dads, and that's been happening from the beginning as well.

Phil Dunster: It's Jamie's biggest moment in the season and, arguably, the show. Kieran was sort of this wind-up toy that just never stopped. He was just bouncing off the walls the whole time and he made it a lot easier, and he did it in season one. It's really hard to just lock your wheels into the tracks and make an impact like that. And he did that in such a way that he found this sort of weird paternal thing with me, so that when he started pushing me around in the scene, he made it a lot more straightforward.

Juno Temple, Keeley Jones, seasons 1–3: That brief moment you see Roy and Jamie have at the end, I was destroyed by that.

James Lance, Trent Crimm, seasons 1–3: It was amazing that Roy is the guy that gives the hug when it's most needed.

Brett Goldstein, writer, Roy Kent, seasons 1–3: When we shot that scene it was so intense, and the whole team was in it. A few people were crying in rehearsal. It was so heavy, and the scene we'd done before was, like, a wacky, wild, funny-funny scene. I was standing with Jason and at one point he went, "This is a weird show, innit?"

Toheeb Jimoh: Me and Moe Hashim, who plays Bumbercatch on the show, were fasting at the time. So when the scene started, I just couldn't wait to eat. Then by the end of it [a producer] was there like, "You guys can come have a snack," but there was a sense in the room of: We are in it. Like, we're carrying it, we were all there as a team. Nobody's leaving this room. We're just gonna sit here and hold this moment together.

Brett Goldstein: That scene was so serious. I think it was the only scene I've had with Phil Dunster where I didn't laugh, in the history of *Ted Lasso.*

Jamie's pain and Roy's support in turn inspires Ted to share his

biggest revelation of the series, when he calls Dr. Sharon to tell her his own father committed suicide when he was sixteen. The reveal infuses past moments from the show, like the darts scene and Ted's interactions with his son, with new emotional context even as Ted suspects that he's repeating his father's flight from responsibility.

Jason Sudeikis, creator, Ted Lasso, seasons 1–3: That's mostly a confession scene, where he's saying this thing out loud. I feel like there's a great deal of regret there, but also this profound release. He just was like, "Fuck it, I just watched real pain, I just watched this whole Jamie thing with his father, and Roy hugging Jamie, and I couldn't move. I could only run away, like I feel like my dad did. So now I gotta show up at the gates of heaven and the only person there is Dr. Sharon. I'm gonna dump it all out and say, 'Please let me go back. I want to go back.'" All that kind of shit could probably make me cry now if I would think about it.

The "Man City" episode is significant for yet another reason: it marks the beginning of Sam's relationship with Rebecca after the two have shared plenty of back-and-forth over a dating app, Bantr, with neither realizing whom they are talking to. (Bantr, it should be noted, becomes the team's primary sponsor thanks to Sam's protest of Dubai Air.) While there were subtle hints planted in the first season, only the most eagle-eyed viewer would have intuited that a Sam-Rebecca romance was in the offing. (Unless, perhaps, they caught the Cheers *connection embedded in their names.) When the show did finally pair them off, most viewers were shocked, some unpleasantly so. The actors themselves didn't really see it coming either.*

Toheeb Jimoh: Jason only gave you the pieces of information you really needed to do the job. "This is where Sam is right now, and this is the progression." He was already sowing the seeds for Sam and Rebecca in season one. We never really had that conversation

because at that point Sam isn't thinking, Oh, this is somebody that I'm going to maybe strike a romance with. They just kind of connect with each other, and they have chemistry, and that's enough and that's what it needs to be.

Hannah Waddingham: I actually found, if I'm perfectly honest, the first third of filming [of season two] quite difficult, because I had so much wanted to honor men and women in the middle of their lives being thrust into a place that they never thought they would have to dig themselves out of. So it's quite brilliant, really, because I was uncomfortable doing all the dating app stuff, because I didn't want to insult anyone who's going through that and those choices. I felt it was good that I was uncomfortable doing it, because then that adds a little element of it for Rebecca.

Toheeb Jimoh: I thought the storyline was a really cool twist, and it was really fun to explore this side of Sam. Because we went from a shy kid who had just come to a new country and was just trying to figure himself out on this team, and suddenly he gained the maturity and the integrity to have the balls to like the boss. So yeah, it was a fun arc.

Hannah Waddingham: I loved that Sam was more cool than Rebecca. It starts in that moment in the restaurant when he goes, "Well, you know, we both got to eat." And she's like, "I am hungry . . ."

Toheeb Jimoh: Whenever they have interactions, at the heart of it will [be] that connection between them. Ultimately it's just about them wanting each other to be the best versions of themselves.

Of course it's not only sons who struggle with daddy issues. In the season's tenth episode, "No Weddings and a Funeral," Rebecca learns that her father has died and must reckon with her own complex feelings about him. The episode opens with Hannah's mother, Deborah (played by the great Harriet Walter), dropping by Rebecca's flat one morning to find her and Sam underdressed and aglow, and then she breaks the

news. The forty or so minutes that follow amount to another emotional roller coaster: Ted has another panic attack while he's getting ready and seeks out Dr. Sharon; the entire team comes to the church for the service to share their sympathies and support the boss; Rebecca meets Rupert's new baby with Bex; Rebecca reveals her affair with Sam to Keeley and Sassy, and they and Deborah all cackle inappropriately in the church's vestry; and Rebecca gets through her eulogy by Rickrolling the congregation, singing Rick Astley's "Never Gonna Give You Up" with the assembled singing it back to her in support.

Hannah Waddingham: When Jason first said that I was going to be doing Rick Astley's "Never Gonna Give You Up" as Rebecca's father's eulogy, I was a bit like, What are you doing to me, Sudeikis? He'd already done it to me in season one with "Let It Go."

Brendan Hunt: There was a list of "Hey, what's a list of a bunch of dumb songs?" And we all submitted a list of, like, ten dumb songs. I think "Never Gonna Give You Up" was a placeholder that stuck, and worked out amazingly.

Jane Becker, writer, seasons 1–3: I will say that in my original draft, we were going to have Rebecca sing "Hey Ya" by Outkast during the eulogy because that is my mom's favorite song. It got changed to "Never Gonna Give You Up" during the rewrite, which was the right move.

Jason Sudeikis: Then I asked Hannah, "Can you feel through this song?"

Hannah Waddingham: He left it with me for a while, and then about three weeks after he'd given it to me he went, "Right, do what you want with it." And I was like, "You are not changing this now." Besides, I'd broken it down so much in my head and played with the rhythm so that it suited what she wanted to say. Because in my head it is a love letter to her mother. It's her mother's favorite song, and

it's also what she wants to say to her about how Rebecca feels about her father.

Brett Goldstein: When we did the funeral and Hannah did the speech-song, she did that all day and from the very first rehearsal, we're all crying. Like, every time. It's fucking amazing. And there was more than just the team—there's, like, two hundred extras. It's like putting on a play every night, but three hundred times that day.

Toheeb Jimoh: When we're all together as a group, we are a rowdy bunch, especially the players. So it's a testament to how powerful that scene was and how incredible that performance was, because in that church you can hear a pin drop the entire day. Every single one of us plus a million supporting artists were tuned in. The grips, the camerapeople, the makeup team, costume—everybody on set that day was 100 percent.

Jane Becker: Hannah delivered and brought it all to life in a way I never could have imagined. It was so beautiful that it's hard to explain.

Anthony Head, Rupert Mannion, seasons 1–3: The funeral [is my favorite episode]: brilliantly written and wonderfully directed. My favorite moments: Rebecca and the ladies screaming with laughter in the vestry and the intercutting between Rebecca and her mum and Ted with Dr. Sharon Fieldstone. I got to work with so many of the cast and, again, the writing was just wonderful.

Hannah Waddingham: What most people don't know is that on that very day, my own father was having emergency quintuple open-heart surgery. The day it was happening—because I'd said my goodbye to my own dad in real life, just in case—was the day I was standing in front of the coffin giving the eulogy. I will never forget that, and the reason I won't forget it is because of [my costars] looking up at me going, "Come on, girl. Come on, come on . . ." It was the weirdest art-meets-life moment of my life. And in a way, I'm glad that

I had that as a release that day. Harriet Walter kept saying to me, "I don't know how you're doing this." And I was saying, "I feel like this has been sent to me today to allow me to grieve."

In the scene, Rebecca begins singing the song and falters slightly. Then Ted, who has arrived late after working through some of his anxiety around his own father's death with Dr. Sharon, picks up the lyric. Others join in gradually until "Never Gonna Give You Up" is being performed in a call-and-response that, in a quintessential Ted Lasso mash-up, transmogrifies the inherent comedy of the song—one of the internet's oldest pranks—into a poignant symbol of dramatic emotional support.

Hannah Waddingham: Myself and Jason had done quite a bit of tweaking on the scene. Even if she is singing because she can't speak, I don't believe anybody could sing an entire song. Being a singer myself, I don't think that would happen. He said, "Well, how do you see it going?" And I went, "I think her new family"—which she's now really realizing they are and accepting them into her bloodstream—"I think her new family would help her out." And he went, "OK, who would be first?" And I went, "You. Ted would be first. Then it would be Keeley and then her new love, her new family member, Sam." And he went, "OK, that's what we'll do."

And as usual, mine and her lives jumble along together. The funeral episode I was like, I swear to God, these people have got bloody cameras in my house. It was the greatest thing I think I've ever been given to get my teeth into.

Even amid all the warm feelings, there's a glimpse of the upheaval on the horizon. In a quick moment after the service, we see Rupert pull Nate aside outside the church for a quick word. "At the end of season two, when I was going to be seen to be working on bringing Nate on board, Jason told me confidentially that it was Palpatine, the emperor in Star Wars, turning Anakin Skywalker into Darth Vader," Head said.

"I whispered in Nate's ear at the end of the episode, and I asked Jason to give me a line of Palpatine's to say, which no one else would hear—such fun."

Sure enough, the end of season two is true to the guiding spirit of The Empire Strikes Back, *with heroes facing the Dark Side, alliances coming apart, and, as Sudeikis promised, viewers left with more questions than answers. Nate is finally consumed by his own bitterness, tearing up the hallowed* BELIEVE *sign and decamping for Rupert's new club, West Ham United. Sam resists an overture from the wealthy owner of an African football team, played hilariously by Sam Richardson, and opts to stay in England, but tacitly lets Rebecca know that they are done in a romantic sense. Keeley's surging career is set to take her away from both AFC Richmond and Roy, whose own inner turmoil convinces him that Keeley would be better off without him.*

And also like with The Empire Strikes Back, *it would be a long time before viewers got resolution to those questions. Season two premiered in July 2021, amid the growing surge of* Ted Lasso *excitement, acclaim, and awards. The premiere episode (RIP Earl) dropped ten days after the first season's historic Emmy nomination haul, and* Ted Lasso *was the talk of TV for months, each successive episode fueling the hoopla. The season ran through the late summer and early fall, through the show's triumphant first Emmy night and wrapping up a few weeks before Sudeikis returned to host* Saturday Night Live.

And then . . . 2022 would come and go without any new Ted Lasso *or word about when it would return. Which isn't to imply the year was uneventful in Lassoland. The second season went on to match the first in Emmy nominations, bringing in another twenty in July 2022, and at the September awards ceremony Team Lasso found itself sharing space with fellow top dog* Succession, *TV's reigning best drama.*

Jason Sudeikis: That was a fun table at the Emmys. It was me,

Juno, Hannah, and Brett, and then Brian Cox and his wife and Jeremy Strong and his wife were at the table, too. It reminds me of how my generation at *SNL* came up with all the folks from the American *Office* and *Mad Men*—I always loved when you find yourself at press events with people from other shows who are just getting started, too, and there's a camaraderie and a kinship there. You can all be one another's straight men, like, "This is silly, right? This is crazy?" It always helps when you enjoy each other's show and work as much as the company.

Ted Lasso won four awards in the September ceremony, including repeat wins for best supporting actor for Goldstein, lead actor for Sudeikis, and best comedy for the series. The former surprise hit was now TV's indisputable comedy champion. In his acceptance speech after the show won the big prize, Sudeikis thanked the cast, crew, production office workers, postproduction folks, and, perhaps most important, the COVID marshals who, yes, ruined the occasional take but were also largely responsible for keeping the production on track during lockdown. "Our COVID squad in season two was huge," Sudeikis said from the stage, surrounded by a very merry swarm of his Lasso colleagues. "We didn't have a single shutdown, and that was a lot because of what you men and women did for us.

"This show is about good and evil. This show is about, like, the truth and lies," Sudeikis told the assembled famous people and millions of viewers watching from home. "This show is about all that stuff, but it's mostly about our response to those things. And your response to our show has been overwhelming."

But if fans were hoping for a hint about when they'd be getting more of said show, they were out of luck.

"We'll see you for season three," Sudeikis said as the music began to play him off. "At some point."

"INVERTING THE PYRAMID
OF SUCCESS"

Season 2, Episode 12
Written by: Jason Sudeikis and Joe Kelly
Directed by: Declan Lowney

"A good mentor hopes you will move on. A great mentor knows you will."

That is Higgins in the season two finale, trying to make Keeley feel better about leaving AFC Richmond and more important, Rebecca, to start her own public relations firm. "Ooh, I like that!" Keeley replies.

"Yeah," Higgins says, impressed with himself. "I just made it up!"

He might have come up with it himself, but one of the core ideas of *Ted Lasso* is that none of us do much on our own, whether you're talking about a job, a personal struggle, or just getting through the day. The importance of mentors, specifically, is a notion the show keeps returning to: it's about a coach, for one thing, and multiple characters forging relationships built on nurturing and personal growth. The idea was baked into the concept of the show before it

even *was* a show—in the beginning, Jason Sudeikis asked prospective writers about their own personal mentors and heroes, the people who showed them they could do and be more than they thought possible and then helped them get there. The writers drew on those experiences as they crafted the show.

In the season two finale, there is lots of mentoring and moving on, and it isn't always pleasant. The episode title, "Inverting the Pyramid of Success," refers to one of the twentieth century's preeminent mentors: John Wooden, the longtime coach of the UCLA men's basketball team—arguably the most successful program in NCAA history—and an oft-cited mentor of legends like Kareem Abdul-Jabbar and Bill Walton. The episode opens on Nate staring at a diagram of Wooden's famous pyramid of success—an ascending catalog of the qualities and values that make accomplishment and meaningful life possible—and Ted will later channel the man during training.

"To quote the great UCLA college basketball coach John Obi-Wan Gandalf: it is our choices, gentlemen, that show what we truly are far more than our abilities," Ted says.

The episode title is actually a mash-up of Wooden and the seminal book of soccer tactics, *Inverting the Pyramid,* which we see Beard reading early on. But Nate will in fact flip over Wooden's pyramid, which has a foundation of concepts like friendship, cooperation, and loyalty, when he lashes out at Ted and ditches the team as his demons get the better of him. (Said demons are closely linked to Nate's dysfunctional relationship with his father; paternal relationships, of course, ideally amount to one of the deepest forms of nurturing mentorship and, as mentioned, are another *Ted Lasso* preoccupation.) While Ted, exceptional mentor that he is, must have known Nate the Great would leave someday, per the quotable Higgins, he must have hoped it would go better than it did.

Nate's flight to (eventually) West Ham United is the most dramatic departure in an episode that, despite being a season finale, feels pretty transitional as it sets up the show's endgame (for now, at least). AFC Richmond's epic tie in the final match of the season—soccer being one of the few environments in which an "epic tie" is a thing—returns the club to the Premier League and is a jolly climax for everyone except the architect of the result, which was achieved using Nate's tactics. But season two as a whole is oriented more around individual personal journeys than team ones, and in the finale, we see several of these resolve in surprising ways.

Ted's private struggle with his anxiety goes public after Nate reveals to Trent Crimm that Ted left the field during a match because of a panic attack not a stomach bug, the original explanation. The exposé kicks off a flurry of tabloid headlines—my favorite: "Panic at the Lasso"—but, Richmond being Richmond, everyone has his back. Sam decides to pass on Edwin Akufo's offer to anchor an African superteam, which goes over well. Actor Sam Richardson made a meal of Akufo's resulting tantrum, which includes lots of creative cursing and threats and at least one mannequin-choking. But Sam also makes clear to Rebecca that he isn't staying for her. When Ted asks why he turned down Akufo's offer, Sam says, "I wish I could say it was because of my feelings for you. But the truth is, I think I need to stop worrying about how others feel about me. I'm staying because it's what's best for me and my personal journey." (Ted, after he leaves: "You know, I think he might have been talking to you when he was looking at me. . . ." Rebecca: "Yes, I know that, Ted.") In the season's final shot of Sam, we see him settling the lease on what will become his Nigerian restaurant in season three.

Jamie, who told Keeley he still loved her in the funeral episode, finally objectively embraces maturity by owning up and apologizing

to Roy for it—the decency of the mea culpa enrages Roy as much as anything else. "Instead of beating him to death I fucking forgave him," he says later. "I'm still fucking furious about it!" The act, like Roy's embrace of Jamie in "Man City," sets up the mentoring friendship that will flourish between them in season three. Jamie also helps Dani reembrace his old "Football is life" élan by handing him the crucial penalty kick. While this is ridiculous from a professional soccer standpoint, Dani's goal paired with a shot of the adorable Macy Greyhound, the new mascot, puts a bow on the season's canicide opener. Dr. Sharon leaves without saying goodbye. Even Trent Crimm has a turning point, when he is fired from *The Independent* for telling Ted that his anonymous source was Nate. (For the record, this is astounding journalistic malpractice and hard to square with Trent's well-established professionalism. But this is also a TV show.)

However, the sweet counterpoint to Nate's bitter departure is a mentorship gone right: Rebecca and Keeley. Keeley so quickly became enmeshed in the Richmond day-to-day, it's easy to forget she arrived in the story as Jamie's model girlfriend, a woman who was "sort of famous for being famous," as she once told Rebecca, and was rarely asked to do much beyond look pretty in front of a camera. But she wanted more. And unlike many TV and movie characters who arrive as the girlfriend of another character, Keeley eventually does get to do much more. Her trajectory from pretty face to high-achieving businesswoman is one of the signature arcs of *Ted Lasso*. "What is interesting about Keeley is how nervous she is to be taken seriously," Juno Temple told the actor Dan Fogler on his podcast in 2022. "Because she hasn't taken herself seriously before, really."

Keeley was loosely based on Keeley Hazell, a former pinup, who played Bex, Rupert's young wife, and became a writer on *Ted Lasso* in season three. (She also wrote a memoir, released in 2024, with the

comically blunt title: *Everyone's Seen My Tits*.) But Keeley Jones's story, particularly the insecurity she felt in the early going, is also based on Sudeikis's experience as a young, up-and-coming performer in a way that links her to the very inception of *Ted Lasso*. "When you get the opportunity to work at a place like *Saturday Night Live*, people on the business side of things are champing at the bit to work with you because, lo and behold, you might turn into the next Mike Myers or Adam Sandler or Tina Fey," he told me in 2021. He continued:

> So they also put you in a box and you can sometimes allow yourself to stay in that box, that box being, "Oh, they're a comedian, they do comedy." And yet you look at Tina's work and Mike Myers's work, Adam Sandler—those exact same people's work—and know that they're more than that. And so the Keeley character, while inspired by a friend of mine, is also as much about my journey of realizing, Oh, I might have more to give than just jokes. And more importantly, I might want to.

In Rebecca, who hired her to run Richmond's publicity and marketing, Keeley found a woman who could both serve as a model of professionalism and leadership in a mostly man's world (pro sports) and infuse her with the most crucial thing for someone aiming for new heights: the belief that you can actually do it. "It's Rebecca mentoring her, being like, 'What's your Plan B? What do you do for a living?'" Sudeikis said. "That is a speech that a mentor would, could, and should give me. When I had imposter syndrome of being a writer—I'd only been an actor, an improviser, then hired as a writer at *SNL*—it was my then hero, eventual mentor, then coworker, then friend Tina Fey, who was like, 'Hey, if you can improvise, you can

write.' And that was the antidote that I needed to get over that syndrome of being an imposter."

At the same time, Keeley's emotional intelligence and effervescent embrace of life showed Rebecca a path forward, post-Rupert. And in openly admiring Rebecca and looking to her as an exemplar of excellence and poise, Keeley helped to show Rebecca her own self-worth. Their bond soon deepened into something that is all too rare on television: a rich, mutually supportive friendship between two women, one that paralleled the real bond Hannah Waddingham and Temple felt from the earliest days of *Ted Lasso.*

"It reflects me and Juno," Waddingham told the Television Academy in 2022. "We are each other's yin and yang, absolutely."

Temple and Waddingham didn't know each other before being cast on the series. They quickly rectified that, however, encountering each other in the ladies' room just before the first script read-through and immediately hitting it off. "We had a moment where we connected with each other," Temple told Shondaland in 2021, "and the rest was history."

While neither knew exactly where the story was going, both recognized early on that the relationship between their characters was special. Television has certainly had its share of nurturing, anchoring female friendships, in shows like *Sex and the City, Girlfriends, Girls,* and others. But as suggested by some of those titles, the friendships are the entire point, or at least the centers of series that are explicitly told from a female perspective.

Less common is such a relationship within a milieu as testosterone-laden as a men's professional sports franchise. "That is so precious to

me and Juno," Waddingham told *Entertainment Weekly* in 2022. "That separate little family." And while the aforementioned shows derived plenty of story from shifting alliances and internal conflicts and rivalries—which, to be fair, are familiar to anyone who has ever had a friend—and plenty of bonding over the characters' relationships with men, Rebecca and Keeley invariably had each other's backs once their friendship solidified, and spent more time on professional and personal growth. The characters' bond first begins to take shape and deepen in "Make Rebecca Great Again," the Liverpool karaoke panic-attack extravaganza that also sees Keeley and Sassy, Rebecca's irreverent childhood buddy (played by Ellie Taylor), help Rebecca through her first postdivorce wedding anniversary. Even when an older, closer pal of Rebecca's arrives on the scene, Keeley reacts with excitement and affection rather than insecurity and competitiveness. "When Sassy and Keeley meet, we both presumed that there would be some friction there, because you're so used to it in everything that we see, all the time," Waddingham said in a 2022 panel discussion. "And when she's immediately like, 'Oh my god, you're amazing,' that was just so gorgeous for us."

Declan Lowney, the director of "Inverting the Pyramid of Success," also directed "Make Rebecca Great Again"—which was his first *Ted Lasso* installment, though he would go on to oversee more episodes than any other director. While that episode didn't come until midway through the first season, Lowney had been in communication with the creators earlier in the show's development, and he told me he had envisioned other actors for the role of Rebecca and Keeley. "I didn't know Hannah and I didn't know Juno, but one of the first things I shot was the two of them together when they're planning to go to the game, and they're talking about going on the plane," Lowney recalled. "The dynamic between the two girls was fantastic, and I loved it.

"They ended up spending an awful lot of time together and their friendship is very, very real," he added. "What you see on-screen is very much what they're like off the screen."

Like Rebecca and Keeley, Waddingham and Temple took dramatically different paths to "AFC Richmond." Waddingham was a showstopping singer, theater veteran, and mother more than a decade older than Temple, the daughter of an experimental filmmaker, who began acting on-screen as a child. But both had been around long enough to have had their fill of Hollywood's tendency to pit women against one another. Sudeikis has talked plenty about how *Ted Lasso* embraces the "divine feminine," or those more open, cooperative qualities of the human spirit like vulnerability, emotional sensitivity, and sublimation of self-interest in the name of the greater good. But Waddingham and Temple stress that while their on-screen relationship is based on unconditional support, a big part of what makes it authentic is the way their characters hold each other accountable. In a 2022 panel discussion, they discussed why tough love is such a key element. "It's been so gorgeous to actually play two women that are different but at the same time go through some of the same pain," Temple said. "And some very different pains, but really truly support each other through and call each other out on each other's shit as well. It's a real friendship."

"That's the biggest thing, I think: calling each other out," Waddingham said. "People don't actually ever focus on the fact that women can call each other out and still love each other deeply and push the other one forward."

Of their off-screen friendship, Temple said it was "one of the greatest gifts that can happen in this mad industry."

"I actually don't really know what to say about it anymore," Waddingham said. "Because it's so in there for good with us both."

Keeley's revelation that she's leaving to start her own firm proves to be a warm moment with the expected volume of tears. She thanks Rebecca for helping "this panda turn into a lion," a callback to the second episode of *Ted Lasso*. Rebecca gives Keeley some guidance that's sweet in the moment but in retrospect, maybe isn't the best. "A bit of advice for being the boss," she says tearfully. "Hire your best friend."

Season three reveals the flaw in that plan when Keeley impulsively hires her twittish former pal Shandy, who's a disaster for Keeley's company and arguably for the show, too. At the same time, Rebecca backslides into acrimony and her own impulsiveness, driven by her competitiveness with Rupert and his newly purchased football club, West Ham. It's easy to conclude that Rebecca and Keeley miss each other's stabilizing influence, and again, the show suffers from their separation as well. But whatever the creators' intentions, Keeley's and Rebecca's respective flailings offer a good reminder that progress and growth is never a straight line. Eventually Keeley learns from mistakes like hiring Shandy, and her empathy and emotional intelligence allow her to succeed where she initially failed, like in making inroads with her taciturn chief finance officer, Barbara (played by Katy Wix). "I really loved that there was this relationship that developed between Keeley and Barbara," Temple said in a 2023 panel discussion. "She really had to at times think, What would Rebecca Welton do, and how would she handle this with grace?" When Keeley's funding is later pulled and—who else?—Rebecca backs the firm herself, Barbara and Keeley become partners. At the same time, Rebecca is able to free herself from the hold Rupert still had on her emotions and, with Keeley's help, understand that being herself is its own impressive achievement.

People try, people fail, people try again. Hopefully things get better over time, but there are no guarantees, which is one reason it's so important to have people in your life to help you along.

Higgins was right: a great mentor knows that one day you'll move on. But a great mentor also remains in your life after you do, flawed in their way like everyone else but uniquely committed to helping you accept your own imperfections and keep moving forward. They're the ones who understand, even before you do, that you've got this.

WHO WON THE EPISODE?

This is a tough one, because nearly all of the characters were lifted by the elation of Richmond's promotion while also experiencing at least some loss. (Roy and Keeley were on the way out; Ted lost Nate; Nate abandoned the team, losing his own bearings in the process; Rebecca had Keeley leave as well as Sam, although both left kindly.) So let's give it to Sam, who realized his proper place in the world (Richmond, for now, at least), scored a nice goal in the big match, recommitted himself to his personal journey, and hatched a plan to open his own restaurant. Quite a week!

BEST ASSIST

Jamie giving Dani the crucial penalty kick in the promotion match. As I suggested earlier, this is an indefensible decision from a competitive standpoint. As the announcers note, Jamie hasn't missed a penalty all season and Dani hasn't attempted one since he sent poor Earl to the big dog track in the sky in the season premiere. A make-or-break match is no time for immersion therapy. But when Dani is back in "Football is life" mode, we all win.

BEST SAVE

Rupert. Hear me out: *Ted Lasso* has a villain-sized hole in it for much of season two, so when Rupert buys West Ham United in order to compete directly with Richmond—revealing that he gave Rebecca his remaining shares in the club out of cunning, not kindness—it restores some order to the universe. "You know, I'm actually quite reassured to find out that he is still just a selfish, conniving cock," Rebecca says. So am I, Rebecca. So am I.

BEST LINE

Roy, talking about being left out of the *Vanity Fair* photo spread with Keeley: "It hurt my feeling."

RANDOM STATS

- Toheeb Jimoh had a hard time keeping it together throughout Sam Richardson's Akufo freakout. "I laughed my way through that rant every single time," he said on the *Peanut Butter and Biscuits* podcast in 2022.

- A final straw for Nate is the fact that he is apparently such a romantic non-threat, Roy doesn't even care that he made a pass at Keeley. "I deserve to be headbutted!" he says. "I'd be happy to headbutt you, Nate," Beard replies. It is both a reference to Nate's betrayal of Ted and also a bit of foreshadowing to the season three scene in which Beard forgives him.

- The whole post-match celebration scene plays differently when you watch it considering that Nate is hiding under Ted's desk the whole time, as we learn in season three.

- Roy does headbutt his actual romantic rival, Jamie, during the on-field celebration of Richmond's big tie. Then he hugs him. It's

another *Major League* reference, a nod to the moment when, after Cleveland's playoff win, Corbin Bernsen's character punches Charlie Sheen's for sleeping with his wife and then celebrates with him. Remember, kids: sports and violence heal all slights!

- When Keeley marvels that Roy got actual printed airline tickets, he says he got them from his travel agent, Kathy: "She's old school." Sudeikis's mother is a travel agent named Kathy.

- In his postgame press conference, Ted starts by coming clean about his panic attacks. "I want to share with you all the truth about my recent struggles with anxiety," he begins, "and, well, my overall concern about the way we discuss and deal with mental health in athletics." It's the show's clearest statement of purpose in a season designed to emphasize the importance of therapy and attending to mental and emotional health, a focus that will eventually lead to *Ted Lasso* stars and creators being invited to the Biden White House to promote the importance of mental health care.

- Speaking of American presidents, they're known for going gray during their time in office. (Or the non-chemically-enhanced ones do, anyway.) But they have nothing on Nate, who, as we learn in the season's final scene, went from black to full silver in less than a year. Nick Mohammed had flecks of gray in his hair in season one, but they were painted out by makeup artists to make him seem more youthful. They did the opposite in season two, adding more and more gray incrementally until, by the end, he was in a full gray wig. "In the way bitterness, guilt, shame, and stress can often change someone's appearance, they thought it would be fun to track Nate's spiral in this way," Mohammed wrote in a Twitter post after the season finale. He elaborated in an interview with CinemaBlend in 2023. "I like to think that it's a bit of a cautionary tale," he said. "His gray hair is a constant reminder of what he did, really. Like, his act of betrayal is sort of living literally there with him in his head."

NEW SEASON, NEW STAKES

"They really wanted to go out with a bang."

The Ted Lasso *that returned to production in March 2022 was a differ-ent series from the one it had been for the previous two shoots. Season one had been filmed in obscurity and season two in lockdown, and both were written in a kind of vacuum of expectation and outside influ-ence. But by the time everyone reconvened to make the third season,* Ted Lasso *was plainly a smash hit, with a truckload of awards and a cast full of actors who were now bigger stars with bigger paychecks. According to* The Hollywood Reporter, *actors like Brett Goldstein were now making $150,000 an episode, with Jason Sudeikis making $1 million—and as performers who also wrote and produced, they were making even more overall. Nike had hopped aboard the* Ted Lasso *bandwagon, slapping its swoosh on a pricey new line of AFC Rich-mond gear. There were also millions of vocal fans with big expecta-tions, some of whom began traveling to Richmond to go on new* Ted

Lasso *location tours, try to catch a glimpse of Sudeikis and friends during filming, and have a few pints at the Prince's Head, the real pub that stands in for the Crown & Anchor. "I think the pub is probably doing very well," said Sue Lewis, film officer for Richmond-upon-Thames.*

From the beginning, Sudeikis had a three-season plan for the show, but that was before it became a global hit. "We were damn well sure it was going to be three seasons," cocreator Brendan Hunt told me in 2021. "But the math element of the formula we could never have calculated is the degree to which people dig the show. I think we've all been hit in the face by that." In the end, Sudeikis stuck to the original plan (at least for now), but the question of whether the third season would, in fact, be the final one hung over the show.

Filming on season three began later than planned and took months longer than for the first two seasons, stretching from March to November 2022, thanks to delays for rewrites. The episodes were notably longer—starting at around thirty minutes long in the first season, with a few creeping above forty in the second, and then none were shorter than forty-three in the third—and the soccer scenes were more complex. The story had many subplots to wrap up and also added new ones for Keeley, off running her new PR firm, and Nate, coaching at West Ham, and for previously minor characters like Colin and Trent Crimm. It all amounted to plenty to pull off in order to meet the show's self-imposed hard out of three seasons, with more pressure than ever before. But while people who worked on the production acknowledged that you could feel it on set, the creators insisted it wasn't a factor.

Jason Sudeikis, creator, Ted Lasso, seasons 1–3: If anything, [the pressure] provides kind of this hum. You're only hearing it because it's different than what you're used to or what you expect, and then it just becomes part of it. While I'm not taking for granted

people's enthusiasm for the show, it didn't dictate for me the storytelling that we were doing.

Brendan Hunt, creator, Coach Beard, seasons 1–3: This stuff about, did we feel pressure because people love the show and can we stick the landing—none of that is helpful to have in our minds. It was always about getting the story right.

Jason Sudeikis: I knew Ted had to go home. But there's a factor of other people's stories.

Brett Goldstein, writer, Roy Kent, seasons 1–3: Everything was bigger. It's a big season. It's quite epic, season three.

Sara Romanelli, assistant script supervisor and script supervisor, seasons 1–3: A lot of the crew did all three seasons. Season three, they stayed for the duration of the shoot even though it was longer. So there was something in knowing the way it was shot that didn't make it feel bigger, though you could feel that we had more money. What changed was the pressure. Season one, you could do anything you wanted whereas now it was maybe things had to be perfect, or as perfect as possible. There were expectations—obviously more on Jason, Brendan, and Joe [Kelly]. They had to figure out how to end this.

Declan Lowney, director, seasons 1–3: There was a bit of public attention, particularly in and around the town of Richmond, where we shot the outside of the pub and Ted's apartment and all that. Those had become landmarks by then—people would be turning up to look and would see the signs. We had to change the name to "Kansas" on all of our signs, but people figured it out.

Sara Romanelli: It's easy to spot. "Oh, someone is filming next to Richmond Green, hmm, who is it gonna be?" Obviously *Ted Lasso*. But people were usually quite respectful.

Brett Goldstein: It was certainly harder to film in Richmond than it had been the year before. Just people showing up. There were

a few times where it was like, "I think we're going to have to go. We can't be here anymore."

Bronson Webb, Jeremy Blumenthal, seasons 1–3: They've got pictures of us lads in the back of the pub. They've got a section for *Ted Lasso*.

Gareth Roberts, leader of the Richmond Council: The pub's the big one. Some of the local traders have been able to enter into licensing agreements with the crew and the production team so that they can sell *Ted Lasso* stuff—one of them's got a Ted cardboard cut-out in the window, and I think there's the opportunity, should you so wish, to have your photo taken with a cardboard cutout. But it is quite understated. You can imagine that other areas—this is going to sound terribly snobby, but then again we're talking about Richmond, so there we are—might have gone full knockoff market, with every shop *Ted Lasso* this and *Ted Lasso* that, and merch, merch, merch. We don't seem to get that quite so much. The people who are interested in the show and coming to visit, they're far more interested in the experience rather than, you know, a small stuffed Greyhound or something like that. It is much more understated. And I think that, to an extent, speaks to why they came to Richmond to do the filming: it has that very English reticence thing going on, which sort of chimes in well, I think.

Bronson Webb: Richmond is quite a posh area. If you were filming in Camden or Hackney or Brixton, I think we would have had a lot of people heckling and stuff. But filming in Richmond, I think more people were just intrigued by the show.

Brendan Hunt: When it first started, no one in England knew who we were at all and we could walk freely among them. Then shooting the second season was COVID, mostly, so we could still

kind of walk around. I decided for year three I was gonna live in Richmond, sure I could do so quite anonymously. "The UK isn't watching the show yet, and I want the pub on the show to be my local." Well, the UK had caught up to *Ted Lasso*, and I can no longer go to that pub. It's like if tourists go to Boston and go to the *Cheers* bar, and suddenly Cliff is there.

Bronson Webb: My sister lives in Australia. She popped over last year, and she wanted to go to the pub and I was like, "All right, fine. We'll go down there." Whilst I was in there, funny enough, no one really noticed I was in there getting a pint. The whole pub was talking about *Ted Lasso*, it's crazy. And then we went outside and I was heckled quite a lot, did the load of autographs. I think they thought I was coming down just to gloat on the show.

Declan Lowney: So you get a lot of that, but there was no sense of the cast getting cocky or getting big for their boots. An Irish thing, you'd say you "lose the run of yourself"—you get convinced of your own success. And I think that was because Jason's the star of the show, and he sets the tone for how people behave. He was never like that, and people realize you can't be like that.

Sara Romanelli: Some of the actors definitely had way more confidence in season three. They knew they had done a good job. But I don't think there was a big change of like, Oh, now you're on a Hollywood set and we cannot talk with people anymore.

Brett Goldstein: They're really good characters, you know what I mean? Characters like that don't come around so often, and I think everyone knows that. Hannah knows that. Juno knows. These are fucking great parts to play. So no one's like, Oh, fuck this, I've got to do it another year. It's like, Please.

Hannah Waddingham, Rebecca Welton, seasons 1–3: We're all

aware that we're in this beautiful, delicate jewelry box that we're never going to be able to replace. It's a full Greyhound little island, and we all treat it with precious, precious love.

Toheeb Jimoh, Sam Obisanya, seasons 1–3: The biggest thing is coming back to a bit of a freer set [with fewer COVID restrictions than in season two] where we aren't constantly being pushed apart, and we can just talk without having to be *this* far apart from each other. It's been such a crazy offseason; people were all over the place. So when we came back, it felt good to just all be in the same place, for once, being able to decompress together.

Declan Lowney: During COVID we couldn't go out socially or any of that stuff, so you only ever saw the actors in costume and made up. You come in at eight in the morning to rehearse—they've been in for an hour getting made up and you never see them out of it. We were finally able to do a bit of that in season three. So it was always a revelation to see how interesting and how sweet these people were when they're in their civvies, how different they were.

There were plenty of opportunities to do that as the shoot stretched on and on. Initially delayed for rewrites, production had to stop again in the summer for more writing. Bill Lawrence, a showrunner in the first two seasons, was back in Los Angeles working on other series, including Shrinking, the Apple TV+ grief-com he created with Goldstein and the star, Jason Segel. (Harrison Ford stole the show as an avuncular therapist mentor.) This meant that Sudeikis was pulled in more directions than ever before as he tried to bring his story to a satisfying conclusion.

Declan Lowney: I know initially they pushed a few weeks and once or twice during season three. They stopped to kind of catch up with themselves. Jason was running the show completely by season three. That's a hell of a commitment, and then you're performing every day as well.

Annette Badland, Mae Green, seasons 1–3: The writing, they weren't happy with what they had and wanted to improve it. So we took time out for them to work on that, which is a wonderful luxury. But it was important, and Apple allowed Jason and the writers to, in their eyes, improve what they had.

David Elsendoorn, Jan Maas, seasons 2–3: What I heard is that they really wanted to go out with a bang, and so they kept raising the bar.

Declan Lowney: Also, the episodes had gotten longer and you need more days to shoot.

Sara Romanelli: When we were shooting and I was looking at the footage that we had, I was like, These episodes are going to be three hours. They weren't, but we were shooting a lot.

Melissa McCoy, editor, seasons 1–3: We went thirty minutes to forty minutes, I think, by the end of season one, then, like, forty-two, an hour in season two. And then we were at forty, hour-plus in the third season.

A.J. Catoline, editor, seasons 1–3: It's not just about Ted Lasso; it's about these other amazing characters and their stories. So we see the scripts come in at, you know, forty-four, you know, almost fifty pages, and we know that that's going to be a long episode. Jason's not too concerned about the run time; he's concerned about the story.

Annette Badland: Jason, he couldn't leave it alone. He was still working right up to the last minute. You would be in a scene with him and although he was absolutely with you and connected, you just knew that huge brain was powerfully going, That lighting isn't right over there, and let's rewrite that line, it's not good enough. . . . Whatever. That process didn't stop until the very end.

Jason Sudeikis: There was just so much story to go through. So many stories and characters and connections that need to be tied up.

A September 2022 report from the news site Puck, citing unnamed insiders, said the shooting delays were frustrating members of the cast because it kept them from being able to work on other movies and shows. Members of the production team acknowledged that some plans had to change but pushed back on the idea that people were upset about it.

Sara Romanelli: The cast sometimes will talk. It's a big commitment, and it's not only the crew that had other things to do during the year. Everybody had to readjust, but in the end, I think everybody was happy to do it.

Brett Goldstein: Given the success of the show and the exposure of it and how it has launched so many people's careers, the fact that, on season three, everyone remained wonderful and grounded and hardworking and excellent is a real testament to these people. Because I know so many stories where that is not the case, where by season three everyone's falling apart and desperate, trying to sneak off to do films, and they're furious and all that shit. And it really is kind of special that everyone there fucking loves this thing and is incredibly grateful for what this thing is.

Hannah Waddingham: It is a very bloody happy ship.

Said ship was boarded early in season three by a rangy, mystical, prodigiously talented, avocado-farming soccer pirate. The most notable addition to the cast in the final season, at least in the early going, was Zava, a mercurial star based loosely on the similarly talented and tempestuous Swedish striker Zlatan Ibrahimović, who, like Zava, has made many clubs better but rarely stuck around for long. Zava was played by Maximilian Osinski, a very tall (6'4") actor whose performance is made more impressive by the fact that he is American and knew almost nothing about soccer before joining the show.

Maximilian Osinski, Zava, season 3: My parents immigrated

here from Poland in eighty-three, and I was born in Eisenstadt, Austria, in a refugee camp while they waited to get let in. I was about eight months old when I came to Chicago, and I was raised there in a kind of blue-collar, working-class neighborhood. My mom always pushed me into the arts—I did Saturday Polish school. I did piano. I got into Polish folk dancing when I was an early teen because my friends said there were a lot of girls. So I went off and did that, and for some reason I didn't meet any girls.

Theo Park, casting director: The writers had based [Zava] on Zlatan Ibrahimović, so that was super helpful. He had to be ideally of Eastern European descent—or at least be able to do that accent—and be very, very tall and also athletic and also be funny. I never thought we'd find this person. But when Max Osinski did his amazing audition, I felt huge relief. It was so coincidental because he happened to have moved to London with his wife and kid. I reached out to his American agent, and they said, "Oh, yeah, he's available. And guess what? He's living in London."

Maximilian Osinski: Toward the end of the pandemic, lockdowns were lifting and things are starting to get back to normal. Me and my wife were just sitting around in L.A. and [my wife] had this crazy idea. She was like, "Why don't we rent our house and just go to London for a couple months just for an adventure?" About a month into our stay, my manager called: "They want you to read for something." And I was like, "Sure, yeah, I'm available." But in my head I was like, "It's *Ted Lasso* season three. They can get anyone." About a week later, I got the appointment and I read the breakdown and it says, "World's greatest soccer player, any ethnicity, can be from anywhere in the world. Record this scene and then please record yourself demonstrating your soccer skills." I was just like, "I give up. That's not me. I play zero soccer." I started talking myself out of taping for it,

because I've seen the show and I've seen all these great actors like Cristo Fernández and Kola Bokinni and Phil Dunster in these wide shots playing really good soccer.

I called a friend of mine, because I was literally about to call my manager and say we should just pass. He was just like, "No, just show them what you got. Highlight your skills. You're Polish. You're in physical shape like a soccer player." So he talked me into it. With the help of my wife, we did this scene: I improvised a little bit in Polish, then we went out to the park across the street from our apartment, and I just started working out in character. Then we recorded some slow-motion soccer kicks and headbutts. I don't think that fooled anyone at the show, but I think that kind of bravado and confidence to the camera maybe is what caught their interest.

Brendan Hunt: To honor the lawyers, let's just be very clear: Zava is drawn from *any number* of eccentric diva types that have populated football. But yeah, there's a lot of Zlatan in there. We knew with Ted having to try to win the whole effin' thing this year, it was like, OK if that's really gonna happen, you've got to have a world-class player. We kind of already did Ronaldo with Jamie, to a degree, and Messi just fits in too well in any room. But oh, the old Zlatan sparks, those could fly around this room pretty well. And then Zava was where we ended up.

Maximilian Osinski: I trained as much as I could. I did all those kicks that Zava does in the wides. They only used a double for some close footwork and some super-wide shots if there was a long, complicated play to use—he was great. I tried to do as much as I could, and I have the receipts. I'm proud of that.

Cristo Fernández, Dani Rojas, seasons 1–3: Playing those scenes with Zava—Dani represents that inner child that we all have, and seeing Dani behaving like a kid when Zava was around was so much fun.

Maximilian Osinski: Zlatan's book was eye-opening to me because all the players on the teams he's worked for had nothing but amazing things to say about him. Who he was in the locker room was not how he presented to the press. Brendan Hunt told me something: "You know when Michael Jordan went off to play for the White Sox, right? He was part of their team. He rode the team bus. But his hotel was different because he was Michael Jordan." And that's kind of like the dynamic they wanted to capture in that show.

Jason Sudeikis: The example we would give is like if you've got a million dollars to make your small little indie movie, and then Tom Cruise says, "I want to do it." And then you're like, Wait, what? So that increases your budget, increases the eyeballs, gives you all this autonomy. But it's also now Tom Cruise—you got to worry about what he wants at craft services. It's a big darn deal when Tom Cruise says yes to your movie, or Cameron Diaz, or one of these titans of industry. So that's a little of what we're doing there with Zava. It's less of an influence of one specific person.

By season three, it was understood that Ted Lasso *begins and ends its seasons on shots of the character who has the most dramatic trajectory (Rebecca in season one, Nate in season two). So when the opening shot of season three is of Ted sadly preparing to put his son on a plane back home, it's yet another signal that we're entering the final run. (Later, Ted asks Beard, "You ever wonder why we're here?") But as Sudeikis said, the show still had plenty of story to get through.*

The early part of season three finds Richmond, picked by prognosticators to finish dead last and get relegated again, riding Zava on a winning streak that has the club near the top of the standings. Also there: West Ham United, newly owned by Rupert and coached by Nate, the Ted Lasso padawan Rupert brought over to the Dark Side.

Anthony Head, Rupert Mannion, seasons 1–3: When I was

shown Rupert's office, at the beginning of the third season, I was blown away—it gave the *Star Wars* reference more body. The design was brilliant, it was like something off the Death Star—the window, the chair with a headrest they built for it. You saw Rupert's desk up, up, up, at the top of those crazy stairs! Rupert ruled!

Brendan Hunt: OK, Rupert's going to buy another club. What club would Rupert buy? We decided that he wasn't quite rich enough to be an oil oligarch. So we knew Chelsea, Arsenal, anything in Manchester will be out of the question. And anyway, he would want to stay closer to home. Maybe the south? No, no, gotta be London. Process of elimination, West Ham was pretty quickly it.

Nate angrily picks up where he left off at the end of season two. In March 2023, right after the first episode premiered, Nick Mohammed tweeted a scene of Nate dressing down a reporter. "I distinctly remember receiving the first episode of Season 3 desperate to know if the writers were going to lay the foundation for Nate's possible redemption," he wrote. "Then I got to this scene and thought: oh heck!"

Nate would eventually come around. But it was another former bad boy whose redemption would be one of the most rewarding subplots of season three: Jamie Tartt (do-do do-do do-do). Jamie began Ted Lasso as a cocky hotshot and bully whose selfishness and nastiness were revealed, in the final moments of season one, to be related to his abusive father. Season two found him trying to do better and be more accountable for his actions. In season three, confronted by the arrival of a better player in Zava, he tries to make it work while also striving to improve himself on and off the field. "Jamie has learned his lessons in season one, he's put them into practice in season two, and in season three, he's living with the consequences of that," Dunster told me in 2023.

"In season one, in one of the first episodes, Ted says to Jamie, 'If

only you could see yourself as one in eleven rather than one in a million,'" he said. *"We really see that happen in season three."*

Phil Dunster, Jamie Tartt, seasons 1–3: Everyone thinks that they're the good guy in the story, right? Everybody believes that they're the hero. I think that in his own seemingly twisted way, Jamie was fulfilling his rise. From an actor's perspective, I had to go: I like this guy, I know exactly why it is that he's doing these things that he's doing. He's doing it because of the environment he's been in, because he was probably very young when he was found as a footballer, as a lot of footballers are. He's been told he's special, so of course he's gonna act that way.

Jason Sudeikis: Assholes don't know they're assholes. They think they're the star of their own movie; they think they're doing the right thing. When you have that opportunity to empathize with someone that has a disgusting view of the human experience, you play it with reckless abandon, like Phil did.

Phil Dunster: The thing that I love about that arc is that he's still the same person, but he's just choosing to make different decisions now. In season one, Dani Rojas has turned up and [Jamie] thinks that he needs to beat him in order to win. And then in season three, Zava turns up and he thinks that he needs to integrate Zava as one of the eleven to win. It's a perfect example of, he's the same person in the same scenario, but he makes a different decision.

I think it's through Keeley that he learned the most. Like any good relationship, both members know when to be the teacher and when to be the taught. And I think that Jamie learned through Keeley and then practice with Roy how to be the taught. I think there's a wonderful thing that happens where you learn to receive and listen and change.

Juno Temple, Keeley Jones, seasons 1–3: The belief that Keeley has in both Roy and Jamie, and the belief in their friendship and what they are going to give to each other to help find their own strength—Keeley wasn't going to force them. That was one of the storylines that I was so profoundly moved by and invested in this season: the friendship that blossomed between these two gentlemen and how much it brought out both of these characters. You saw different sides of them that I personally found very moving and also at times incredibly funny—"poopeh"—to watch.

A.J. Catoline: There was a great piece of improv when the team was down in the sewer [in the season three premiere] and Ted asked the team, "So what are we surrounded by down here?" And Jamie Tartt raises his hand and says, "Coach, we're surrounded by poopeh." That was something [Dunster] had come up with. I think he might have talked about it with Jason, but he did not tell the rest of the team. And I used Phil and Brett's two-shot close coverage, and Brett Goldstein is standing right next to him, and I used the take as long as I could before Brett just started cracking up at that, and then the whole cast just started laughing.

Phil Dunster: I think the line was "Coach, we're surrounded by poo." And I was next to Brett, and I just was trying to make him laugh as I always do. So it was basically just born out of being an idiot, really.

Brett Goldstein: People have been asking, Why was the shoot longer this season? I can tell you it was because of scenes of me and Jamie taking three times as long to film.

By "Sunflowers," the sixth episode of the season, Zava is gone, off to run his avocado farm (naturally), and Jamie is back as the leader of the team—not that we see any match action. The concept of the episode, written by Hunt, was Richmond traveling to play an international friendly (an exhibition match) against the legendary AFC Ajax,

a 5–0 drubbing for the Greyhounds that inspires Ted to suspend curfew to help the team get over the loss. But really it was an excuse for various characters to mess around in Amsterdam for a night and a love letter to arguably the founding city of Ted Lasso.

The episode is a compendium of wholesome activities in a city known for sin: Jamie teaches Roy how to ride a bicycle to the strains of "Raindrops Keep Fallin' on My Head," *à la* Butch Cassidy and the Sundance Kid; *Ted and Beard drink dud psychotropic tea but Ted still hallucinates his way into reinventing Total Football, an old Dutch style of play; Higgins takes* Will the kitman *to see jazz; and—in one of the* Ted Lasso*–est scenes in all of* Ted Lasso*—the rest of the team has a big, bonding pillow fight, a callback to a past Ted remark. Even Rebecca's impromptu evening (and foot massage) with a handsome stranger after she falls into a canal is relatively chaste. (Her mystery man was played by Matteo van der Grijn, a Dutch actor who is well known in the Netherlands.) At the end of the hour-plus episode, the show's longest to that point, Beard returns in the guise of early 1970s David Bowie with a pig nose strapped to his face.*

"Wait, let me guess," Ted says. "Piggy Stardust."

"Rashers to rashers, oink to oink," Beard replies.

Brendan Hunt: The Amsterdam episode is meant to touch on a bunch of things that can happen to anyone in Amsterdam—finding creativity, finding yourself, finding a friend on a bike ride. But it's also specific to certain things I did and found in my time there. And one thing I did was I got a band together, and I *Aladdin Sane*d out and we performed the entire *Ziggy Stardust* album. So that was a nod to that. And then at the last minute, Jason goes, "And a pig nose." And a pig nose? All right. And now we're one half-hour writing session away from a spin-off.

David Elsendoorn: As soon as I heard the days that we were

going to shoot I was like, Huh. Because they were planning to shoot on King's Day, which is hands down the most chaotic day in Amsterdam—people will be drunk in the streets, everyone dressed in orange and selling stuff, parties on boats. It's just chaos, and I was like, Wow, you couldn't have picked a worse day. But then because they did scenes in the stadium, scenes in the Van Gogh Museum here, we're all inside. So in the end, it turned out all right.

Phil Dunster: One of my favorite days of filming: with Brett, when we're riding bicycles. It's just absolute idiocy, and it was so much fun.

Roy and Jamie's bicycle adventures were inspired by a crash Hunt had on his own bike in Amsterdam. On the back was his Boom Chicago castmate—and future Oscar-winning director—Jordan Peele.

Brendan Hunt: I passed him and it's like three in the morning: "Jordan, let me ride you the rest of the way home!" Because riding on the back of someone's wheel and just grabbing someone by the waist and biking along was common practice. And he said, "Brendan, no, no." "Come on. Jordan Peele, I insist you get on my bike right now!" And he did. And I remember it clear as day: "OK, you good? You good? Okay. Woo." [They crashed.] And Jordan landed on his back and we both died laughing, admitting defeat.

Similarly, Higgins's impromptu performance in a jazz club of Chet Baker's "Let's Get Lost," a kind of theme song for an episode in which many characters got lost in their own adventures, was also based directly on Hunt's time in the city.

Brendan Hunt: Part of my Amsterdam experience was this flush of joy of having these powerful performance experiences onstage. And on top of that, there was a hell of a jazz club down the street called the Alto, which we tried to honor with that scene with Higgins.

David Elsendoorn: Coming back to Amsterdam, the city where

I've lived for ten years and I went to theater school, and being able to shoot there was such a full-circle kind of moment. I always had that dream. Just walking over the canals with James Lance and having a chat with him about his career was really nice, and being with Billy [Harris, who plays Colin] and Charlie [Hiscock, who plays Will] eating something and showing them around a little was cool. And they put us up in a very luxurious hotel, so obviously that was very nice.

Rebecca's night on the boat marked a turning point in her journey to get over her resentment of Rupert—refreshed in season three by his purchase of West Ham—and find herself again.

Jason Sudeikis: There are quotes that I have in my wallet from [*Leaving Las Vegas*]. This is from the book: "A slight, elusive chemistry which occurs only occasionally when two people meet. Always a welcome surprise, it is a sort of quick familiarity, implied permission to conduct relations at a level which is a bit deeper than the superficiality of introduction." Last time I pulled this out of my wallet and showed it to people was when Hannah was shooting her scenes on the boat, because I believe in that. It happens all the time between men and women, and men, women and women, and I think that's sexy.

Hannah Waddingham: Companionship and being soulmates come in various different forms. And I don't think that they needed to have sex on the barge. And I quite liked the fact that they have been so bamboozled by each other that they forget to actually ask each other's names, because they're just two humans bouncing off each other.

It also finally delivered the experience Roy prescribed for Rebecca back in season one, when he told her she deserved to get "struck by fucking lightning."

Hannah Waddingham: When he's cooking dinner, and you see

nervousness and an excitement in her that you've never seen before, I tried to make her as much back to the woman that Sassy was describing when she says, "No, this isn't Rebecca. Rebecca is silly and funny and excitable." Matteo van der Grijn was the most perfect choice. It was so gorgeous because when I was shooting the scene on the other side of the canal—the stuff on the phone, and then he suddenly starts talking to me—he and I hadn't been introduced to each other before that. And it was immediate, like, Oh, this is going to be absolutely fine.

For all its frivolity, the Amsterdam episode does include one poignant plot development, when Colin, a closeted gay member of the team, is able to open up to Trent Crimm, who is also revealed to be gay. Colin's journey, telegraphed earlier in the series and then unfolding over multiple episodes in season three, is the most substantive aspect of the show's effort this season to include queer characters and stories. (Another is the arrival of Jodi Balfour to play Jack, a short-lived love interest for Keeley.) While having a gay TV character is hardly groundbreaking in the twenty-first century, Colin's story is authentic in the context of professional men's sports, which have been slow to accept gay athletes. (A few pros have come out, but as of early 2024, the Premier League still has never had an openly gay active player.) In the Amsterdam episode's most moving scene, Colin tells Trent, "My whole life is two lives," and shares his simple but powerful dream to live and love as freely and openly as his teammates or anyone else. "I don't want to be a spokesperson. I don't want a bunch of apologies," he says. "All I want is when we win a match, to be able to kiss my fella the same way the guys get to kiss their girls."

Billy Harris is not gay, nor is he Welsh, for that matter. Raised in Essex, England, he was not long out of Bristol Old Vic Theatre School, the same place Dunster studied (as well as luminaries like Daniel

Day-Lewis, Olivia Colman, and Jeremy Irons) when he got the chance to audition for Ted Lasso. Colin was only vaguely defined in season one, aside from his penchant for flashy cars and picking on Nate, both qualities that, in retrospect, fit a man trying to put up a macho front. But when Colin referred familiarly to the gay dating app Grindr early in season two, many fans on social media began to suspect he may be hiding his true self. And they weren't the only ones.

Billy Harris, Colin Hughes, seasons 1–3: In season two, once I started seeing that Colin was going to therapy and there was the line about Grindr, my actor-investigatory brain goes, OK, there's something more here. I always found that he was a bit quiet and I wondered why. That was something I found out in season two, then we weren't going to touch on it until season three.

A.J. Catoline: I love doing cutaways that really mean something. One that sticks out to me is in episode five, in "Signs"—Ted's giving a speech to the locker room after he rips the BELIEVE sign, and he's talking about how he doesn't want to deal with anger and shame and all these issues that bog people down. And on the word *shame,* we cut to Colin kind of giving this reaction, because he hasn't come out yet and he's holding that in and he still has shame around who he is.

Billy Harris: There was the scene [earlier in season three] where Trent sees Colin and Michael kissing, and then I had a couple weeks' wait to think about how Trent is gonna go about this. I didn't know. Could he out Colin? Could he tell Ted? Could he tell the team? I had all of these thoughts in my head, but what's great is that he didn't, and he became an ally for Colin and just a friend. That was what me and Jimmy [Lance] wanted—that was the way we wanted to go about this storyline because I think that's really important.

James Lance, Trent Crimm, seasons 1–3: There's this really interesting thing that happens: There's the two actors and the two

characters, and you kind of develop these two relationships side by side. There's a resonance that rolls between the two, and they're both really complementary. I guess our kind of baptism of fire was our storyline in Amsterdam.

We shot all of that stuff in one night from maybe six in the evening until, I think, we finished about five a.m., four thirty, something like that. The last scene was on the monument where Billy had that amazing speech, which was rewritten really heavily beforehand, as is often the way on this show. And then when we did it, maybe about three takes of it. And it was so beautiful to be there as Trent with him in that scene. It was just a privilege to embody that moment, you know? Both of us have done a fair bit of research and are well aware that there are a lot of closeted athletes. And not just athletes—you know, people that feel that it might jeopardize their job or their social standing if they come out. And so you do feel a real kind of . . . I don't know. It's just an honor.

Billy Harris: Yeah, I think it took three takes. The good one was the last one. It was two a.m. in Amsterdam, and I thought, Let's just go with it. I think I was being a little cautious because I knew the storyline was so important. The third take, I was like, This is Colin's truth and he just wants to live a normal life; he feels like it's impossible for two lives to merge. And then as I started to really get the lines down, I just felt more and more heartbroken for him. I'm there as the actor nearly crying but I can't cry for Colin, because Colin in the moment is like, "I can't do anything about this."

Toheeb Jimoh: Every now and then you just go, Wow, we are really surrounded by some extraordinarily talented people. Both James and Billy, that scene was gorgeous.

Billy Harris: I know that from my DMs and everything like that, people say that they wish that they would have had this when they

were younger. There was a teacher that messaged me and said that one of their students was struggling with the feeling of being bisexual but loving football. The teacher referenced my character to the child, and I just thought that was so amazing. So this is something that we've given to the world in the hopes that there can be change.

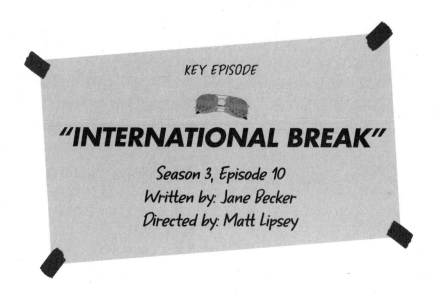

KEY EPISODE

"INTERNATIONAL BREAK"

Season 3, Episode 10
Written by: Jane Becker
Directed by: Matt Lipsey

Ted Lasso is so widely remembered as the show we needed during the hellscape that was 2020, it's easy to forget that the basic concept was hashed out years before the coronavirus pandemic. Not just the original ad but the broad contours of the series itself, conceived as a corrective to the increasingly sour state of human interaction as embodied by social media platforms like Twitter (and, around the time Jason Sudeikis and Bill Lawrence were pitching it around Hollywood, by a national tone shaped by then President Trump's bellicose rhetoric). The creators were interested in how the mercurial ego drip of social media and, more broadly, the unforgiving light of public attention shape the way we see the world and ourselves in a time when most of us, via the phones in our pockets and all around us every day, are living increasingly public lives whether we like it or not.

Sudeikis and Co.'s general attitude about this stuff is illustrated

by the character who undergoes the most dramatic heel turn: Nate the Great, who pivots hard to Not So Great before trending back toward, if not greatness, then something *Ted Lasso* values even more: decency. No other characters in *Ted Lasso* obsess over how they are perceived as much as the Wonder Kid—seen constantly using Twitter as his own personal focus group—and look where it gets him. Nate's own brand of brokenness plus the empty praise of strangers and master manipulators like Rupert have led him to betray and lash out against Ted, his biggest supporter, and align himself with the show's version of the Empire. (From the themes to the styling, *Star Wars* continued to be a conspicuous influence throughout.)

Nathan Shelley's fitful journey from obscurity to prominence and back toward grace and emotional equilibrium is deeply informed, like so much of *Ted Lasso*, by his daddy issues. Those finally receive some resolution (perhaps a bit too tidily) in the tenth episode of season three, which finds him fleeing his lofty Premier League perch, his Dark Side mentor, Rupert, and the press in order to reconnect with his family and something real, as symbolized by a lovely violin piece that Nick Mohammed, a talented musician, performs near the end of the episode. It is Nate rediscovering a piece of himself he loves but has let go amid hurtful recriminations from his father, and his reembrace of it is what allows him to reset his relationship with his dad and eventually return to Richmond.

Overall it's a good week for letting go of malign influences, which means it's a bad one for Rupert—the malevolent puppet master sees both Nate and Rebecca finally cut his strings once and for all. Elsewhere, Sam meets new persecution from Edwin Akufo with relative equanimity, after the emotionally erratic billionaire (per the ever quotable Higgins) has worked to hobble Sam's restaurant and given the Nigerian government $20 million to leave him off the national

team, which initially guts Sam. (Sam eventually makes the team, we now know.) Keeley finally rids herself of Jack—well, actually, it's the opposite, after Jack's venture capital firm pulls Keeley's funding, briefly closing KJPR. But the happy result is (a) Keeley resumes working for Rebecca, after her old boss agrees to fund the firm; and (b) we are effectively done with the show's least satisfying subplot, speaking of shedding burdens. In the episode's main comic storyline, the terminally cheerful Dani Rojas bullies Zoreaux/Van Damme ahead of their international face-off and then breaks his nose during the match. He will later give the goalie the signature black face-wear we've all wanted for him from the start. (I think it was Chekhov who wrote, "One must never name a character Zoreaux unless he will wear a mask by the end.")

Rebecca's victory over the darkness is arguably the most hard-fought and deserved. After her emotional progress in the first two seasons, she has regressed into bitterness after Rupert's purchase of West Ham, spending the early part of season three lambasting Ted and making impulsive personnel moves (Zava) out of a vengeful desire to make Rupert pay on the pitch. When he invites her to be part of Akufo's plot for a super league, she sees only more manipulation at work. "I think the only reason Rupert has invited me in is because I'm a woman, and it'll make them look good," she tells Higgins. But Higgins helps her understand that Rupert's motives are beside the point—and, by extension, that she is still letting him affect her decisions and behavior.

"Who cares why Rupert invited you?" he says. "You've got a seat at the table, so go and see what's what."

Once there, Rebecca sees what she and the rest of us would expect to see: a gaggle of craven rich men scheming to get even richer. As she walks into the clubby summit, the only woman, her inner

insecurities are embodied by the reflection she sees in a hallway mirror, an image of herself as a little girl. An old lech named Robert then makes a creepy, belittling comment about her appearance. But with the help of her confidence-boosting gargoyle move, which she demonstrated in an earlier episode, along with Keeley's timely text reminding her the members of this gilded boys' club were once, in fact, actual boys—which is how Rebecca then literally sees them—she is able to speak with clarity and ultimately defeat the plan. Rebecca evokes Rupert's humble origin story in her argument against making football more exclusive. This plus the hearty laugh they share after Akufo's latest tantrum, which leaves everyone covered in Ghanaian cuisine and Chicago-style hot dogs, seems to presage a possible reunion between the former couple.

Instead it sets up what Rebecca has needed from the beginning: a final clean break from her loathsome ex-husband. When Rupert goes in for a kiss, she stops him and walks away. By the end of the episode, she has returned to her office wall the David Hockney drawing she removed in the pilot and is finally completely over Rupert.

"I've realized I no longer care if I beat Rupert," she tells Ted. "I mean, I still want to win. But for all of us, for Richmond."

Nate will eventually get back to wanting to win for Richmond, too. But before he feels that he deserves to be taken back, he will have to confront the relationship that left him so ill-equipped to deal with success in the first place.

Nick Mohammed felt more comfortable portraying the bright but bumbling Nate we first meet as a kitman in season one than the nasty and arrogant coach he turns into in seasons two and three. "I found

that kind of sweet spot for Nate in season one, which was this kind of awkward, quite funny guy," Mohammed said in a 2022 panel discussion for In Creative Company, an online interview series. "But there were decidedly less jokes or less moments of humor for Nate in season two, so it definitely became more of a challenge to act." But he believed both versions stemmed from the same place: a bitter insecurity that came from growing up without support or approval from his critical father. "He's never been able to please him, regardless of what he does, and so I think Nate is quite an embittered soul, sadly," Mohammed told me in a 2021 interview for *The New York Times.* "Whereas that manifested itself in shyness in season one, and he just was shut off from the world, now he's entered the world but is struggling to find his place in it and do the right thing."

The *Ted Lasso* writers had blueprints for the various characters going into casting, but most of them evolved as filming progressed, modified to reflect the qualities and strengths of the actors who played them. "Jason had thoughts for every character of what they're going to be doing for three seasons," episode writer Jane Becker told *Script* magazine in 2022. "I think Nate, as far as I know, is the one that has stayed true to his vision, that he was very clear about.

"With Nate, it was very *Star Wars*–ian," she added.

It's true: Nate's story is essentially that of Anakin Skywalker but with coaching whistles instead of lightsabers, in which a brilliant young Jedi being nurtured by a kind, bewhiskered teacher—with Ted as Obi-Wan—is convinced by a dark mentor to instead embrace and draw power from all his angriest feelings. Sudeikis told Anthony Head that, as Rupert, when it came to Nate, he was essentially playing Emperor Palpatine turning Anakin into Darth Vader.

However, Sudeikis also drew inspiration for Nate from a different pop culture juggernaut: *Saturday Night Live,* where he worked, first

as a writer and then as a cast member, from 2003 to 2013. "One thing Jason did say is that just through his experience on *Saturday Night Live,* you can see a change in people," Mohammed said. "When they first start out, they're really hungry and loving it and being really creative. But there is a tipping point when they get a little bit of recognition, when it starts to go to people's heads. Not everyone, but some people—things can sometimes take a slightly different turn. So I think Nate's story is absolutely based on a truth."

For Nate the trigger is not a catchphrase or movie deal but Twitter and the renown of his Wonder Kid persona, as well as his growing power as a coach. His locker room roast of the team, in season one, offers the first glimpse of Nate's seething side, though the scene itself is mostly comic. By season two he is bullying his kitman replacement, Will, and turning on Ted, his insecurities piqued by the arrival of Roy as another assistant coach. By the time Nate gets to West Ham, he is openly ridiculing his players and, encouraged by Rupert, using his press conferences to make snide remarks about Ted, Richmond, and even the reporters in the room.

Mohammed lived in Richmond while he was making *Ted Lasso,* and ahead of Nate's turn, he joked about being nervous about how people would react when they saw him jogging by Richmond Green. But when the hate actually did start coming his way, after Nate tore up the BELIEVE sign and abandoned Ted and Richmond, it was— where else?—on social media. "He catches heat as a human being for being an asshole, and he's the sweetest guy in the world," Bill Lawrence told me in 2023, before season three premiered.

Mohammed fell in love with performing as a kid growing up in Leeds and went on to become a professional magician for a time, but he eventually decided to pursue a PhD in geophysics at Cambridge and work in the petroleum industry. However, he fell in with the

Footlights, the university's famous sketch troupe that counts comedy stars like Peter Cook, Eric Idle, Hugh Laurie, and Richard Ayoade as alumni, and his career aspirations took their own turn. "I just got bitten by the comedy bug and thought, This is just far more entertaining than drilling for oil," he said in *The New York Times*.

Before *Ted Lasso*, he was probably best known for creating *Intelligence*, a national security satire Mohammed also starred in with David Schwimmer. He was known to work on *Intelligence* scripts in between scenes on the set of *Ted Lasso*—costars have marveled at the way he would pleasantly tap away on his laptop minutes before an intense scene and then, when "action" was called, transform into the brooding Nate. "Multitasking, you know?" Mohammed explained on the *Peanut Butter and Biscuits* podcast in 2022. "When I'm at work, whether it's filming or it's a writing day or whatever, I really feel like I've got to maximize use of time because when I'm home, it's really to be spent with the family."

Mohammed originally met his wife, Becka, in college at a rehearsal for their university orchestra. She accompanies Mohammed on piano during his violin scene in "International Break," the two of them collaborating on a performance of Estonian composer Arvo Pärt's melancholy "Spiegel im Spiegel" (translation: "Mirror in the Mirror"; Sudeikis picked the piece). When Nate begins to play (using Mohammed's own violin), it becomes a kind of soundtrack for his liberation from Rupert as well as Rebecca's—the scene intercuts shots of him playing and of her stirring rebuttal to the wealthy club owners' super league plan. After the episode debuted, Mohammed posted a lengthy note on Twitter elaborating on the scene and on Nate's broader journey. "Both Rebecca (the character) and Nate are connected through Rupert—who once had a hold over both of them," he wrote. "And so to underscore her speech with Nate playing violin was

such a great move on the writers' part (the intercut sequence was all scripted). A perfect example of 'show don't tell' by colliding their two storylines in this way."

Soon Nate's father arrives to listen to his son, the moment giving way to a long-overdue conversation about the breakdown of their relationship. The violin stands in for all the ways in which Nate was made to feel like a failure by his father, who admits that he was hard on him partly because Nate had privileges he himself had never enjoyed, and partly because he didn't know how to raise "a genius." The scene mirrors Nate's misdirected attack on Ted at the end of season two—Mohammed asked Sudeikis to stand in his eyeline as he performed the scene with Nate's father, he wrote, "because when Nate aims his words at Ted in [the season two finale] those were undoubtedly intended for his dad.

"Nate doesn't cry here like he did in front of Ted, though (and will again in [the season three finale]), and it's important that that's not Nate and his dad 'fixed,'" Mohammed wrote. "It does represent the start of a healing process, though."

<hr />

It was perhaps fitting that Nate, a character designed to be undone by social media, as a commentary on its corrupting influence, ended up being the target of plenty of scorn on . . . social media. First, when his heel turn had random fans taking it out on the poor actor playing him, and then when many viewers found his resolution unsatisfying.

Given the narrative's general arc toward uplift, there was little doubt that Nate eventually would return to Richmond—it was only a question of how it would go down. The main vehicle for his redemption was his new girlfriend, Jade (played by Edyta Budnik), who gave

him the emotional ballast and security he had never possessed, which helps him see Rupert more clearly and leave him behind. (The final straw was apparently Rupert trying to get him to cheat on her.) But what annoyed some viewers and critics was what we didn't see, namely a scene of Nate actually leaving West Ham or meaningfully atoning or even grappling with the depth of his betrayal of Ted and Richmond, or of the Richmond players—who once hated Nate so much they assaulted half of his team in a match—discussing anything before unanimously deciding to invite him back. "One of its biggest season two arcs, the vilification of former kitman turned coach Nate Shelley, was quickly revealed to be more like an unfortunate mistake Nate made, a brief lapse with reason," TV critic Kathryn VanArendonk wrote in *Vulture*, speaking for many. "By the end, Shelley's Darth Vader turn was undone with barely a moment of onscreen conflict or conversation, a fait accompli performed with a single retroactive hug."

Poor Nate couldn't catch a break even when he was trying to do the right thing. For what it's worth, Mohammed said he was working toward saving Nate's soul practically from the time he arrived at West Ham. "I felt it was important to aim for redemption right from the start of Season 3, even if it was primarily in the pauses between lines or in the way Nate's posture betrays his confidence," he wrote on Twitter. "The horror of what Nate's done, of what he's becoming, of how he betrayed Ted, of the specific things he said haunt him throughout Season 3, and no amount of bravado, fancy cars or words of 'encouragement' from Rupert can ever fully hide that."

In the end, he was right. And while I agree that Nate's rehabilitation was far too dependent upon Jade—who had no discernible motives or facial expressions, even—his change of heart set up one of the most purely enjoyable scenes in the show: when Beard comes by in

the following episode to offer Nate forgiveness and share his life story of drugs, jail, betrayal, and Ted's forgiveness.

"Just like *Les Mis*," Nate replies.

Beard: "Our story is very similar to *Les Mis*, yes."

"You went to prison?"

"Yes, for stealing a loaf of meth," Beard says. "Then I stole from my friend, who forgave me and gave me a job and a life. So to honor that, I forgive you. I offer you a job. The life part is up to you."

By the end of the season, the two of them are together helping Roy plan the future of the Greyhounds, which is a show I will absolutely watch if Sudeikis and friends decide to make it happen. However he got there, AFC Richmond is a better place with the Wonder Kid in it.

WHO WON THE EPISODE?

Draw: This was the episode of Nate's awakening and catharsis, but Rebecca's big milestone, in moving beyond Rupert once and for all, was just as profound, if not more so.

BEST SAVE

Rebecca again. She saves scores of soccer fans from Akufo's super-league cabal, she saves Keeley from having to close her firm, and she saves us from having to hear about Jack again.

BEST ASSIST

Mrs. Bowen, the flirty teacher. (First name: Leann—she is presumably named for one of the show's writers, Leann Bowen.) Captivated

by Roy's new tie-dyed shirt when he drops his niece, Phoebe, at school, she approaches and inadvertently gives him the best insight he has ever received. Explaining that she previously flirted with Roy because "I teach kids, I don't mind cleaning up a mess," she added, "I just hope that mess didn't cause too much damage." It opens Roy's eyes to a truth he has somehow failed to totally grasp: it was his self-destructiveness that led to his breakup with Keeley. One apology letter later and he is back inside Keeley's place wearing her robe, though the reunion isn't destined to last.

BEST LINE

Mae, offering food to a self-pitying, increasingly inebriated Keeley: "I can't have another sad skinny girl pass out in my pub, fucks me Yelp rating."

RANDOM STATS

- I enjoyed Barbara's explanation for her expansively logoed Juicy tracksuit: "I like clothes that tell the truth."

- Ted, sending his players off to their international matches: "Let's go ahead and wish our friends safe travels and godspeed, or whatever narcotic your deity chooses to self-medicate with." Admission: I often find Ted's corny asides and references labored and distracting. But as a word nerd, I love when figures of speech get taken apart in surprising ways.

- When Nate is riffling through the closets at his parents' house, he finds an old magic hat and scarves, a nod to Mohammed's past and his and Sudeikis's shared interest in magic.

- Near the end of the episode, Nate returns to do Will's locker duties for him and leaves a note of apology with a sprig of lavender on it.

It's a callback to the season two episode "Lavender," in which Nate goes off on Will for using lavender fabric softener on the team's laundry, because he thinks it will distract the players.

- Nate's mother is named Maria Shelley. Fans of gothic literature might note the similarity to Mary Shelley, who, as the author of *Frankenstein; or, the Modern Prometheus,* is the mother of modern horror, though in this case it was the father who created the monster.

CHAPTER 11

THE FINAL WHISTLE

"It was the end of something really special."

AFC Richmond rolls out of Amsterdam with a group sing-along of Bob Marley's "Three Little Birds," and for the most part, eventually everything's gonna be all right for everyone other than Rupert and maybe Edwin Akufo. But first various characters have to face and overcome personal challenges in the second half of season three as *Ted Lasso* sets up its endgame.

Sam will face the repercussions of his outspokenness when vandals trash his restaurant, spray-painting "Shut up and dribble!" on the wall. Back in the locker room, enraged, he lashes out at the hypocrisies athletes, particularly immigrants and people of color, face within the public pressure cooker of professional sports. "The world is full of evil people who do shitty things, but I can't deal with that right now because I have to go and kick a little ball around," he tells his teammates. "Which those same people love me for! That is, until I fuck up, or I miss a

penalty, or I decide to fight back, and then they're just gonna wanna ship me back to wherever I fucking came from!"

"Ted Lasso *can sometimes feel like this utopia universe where the best of humanity is consistently on show," Toheeb Jimoh said in a 2023 panel discussion for* Half Hour With, *an online interview series. "So what I really wanted was to see Sam, this really optimistic, really joyful, happy kid, have to deal with some of the consequences of his political activism, and thankfully we got that."*

In ensuing episodes, Colin finally comes out to the team after Isaac attacks a fan for shouting a gay slur. Nate leaves West Ham and goes home to face his father. Rebecca finally, totally moves past Rupert. This being Ted Lasso, *each makes it through with the help and support of those around them. But collectively it's as if various Richmonders have to prove they are emotionally and spiritually prepared to carry forth on their own without Ted around to guide them.*

Kola Bokinni, Isaac McAdoo, seasons 1–3: The first season was all about breaking molds and showing people that you have a lot more potential than [they thought] you did. The second season was about mental illness, and showing everyone that you're not perfect. This season is more about, you know, you can do it, and you're a lot stronger than you think you are.

Toheeb Jimoh, Sam Obisanya, seasons 1–3: The response to season one and season two has allowed our creators to take bigger and bigger swings with season three, and that confidence has filtered down to us. And you can see that in the performances: we're seeing shades of these characters we've never seen before.

Billy Harris, Colin Hughes, seasons 1–3: We're an ensemble, but there comes a time where you can see Jason honing in on, "This is Toheeb's bit, this is Kola's, this is Cristo's, this is Billy's, this is Phil's." That gives us space to be silly and funny in the background. But then

there's real issues at play, and they have such respect for all of the storylines.

Toheeb Jimoh: We know the Lasso Way, and we're starting to see that the players don't need Ted anymore in the same way that we did in the first season. For all of our characters, we can all stand on our own two feet. Thinking about Sam, for instance, the kid that we met in season one is not the kid that we have in season three. He's a business owner. He's one of the leaders on the team. It feels like they've got it, and they can be their own people.

Rebecca will conclusively reclaim her independence with a rejected kiss, which finally puts to rest the broken relationship that provided the impetus for Ted Lasso. *When Rebecca and Rupert come together to discuss and ultimately reject Edwin Akufo's proposal of a soccer super league—spurring another tantrum by Sam Richardson, who won an Emmy for the role—Rebecca finally realizes that she can be cool and confident in a roomful of rich men and that Rupert truly means nothing to her anymore.*

Anthony Head, Rupert Mannion, seasons 1–3: The superleague lunch—such fun, and the transition of Rupert's relationship with Rebecca, seeing how it had all begun and his feeling that they had come closer again, only to blow it by going in for a kiss.

Hannah Waddingham, Rebecca Welton, seasons 1–3: I really missed [Head and Rupert] last season. That's kind of a weird thing to feel, that you miss the toxic energy, but it's because he's so brilliant at playing it. I really felt kind of adrift, and having him back I was like, Ah, there she is. As in, it brought out whatever in me that I needed to get to.

Anthony Head: Jason told me how it would manifest—the superleague discussion and the apparent reuniting with Rebecca. Even so, when I read the episode, it fascinated me—a sociopath finding that

his prey has changed, has become strong and invincible. The journey was really exciting to play, especially to coax the audience into thinking that the two of them might actually come together again.

Juno Temple, Keeley Jones, seasons 1–3: For her, it's no longer about just winning out of revenge—that's all gone. So that was really special.

As for Keeley herself, she sees the dream she nurtured all season disintegrate when her PR firm collapses, after her ex Jack's company pulls its funding. But her old mentor comes to the rescue and finances the company.

Juno Temple: Keeley can't really approach anybody about the business falling apart. And Rebecca [helps her] with not even a flicker of judgment, not a question about [whether] Keeley is good enough to do what she's doing. That core friendship came back really strong. So Keeley goes off, and she is independent in that, but her mentor and female inspiration is very present, too.

Also present: Roy, at least for an afternoon. The relationship between Keeley and Roy, a primary narrative driver in seasons one and two and arguably the show's most appealing romance, was mostly cast aside in season three, which rankled many fans. That changes when a stray comment from Phoebe's teacher convinces Roy to make a heartfelt apology, but his and Keeley's reunion is brief. In another assertion of her independence, Keeley, disgusted by Roy and Jamie's resurrected competition for her affections, decides she doesn't need either of them, romantically, though we'll see them all together in the series finale montage.

Juno Temple: The romances that Keeley has had throughout this incredible journey, they grow and change this season. Keeley witnesses that when Jamie is accountable and comes to her house and apologizes for that email being leaked, and then also how Roy comes

to her and asks for help with Jamie. She knows that those two will teach each other things, and both will learn from each other. I think she knew that from the beginning, so her getting to see that was important and another reason why she's like, "Get out, both of you. Fuck off, you idiots." Because they still have their journey to go as well, while she's on hers.

Brett Goldstein, writer, Roy Kent, seasons 1–3: I like the fact that some things aren't resolved, so I can dream what I want to dream. In my dream, there's a lot of Roy and Keeley, *and* there's a lot of Roy and Keeley and Jamie. A throuple is absolutely fine with me.

Jamie's challenge comes in the penultimate episode, the portentously named "Mom City," when he must return to Manchester to play in front of, he assumes, his toxic father. Instead he spends the trip visiting his mother—her house is filled with Phil Dunster's actual family photos of him playing soccer as a boy—and vanquishing his old team.

Phil Dunster, Jamie Tartt, seasons 1–3: Leanne Best, who plays Jamie's mom, was just unbelievable. And suddenly it made so much sense for who Jamie is and who he was. We've seen his dad and that makes sense for the darker element of Jamie. And then you see that there is this person who's full of love, direct and honest. And so you're like, That makes sense.

A similar skeleton key appears in the form of Ted's mother. (As Ted says earlier in the season: "Boy, I love meeting people's moms. It's like reading an instruction manual as to why they're nuts.") Played by the great character actor Becky Ann Baker, Dottie Lasso is revealed to be the source of both her son's folksy charm and—less charming—his flair for avoidance and denial.

Ted's and Jamie's narratives correspond in interesting ways throughout Ted Lasso, *from their shared romantic troubles, to Jamie's confrontation with his drunk dad spurring Ted to face his own father's suicide,*

to both of their mothers illuminating their personalities. "What would you say to your father if he was here right now?" Ted asks Jamie at the Man City match. "Fuck you and thank you," he responds. In this, too, they are aligned.

"Thank you for cooking dinner," Ted tells his own mother when he sees her later. "And fuck you for not wanting to talk." He goes on to show gratitude for the things she did for him while lamenting the emotionally withdrawn example she set after his father's death. "Thank you for the apology," he replies after she says she's sorry. "And fuck you for making me think I had to pretend, too."

But also like Jamie, Ted's mother's support and love pushes him forward. Dottie admits that she does, in fact, want to talk. "Your son misses you," she says, triggering the eventuality that has hung over all of season three, if not the entire series: Ted's Dorothyesque return home to Kansas. The episode ends with Ted telling Rebecca he has something to tell her and then, in case it isn't clear, Brandi Carlile's cover of "Home," from The Wiz, plays over the closing credits.

In the season (and perhaps series) finale, Ted's—and the show's—impending departure infuses poignance and melancholy into an episode that otherwise, true to Ted Lasso form, is overstuffed with happy endings and dreams fulfilled. Nate is back and apologizes to Ted. Roy begins therapy. Jamie reconnects with his now sober father. Sam joins the Nigerian national team. Trent finishes his book. Mae and the pub fans get their own shares of the club. Colin kisses his fella on the field. Beard gets married.

There is joy (the team singing and dancing its way through "So Long, Farewell") and pain (Rebecca's tearful farewell to Ted), sunshine (Richmond beats West Ham) and rain (a torrential downpour of "Wanker!" as Rupert storms off the pitch, humiliated). We learn Beard's first name is Willis.

Rebecca's dismissal of said wanker clears the way for her own dream to come true—along with, perhaps, the psychic's prophecy that has kept coming back to her throughout the season. In her final scene of the show, after saying goodbye to Ted, Rebecca helps up a little girl at the airport and discovers that the girl is the daughter of the man she met in Amsterdam. Rebecca's evolution and growing self-acceptance over the course of Ted Lasso is signaled by the fact that her first word in the series is "Rupert," and her last, as she finally properly introduces herself to the flying Dutchman, is "Rebecca."

Hannah Waddingham: I think it's genius that they did the whole thing of them not exchanging numbers, not exchanging names, so that they then bump into each other at a transient place like an airport. I just think it's just lovely, and she sees the child and helps the child first.

Just as Sudeikis promised all along, the finale clearly puts an end to the story we've watched over three seasons, even as it sets up multiple possible spin-offs: Beard, Roy, and Nate take over AFC Richmond. Keeley and Rebecca hatch a plan for a women's team.

Juno Temple: The last day I shot on season three was actually the moment where Keeley goes into Rebecca's office and presents this idea of the AFC Richmond's women's team. What a full circle, right? It was a really big moment to present this to her mentor and best friend. But then all these people came to clap me out and say goodbye. It's gonna make me cry thinking about it, because this team is just extraordinary, from every single department.

Temple had to leave the shoot early, but most people stayed to the bittersweet end. As one might suspect on a show as in touch with its feelings as Ted Lasso, the final day on set was an emotional one.

Brett Goldstein: Oof, everyone was a wreck.

Annette Badland, Mae Green, seasons 1–3: It was horrid. The

day was good and fine and to be relished, and then really tough, the end.

Bronson Webb, Jeremy Blumenthal, seasons 1–3: People had tears in their eyes that day. Yeah, it was tough. I don't know if anyone in that show actually [wanted] it to end.

Anthony Head: Working on this project was quite extraordinary. The last day of filming, I had some lovely stuff to shoot—especially the scene with Hannah and Ellie [Taylor, who plays Sassy], in the VIP room. I felt so connected to the crew and really emotional about finishing, which gave me a core for Rupert's state of mind, as he walked through the corridors. At my wrap, I wanted to thank everyone involved in the show. I started—and just cried.

David Elsendoorn, Jan Maas, seasons 2–3: It was a lot of mixed feelings. I did little interviews in between the scenes that they wanted to document for Apple. So it really felt like the last day, but it was really nice to end on the pitch. We did the dance and song performance, which we rehearsed quite a bit because we wanted it to be really good.

Phil Dunster: That's one of the things Jason really loves: the quirk of these young footballers, twenty-year-old lads who know these weird references to eighties American TV, or different Renaissance artists, or show tunes. The choreography was far more simple on this, because I think previously it had been quite difficult for people to pick up.

Declan Lowney, director, seasons 1–3 , including the season 3 finale: With stuff like that, you can read it and go, Hmm, I'm not sure that'll work. But when you shoot it, that's what matters. The song ended and he said, "Guys, that was perfect, thank you," and then they reacted the way they did. They went fucking batshit and were pulling off the jumpers and swinging them around the place, and we said, "Just do that again and again." So the guys did that multiple times for us.

David Elsendoorn: Yeah, we went nuts. That was very electrifying, and really funny as well. When we did the close-up between me and Toheeb, where we're grabbing each other's faces like "Aaaaah," so funny to see.

Declan Lowney: There was something real in that outpouring of love and expression, for Jason as much as anything, because it was the last day of training. Whether that cuts through for the audience, I don't know. I just hope by then we had earned the right to fuck around a bit, to let the team do something nice back for him.

The last thing filmed was, fittingly, the scene in which the coaches show the team a compilation of clips from the past three years. The video is meant to motivate the players before their match against West Ham, but instead it sends the entire team onto the pitch in tears.

Melissa McCoy, editor, seasons 1–3: They did, like, three or four run-throughs of that panning shot of the team. Then they did one and Jason spoke to the guys, and was like, "Think about: some of you bought houses; your lives have changed because of this show . . ." And, like, I'm bawling, the guys were bawling. My first cut of that, I used a lot of the actual tears—some of them couldn't keep it together. And we sent the cut out and they were like, "I think this is undercutting the joke, because they're going to cry out on the field." So we had to dial that back. That was the very last thing they shot, and everybody was crying. Then they called "cut" and you just see everybody flooding in.

Brett Goldstein: I think the assistant directors had deliberately scheduled the final scene to be a scene that everyone was in. The entire cast were in this scene, and then it was like, "That's it." And then everyone—from accounts, from production design, everyone was just outside the doors of the locker room, and then everyone streamed in. There were, like, two hundred people there.

Brendan Hunt, creator, Coach Beard, seasons 1–3: It was a great moment of connection. It felt like a culmination, and it is definitely a treasured memory from this whole experience.

Jason Sudeikis, creator, Ted Lasso, seasons 1–3: It was lovely. It was jam-packed, which our COVID team was very anxious about, understandably. Lot of tears, lot of cheers, lot of clapping.

James Lance, Trent Crimm, seasons 1–3: Jason did a little speech and it was so moving. I was in tears, and pretty much every single person in the room was in tears.

Brett Goldstein: Jason got on a thing and did a very nice speech, and then everyone cried and hugged each other. I kept sneaking off to the showers to have a cry and then come back in.

James Lance: Basically what he said in that speech was, "You know, this has been a piece of magic and let's take it out there and let's take it to our families. Let's take it to our next jobs. Let's take it into our work, into whatever we're going to create, let's take it into our interactions with people. Let's see how far it can go."

Jason Sudeikis: We talked about taking it forward, taking it to the next place. Taking it to your next project, your dining-room table, your family's home, whatever. Wherever you can be around other people, do it kindly with curiosity.

Declan Lowney: He made the most beautiful speech, and big hairy-ass grips and electricians and guys who wouldn't normally cry—there wasn't a dry eye in the house. There was something very special about it.

Sara Romanelli, assistant script supervisor and script supervisor, seasons 1–3: The cast obviously had been there for a long time, but the nice thing is most of the crew had also done all three seasons. So for the crew it also felt like the end of a journey. So it was very emotional. A lot of tears. But also laughs, because Jason made this

speech and it was obviously very emotional but at the same time, it was also very funny.

Declan Lowney: The thing is with Jason, it's very real. He almost *is* Ted Lasso, or Ted Lasso almost is him. He just made us all feel really great about what we had done and about what the show had achieved. The endpoint was: there's a bit of magic that we've all created here, but let's all take some of that with us in our lives when you're talking to your kids and your family. Just all try to be that bit better, which isn't too much to ask, really. And you know, Americans like that sort of schmaltzy stuff and the Brits are a bit [*sniffy expression*]. But guys were crying and it was absolutely gorgeous—it was like a fucking weighted blanket for four hundred people.

David Elsendoorn: It was just lots of vibrating energy in the room. We felt so lucky to have each other and to have a group of people that got along so well on and off the pitch. It was genuinely like a family. So it was the end of something really special.

Jason Sudeikis: That last day of shooting, it was very emotional. But it's one of those . . . I remember my high school basketball coach trying to tell us, our first day of practice in our senior year, "Hey, this is going to go away, but enjoy it while it's here." And there's something about putting a cap on that, you know? One of the benefits is that people really enjoy it while they're there as opposed to suffering, perhaps, from what Pat Riley described as the disease of more: complacency or greed or whatever. We didn't have the time to get there. It was a love story through and through. So while it was sad, it was also very joyful and very inspiring, is the way I remember those last times.

Brett Goldstein: It's such a huge, magical thing that happened for all of us. So it's very, very emotional, and I also think it took a while to even consider having finished. But yeah, it was very special, the last day.

"SO LONG, FAREWELL"

Season 3, Episode 12
Written by: Jason Sudeikis, Brendan Hunt, & Joe Kelly
Directed by: Declan Lowney

Yeah, it might be all that you get.

Yeah, I guess this might well be it.

But heaven knows I've tried.

Watch enough *Ted Lasso,* and the words above cease to have any meaning, if you even hear them at all. Marcus Mumford, the man who performed them as the chorus of the *Ted Lasso* theme song (you can find a full two-plus-minute version online), has joked that he worked on the show's score for months but all anyone ever hears is "Yeeeeah—" before they click Skip Intro.

But if you take a few minutes to consider them, you start to realize that they pretty much sum up the show before every episode. The reason it's so important to be curious rather than judgmental, to treat others and yourself with kindness and compassion, to make strong connections and build deep relationships and foster supportive

communities is because this thing called life, to quote a different songwriter, *might be* all that you get. It might be it. And wouldn't you rather spend it moving through the world with grace, with empathy, and with people you love? With a sense of purpose based not on riches or career achievements—though those aren't bad things in and of themselves—but on leaving the place a little better than you found it? In other words, to boil it all down: Wouldn't you rather try?

For all of his cornball aphorisms and meat-and-potatoes aesthetics and tastes, Ted is a bit of a Buddhist in coach's clothing. The first time we see him, on the plane ride over, he's reading Jack Kerouac's *The Dharma Bums.* In the end, in his final big locker room speech, he tells his team, "We don't want to know the future. No, no, we wanna be here right now." In between he repeatedly extols the virtues of being present and embracing the moment, both to fully experience the world and to be more in control of how you respond to whatever you encounter. (If Ted ever gets tired of "Be curious, not judgmental," an alternate motto could be—apologies in advance to Ram Dass—"Be kind, and be here now.") It was one irony of Jason Sudeikis and the cast being repeatedly asked about the show's future even before it had begun its final season. "I'm like, If that's not the most anti–Ted Lasso fucking question, you know?" Sudeikis said on *The Great Creators with Guy Raz* podcast in 2023.

The continuing absence of an answer to that question means that, planned or not, Mumford's lyrics apply more literally to the season three finale: It might be all the *Ted Lasso* we get; it might be it. And whatever you think about season three or how the show wrapped up—or whether it should continue in some way—Sudeikis and friends clearly tried from beginning to end. The care that went into crafting the show, from the direction to the wardrobe to the

cinematography, sets, and music, is palpable in every episode. And while season three was flawed and at times unfocused, with some choices that were difficult to fathom—I will never be able to defend Shandy, the Jack subplot, or people's penises being tied together—most of the drawbacks seemingly resulted from a desire to give as many people as possible their own stories, epiphanies, and happy endings. (Well, except for Rupert, but even he got a big scene at the end.) They were largely the product of narrative generosity.

For proof look no further than the sprawling finale, which includes emotional payoffs for nearly everyone in the enormous cast. (Any Greyhounds who didn't get their own moments got to celebrate first nailing the *Sound of Music* number that gives the episode its title, then later beating West Ham in a thrilling fashion.) On the whole, it does a remarkable job of wrapping up all the stories the show floated this season, even as it displays some of the same questionable scripting that plagued season three at times. In deference to the spirit of the show, I won't judge these choices. But I am *curious* about why Isaac needs to take the crucial penalty kick when he never has before nor has expressed any desire to do so. (It does result in a busted face for the tedious John Wingsnight, so that's something.) I'm also *curious* about why Roy and Jamie, who've spent the previous eleven episodes bonding and growing, probably the most enjoyable subplot of the season, suddenly resort to beating each other up over Keeley. (Maybe Jamie's first beer in months hits him extra hard?)

But overall the season (and possibly series) finale is a satisfying send-off for Ted and the gang, a seventy-five-minute helping of the kind of jokes, grace notes, and shameless heartstring tugs that make *Ted Lasso* the defining comedy of its era, however brief.

Before we get into the details of the episode, let's pause to spare a thought for Rebecca's maid. I'm sure the woman works hard and sees many things no one would want to see. But I'm guessing the sight of Willis Beard in a banana hammock just jumped to the top of that list. (It jumped to the top of mine, anyway.)

It's a peculiar way to begin a finale full of callbacks and cameos—Wingsnight, Mary and Darren from "Beard After Hours," the "ussie" kid, George Catrick's testicles—and other bits of fan service. The opening scene is more like fan trolling, faking out the vocal cohort who wanted to see Ted and Rebecca pair off. As Rebecca sits in her kitchen watching TV, we see Ted stumble awkwardly into view, and they then spend several clumsy minutes having cryptic morning-after conversation that ends up being about—gotcha!—Ted's impending departure, not anything that transpired the previous night. (Beard and Jane seem to have enjoyed themselves, though.)

From there, the episode tidily ties up nearly every loose end. Series finales are always tricky, and as a class they have a mixed track record. But they usually reflect something fundamental about the shows themselves, intentionally or otherwise. The final episode of *The Sopranos*, with its legendary cut to black, was masterful and uncompromising; *Breaking Bad* was tense, tragic, and efficient; *Lost* was heroic and ambitious but all over the place and somewhat inscrutable; *Cheers* was warm, confident, and easygoing; *Game of Thrones* was spectacular and uneven, with great minor moments and odd major ones; *Seinfeld* was eccentrically silly and either hilariously or annoyingly self-indulgent, depending on your vantage. (I fall into the former camp.) Ditto for *Curb Your Enthusiasm*. (Ditto for me, too.)

Ted Lasso told tough stories wrapped in a weighted blanket of folk

wisdom, emotional uplift, and well-crafted comedy; its mission, we were reminded over and over, was to help its characters become their best, most empathetic and self-accepting selves. After they, like all of us, were run through wringers of heartbreak and failure, trauma and loss, seeing these essentially good people helping one another try to do better—and succeeding—can't help but be deeply emotionally satisfying.

So *of course* Nate and Ted hash and hug it out in front of the empty BELIEVE sign spot. *Of course* Rebecca meets her Dutchman and his daughter. *Of course* Sam makes the Nigerian team. *Of course* Colin gets to kiss his fella on the field. *Of course* the BELIEVE sign is reassembled in the most stirring, cooperative way possible. They are unabashedly crowd-pleasing moments, but for *Ted Lasso* to have omitted them or handled them in less hopeful ways would have been a betrayal of its own nature.

The sign assembly is particularly meaningful, with the places the players kept their individual fragments having significance for each of them. Jamie has been using his as a bookmark for *The Beautiful and the Damned*, the book he discarded in season one when Ted gave it to him. Isaac's is beneath his captain's band, Colin's behind a protective shin guard. Declan Lowney, who directed the episode, said that in a rehearsal Sudeikis told each of the actors where their characters had kept their pieces, and why. "He gave everybody a place to put theirs and what they were thinking when they took it, why they kept it," Lowney recalled. "And it meant that when we came to shoot it the next day, each time a guy stood up and put it down, it was loaded with emotion." When the players bend over to start putting it back together, it leaves Ted and Nate facing each other from opposite sides of the scrum as the tattered totem that links them is restored. "That's a gorgeous moment for me," Lowney said.

The emotional high point of the episode comes when Ted and Rebecca finally discuss the topic she has been avoiding: Ted's departure. They are sitting in Nelson Road's designated tough-love seats, the same ones where Ted and Roy discussed the latter's fading skills in season one. There is a kind of desperation in Rebecca—Hannah Waddingham gives a heartbreaking performance—as she has moved from the denial stage of grief to bargaining as she offers to make Ted the Premier League's highest-paid coach and spins out proposals for him to bring his family to London instead. (Presumably her anger stage happened off-camera, like so much of the third season.) She resolves to sell the team if Ted leaves—"If you go, I go"—and at the Crown & Anchor later, her mother tells her to go for it. But the pub lads, in their most narratively momentous act, convince her with their gratitude—"Kinda like the mother we never had," Paul tells her, which at least partly explains their attachment to Mae—to sell 49 percent of the team to the fans. (For the record, there are a number of football clubs in England that are partially or fully owned by supporters or communities, but none in the Premier League.)

When Rebecca accepts Ted's return home and resolves to stay in Richmond with her family, as she puts it, it represents the final step in her evolution. She has rid herself of Rupert: earlier she declined to comment on his divorce and scandal because "I just genuinely don't care anymore." In letting go of Ted, a kind of emotional support mustache, she is finally, conclusively reclaiming herself, which clears the way for her to let a strapping pilot and his little girl into her life.

Sudeikis has said the goal of Ted Lasso was to leave all its characters at least a little better than they were at the beginning. (Again, aside from Rupert, though maybe his disgrace will provoke some productive soul-searching.) As Ted and Rebecca go their separate ways, they are leaving behind the sadness that, though they didn't

realize it at first, has bonded them. They are able to do so because each helped the other overcome it.

While there are plenty of meaningful quiet, poignant moments in the finale, the twin poles of *Ted Lasso* are represented by its two big, noisy set pieces: the "So Long, Farewell" performance and the big match against West Ham.

How you felt about the former was likely determined by whether you are among the fans delighted by all the show's musical references—"*Wicked!*" the ussie kid says later; "*Kinky Boots,*" Ted replies—or merely tolerated them. Unlike all the quick dialogue references to *Oklahoma!*, *West Side Story*, *The King and I*, and so on that *Ted Lasso* has deployed from the beginning, the finale's "So Long, Farewell" performance is truly showstopping, in a literal sense. It's mostly a delight, though, particularly Dani's Gretl von Trapp impersonation at the end ("Adiooooos!"). The whole thing was highly produced, and you can watch a video online of the cast recording the song. "We had this debate about, How good could it be?" Lowney recalled. "How good could the singing be? How good could the choreography be? The guys had gone into the studio and recorded the lyrics beforehand, but on the day, I got them all to sing live again. So each one of them was miked and had an earpiece playing the backing track. I think in the final mix, it's mainly the lead vocal put in with some of the stuff that was already recorded. It has a kind of roughness about it still, so it wasn't too perfect."

But to Ted it's just right. "Thank you, fellas," he says. "That was perfect." And as the show's big closing number, it is hard to argue the point.

As for the sports half of the equation, even though *Ted Lasso* was never really *about* soccer, it took the sport and its depictions of it seriously, and the game scenes steadily improved over the three seasons. It also is a sports movie at heart, borrowing its original premise from *Major League* and using the genre's story beats and dramatic swings to illustrate the paths of its characters. For the final game-winning goal, for instance, Ted uses the prodigal kitman Nate's play, which features Jamie, the reformed prima donna, serving as a decoy for the increasingly self-possessed Sam, the player Jamie spent much of season one tormenting. It's the same setup the team practiced back in that first season, when Jamie bristled at not being the scorer and Sam was more callow, and the scene illustrates how far they have all come as it delivers the episode's most exciting moment. At the same time, the rich villain gets his comeuppance in dramatic fashion, with Rupert in full Palpatine mode, his black cape billowing behind him, being chased from what was once his favorite place on earth by a chorus of jeers. While that sequence was a composite of exterior, interior, and green-screen shots, Anthony Head told me, there really was a crowd of extras shouting "Wanker!" at him.

"It was really strong—they actually enjoyed it," he said. "It gave me the core of Rupert losing his connection with the club, the love he had for being a fan. So the last shot of me, taking everything in and walking into the tunnel, felt as real as it could. A devastating moment."

And because *Ted Lasso* is more specifically an *underdog* sports movie at heart, even though AFC Richmond won the big match, it still came in second. The writers did us the favor, though, in an earlier scene in which Ted rails against the confusing semantics of European football, by letting us know in advance that the club would

be going on to the Champions League anyway, presumably coached by Roy, Beard, and Nate. (So why wouldn't Ted wait until after the Champions League tournament to go ho— Oh, why ruin it with details?)

But where *Ted Lasso* finds its most fundamental harmony with sports movies is in that signature showcase: the big halftime speech. Ted uses his final one at Richmond for one last message of love, encouragement, and instruction and to remind his players, as mentioned, to "be here right now." He makes the case that sports is the ultimate expression of living in the moment.

"Now regarding this second half . . . I don't know what's gonna happen. No one does," he says. "Sports would be a lot less fun if we did."

You could say the same about life, and Ted probably would. It's a simple lesson, one you probably and I definitely have been hearing for decades: live for the moment, carpe diem, et cetera. But it is the most obvious, most ubiquitous messages that can be the hardest to internalize—they can seem like clichés, ceasing to have any meaning through repetition.

But part of accepting the beauty (and occasional frustration) of not knowing is accepting that some days I will fall short. I will not always be able to be present and be grateful for the time and experiences I have before me. I'll struggle to meet each day as if it might be all that I get, and treat it with the reverence that demands.

But partly thanks to *Ted Lasso*, heaven knows I'll try.

WHO WON THE EPISODE?

Everyone! (Again, except for Rupert.)

BEST SAVE

The AFC Richmond players, for saving their bits of the BELIEVE sign.

BEST ASSIST

Yusuf Islam, who as Cat Stevens wrote and recorded the only song that could score the final *Ted Lasso* montage: "Father and Son."

BEST LINE

Sassy to Rupert: "I do wish you the best, because you are the fucking worst." Sure, I could go with something more inspirational for the final episode, but Sassy, as played by Ellie Taylor, always delivers and deserves credit for it.

RANDOM STATS

- *Ted Lasso* has always loved a callback, and never more so than in the finale. Others not already mentioned (though this list is far from comprehensive): Rebecca saying "Shut up, Thierry Henry!" to her TV; Roy and Keeley meeting in the parking lot; Rebecca's spit take in her office; Keeley asking the locker room, "Is everybody decent?"; Roy mouthing along to the lyrics of "So Long, Farewell"; Jamie telling Roy that Keeley's illicit video was made for him; Jamie repeating Ted's decoy script from season one; Ted saying "barbecue sauce" right before Sam strikes home the winning goal; Ted and Nate's hug-hoist at the end of the game; and of course, Ted dancing on the field after the big win. "I never know how to react when a white guy does the Running Man in front of everyone," commentator Chris Powell says. It's a fair point.

- "I hear he wants to be called Zorro now," Powell says earlier,

referring to the goalie formerly known as Zoreaux and Van Damme. "Well it's about time!" his partner, Arlo White, replies, speaking for all of us.

- In the last scene in the Crown & Anchor, Mae straightens a small portrait of Geronimo, the Apache warrior and leader. It is a tribute to *Cheers*—Ted Danson's Sam Malone does the same to a larger version in the series finale. The picture itself was a tribute to Nicholas Colasanto, who played Coach and put the portrait on the wall of his dressing room. When Colasanto died after the third season, the show moved it to the bar set.

- The Richmond Green snow globe Keeley gives Ted after he leaves his job is presumably the one she previously gave her new partner, Barbara—note the KBPR sign at the end—earlier when she left her job, which Barbara then returned when she came back. It is also perhaps a nod to the 1980s hospital drama *St. Elsewhere*, which famously ended its acclaimed run—thirty-six-year-old spoiler alert—by revealing, in the finale, that the whole thing had been a child's fantasy inspired by a snow globe.

- Some people thought the show's final montage, which ends with Ted waking up on the plane, had been his dream. (Or at least that Beard and Jane's fantastical Stonehenge wedding had been.) But Brendan Hunt confirmed in a Reddit AMA after the finale that it was all real, or as real as a fictional TV montage can be.

- The wedding, featuring a pregnant Jane, and Beard in his magic trousers—another callback—was filmed in a different studio than the rest of the show. It was also the last thing Mae and the pub lads shot. "That was rather a nice way to end," Annette Badland told me. "It was just a very strange experience that it would now go into the ether and that would be it." The lads are wearing the same suits they wore in the "Beard After Hours" episode. "So it was a bit of newness, like, this is an interesting way to end because we've never been here before," Adam Colborne said. "And then also some

amazing nostalgia with these old costumes and also everyone being together in that moment. And there were tears, yeah."

- When Ted arrives back in Kansas near the end of the episode, it's unclear exactly what kind of welcome awaits him from Michelle, his ex (if she ever filed the divorce paperwork). But it does seem like the absurdly unethical Dr. Jacob has hit the bricks—it's hard to imagine Ted rolling his suitcase into the house if Jacob is still around, and there is no sign of him with Michelle at Henry's game. (So many people get second chances in the final season, from Nate to Keeley to Jamie's rehabbing dad. Why not Ted?) But whatever the state of Ted's marriage, the last match of the series—presumably the only rec league game in America with a former Premier League manager on the sideline—finds him finally synthesizing the defining halves of his spirit: coach and father. And in our final glimpse of Ted Lasso, a contented counterpoint to the forlorn shot of him that opened the season, we see a smile not of ingratiation, folksy humor, or deflective cheer, but of a man who has earned his equanimity and is finally, in every sense of the word, home.

STOPPAGE TIME

THIS IS THE END?

"It has been a tremendous, wonderful experience."

The third season of Ted Lasso premiered on March 15, 2023, or 523 days after the season two finale dropped on October 8, 2021. Anticipation was high; press coverage was intense. The show was the two-time reigning top comedy at the Emmys, and fans had been waiting for nearly a year and a half to see more. Finally more was here: twelve new episodes to roll out weekly over the next few months.

So it was a little odd that the thing people most wanted to know was: What happens after that?

Jason Sudeikis had said from the beginning that Ted Lasso *was a three-act story. He, Brendan Hunt, and Joe Kelly initially conceived it on the model of the British* Office: *two short seasons and a special. When it took off in its first season, Apple gave them two more entire seasons and asked for more episodes. Those episodes got longer. A show that began with a season of ten roughly thirty-minute episodes ended*

with two twelve-episode ones and a finale that was well over an hour. So it ended up being much more robust than its creators had originally anticipated.

But no matter how many times Sudeikis said some version of "This story will be over after three seasons," the response was "OK but seriously: Is the show ending or not?" And because no one ever said definitively that it was—and because Apple rejected any reports suggesting that it was—the question kept getting asked and everyone involved with the show kept saying "We don't know" and Ted Lasso was denied the sort of final-season victory lap that its dramatic juggernaut counterpart, HBO's Succession, was enjoying at the same time.

Jason Sudeikis, creator, Ted Lasso, seasons 1–3: I've always said this was the story we wanted to tell. So it feels a little silly to keep going back to it. But again, not ever expecting or imagining people's reaction or response to it, and also with the process of making it being such a joyful one, it's like, OK, maybe there's more there. But it has to come from the stories and the characters, and we have to satisfy these ends here before really having that conversation. It feels a little like you're talking about next season when you're in the playoffs.

Brendan Hunt, creator, Coach Beard, seasons 1–3: We need a break and will take one presently. Nothing has been ruled out, everything is possible; but that includes the possibility that we're done. We won't know until we've sat with it for a while, decompressed, et cetera.

Jason Sudeikis: The workload of doing these last three seasons has been a tremendous experience, but also one that's dominated my time and creative energy. Just pulling off these three seasons, the stories we're telling in the way we were telling them, has been a wonderful labor of love, but a labor nonetheless. It's like, How do I answer? Do I say, "No, it's done," and then three years from now there

is one, and I'm a liar? That doesn't seem like any fun. I say, "Yes, there is gonna be one," and then let a bunch of people down? So I just haven't allowed myself the opportunity to mull it over with the intention that I think something like that should be given. There's all sorts of tangible reasons why one should do it, why many people would say yes immediately. I just have a different metric for the decision.

Succession aside, Ted Lasso *again dominated the TV conversation in its final (?) season, particularly among streaming shows. Each week brought abundant recaps, explainers, interviews, and other features. Parrot Analytics, which assesses the popularity of shows by analyzing streaming, social media, and search and other online behaviors, said it was the world's most in-demand streaming original series from April to June 2023. According to Nielsen,* Ted Lasso *was the most-streamed original series of 2023, with an estimated 16.9 billion minutes of viewing. ("Streaming originals" are shows produced by a streaming platform, as opposed to "acquired series," like, say,* Grey's Anatomy *airing first on ABC but also streaming on Netflix.)*

Such popularity and audience enthusiasm had become typical for Ted Lasso. *But the new season also brought something new to the pitch: the first significant backlash against the series. While there had been some grumblings during season two, a small but hostile crowd of dissenters seemed to grow by the week in season three. Some didn't like how the core cast had been scattered into different storylines; others complained that the narrative had gotten too diffuse and unfocused. Critics thought Keeley's subplot was pointless, Nate's mishandled, and Zava's random and randomly abandoned. About midway through the season, headlines started appearing like "Ted Lasso Has Lost Its Way" (The Atlantic); "Ted Lasso Is a Mess This Season. What Happened?" (IndieWire); and "Ted Lasso's Fans Need to Just Accept That the Show Is Bad Now" (Slate).*

To the people who actually made the show, the griping, as Ted might say, was like Woody Allen playing the clarinet: they didn't want to hear it.

Brendan Hunt: It's easily compartmentalized because we can't worry about people's reactions that much. We just can't. It does not help us make the show. It doesn't help us make the show better.

Declan Lowney, director, seasons 1–3: Look, that's inevitable, isn't it? You can't keep saying how lovely something is year in and year out. Maybe season three pushed the luck a little bit by going so long. Like the last episode running seventy-five minutes, you go, Fuck me, do we really want to do this? But again, I don't know any fans who said, "Oh, I wish the show wasn't quite so long."

Sara Romanelli, assistant script supervisor and script supervisor, seasons 1–3: It's difficult to have an ending that pleases everybody, that's obviously part of it. There are maybe some arcs that work better than others. Season one, you have a specific theme and it is very self-contained. Season two expanded it a little, so it gave more attention to some of the characters that were secondary in season two. Maybe season three had a little bit less cohesion in that sense. It was less a season with a beginning, middle, and end in the classical sense. Maybe some episodes work better than others. But when it comes to the conclusion, I don't know, for me it works.

Jason Sudeikis: Much like live theater, the show, especially season three, was asking the audience to be an active participant. Some people want to do that, some people don't. Some people want to judge—they don't want to be curious. I'll never understand people who will go on talking about something so brazenly that they, in my opinion, clearly don't understand. And God bless 'em for it; it's not their fault. They don't have imaginations and they're not open to the experience of what it's like to have one.

Melissa McCoy, editor, seasons 1–3: I think so many people had so many expectations for every episode, and we did, too. People are talking about it everywhere: Twitter and Reddit and Facebook and Instagram. It's so fulfilling to see it when it hits, and then it's heartbreaking if somebody doesn't like it. You go on all those wild emotions. But when you would see something negative, I would just say, like, I'm so proud of this show. And when all is said and done—whether people love it or hate it—there are things in each episode that I worked on that I absolutely adore and love and I'm so, so proud of as a team, as a group of writers, actors.

Jason Sudeikis: All we want to do is leave a little green arrow next to everybody. Everybody's in better shape than when they started. Like a good Boy or Girl Scout at a campsite, we left it better than we found it. And if you don't see that in that show, then I don't know what show you were watching.

Ted Lasso presented its final episode—for now or forever—on May 31, 2023. While the consensus seemed to be that the show delivered a generally satisfying finale, TV critics, in particular, tended to describe the final season as a disappointment on the whole. Even Kristen Baldwin at Entertainment Weekly, *whose early rave had so encouraged the cast and creators in 2020, was among the detractors in 2023. "Much has been written about the quality of this season—or, more accurately, the disheartening decline in quality—and even as a champion of the show from the beginning, I share those complaints," she wrote in a review of the finale. "The third (and final?) season of Jason Sudeikis' hit football series consisted of bloated episodes, disjointed plotting that kept characters siloed in their own little bubbles, and arcs that meandered to nowhere."*

Emmy voters, however, were another story. In July they gave Ted Lasso *twenty-one nominations, the most of any comedy for the third*

year in a row and the most the show had ever received for one season. It won only two—and none in the major categories—once the strike-delayed ceremony finally happened in January 2024. (Instead the buzzy new kitchen hit The Bear *dominated the comedy categories, though whether it is actually a comedy remains an open question.) But the Emmy extravaganza gave the* Ted Lasso *cast a chance to be together again, at least. They still took every opportunity to do so more than a year after shooting had wrapped. "We travel in a nauseating pack," Hannah Waddingham told Seth Meyers on his late-night show in December 2023.*

There was plenty of proof of this on offer after Ted Lasso *ended. The cast and creators picketed together during the writing and acting guild strikes that essentially shut down Hollywood in the second half of 2023. Waddingham and Hunt appeared at* Thundergong!, *Sudeikis's annual charity event in Kansas City to raise money for amputee medical services—Waddingham sang several songs with Sudeikis and Hunt and also shaved off Hunt's now-iconic beard onstage so the whole thing, presumably contained in an AFC Richmond kit bag or some other commemorative receptacle, could be auctioned off for charity. Hunt, Nick Mohammed, Phil Dunster, James Lance, Billy Harris, and Kola Bokinni performed in Waddingham's ritzy Apple TV+ Christmas special. The cast had a reunion at Sudeikis's old stomping grounds,* Saturday Night Live, *for the December 2023 Christmas episode. Jeremy Swift posted a photo of them all posing on the show's famous main stage. "Poignant pic as it will be one of the last times we are all together," he wrote.*

Nearly everyone associated with the show has said they would come back if Sudeikis ever decided to make more. "I would happily do it for twenty-five more years," Brett Goldstein told me in 2023 for a New York Times *profile. But even if it never happens, if the various spin-offs*

the finale seemed to set up never materialize, the experience of making Ted Lasso *is one the people involved say they will never forget.*

Jason Sudeikis: I'm proud as hell of what we made. I'm proud as hell of how we made it. I think it's a testament to the people that I got to work with. And we did our darnedest to pass that on and carry that through this whole thing.

Jeremy Swift, Leslie Higgins, seasons 1–3: Jason started using this term in the last season: we're all multiples. There are multiple amounts of experiences throughout the show. There's the ongoing reverberation of the show's impact, which you take away with you and talk to each other about and feel the aesthetic of the show and feel the positivity of it. And that's just incredible. That is really a completely unique experience to me. I've worked for forty years before this show. I don't think I'll have it again.

Brett Goldstein, writer, Roy Kent, seasons 1–3: *Ted Lasso* is such a wonderful thing and feels like such a once-in-a-lifetime thing. I'm sure whatever else happens in my life will probably (a) be compared to *Ted Lasso*; and (b) I don't think anything will be that big again. And that's fucking great, because I had that one experience.

Phil Dunster, Jamie Tartt, seasons 1–3: It's not necessarily the end of the show—we don't know. But certainly the closing of a chapter; it feels very strongly like that. It's a culmination of so many people's huge efforts. I'm just glad that it is out there, and it seems to have struck a chord with people.

Brendan Hunt: I don't think it's any particular single secret. It's just a lot of really well-chosen ingredients. Our writers' room was really well curated. Our cast is excellent. Our designers are excellent, our directors. We have a rule, or at least a hope, of "no turkeys," meaning no one's a dick, no one's bringing everybody down and not pulling their weight. We just have a lot of people who are good at

what they do and whose hearts are in the right place and who give a shit about their work and what they're working on. Those are kind of Ted qualities to have, too, so it's all of a piece.

Anthony Head, Rupert Mannion, seasons 1–3: Everyone on the show contributed so amazingly—it was wonderful to be part of such a lovely family. Wardrobe, makeup, designers, writers, camera crew, lighting, ADs, directors, production, everyone. From the moment I stepped onto the makeup truck in the morning and said hi to the lovely team there, I'd feel like I'd come home after being away.

Declan Lowney: I feel so lucky to have gotten anywhere near this and to be so trusted by Jason with his baby.

Annette Badland, Mae Green, seasons 1–3: I'm highly unlikely to encounter Jason again, or Brendan or all those people. My boys, I'll keep in touch with them—we keep planning meals that one of us can never make. For all of us, it was a very special event. It was a phenomenal team of folks, and I think it was a very rare piece of work. It certainly will be in my life, I think, and my acting career. Very particular indeed.

David Elsendoorn, Jan Maas, seasons 2–3: So many doors would open to you. Being in L.A. when we won the Emmys, Steve Carell walking up to me and saying, "Hey, congrats on all the wins." And I was like, This is just so weird. So many of those surreal moments, you know?

Billy Harris, Colin Hughes, seasons 1–3: If you're doing a show like *Ted Lasso*, you can't go "cut" and then be not nice on set. It just doesn't work. So the atmosphere on set, as a community, was great. And now in Richmond, down in London, you see these tours going on, AFC Richmond tours, and they're going into the pub and everything like that. I don't know what we've done, but it feels like we've done something.

Juno Temple, Keeley Jones, seasons 1–3: I'm so proud to be a part of the show and to be a part of the light that it's put out in the world, but also vulnerability and space for creating conversations. It's been so lovely talking to people, whether it's friends or family or people that I've met around the world, about how much it brings their families together.

Toheeb Jimoh, Sam Obisanya, seasons 1–3: If all of us are going somewhere together, people will find out where we are, what hotel we're staying in, and stuff like that. It's fun, though, because *Ted Lasso* fans are so wholesome, right? Usually, it's just people wanting to say hello because they feel like you represent their best friend. It's almost never gonna be like this again, where everybody that says hello to me has such an overwhelmingly positive response.

Billy Harris: I don't think you can be a negative *Ted Lasso* fan. When we're out on the street, everyone that comes up to us, we know we're gonna have a decent conversation because they watched the show and they love the show.

Toheeb Jimoh: Every time it's a reminder, not just of the show being really entertaining, but that it means so much to people. It really hits people in their souls, man. Every now and then, you can just run into someone who's like, "I was at my lowest point during the pandemic and this show was the thing that kept me going." It's a lot to deal with, but it's also really humbling.

Jason Sudeikis: All of us on camera, we get approached. People will say to us, "This show saved me." And I will say back, "Me, too." The questions we get about this show, the stories, are tremendous. They're tremendous in their size and scope, whether it be someone that's decided not to take their own life because they're a parent, and they're thinking about what Ted's gone through and what the father had gone through, or people just being like, "I'm going to

be nicer at work." People in hospital rooms putting up BELIEVE posters, all that stuff. The show isn't made from anywhere but love.

Adam Colborne, Baz Primrose, seasons 1–3: It is authentic, you know, there's a lot of real love in the company. Obviously, British TV is great, but for them to bring this show to England just felt really special to us all. We were just so grateful for it.

Bronson Webb, Jeremy Blumenthal, seasons 1–3: I mean, I've never had an award before but I'm part of an ensemble award at the Screen Actors Guild. It's incredible to be part of something that's touched so many people, and I still to this day get so many people on Instagram inspired by the show and talking about what it means to them and what it has helped them with.

Maximilian Osinski, Zava, season 3: People have reached out to me on social media or stopped me on the street in the States or in London. It's been very surreal and heartwarming. It's nice to meet people who say they like the work you did and love the character you worked on. With Zava, you're not sure how people are going to take him in because of the kind of role he is. It's mainly like, "Hey, are you Zava from *Ted Lasso*?" or "Oh my god. You are Zava," that kind of thing. Then I just always laugh like, "Oh, yeah, yes, I am." I try to get to know them a little bit. I'm still at this stage in my life where it's very flattering and humbling, and it's really nice.

Chris Powell, soccer coach, played himself as a commentator, seasons 1–3: Even yesterday, we had our first home game. [Powell is currently an assistant coach at Sheffield Wednesday F.C.] And the first thing two people said to me was, "Oh, can I have a picture? I loved you in *Ted Lasso*." I had a twenty-four-year career as a player, ten to fifteen years as a coach or manager, and they're asking me about *Ted Lasso*. It happens a lot. And they want more. They asked me yesterday, "Is there going to be a season four?" And I said, "Well,

I don't know, the way it ended, I doubt it." There is scope to do something else, whether it's a film, whether it's one of the other characters.

Bronson Webb: Everyone's asking about season four. We are all up for it. We always talk about that in that Crown & Anchor group, we're just constantly saying, "We can have a spin-off!" Maybe we should write it ourselves and pitch it to Apple.

Adam Colborne: I think there's definitely scope there for that world to be revisited at some point.

Toheeb Jimoh: It feels like there's a closing of sorts. Whether that's closing of chapter one, or whether that's the closing of the book of *Ted Lasso*, I don't know. That's up to them. But there are avenues, if we wanted to carry on.

Nick Mohammed, Nathan Shelley, seasons 1–3: I feel like there are so many stories still to tell. You could watch a lot of these characters. I would love to see how their stories continue. Given the way that the finale played out, it feels like it couldn't be a show without Ted. But I struggle to work out why Ted would ever come back, because his story has always been pointing toward going back to his family. There's a sense of finality there. I don't know. I would just love to hang out with all those guys and girls again, because we're such a family.

Hannah Waddingham, Rebecca Welton, seasons 1–3: Sometimes I think people think it's contractual that we spend time together. But even things that we do like Q&As and stuff, we're trying to slip out the door to start our evening together, which is so lovely. And I think that comes through the camera and that's why people have loved *Ted* so much. Yeah, we miss it. We miss it, Jason!

Jason Sudeikis: It's been lifesaving, life-giving. And in the most thrilling way of not solely for myself, but for people that I care about, that I cared about before this thing ever existed. People that I care

about since it's happened, that I've met through the process of doing it. The way the world and the universe has responded to our show and the way that people respond to us as people—it has been a tremendous, wonderful experience.

Brett Goldstein: I am amazed and I love that it means something to quite a few people. And I think that those people would be delighted if they knew the truth, which is it means the same to us.

ACKNOWLEDGMENTS

There's just the one name on the jacket, but book-writing—like soccer, like TV production, like nearly anything worth doing—is a team effort.

I know that now because my agent, Rick Richter, reached out in March 2023 with a simple question: Have you ever considered writing a book about *Ted Lasso?* Me: "I have not, but tell me more. . . ." So he was the mastermind of this whole scheme, and he patiently talked and walked me through a process that went from bewildering and intimidating to impossible to quasi-manageable to rewarding to—ta-da!—done. I am grateful for his support and expert guidance throughout.

I couldn't have asked for a better editor for my first book than Jill Schwartzman, who had great ideas for, well, everything—schedule, structure, focus, the text itself—and made everything she touched immeasurably better. Charlotte Peters handled all the extra tasks publishing a book entails (and my procrastination in doing most of them) with excellence and grace. The entire team at Dutton was fantastic, including Emily Kimball, Isabel DaSilva, Hannah Poole, and Erika Semprun. They are all incredibly sharp, pleasant (and patient) folks who held my hand and saved me from myself on multiple occasions. I am very grateful.

Sia Michel, my brilliant boss at *The New York Times,* helped me carve out time to work on this book, and my colleagues on the Culture desk made it possible. Their creativity, integrity, camaraderie, and brilliance

inspire me daily, and I'm never not honored to be part of an organization committed to art, civic enlightenment, objective truth, and holding power to account. (And Wordle.)

Oriana Schwindt provided valuable research assistance. Emmy Mc-Morrow, a gifted London actor, was my Richmond guru and helped connect me with its leaders. (If you're ever in the area, don't miss her *Ted Lasso* walking tour.) Cory Jamieson, cofounder and executive producer for Barnstorm VFX, patiently explained the amazing (and amazingly complex) technical process that turned a bunch of actors kicking a ball in a field into, say, a Richmond–Man City match in the Etihad Stadium. (Any errant facts herein are entirely my fault.)

My friend Nick Sonderup was my go-to authority for both the advertising industry and the Premier League. My old pal Jay Ray, with his steady stream of NBA commentary and stupidly brilliant (and vice versa) text jokes, kept me intact when deadline pressure nearly broke me in half pretty bad. (I'm just as God made me.)

Ted Lasso nation, as thoughtful and devoted a TV fandom as I've encountered, inspired me throughout the writing of *Believe*. My thanks also to the diligent, insightful reporters, critics, editors, and recappers who covered the show during its run, especially to Yvette Nicole Brown, Rich Eisen, Jeremy Goeckner, Zach Goins, Scott Mantz, Craig McFarland, Matt Noble, Guy Raz, Jenelle Riley, Kate Thornton, and the many other smart, perceptive interviewers and moderators whose work informed this book. SAG-AFTRA's various conversation and interview series, in particular, were a vital resource.

I am extremely appreciative of everyone who spoke with me for *Believe*. I'm particularly indebted to Declan Lowney, Sara Romanelli, Annette Badland, Anthony Head, Chris Powell, Adam Colborne, Bronson Webb, David Elsendoorn, Bill Bergofin, and John Miller for their wide-ranging insights, thoughts, and memories. Though I didn't realize it when I was reporting and writing it, my 2023 profile of Brett Goldstein in

The New York Times was the seed of this book, and it wouldn't have been possible without his openness and generosity. Thanks, Brett. And, of course, thanks to Jason Sudeikis, Brendan Hunt, Joe Kelly, and Bill Lawrence for creating a show that means so much to so many and is so worthy of deep exploration.

One of the key tenets of *Ted Lasso* is that people need people, that it is our relationships that carry us forward to where we're supposed to be. In this regard, I have been truly blessed, with many great friends and colleagues who enrich my life, and family who have given it meaning since before I can remember. My parents, Pam and Doug Egner, have provided a foundation of love, support, and encouragement that I can never repay, only appreciate forever. My brothers, Ben and Alex Egner, make me very proud and make me laugh very hard, especially if there's whiskey around.

My wife, Leslie Yazel, is my love, my partner, my first reader, and my biggest fan, the one who makes all things possible. My daughter, Jemma, is my entire world. It's all for you, my very special girl.

SOURCE NOTES

INTRODUCTION
Archival author interviews with Brett Goldstein (2022) and Jason Sudeikis (2021).

CHAPTER 1: THE BIRTH OF TED
Author interviews with Bill Bergofin, Donna-Maria Cullen, and John Miller.
Archival author interview with Jason Sudeikis (2021).
Quotes by Guy Barnett, Bill Bergofin, and John Miller: Tim Nudd, "*Ted Lasso's* Origin Story," November 14, 2022, in *Tagline*, podcast, 45:00.
"Chicago White Sox vs. Chicago Cubs," New Era Cap ad, 2012.
"Jason Sudeikis," May 31, 2023, in *Fly on the Wall with Dana Carvey and David Spade*, podcast, 2:01:00.
"Coach Bert," *Saturday Night Live*, season 37, episode 8, featuring Jason Sudeikis and Steve Buscemi, aired December 3, 2011, on NBC.
Jason Sudeikis interview, *Late Show with David Letterman*, aired July 24, 2013, on CBS.
Quotes from Guy Barnett: Guy Barnett, "'Ted Lasso' Ad Creator Tells the Origin Story of the Emmy-Winning Character," *Ad Age*, September 20, 2021.
Quotes from Brendan Hunt: "Brendan Hunt Talks Playing Ted Lasso's 'Coach Beard' & More," August 5, 2021, in *The Rich Eisen Show*, podcast, 16:11; "Brendan Hunt—Hour 3," March 30, 2023, in *The Rich Eisen Show*, podcast, 50:25.
Quotes from Jason Sudeikis: "Jason Sudeikis on Becoming Ted Lasso: 'I Didn't Want to Snark Out Anymore,'" April 4, 2023, in *The Great Creators with Guy Raz*, podcast, 1:12:59.
"Jason Sudeikis Tells Chris Evans 'It's Flattering That People Want More' *Ted Lasso*," Virgin Radio, April 28, 2023.
Quotes from Jason Sudeikis: Oliver Franklin-Wallis, "GQ&A: Jason Sudeikis on Jennifer Aniston's Striptease, His High-Tops Obsession and That Mumford & Sons Video," *GQ*, September 16, 2013.

"An American Coach in London: NBC Sports Premier League Film Featuring Jason Sudeikis," YouTube video, 4:41, posted by "NBCSportsNetwork," August 3, 2013, https://www.youtube.com/watch?v=6KeG_i8CWE8.

Quotes from Jason Sudeikis: *Late Night with Seth Meyers*, aired August 16, 2020, on NBC.

"The Return of Coach Lasso: NBC Sports Premier League Film featuring Jason Sudeikis," YouTube video, 6:05, posted by "NBCSportsNetwork," August 8, 2014, https://www.youtube.com/watch?v=iRqypM7jb5Y.

CHAPTER 2: TED FINDS PURPOSE (AND A HOME)

Archival author interviews with Brett Goldstein (2023), Brendan Hunt (2021), Bill Lawrence (2021), and Jason Sudeikis (2021).

Quotes from Jason Sudeikis: "Jason Sudeikis on Becoming Ted Lasso: 'I Didn't Want to Snark Out Anymore,'" April 4, 2023, in *The Great Creators with Guy Raz*, podcast, 1:12:59.

Quotes from Brendan Hunt: "Brendan Hunt—Hour 3," March 30, 2023, in *The Rich Eisen Show*, podcast, 50:25.

Quotes from Bill Lawrence: Luis Miguel Echegaray, "'Ted Lasso' and the Journey from Viral Promo to TV Series," *Sports Illustrated*, August 11, 2020.

Quotes from Bill Wrubel: Adam Turteltaub, "*Ted Lasso* Executive Producer Bill Wrubel on Culture and Ethics," August 21, 2021, in *Compliance Perspectives*, podcast, 19:24.

Quotes from Joe Kelly: "The Creators of *Ted Lasso* Laugh about the Show's Initial Reception," YouTube video, 0:41, posted by "60 Minutes," March 17, 2023, https://www.youtube.com/watch?v=752Gyu8nNmA.

Quotes from Jane Becker: Quincy Cho, "Jane Becker on the Sincerity of Writing 'Ted Lasso,'" *Final Draft* (blog), June 6, 2022, https://blog.finaldraft.com/jane-becker-on-the-sincerity-of-writing-ted-lasso.

Quotes from Brett Goldstein and Jason Sudeikis: South by Southwest, "'Ted Lasso' Strikes Back," panel discussion, Austin, TX, March 14, 2022.

Quotes from Jane Becker: Sadie Dean, "Telling Your Truth on the Page with 'Ted Lasso' Writer Jane Becker," *Script*, June 10, 2022.

Quotes from Brendan Hunt: "Meet *Ted Lasso* Stars Brett Goldstein and Brendan Hunt," *Entertainment Weekly*, June 4, 2021; Sadie Dean, "The Calling of 'Ted Lasso' the Feel-Good Show of 2020," *Script*, May 28, 2021.

CHAPTER 3: PICKING THE TEAM

Author interview with Tom Marshall.

Archival author interviews with Brett Goldstein (2023), Bill Lawrence (2023), Nick Mohammed (2021), and Jason Sudeikis (2023).

Quotes from Theo Park: "'Ted Lasso' Creators on Working Behind the Scenes with Jason Sudeikis," Closer Look, YouTube video, 17:49, posted by *The Hollywood Reporter*, August 18, 2023, https://www.youtube.com/watch?v=ANBPiZ6naoo.

Quotes from Bill Lawrence and Theo Park: "Bill Lawrence and Theo Park," May 26, 2021, in *Crew Call with Anthony D'Alessandro*, podcast, 31:48.

Quotes from Theo Park: Robin Milling, *"Ted Lasso* Casting Director Theo Park Fulfills Each Role with the 'Ted Lasso Effect,'" *Below the Line*, August 24, 2021.

Quotes from Jason Sudeikis: "Conversations at Home with Jason Sudeikis and Brendan Hunt of TED LASSO," YouTube video, 42:07, posted by "SAG-AFTRA Foundation," December 9, 2020, https://www.youtube.com/watch?v=o3kHBzmNjl8; "Jason Sudeikis Talks 'Ted Lasso' Future, 'SNL,' Big Slick & More with Rich Eisen," May 11, 2023, in *The Rich Eisen Show*, podcast, 32:03.

Hannah Waddingham interview, *Jimmy Kimmel Live*, aired September 16, 2021, on ABC.

Benjamin Lindsay, "Hannah Waddingham Booked 'Ted Lasso' Thanks to This Self-Tape Audition Trick," *Backstage*, August 11, 2021.

Quotes from Hannah Waddingham: Kate Thornton, "Hannah Waddingham," August 26, 2021, in *White Wine Question Time*, podcast, 52:00; "Hannah Waddingham," September 2020, in *Films to Be Buried With with Brett Goldstein*, podcast, 68:37.

Quotes from Theo Park: Cat Elliott, "Theo Park Pulls Back the Curtain on Casting 'Ted Lasso,'" Casting Networks, August 25, 2023.

Juno Temple interview, *The Tonight Show Starring Jimmy Fallon*, aired August 18, 2022, on NBC.

Quotes from Juno Temple: "Join Juno Temple's Youth Sanctuary!" June 16, 2022, in *Dan Fogler's 4d Xperience!*, podcast, 57:00.

Quotes from Phil Dunster, Nick Mohammed, Jason Sudeikis, Jeremy Swift, and Juno Temple: Jacob Stolworthy, *"Ted Lasso*: An Oral History on the Rise of Jason Sudeikis's Feel-Good Comedy for the Ages," *Independent*, July 22, 2021.

Quotes from Brett Goldstein: Alexis Soloski, "In 'Ted Lasso,' Juno Temple Makes Nice," *New York Times*, July 22, 2021.

Quotes from Juno Temple: Joe Utichi, "Juno Temple on Her Character in Comedy Debut 'Ted Lasso': 'Keeley Has Saved My Mental Health, Truly,'" *Deadline*, June 6, 2021.

Quotes from Brett Goldstein: Jeremy Egner, "Brett Goldstein Faces Life after 'Lasso,'" *New York Times*, March 11, 2023; "Meet *Ted Lasso* Stars Brett Goldstein and Brendan Hunt," *Entertainment Weekly*, June 4, 2021; interview, *Deadline's Behind the Lens with Pete Hammond*, June 23, 2023, video, 24:04.

Quotes from Brendan Hunt: "Brendan Hunt—Hour 3," March 30, 2023, in *The Rich Eisen Show*, podcast, 50:25.

Quotes from Brendan Hunt, Nick Mohammed, and Jeremy Swift: "Ted Lasso HCA Roundtable: Brendan Hunt, Jeremy Swift, and Nick Mohammed," Hollywood Critics Association, June 10, 2021.

Quotes from Brett Goldstein, Brendan Hunt, and Jason Sudeikis: Steve Pond, "'Ted Lasso' Stars Admit Ted's Sunny Philosophy Doesn't Always Work," *The Wrap*, August 18, 2021.

Quotes from Jeremy Swift: Jeandra LeBeauf, "Hannah Waddingham Dominates and Jeremy Swift Serves in 'Ted Lasso,'" *Black Girl Nerds*, August 14, 2020, https://blackgirlnerds.com/hannah-waddingham-dominates-and-jeremy -swift-serves-in-ted-lasso/.

Quotes from Toheeb Jimoh: Jeremy Goeckner and Craig McFarland, "An Interview with Toheeb Jimoh (Sam Obisanya on 'Ted Lasso')," May 6, 2022, in *Peanut Butter and Biscuits Shrinks: A Ted Lasso/Shrinking Fancast*, podcast, 53:15; "Toheeb Jimoh on His Breakout Role in Ted Lasso," *Q with Tom Power*, April 4, 2023, radio broadcast, 31:13, CBC.

Quotes from Brendan Hunt: Michael Ordoña, "How Toheeb Jimoh of 'Ted Lasso' Found His Character's Home—and His Own," *Los Angeles Times*, August 3, 2022.

Quotes from Phil Dunster and Toheeb Jimoh: Hannah Jackson, "Toheeb Jimoh Is 'Ted Lasso's' MVP," *Bustle*, March 28, 2023.

Quotes from Brett Goldstein: Tim Lewis, "'I Look for the Good in All Situations': The Power's Toheeb Jimoh," *Guardian*, April 9, 2023.

Kara Warner, "'Ted Lasso's' Phil Dunster on Playing Lovable Bad Boy Jamie Tartt: 'He's a Lot Softer on the Inside,'" *People*, August 16, 2021.

Quotes from Phil Dunster: "Andrew Whitworth & Phil Dunster/Jamie Tartt—Hour 3," October, 8, 2021, in *The Rich Eisen Show*, podcast, 56:00; Calum Marsh, "'Ted Lasso' Taught Phil Dunster How to Play Nice," *New York Times*, May 31, 2023.

Quotes from Kola Bokinni: Jeremy Goeckner and Craig McFarland, "An Interview with Kola Bokinni (Isaac McAdoo in *Ted Lasso*)," November 19, 2021, in *Peanut Butter and Biscuits Shrinks: A Ted Lasso/Shrinking Fancast*, podcast, 58:00.

Quotes from Cristo Fernández and Theo Park: Apple TV+, "The Cast and Casting Director of 'Ted Lasso' in Conversation with Yvette Nicole Brown," panel discussion, June 10, 2023; SAG-AFTRA Foundation Conversations series, "Ted Lasso" cast panel discussion at TCL Chinese Theatre, Los Angeles, January 16, 2024.

KEY INFLUENCES: THE SURPRISING INGREDIENTS OF A SURPRISE HIT

Author interview with Adam Colborne.

Archival author interviews with Jason Sudeikis (2021, 2023).

"Brendan Hunt—Hour 3," March 30, 2023, in *The Rich Eisen Show*, podcast, 50:25.

"Juno Temple and Phil Dunster Q&A for 'Ted Lasso' | SAG-AFTRA Foundation Conversations," YouTube video, 33:06, posted by "SAG-AFTRA Foundation," June 6, 2023, https://www.youtube.com/watch?v=NAVZnUVKx78.

Allen Iverson, NBA press conference, May 7, 2022.

Ted Lasso, season 1, episode 6, "Two Aces," directed by Elliot Hegarty (Warner Bros. Television and Apple TV+, 2020).

"Jason Sudeikis on the Hidden Truths behind Ted Lasso's Allen Iverson Tribute," IndieWire, July 23, 2021, https://www.indiewire.com/video/jason-sudeikis-ted -lasso-allen-iverson-not-funny-interview-1234641283/.

"Jason Sudeikis (Part 1)," August 16, 2023, in *Films to Be Buried With with Brett Goldstein*, podcast, 1:22:34.

The Empire Strikes Back, directed by Irvin Kershner (Los Angeles: 20th Century Fox, 1980).

Sadie Dean, "Telling Your Truth on the Page with 'Ted Lasso' Writer Jane Becker," *Script*, June 10, 2022.

Ted Lasso, season 2, episode 5, "Rainbow," directed by Erica Dunton (Warner Bros. Television and Apple TV+, 2021).

"Ted Lasso Q&A with Jason Sudeikis and Costars on Their New Apple TV Plus Comedy Series," YouTube video, 41:17, posted by GoldDerby, March 18, 2021, https://www.youtube.com/watch?v=QMqKFHe93ZE.

CHAPTER 4: GOING TO RICHMOND

Author interviews with Annette Badland, Adam Colborne, Lola Dauda, Anthony Head, Sue Lewis, Declan Lowney, Tom Marshall, Chris Powell, Gareth Roberts, Sara Romanelli, and Bronson Webb.

Archival author interviews with Brett Goldstein (2022), Nick Mohammed (2021), and Jason Sudeikis (2021).

Quotes from Brendan Hunt: "Conversations at Home with Jason Sudeikis and Brendan Hunt of TED LASSO," YouTube video, 42:07, posted by "SAG-AFTRA Foundation," December 9, 2020, https://www.youtube.com /watch?v=o3kHBzmNjl8.

Quotes from Brendan Hunt: "Ted Lasso HCA Roundtable: Brendan Hunt, Jeremy Swift, and Nick Mohammed," Hollywood Critics Association, June 10, 2021.

Quotes from Brett Goldstein and Bill Lawrence: "The Business Online: Q&A with Bill Lawrence and Brett Goldstein of TED LASSO," YouTube video, 50:31, posted by "SAG-AFTRA Foundation," February 24, 2021, https://www.youtube .com/watch?v=wZ6pJ4Qj-j0.

Quotes from Juno Temple: "Join Juno Temple's Youth Sanctuary!," June 16, 2022, in *Dan Fogler's 4D Xperience!*, podcast, 57:00.

Quotes from Nick Mohammed: "Conversations at Home with TED LASSO," YouTube video, 42:22, posted by "SAG-AFTRA Foundation," February 21, 2022, https://www.youtube.com/watch?v=g-dKTlwhL4c.

Quotes from Kola Bokinni: Jeremy Goeckner and Craig McFarland, "An Interview with Kola Bokinni (Isaac McAdoo in *Ted Lasso*)," November 19, 2021, in *Peanut Butter and Biscuits Shrinks: A Ted Lasso/Shrinking Fancast*, podcast, 58:00.

Quotes from Brett Goldstein and Hannah Waddingham: "3 Rounds with 'Ted Lasso' Stars Hannah Waddingham and Brett Goldstein," *Entertainment Weekly*, August 8, 2022.

Quotes from Phil Dunster: Bonnie Laufer, "Ted Lasso—Brett Goldstein and Phil Dunster Interview," Smart Entertainment Group, July 31, 2020.

Quotes from Jason Sudeikis: "Jason Sudeikis and Brendan Hunt on the Making of Apple TV+'s 'Ted Lasso,'" YouTube video, 51:03, posted by "Backstage," November 19, 2020, https://www.youtube.com/watch?v=5dKJS1NMT5E.

Quotes from Jeremy Swift: "Bonus: Jeremy Swift, Higgins on 'Ted Lasso,'" June 2021, in *Richmond Til We Die: A Ted Lasso Podcast*, 37:36.

Quotes from Jason Sudeikis: "Jason Sudeikis on Becoming Ted Lasso: 'I Didn't Want to Snark Out Anymore,'" April 4, 2023, in *The Great Creators with Guy Raz*, podcast, 1:12:59.

Quotes from Toheeb Jimoh: Jeremy Goeckner and Craig McFarland, "An Interview with Toheeb Jimoh (Sam Obisanya on 'Ted Lasso')," May 6, 2022, in *Peanut Butter and Biscuits Shrinks: A Ted Lasso/Shrinking Fancast*, podcast, 53:15.

Quotes from Hannah Waddingham: Kate Thornton, "Hannah Waddingham," August 26, 2021, in *White Wine Question Time*, podcast, 52:00; *Jimmy Kimmel Live*, aired September 16, 2021, on ABC.

Jeremy Goeckner and Craig McFarland, "An Interview with Jeremy Swift (Leslie Higgins in Ted Lasso)," September 9, 2022, in *Peanut Butter and Biscuits Shrinks: A Ted Lasso/Shrinking Fancast*, podcast, 43:00.

Quotes from Bill Lawrence: "Bill Lawrence and Theo Park," May 26, 2021, in *Crew Call with Anthony D'Alessandro*, podcast, 31:48.

Quotes from James Lance: "James Lance," May 31, 2023, in *Films to Be Buried With with Brett Goldstein*, podcast, 1:00:30.

KEY EPISODE: "PILOT"

Ted Lasso, season 1, episode 1, "Pilot," directed by Tom Marshall (Warner Bros. Television and Apple TV+, 2020).

"Town Hall: Jason Sudeikis & the Cast of Ted Lasso," March 21, 2023, in *The Jess Cagle Podcast with Julia Cunningham*, 49:17.

Ted Lasso Emmy screening panel, May Fair Hotel, London, July 14, 2022.

CHAPTER 5: THE TEAM BEGINS TO GEL

Author interviews with Annette Badland, Anthony Head, and Tom Marshall.

Archival author interviews with Brett Goldstein (2022), Nick Mohammed (2021), and Jason Sudeikis (2021).

"Toheeb Jimoh on His Breakout Role in Ted Lasso," *Q with Tom Power*, April 4, 2023, radio broadcast, 31:13, CBC.

Quotes from Brett Goldstein and Jason Sudeikis: "Jason Sudeikis (Part 1)," August 16, 2023, in *Films to Be Buried With with Brett Goldstein*, podcast, 1:22:34.

Quotes from Juno Temple and Hannah Waddingham: Brad Galli, "'Ted Lasso' Stars Hannah Waddingham and Juno Temple Share Their Favorite Scenes from Season 1," WXYZ, March 9, 2021.

Ted Lasso, season 1, episode 8, "The Diamond Dogs," directed by Declan Lowney (Warner Bros. Television and Apple TV+, 2020).

Quotes from Jason Sudeikis: "Jason Sudeikis on Becoming Ted Lasso: 'I Didn't Want to Snark Out Anymore,'" April 4, 2023, in *The Great Creators with Guy Raz*, podcast, 1:12:59.

Quotes from Jeremy Swift: "Bonus: Jeremy Swift, Higgins on 'Ted Lasso,'" June 2021, in *Richmond Til We Die: A Ted Lasso Podcast*, 37:36.

Quotes from Jason Sudeikis: *Variety*, *Ted Lasso* cast panel discussion, Lincoln Center, New York, March 22, 2023.

KEY EPISODE: "MAKE REBECCA GREAT AGAIN"

Ted Lasso, season 1, episode 7, "Make Rebecca Great Again," directed by Declan Lowney (Warner Bros. Television and Apple TV+, 2020).

Author interview with Declan Lowney.

Archival author interview with Nick Mohammed (2021).

RealCoachBeard, "I'm Brendan Hunt (Co-Creator of 'Ted Lasso' and Coach Beard)! Ask Me Anything!" r/TedLasso, Reddit, June 1, 2023, https://www.reddit .com/r/TedLasso/comments/13xllge/im_brendan_hunt_cocreator_of_ted_lasso _and_coach.

"Gary Neville meets Ted Lasso!" YouTube video, 16:11, posted by "Sky Sports Premier League," April 28, 2023, https://www.youtube.com/watch?v=gIwKl3-AGTE.

Apple TV+, "The Cast and Casting Director of 'Ted Lasso' in Conversation with Yvette Nicole Brown," panel discussion, June 10, 2023.

"'Ted Lasso' Cast Members Speak about Their Characters," YouTube video, 3:23, posted by "60 Minutes," March 14, 2022, https://www.youtube.com/watch?v =gIBBnibrOBs.

Elizabeth Wagmeister, "Olivia's Wilde Ride: Directing 'Don't Worry Darling,' Making Harry Styles a Movie Star and Being 'Blown the F— Away' by Florence Pugh," *Variety*, August 24, 2022.

Ruth Styles, "Ex-Nanny Tells How Smitten Olivia Wilde Broke Up with Devastated Jason Sudeikis Just Weeks after She Began Filming Don't Worry Darling with Harry Styles in Palm Springs," *DailyMail.com*, October 17, 2022, https://www.dailymail.co.uk/news/article-11299523/Jason-Sudeikis-tried-prevent-Olivia-Wilde-seeing-Harry-Styles-fight.html.

J. Kim Murphy, "Olivia Wilde Posts Dramatic 'Heartburn' Salad Dressing Recipe after Nanny Allegation," *Variety*, October 18, 2022.

"Jason Sudeikis," May 31, 2023, in *Fly on the Wall with Dana Carvey and David Spade*, podcast, 2:01:00.

Zach Baron, "Jason Sudeikis Is Having One Hell of a Year," *GQ*, July 13, 2021.

Variety, *Ted Lasso* cast panel discussion, Lincoln Center, New York, March 22, 2023.

"3 Rounds with 'Ted Lasso' Stars Hannah Waddingham and Brett Goldstein," *Entertainment Weekly*, August 8, 2022.

Kate Thornton, "Hannah Waddingham," August 26, 2021, in *White Wine Question Time*, podcast, 52:00.

"Brendan Hunt Talks Playing Ted Lasso's 'Coach Beard' & More," August 5, 2021, in *The Rich Eisen Show*, podcast, 16:11.

"Strange," track 1 on Celeste, *Compilation 1.1*, Polydor, 2019.

Jeremy Goeckner and Craig McFarland, "Editing Ted Lasso with A.J. Catoline and Melissa McCoy," January 28, 2022, in *Peanut Butter and Biscuits Shrinks: A Ted Lasso/Shrinking Fancast*, podcast, 1:26:00.

CHAPTER 6: ON THE PITCH

Author interviews with Donna-Maria Cullen, Lola Dauda, David Elsendoorn, Cory Jamieson, Declan Lowney, Chris Powell, and Sara Romanelli.

Archival author interviews with Brett Goldstein (2022).

Quotes from Brendan Hunt and Jason Sudeikis: "Conversations at Home with Jason Sudeikis and Brendan Hunt of TED LASSO," YouTube video, 42:07, posted by "SAG-AFTRA Foundation," December 9, 2020, https://www.youtube.com/watch?v=o3kHBzmNjl8.

Quotes from Theo Park: Carlos Aguilar, "'Ted Lasso' Casting Process Changed the International Team's Composition," IndieWire, June 14, 2021.

Quotes from Toheeb Jimoh: Jeremy Goeckner and Craig McFarland, "An Interview with Toheeb Jimoh (Sam Obisanya on 'Ted Lasso')," May 6, 2022, in *Peanut Butter and Biscuits Shrinks: A Ted Lasso/Shrinking Fancast*, podcast, 53:15.

Quotes from Kola Bokinni: Jeremy Goeckner and Craig McFarland, "An Interview with Kola Bokinni (Isaac McAdoo in *Ted Lasso*)," November 19, 2021, in *Peanut Butter and Biscuits Shrinks: A Ted Lasso/Shrinking Fancast,* podcast, 58:00.

Quotes from Phil Dunster: Bonnie Laufer, "Ted Lasso—Brett Goldstein and Phil Dunster Interview," Smart Entertainment Group, July 31, 2020.

Quotes from Bill Lawrence: "How Palace and Selhurst Park Inspired the Makers of Hit Apple Series Ted Lasso," Crystal Palace F.C., September 19, 2020, https://www.cpfc.co.uk/news/features/how-palace-and-selhurst-park-inspired-the-makers-of-hit-apple-series-ted-lasso.

Quotes from Paul Cripps and Jacky Levy: Cortland Jacoby, "'Ted Lasso' Interview: The Pre-Production Team Breaks Down How They Tackled Designing and Casting the Hit Show," Punch Drunk Critics, May 31, 2021.

Quotes from Phil Dunster and Pedro Romhanyi: Josh Weinfuss, "*Ted Lasso* and Its Cristiano Ronaldo Moment: How the Hit Show Strives to Get the Soccer Right," ESPN, September 21, 2021.

Quotes from James MacLachlan: Ian Failes, "Ted Lasso's Football Matches Were Made on a 'Stand-In' Field, with Greenscreen, Crowd Sprites and Other VFX," August 6, 2023, in *Befores & Afters*, podcast, 31:55.

Quotes from Cristo Fernández, Brett Goldstein, Brendan Hunt, and Jason Sudeikis: SAG-AFTRA Foundation Conversations series, "Ted Lasso" cast panel discussion at TCL Chinese Theatre, Los Angeles, January 16, 2024.

Quotes from Kasali Casal: Stuart Higgins, "Why the Football in Ted Lasso Looks Better Than in Other Shows," FourFourTwo, March 15, 2023.

Quotes from Declan Lowney: *Ted Lasso*: A Look at the Directing, Editing and VFX Nominees," *Post*, August 14, 2023.

Quotes from Jeremy Swift, Juno Temple, and Hannah Waddingham: Apple TV+, "The Cast and Casting Director of 'Ted Lasso' in Conversation with Yvette Nicole Brown," panel discussion, June 10, 2023.

Quotes from David Rom and Vanessa Whyte: Ben Rock and Illya Friedman, "Ted Lasso Cinematographers David Rom and Vanessa Whyte," *The Cinematography Podcast*, June 3, 2023.

Quotes from James MacLachlan: "TED LASSO: VFX Behind-the-Scene Secrets Exposed by Supervisor James MacLaghlan! [*sic*]," YouTube video, 9:28, posted by "Allan McKay," October 3, 2023, https://www.youtube.com/watch?app=desktop&v=UtztZxNU0OM.

Natasha Everitt, "Todd Boehly Responds to Angry Chelsea Fans after 'Disrespectful' Edit of Ray Wilkins Banner in Ted Lasso Series," talkSPORT, March 23, 2023.

Quotes from Jürgen Klopp: Interview, CBS Sports Golazo, November 3, 2021.

Quotes from Mikel Arteta: "Mikel Arteta on What Ted Lasso Means to Him and Builds a Stacked 5-a-Side! | Astro SuperSport," YouTube video, 8:06, posted by "Stadium Astro," March 2, 2024, https://www.youtube.com/watch?v=qT6dM5Z4YkA.

Quotes from Toheeb Jimoh: Nick Clark, "Toheeb Jimoh on His Romeo at the Almeida, Meeting Thierry Henry and the Ted Lasso Effect," *Standard*, June 15, 2023.

Quotes from Jesse Marsch: "'I'm Not Sure *Ted Lasso* Helped!'—Jesse Marsch on the Stigma around American Managers," Sky Sports News, March 3, 2022.

Quotes from Jason Sudeikis: "Gary Neville meets Ted Lasso!" YouTube video, 16:11, posted by "Sky Sports Premier League," April 28, 2023, https://www.youtube.com/watch?v=gIwKl3-AGTE.

Ted Lasso, season 3, episode 11, "Mom City," directed by Declan Lowney (Warner Bros. Television and Apple TV+, 2023).

Quotes from Pep Guardiola: "WE ALL LOVE TED LASSO | Pep Talks Family Viewing Habits! | Brentford vs Man City | Press Conference," YouTube video, 15:17, posted by "Man City," May 26, 2023, https://www.youtube.com/watch?v=M-g8e2vbioM.

Quotes from Brendan Hunt: Roger Bennett, "Ted Lasso Pod Special with Jason Sudeikis and Brendan Hunt," May 3, 2023, in *Men in Blazers*, podcast, 34:00.

Quotes from Brendan Hunt and Jason Sudeikis: "Jason Sudeikis and Brendan Hunt on the Making of Apple TV+'s 'Ted Lasso,'" YouTube video, 51:03, posted by "Backstage," November 19, 2020, https://www.youtube.com/watch?v=5dKJS1NMT5E.

Quotes from Brett Goldstein and Jason Sudeikis: "Ted Lasso Q&A with Jason Sudeikis and Costars on Their New Apple TV Plus Comedy Series | GOLD DERBY," YouTube video, 41:17, posted by "GoldDerby / Gold Derby," March 18, 2021, https://www.youtube.com/watch?v=QMqKFHe93ZE.

Quotes from Bill Lawrence: "The Business Online: Q&A with Bill Lawrence and Brett Goldstein of TED LASSO," YouTube video, 50:31, posted by "SAG-AFTRA Foundation," February 24, 2021, https://www.youtube.com/watch?v=wZ6pJ4Qj-j0.

KEY EPISODE: "THE HOPE THAT KILLS YOU"

Ted Lasso, season 1, episode 10, "The Hope That Kills You," directed by MJ Delaney (Warner Bros. Television and Apple TV+, 2020).

Author interview with Chris Powell (2023).

Archival author interviews with Phil Dunster (2023), Brett Goldstein (2023), Bill Lawrence (2023), Nick Mohammed (2021), and Jason Sudeikis (2021, 2023).

"Roy Keane Reacts to Roy Kent | I'm a Lot Nicer than Him," Sky Sports, March 5, 2023.

Kimberly Potts, "How *Ted Lasso*'s Brett Goldstein Found the Softer Side of Roy Kent," *Vulture*, October 2, 2020.

"Town Hall: Jason Sudeikis & the Cast of Ted Lasso," March 21, 2023, in *The Jess Cagle Podcast with Julia Cunningham*, 49:17.

CHAPTER 7: SOMETHING LIKE A PHENOMENON

Author interviews with Annette Badland, Lola Dauda, Anthony Head, Declan Lowney, Tom Marshall, Chris Powell, and Sara Romanelli.

Archival author interviews with Brett Goldstein (2022, 2023), Brendan Hunt (2021), Bill Lawrence (2021), Nick Mohammed (2021), and Jason Sudeikis (2021).

Denise Lu, "The True Coronavirus Toll in the U.S. Has Already Surpassed 200,000," *New York Times*, August 14, 2020.

Quotes from Jeremy Swift: "Bonus: Jeremy Swift, Higgins on 'Ted Lasso,'" June 2021, in *Richmond Til We Die: A Ted Lasso Podcast*, 37:36.

Benjamin Lee, "Ted Lasso Review—Apple's Soccer Sitcom Plays an Unfunny Old Game," *Guardian*, August 13, 2020.

Mike Hale, "'Ted Lasso' Review: Jason Sudeikis as America's Nicest Export," *New York Times*, August 14, 2020.

Ed Cumming, "Ted Lasso Review: Jason Sudeikis Is a Hapless Football Coach in This Likable if Uneven Comedy," *Independent*, August 14, 2020.

Kristen Baldwin, "Jason Sudeikis Is Pitch-Perfect in *Ted Lasso* on Apple TV+: Review," *Entertainment Weekly*, August 3, 2020.

Quotes from Brett Goldstein and Brendan Hunt: "Meet 'Ted Lasso' Stars Brett Goldstein and Brendan Hunt," *Entertainment Weekly*, June 4, 2021.

Quotes from Jason Sudeikis: *Conan*, aired August 31, 2020, on TBS.

Patton Oswalt (@pattonoswalt), X (formerly Twitter), October 15, 2020, 1:12 p.m., https://twitter.com/pattonoswalt/status/1316834254408413184.

"Jason Sudeikis and Brendan Hunt on *Ted Lasso*," October 7, 2020, in *Unlocking Us with Brené Brown*, podcast, 51:34.

Dave Holmes, "'They're Walking a Fucking Tightrope and It's Perfect': How *Ted Lasso* Made Nice Comedy Funny," *Esquire*, February 28, 2021.

Quotes from Brendan Hunt and Nick Mohammed: "Ted Lasso HCA Roundtable: Brendan Hunt, Jeremy Swift, and Nick Mohammed," Hollywood Critics Association, June 10, 2021.

Quotes from Juno Temple: "Join Juno Temple's Youth Sanctuary!" June 16, 2022, in *Dan Fogler's 4D Xperience!*, podcast, 57:00.

Quotes from Toheeb Jimoh: Tim Lewis, "'I Look for the Good in All Situations': The Power's Toheeb Jimoh," *Guardian*, April 9, 2023.

James Poniewozik, "'Ted Lasso,' 'The Great North' and the Art of Nice," *New York Times*, February 11, 2021.

Tim Lewis, "'I'm Pleased as Pie!': Jason Sudeikis on Ted Lasso—and Lessons in Kindness," *Guardian*, May 14, 2023.

Quotes from Kola Bokinni: Jeremy Goeckner and Craig McFarland, "An Interview with Kola Bokinni (Isaac McAdoo in *Ted Lasso*)," November 19, 2021, in *Peanut Butter and Biscuits Shrinks: A Ted Lasso/Shrinking Fancast*, podcast, 58:00.

Quotes from Toheeb Jimoh: "Conversations at Home with TED LASSO," YouTube video, 42:07, posted by "SAG-AFTRA Foundation," December 9, 2020, https://www.youtube.com/watch?v=o3kHBzmNjl8.

Quotes from Hannah Waddingham: Kate Thornton, "Hannah Waddingham," August 26, 2021, in *White Wine Question Time*, podcast, 52:00.

Lauren Sarner, "Twitter Wonders if Jason Sudeikis Was High for Golden Globes Award Speech," *New York Post*, February 28, 2021.

Zach Baron, "Jason Sudeikis Is Having One Hell of a Year," *GQ*, July 13, 2021.

"Ted Lasso," Peabody Awards, June 2021, https://peabodyawards.com/award-profile/ted-lasso/.

"Watch Brett Goldstein Crash Hannah Waddingham's Emmys Interview," YouTube video, 4:38, posted by "Entertainment Tonight," September 20, 2021, https://www.youtube.com/watch?v=Y3JAXHMQOcA.

Quotes from Juno Temple: *The Tonight Show Starring Jimmy Fallon*, aired August 18, 2022, on NBC.

Quotes from Brett Goldstein: *Late Night with Seth Meyers*, aired October 6, 2021, on NBC.

Quotes from Jason Sudeikis: *Late Night with Seth Meyers*, aired October 7, 2021, on NBC.

Quotes from Hannah Waddingham: "Watch Brett Goldstein Crash Hannah Waddingham's Emmys Interview"; "Ted Lasso Star Hannah Waddingham on Her Role of a Lifetime," *Q with Tom Power*, October 8, 2021, radio broadcast, 28:18, CBC; "'Ted Lasso' Star Hannah Waddingham and Brett Goldstein on Their 2021 Emmy Wins," YouTube video, 2:35, posted by "People," September 20, 2021, https://youtube.com/watch?v=S0Uh7dwr7jU.

73rd Primetime Emmy Awards, Television Academy, CBS, September 19, 2021.

Saturday Night Live, aired October 23, 2021, on NBC.

Quotes from Brendan Hunt and Jason Sudeikis: "Jason Sudeikis and Brendan Hunt on *Ted Lasso*."

Quotes from Jason Sudeikis: "Gary Neville meets Ted Lasso!" YouTube video, 16:11, posted by "Sky Sports Premier League," April 28, 2023, https://www.youtube.com/watch?v=gIwKl3-AGTE.

CHAPTER 8: A SOCIALLY DISTANCED HIT

Author interviews with Annette Badland, David Elsendoorn, Anthony Head, Sue
 Lewis, Declan Lowney, Chris Powell, Sara Romanelli, and Bronson Webb.

Archival author interviews with Brendan Hunt (2021), Nick Mohammed (2021),
 and Jason Sudeikis (2021, 2023).

Quotes from Phil Dunster, Brett Goldstein, James Lance, Jason Sudeikis, and Juno
 Temple: *Ted Lasso* Emmy screening panel, May Fair Hotel, London, July 14,
 2022.

Quotes from Brendan Hunt and Jason Sudeikis: "Conversations at Home with
 Jason Sudeikis and Brendan Hunt of TED LASSO," YouTube video, 42:07,
 posted by "SAG-AFTRA Foundation," December 9, 2020, https://www.youtube
 .com/watch?v=o3kHBzmNjl8.

Quotes from Brett Goldstein and Bill Lawrence: "The Business Online: Q&A with
 Bill Lawrence and Brett Goldstein of TED LASSO," YouTube video, 50:31,
 posted by "SAG-AFTRA Foundation," February 24, 2021, https://www.youtube
 .com/watch?v=wZ6pJ4Qj-j0.

Quotes from Nick Mohammed and Jeremy Swift: "Ted Lasso HCA Roundtable:
 Brendan Hunt, Jeremy Swift, and Nick Mohammed," Hollywood Critics
 Association, June 10, 2021.

Quotes from Phil Dunster, Brett Goldstein, Toheeb Jimoh, and Sarah Niles:
 "Conversations at Home with TED LASSO," YouTube video, 42:22, posted by
 "SAG-AFTRA Foundation," February 21, 2022, https://www.youtube.com
 /watch?v=g-dKTlwhL4c.

Quotes from Sarah Niles: "Sarah Niles on Life, Truth, and *Ted Lasso*," in
 Unlocking Us with Brené Brown, September 29, 2021, podcast, 48:32; Matt
 Noble, "Sarah Niles ('Ted Lasso'): 'It Was Really Hard for Me to Shoot without
 Corpsing,'" YouTube video, 18:29, posted by "GoldDerby / Gold Derby," June 1,
 2022, https://www.youtube.com/watch?v=md3HXO9rV0Y.

Quotes from Brendan Hunt: "Hour 3-Brendan Hunt," March 10, 2023, in *The Dan
 Patrick Show*, podcast, 43:00.

Quotes from Cristo Fernández: "'Ted Lasso' with Brendan Hunt, Hannah
 Waddingham, Brett Goldstein, Phil Dunster, Nick Mohammad [sic] & More!,"
 YouTube video, 26:25, posted by "In Creative Company," June 13, 2022,
 https://www.youtube.com/watch?v=B9iMWmg0zNI.

Quotes from Brett Goldstein and Juno Temple: "'Ted Lasso' Stars Juno
 Temple & Brett Goldstein on Keeley & Roy," *E! Insider*,
 July 22, 2021.

Quotes from Juno Temple: "Join Juno Temple's Youth Sanctuary!," June 16, 2022,
 in *Dan Fogler's 4d Xperience!*, podcast, 57:00.

Michael Ordoña, "How Toheeb Jimoh of 'Ted Lasso' Found His Character's Home—and His Own," *Los Angeles Times*, August 3, 2022.

Quotes from Toheeb Jimoh: Jeremy Goeckner and Craig McFarland, "An Interview with Toheeb Jimoh (Sam Obisanya on 'Ted Lasso')," May 6, 2022, in *Peanut Butter and Biscuits Shrinks: A Ted Lasso/Shrinking Fancast*, podcast, 53:15.

Quotes from Brendan Hunt: Bryan Kalbrosky, "'Ted Lasso' Creators Explain How They Made a Perfect Episode about Protest and Activism," *USA Today*, August 6, 2021.

Ted Lasso, season 2, episode 4, "Carol of the Bells," directed by Declan Lowney (Warner Bros. Television and Apple TV+, 2021).

Quotes from Jeremy Swift: Jeremy Goeckner and Craig McFarland, "An Interview with Jeremy Swift (Leslie Higgins in Ted Lasso)," September 9, 2022, in *Peanut Butter and Biscuits Shrinks: A Ted Lasso/Shrinking Fancast*, podcast, 43:00.

Quotes from Moe Jeudy-Lamour: Jeremy Goeckner and Craig McFarland, "An Interview with Moe Jeudy-Lamour (Thierry Zoreaux in Ted Lasso)," February 24, 2022, in *Peanut Butter and Biscuits Shrinks: A Ted Lasso/Shrinking Fancast*, podcast, 55:00.

Quotes from Joe Kelly: Lee Ashley, "'Ted Lasso's' Christmas Episode Wasn't Part of the Plan. Here's How They Pulled It Off," *Los Angeles Times*, August 13, 2021.

Ted Lasso, season 2, episode 5, "Rainbow," directed by Erica Dunton (Warner Bros. Television and Apple TV+, 2021).

Quotes from Melissa McCoy: Jeremy Goeckner and Craig McFarland, "Editing Ted Lasso with A.J. Catoline and Melissa McCoy," January 28, 2022, in *Peanut Butter and Biscuits Shrinks: A Ted Lasso/Shrinking Fancast*, podcast, 1:26:00.

Quotes from Tony Von Pervieux and Melinda Newman, "Executive of the Week: 'Ted Lasso' Music Supervisor Tony Von Pervieux," *Billboard*, October 8, 2021.

Quotes from Tom Howe: Jeremy Goeckner and Craig McFarland, "The Music of Ted Lasso with Composer Tom Howe," April 8, 2022, in *Peanut Butter and Biscuits Shrinks: A Ted Lasso/Shrinking Fancast*, podcast, 40:02.

Quotes from Marcus Mumford: *The Tonight Show Starring Jimmy Fallon*, aired November 4, 2022, on NBC.

Quotes from Tom Howe and Marcus Mumford: Matt Noble, "Tom Howe and Marcus Mumford ('Ted Lasso' composers): 'The hope is what keeps you going,'" YouTube video, 20:02, posted by "GoldDerby / Gold Derby," June 14, 2021, https://www.youtube.com/watch?v=kwKp02QcTiM.

Quotes from Marcus Mumford: "Marcus Mumford ('Ted Lasso') Discusses His 1st Emmy Nomination and Past Grammy Wins," YouTube video, 2:49, posted by "GoldDerby / Gold Derby," July 16, 2021, https://www.youtube.com/watch?v=eCxYloV0ezM.

Quotes from Declan Lowney, *"Ted Lasso*: A look at the Directing, Editing and VFX Nominees," *Post*, August 14, 2023.

Quotes from Brendan Hunt: "Ted Lasso's Brendan Hunt on Coach Beard, Happiness, & Piggy Stardust," May 3, 2023, in *Kyle Meredith With . . .* , podcast, 11:15.

Quotes from Jason Sudeikis: "Jason Sudeikis and Brendan Hunt on *Ted Lasso*," October 7, 2020, in *Unlocking Us with Brené Brown*, podcast, 51:34.

Quotes from A.J. Catoline and Tony Von Pervieux: Cortland Jacoby, "'Ted Lasso' Interview: The Pre-Production Team Breaks Down How They Tackled Designing and Casting the Hit Show," Punch Drunk Critics, May 31, 2021.

Quotes from Tony Von Pervieux: Lauren Coates, "'Ted Lasso' Music Supervisor Tony Von Pervieux Told Us All about How That Eclectic Soundtrack Came Together," The Mary Sue, June 5, 2023.

Quotes from Tony Von Pervieux: Natalie Fisher, "'Ted Lasso' Music Supervisor Tony Von Pervieux Discusses Creating the Soundtrack for Season 3," Subjectify Media, June 21, 2023.

Quotes from Brendan Hunt: Steve Greene, "The Perfect 'Ted Lasso' Beyoncé Needle Drop Came from a Very Literal Place," IndieWire, March 16, 2023.

Quotes from Jason Sudeikis: *Ted Lasso* Emmy screening panel, May Fair Hotel, London, July 14, 2022.

Melinda Newman, "Executive of the Week: 'Ted Lasso' Music Supervisor Tony Von Pervieux," *Billboard*, October 8, 2021.

Quotes from Tony Von Pervieux: Meaghan Kirby, "Ted Lasso's Big Frozen Musical Number Almost Didn't Happen," Nerdist, May 14, 2021.

Quotes from A.J. Catoline: Jeremy Goeckner and Craig McFarland, "The Return of the Editors of 'Ted Lasso'! Melissa McCoy and A.J. Catoline," June 9, 2023, in *Peanut Butter and Biscuits Shrinks: A Ted Lasso/Shrinking Fancast*, podcast, 1:44:00.

Quotes from Declan Lowney: "'Ted Lasso' Director Declan Lowney Says 'So Long, Farewell' to the Series. But, Was It All a Dream?," YouTube video, 16:39, posted by "AwardsRadar," August 16, 2023, https://www.youtube.com/watch?v=KStwuXy7a8Y.

KEY EPISODE: "BEARD AFTER HOURS"

Ted Lasso, season 2, episode 9, "Beard After Hours," directed by Sam Jones (Warner Bros. Television and Apple TV+, 2021).

Author interviews with Adam Colborne and Bronson Webb.

Becca Newton, "Ted Lasso Season 2 Episode 9 Review: Beard After Hours," TV Fanatic, September 17, 2021.

Alan Sepinwall, "'Ted Lasso' Recap: Beard's Dark Night of the Soul," *Rolling Stone*, September 17, 2021.

Keith Phipps, *"Ted Lasso* Recap: A Night on the Town," *Vulture*, September 17, 2021.

Myles McNutt, *"Ted Lasso* Takes a Narrative Detour without a Whole Lot to Show for It," *AV Club*, September 17, 2021.

Christopher Orr, "'Ted Lasso' Recap, Season 2 Episode 9: Beard Has a Late Night," *New York Times*, September 17, 2021.

Phillip Maciak, "'Ted Lasso' Just Can't Win," *New Republic*, March 15, 2023.

South by Southwest, "'Ted Lasso' Strikes Back," panel discussion, Austin, TX, March 14, 2022.

"Hour 3-Brendan Hunt," March 10, 2023, in *The Dan Patrick Show*, podcast, 43:00.

Andrew Moskos and Pep Rosenfeld, *Boom Chicago Presents: The 30 Most Important Years in Dutch History* (Brooklyn, NY: Akashic Books, 2023).

Kristi K., "A Conversation with Brendan Hunt (aka Coach Beard)," December 5, 2023, in *Business | Life After Hours*, podcast, 9:01.

"'Ted Lasso' with Brendan Hunt, Hannah Waddingham, Brett Goldstein, Phil Dunster, Nick Mohammad [*sic*] & More!," YouTube video, 26:25, posted by "In Creative Company," June 13, 2022, https://www.youtube.com/watch?v=B9iMWmg0zNI.

CHAPTER 9: FATHERS AND SONS AND DAUGHTERS

Author interviews with Anthony Head.

Archival author interviews with Jason Sudeikis (2023).

Philip Larkin, "This Be the Verse," in *Collected Poems* (New York: Farrar, Straus and Giroux, 2001), Poetry Foundation, https://www.poetryfoundation.org/poems/48419/this-be-the-verse.

Quotes from Phil Dunster: "Andrew Whitworth & Phil Dunster/Jamie Tartt—Hour 3," October 8, 2021, in *The Rich Eisen Show*, podcast, 56:00.

Quotes from Moe Jeudy-Lamour: Jeremy Goeckner and Craig McFarland, "An Interview with Moe Jeudy-Lamour (Thierry Zoreaux in Ted Lasso)," February 24, 2022, in *Peanut Butter and Biscuits Shrinks: A Ted Lasso/Shrinking Fancast*, podcast, 55:00.

Quotes from Toheeb Jimoh and Hannah Waddingham: *Variety, Ted Lasso* cast panel discussion, Lincoln Center, New York, March 22, 2023.

Quotes from Phil Dunster, Brendan Hunt, and Pedro Romhanyi: Josh Weinfuss, "*Ted Lasso* and Its Cristiano Ronaldo Moment: How the Hit Show Strives to Get the Soccer Right," ESPN, September 21, 2021.

Quotes from Kola Bokinni: Jeremy Goeckner and Craig McFarland, "An Interview with Kola Bokinni (Isaac McAdoo in *Ted Lasso*)," November 19, 2021, in *Peanut Butter and Biscuits Shrinks: A Ted Lasso/Shrinking Fancast*, podcast, 58:00.

Quotes from Brendan Hunt, Toheeb Jimoh, and Hannah Waddingham: "'Ted Lasso' with Brendan Hunt, Hannah Waddingham, Brett Goldstein, Phil Dunster, Nick Mohammad [sic] & More!," YouTube video, 26:25, posted by "In Creative Company," June 13, 2022, https://www.youtube.com/watch?v =B9iMWmg0zNI.

Quotes from Phil Dunster, Brett Goldstein, Brendan Hunt, Toheeb Jimoh, James Lance, Jason Sudeikis, and Juno Temple: *Ted Lasso* Emmy screening panel, May Fair Hotel, London, July 14, 2022.

Quotes from Jason Sudeikis: "Jason Sudeikis (Part 1)," August 16, 2023, in *Films to Be Buried With with Brett Goldstein*, podcast, 1:22:34.

Quotes from Toheeb Jimoh: Jeremy Goeckner and Craig McFarland, "An Interview with Toheeb Jimoh (Sam Obisanya on 'Ted Lasso')," May 6, 2022, in *Peanut Butter and Biscuits Shrinks: A Ted Lasso/Shrinking Fancast*, podcast, 53:15.

Quotes from Toheeb Jimoh: "Toheeb Jimoh on the Final Season of *Ted Lasso*," *AV Club* video, 1:55, April 6, 2023, https://www.avclub.com/toheeb-jimoh-on -the-final-season-of-ted-lasso-1850309454.

Quotes from Hannah Waddingham: "Ted Lasso Star Hannah Waddingham on Her Role of a Lifetime," *Q with Tom Power*, October 8, 2021, radio broadcast, 28:18, CBC.

Quotes from Jane Becker: Sadie Dean, "Telling Your Truth on the Page with 'Ted Lasso' Writer Jane Becker," *Script*, June 10, 2022.

Quotes from Toheeb Jimoh and Hannah Waddingham: "Half Hour With: 'Ted Lasso' (Hannah Waddingham, Juno Temple, Nick Mohammed & Toheeb Jimoh)," YouTube video, 30:49, posted by "Half Hour With," June 9, 2022, https://www.youtube.com/watch?v=gIxR8rHkkYQ.

Quotes from Jason Sudeikis: *74th Primetime Emmy Awards*, Television Academy, CBS, September 12, 2022.

KEY EPISODE: "INVERTING THE PYRAMID OF SUCCESS"

Ted Lasso, season 2, episode 12, "Inverting the Pyramid of Success," directed by Declan Lowney (Warner Bros. Television and Apple TV+, 2021).

Author interview with Declan Lowney.

Archival author interview with Jason Sudeikis (2021).

"Join Juno Temple's Youth Sanctuary!" June 16, 2022, in *Dan Fogler's 4D Xperience!*, podcast, 57:00.

Mara Reinstein, "In Conversation: *Ted Lasso* Co-Star Hannah Waddingham and Writer Jane Becker," Television Academy, June 15, 2022, https://www.emmys .com/news/online-originals/conversation-ted-lasso-waddingham-becker.

Valentina Valentini, "Juno Temple and Hannah Waddingham on Season Two of 'Ted Lasso,'" Shondaland, July 21, 2021, https://www.shondaland.com/inspire /a37069690/juno-temple-and-hannah-waddingham-on-season-two-of-ted-lasso/.

"3 Rounds with 'Ted Lasso' Stars Hannah Waddingham and Brett Goldstein," *Entertainment Weekly*, August 8, 2022.

Ted Lasso Emmy screening panel, May Fair Hotel, London, July 14, 2022.

Apple TV+, "The Cast and Casting Director of 'Ted Lasso' in Conversation with Yvette Nicole Brown," panel discussion, June 10, 2023.

Jeremy Goeckner and Craig McFarland, "An Interview with Toheeb Jimoh (Sam Obisanya on 'Ted Lasso')," May 6, 2022, in *Peanut Butter and Biscuits Shrinks: A Ted Lasso/Shrinking Fancast*, podcast, 53:15.

Nick Mohammed (@nickmohammed), X (formerly Twitter), October 8, 2021, 8:32 a.m., https://twitter.com/nickmohammed/status/1446498835686064135.

Riley Utley, "*Ted Lasso*'s Nick Mohammed Explains Why You Might Want to Pay Close Attention to Nate's Suits This Season," CinemaBlend, May 16, 2023.

CHAPTER 10: NEW SEASON, NEW STAKES

Author interviews with Annette Badland, David Elsendoorn, Anthony Head, Sue Lewis, Declan Lowney, Gareth Roberts, Sara Romanelli, and Bronson Webb.

Archival author interviews with Phil Dunster (2023), Brett Goldstein (2022), and Brendan Hunt (2021).

Lesley Goldberg, "*Ted Lasso* Stars, Writers Score Big Paydays for Season 3 (Exclusive)," *Hollywood Reporter*, September 13, 2021.

Quotes from Jason Sudeikis and Brendan Hunt: Marco della Cava, "*Ted Lasso* Season 3 Took Forever, but Jason Sudeikis Promises Fans 'It's All on the Screen,'" *USA Today*, March 14, 2023.

Quotes from Jason Sudeikis: "Jason Sudeikis (Part 1)," August 16, 2023, in *Films to Be Buried With with Brett Goldstein*, podcast, 1:22:34.

Quotes from Brendan Hunt: "Hour 3-Brendan Hunt," March 10, 2023, in *The Dan Patrick Show*, podcast, 43:00.

Quotes from Hannah Waddingham: "3 Rounds with 'Ted Lasso' Stars Hannah Waddingham and Brett Goldstein," *Entertainment Weekly*, August 8, 2022.

Quotes from Toheeb Jimoh: Jeremy Goeckner and Craig McFarland, "An Interview with Toheeb Jimoh (Sam Obisanya on 'Ted Lasso')," May 6, 2022, in *Peanut Butter and Biscuits Shrinks: A Ted Lasso/Shrinking Fancast*, podcast, 53:15.

Quotes from A.J. Catoline and Melissa McCoy: Jeremy Goeckner and Craig McFarland, "The Return of the Editors of 'Ted Lasso'! Melissa McCoy and A.J. Catoline," June 9, 2023, in *Peanut Butter and Biscuits Shrinks: A Ted Lasso/ Shrinking Fancast*, podcast, 1:44:00.

Matthew Belloni, "What the Hell Is Happening with 'Ted Lasso'?" *Puck*, September 16, 2022.

Quotes from Maximilian Osinski: Jeremy Goeckner and Craig McFarland, "We Got Zava! Interview with Maximilian Osinski," April 1, 2023, in *Peanut Butter and Biscuits Shrinks: A Ted Lasso/Shrinking Fancast*, podcast, 59:53.

Quotes from Theo Park: Joyce Eng, "'Ted Lasso's' Theo Park on Casting Zava: 'I Never Thought We'd Find This Person,'" GoldDerby, May 18, 2023.

Quotes from Maximilian Osinski: John Boccacino, "Episode 142: Zava! Meet Maximilian Osinski '06, the Breakout Star of Season 3 of 'Ted Lasso,'" June 13, 2023, in *'Cuse Conversations*, podcast, 40:05.

Quotes from Brendan Hunt and Jason Sudeikis: Roger Bennett, "Ted Lasso Pod Special with Jason Sudeikis and Brendan Hunt," May 3, 2023, in *Men in Blazers*, podcast, 34:00.

Quotes from Cristo Fernández, Billy Harris, and Toheeb Jimoh: "Half Hour With: *Ted Lasso* (Toheeb Jimoh, Kola Bokinni, Billy Harris & Cristo Fernández)," YouTube video, 30:10, posted by "Half Hour With," May 31, 2023, https://www .youtube.com/watch?v=k4p6_al20rk.

Nick Mohammed (@nickmohammed), X (formerly Twitter), March 15, 2023, https://twitter.com/nickmohammed/status/1636008885122220033?.

Quotes by Phil Dunster and Jason Sudeikis: Paley Center for Media, "Ted Lasso at PaleyFest LA 2021," virtual panel discussion, February 14, 2022.

Quotes by Phil Dunster: Apple TV+, "The Cast and Casting Director of 'Ted Lasso' in Conversation with Yvette Nicole Brown," panel discussion, June 10, 2023.

Quotes by Phil Dunster and Juno Temple: "Juno Temple and Phil Dunster Q&A for 'Ted Lasso' | SAG-AFTRA Foundation Conversations," YouTube video, 33:06, posted by "SAG-AFTRA Foundation," June 6, 2023, https://www.youtube .com/watch?v=NAVZnUVKx78.

Quotes by A.J. Catoline: "'Ted Lasso' Creators on Working Behind the Scenes with Jason Sudeikis," *Hollywood Reporter* video, 17:49, August 18, 2023, https://www .hollywoodreporter.com/video/ted-lasso-creators-working-behind-the-scenes -with-jason-sudeikis/.

Quotes by Brett Goldstein: Dessi Gomez, "'Ted Lasso' Star Brett Goldstein Thinks if It Were Up to Roy Kent, 'He'd Be a Player Forever,'" *The Wrap*, May 2, 2023.

Ted Lasso, season 3, episode 6, "Sunflowers," directed by Matt Lipsey (Warner Bros. Television and Apple TV+, 2023).

Quotes from Brendan Hunt: "Ted Lasso's Brendan Hunt on Coach Beard, Happiness, & Piggy Stardust," May 3, 2023, in *Kyle Meredith With. . .*, podcast, 11:15; Jason Tabrys, "Brendan Hunt on 'Ted Lasso' Spinoffs and Jordan Peele's Influence on That Bike Scene," Uproxx, April 25, 2023.

Quotes from Brendan Hunt and Jason Sudeikis: SAG-AFTRA Foundation Conversations series, "Ted Lasso" cast panel discussion at TCL Chinese Theatre, Los Angeles, January 16, 2024.

Quotes from Jason Sudeikis: "Jason Sudeikis (Part 2)," August 23, 2023, in *Films to Be Buried With with Brett Goldstein*, podcast, 50:00.

Quotes from Hannah Waddingham: Whitney Friedlander, "One Magical Night on the Set of *Ted Lasso*," *Vanity Fair*, June 15, 2023; "Ted Lasso Interview: Hannah Waddingham Dishes on TedBecca and Rebecca's Season 3 Ending," YouTube video, 18:09, posted by "Inside The Film Room," June 12, 2023, https://www.youtube.com/watch?v=OVE7lJarBf0&.

Quotes from Billy Harris: Matt Noble, "Billy Harris ('Ted Lasso') on Colin's Struggle as a Closeted Gay Member of the Team," GoldDerby, May 19, 2023.

Quotes from James Lance: Jeremy Goeckner and Craig McFarland, "An Interview with James Lance (Trent Crimm on Ted Lasso)," May 18, 2023, in *Peanut Butter and Biscuits Shrinks: A Ted Lasso/Shrinking Fancast*, podcast, 58:00.

Quotes from Billy Harris: "'Ted Lasso' interview: Billy Harris on His Breakout Role in Season 3 and Colin Hughes' Coming Out," YouTube video, 16:39, posted by "Inside The Film Room," June 14, 2023, https://www.youtube.com/watch?v=R48-J0PHSOI.

KEY EPISODE: "INTERNATIONAL BREAK"

Ted Lasso, season 3, episode 10, "International Break," directed by Matt Lipsey (Warner Bros. Television and Apple TV+, 2023).

Archival author interviews with Bill Lawrence (2023) and Nick Mohammed (2021).

"'Ted Lasso' with Brendan Hunt, Hannah Waddingham, Brett Goldstein, Phil Dunster, Nick Mohammad [sic] & More!," YouTube video, 26:25, posted by "In Creative Company," June 13, 2022, https://www.youtube.com/watch?v=B9iMWmg0zNI.

Jeremy Egner, "Nick Mohammed Has Been Faking It on *Ted Lasso*," *New York Times*, August 26, 2021.

Sadie Dean, "Telling Your Truth on the Page with 'Ted Lasso' Writer Jane Becker," *Script*, June 10, 2022.

Jeremy Goeckner and Craig McFarland, "An Interview with Nick Mohammed (Nate Shelley in Ted Lasso)," June 17, 2022, in *Peanut Butter and Biscuits Shrinks: A Ted Lasso/Shrinking Fancast*, podcast, 47:00.

Nick Mohammed (@nickmohammed), X (formerly Twitter), May 31, 2023, https://twitter.com/nickmohammed/status/1663992846020648961.

Kathryn VanArendonk, "*Ted Lasso* Wanted to Do It All," *Vulture*, May 31, 2023.

Ted Lasso, season 3, episode 11, "Mom City," directed by Declan Lowney (Warner Bros. Television and Apple TV+, 2023).

CHAPTER 11: THE FINAL WHISTLE

Author interviews with Annette Badland, David Elsendoorn, Anthony Head, Declan Lowney, Sara Romanelli, and Bronson Webb.

Archival author interviews with Brett Goldstein (2023) and Jason Sudeikis (2023).

Ted Lasso, season 3, episode 7, "The Strings That Bind Us," directed by Matt Lipsey (Warner Bros. Television and Apple TV+, 2023).

Quotes from Kola Bokinni, Billy Harris, and Toheeb Jimoh: "Half Hour With: *Ted Lasso* (Toheeb Jimoh, Kola Bokinni, Billy Harris & Cristo Fernández)," YouTube video, 30:10, posted by "Half Hour With," May 31, 2023, https://www.youtube .com/watch?v=k4p6_al20rk.

Quotes from Hannah Waddingham: *Variety*, *Ted Lasso* cast panel discussion, Lincoln Center, New York, March 22, 2023.

Quotes from Juno Temple: "Ted Lasso Interview: Juno Temple on Keeley's Branching Out in S3, Her Love Triangle with Roy + Jamie," YouTube video, 14:45, posted by "Inside The Film Room," June 15, 2023, https://www.youtube .com/watch?v=avl39w7hs5k.

Quotes from Brett Goldstein: Gerrad Hall, "*Ted Lasso*'s Brett Goldstein on a Roy/Keeley/Jamie Throuple, the Spin-offs He Wants to See, and Why the Show 'Is Not a Fairy Tale,'" *Entertainment Weekly*, July 20, 2023.

Quotes from Phil Dunster and Juno Temple: Apple TV+, "The Cast and Casting Director of 'Ted Lasso' in Conversation with Yvette Nicole Brown," panel discussion, June 10, 2023.

Ted Lasso, season 3, episode 11, "Mom City," directed by Declan Lowney (Warner Bros. Television and Apple TV+, 2023).

Quotes from Hannah Waddingham: "Ted Lasso Interview: Hannah Waddingham Dishes on TedBecca and Rebecca's Season 3 Ending," YouTube video, 18:09, posted by "Inside The Film Room," June 12, 2023, https://www.youtube.com /watch?v=OVE7lJarBf0&.

Quotes from Phil Dunster: "Ted Lasso Interview: Phil Dunster Talks Jamie Tartt's Growth and the Jamie-Roy-Keeley Love Triangle," YouTube video, 18:49, posted by "Inside The Film Room," June 13, 2023, https://www.youtube.com/watch?v =dHJWRCToUm4.

Quotes from Melissa McCoy: Jeremy Goeckner and Craig McFarland, "The Return of the Editors of 'Ted Lasso'! Melissa McCoy and A.J. Catoline," June 9,

2023, in *Peanut Butter and Biscuits Shrinks: A Ted Lasso/Shrinking Fancast*, podcast, 1:44:00.

Quotes from Brendan Hunt and Jason Sudeikis: Clark Collis, "Jason Sudeikis Says There Were 'a Lot of Tears' on Last Day of *Ted Lasso* Season 3 Shoot," *Entertainment Weekly*, March 17, 2023.

Quotes from James Lance: Jeremy Goeckner and Craig McFarland, "An Interview with James Lance (Trent Crimm on Ted Lasso)," May 18, 2023, in *Peanut Butter and Biscuits Shrinks: A Ted Lasso/Shrinking Fancast*, podcast, 58:00.

Quotes from Jason Sudeikis: SAG-AFTRA Foundation Conversations series, "Ted Lasso" cast panel discussion at TCL Chinese Theatre, Los Angeles, January 16, 2024.

KEY EPISODE: "SO LONG, FAREWELL"

Ted Lasso, "So Long, Farewell," directed by Declan Lowney (Warner Bros. Television and Apple TV+, 2023).

Author interviews with Annette Badland, Adam Colborne, Anthony Head, and Declan Lowney.

Marcus Mumford and Tom Howe, "Ted Lasso Theme," track 1 on *Ted Lasso: Season 1* (Apple TV+ Original Series Soundtrack) (WaterTower Music/Warner Bros. Entertainment, 2020).

Marcus Mumford interview, *The Tonight Show Starring Jimmy Fallon*, aired November 4, 2022, on NBC.

"Jason Sudeikis on Becoming Ted Lasso: 'I Didn't Want to Snark Out Anymore,'" April 4, 2023, in *The Great Creators with Guy Raz*, podcast, 1:12:59.

RealCoachBeard, "I'm Brendan Hunt (Co-Creator of 'Ted Lasso' and Coach Beard)! Ask Me Anything!" r/TedLasso, Reddit, June 1, 2023, https://www.reddit.com/r/TedLasso/comments/13xllge/im_brendan_hunt_cocreator_of_ted_lasso_and_coach.

"Lips Nailed for Cat Stevens Song Similarity," *Billboard*, June 27, 2003.

CHAPTER 12: THIS IS THE END?

Author interviews with Annette Badland, Adam Colborne, David Elsendoorn, Anthony Head, Declan Lowney, Chris Powell, Sara Romanelli, and Bronson Webb.

Archival author interviews with Brett Goldstein (2022, 2023) and Jason Sudeikis (2023).

Quotes from Jason Sudeikis: "Jason Sudeikis Talks 'Ted Lasso' Future, 'SNL,' Big Slick & More with Rich Eisen," May 11, 2023, in *The Rich Eisen Show*, podcast, 32:03.

Quotes from Brendan Hunt: RealCoachBeard, "I'm Brendan Hunt (Co-Creator of 'Ted Lasso' and Coach Beard)! Ask Me Anything!" r/TedLasso, Reddit, June 1, 2023, https://www.reddit.com/r/TedLasso/comments/13xllge/im_brendan_hunt _cocreator_of_ted_lasso_and_coach.

"How Ted Lasso Got Viewers around the World to 'Believe' in Apple TV+," Parrot Analytics, July 17, 2023.

"Streaming Unwrapped: Streaming Viewership Goes to the Library in 2023," Nielsen, January 2024.

David Sims, "Ted Lasso Has Lost Its Way," Atlantic, May 4, 2023.

Steve Greene, "'Ted Lasso' Is a Mess This Season. What Happened?" IndieWire, May 10, 2023.

Sam Adams, "Ted Lasso's Fans Need to Just Accept That the Show Is Bad Now," Slate, May 10, 2023.

Quotes from Brendan Hunt: Jason Tabrys, "Brendan Hunt on 'Ted Lasso' Spinoffs and Jordan Peele's Influence on That Bike Scene," Uproxx, April 25, 2023.

Quotes from Jason Sudeikis: SAG-AFTRA Foundation Conversations series, "Ted Lasso" cast panel discussion at TCL Chinese Theatre, Los Angeles, January 16, 2024.

Quotes from Melissa McCoy: Jeremy Goeckner and Craig McFarland, "The Return of the Editors of 'Ted Lasso'! Melissa McCoy and A.J. Catoline," June 9, 2023, in Peanut Butter and Biscuits Shrinks: A Ted Lasso/Shrinking Fancast, podcast, 1:44:00.

Kristen Baldwin, "Don't Cry Because Ted Lasso Went off the Rails; Smile Because It Happened," Entertainment Weekly, May 31, 2023.

Hannah Waddingham interview, Late Night with Seth Meyers, aired December 18, 2023, on NBC.

Jeremy Swift (@jeremy.swift.68), Instagram photo, December 18, 2023, https://www.instagram.com/p/ClARRPDJNDC.

Jeremy Egner, "Brett Goldstein Faces Life after 'Lasso,'" New York Times, March 11, 2023.

Quotes from Jeremy Swift: Apple TV+, "The Cast and Casting Director of 'Ted Lasso' in Conversation with Yvette Nicole Brown," panel discussion, June 10, 2023.

Quotes from Phil Dunster: "Ted Lasso Interview: Phil Dunster Talks Jamie Tartt's Growth and the Jamie-Roy-Keeley Love Triangle," YouTube video, 18:49, posted by "Inside The Film Room," June 13, 2023, https://www.youtube.com/watch?v =dHJWRCToUm4.

Quotes from Brendan Hunt: "Meet 'Ted Lasso' Stars Brett Goldstein and Brendan Hunt," Entertainment Weekly, June 4, 2021.

Quotes from Billy Harris: Matt Noble, "Billy Harris ('Ted Lasso') on Colin's Struggle as a Closeted Gay Member of the Team," GoldDerby, May 19, 2023.

Quotes from Juno Temple: "Ted Lasso Interview: Juno Temple on Keeley's Branching Out in S3, Her Love Triangle with Roy + Jamie," YouTube video, 14:45, posted by "Inside The Film Room," June 15, 2023, https://www.youtube.com/watch?v=avl39w7hs5k.

Quotes from Toheeb Jimoh: Lucy Ford, "Toheeb Jimoh Is Ready to Hang Up His Boots," GQ, April 19, 2023.

Quotes from Billy Harris: "Half Hour With: *Ted Lasso* (Toheeb Jimoh, Kola Bokinni, Billy Harris & Cristo Fernández)," YouTube video, 30:10, posted by "Half Hour With," May 31, 2023, https://www.youtube.com/watch?v=k4p6_al20rk.

Quotes from Jason Sudeikis: "Jason Sudeikis on Becoming Ted Lasso: 'I Didn't Want to Snark Out Anymore,'" April 4, 2023, in *The Great Creators with Guy Raz*, podcast, 1:12:59.

Quotes from Maximilian Osinski: John Boccacino, "Episode 142: Zava! Meet Maximilian Osinski '06, the Breakout Star of Season 3 of 'Ted Lasso,'" June 13, 2023, in *'Cuse Conversations*, podcast, 40:05.

Quotes from Toheeb Jimoh: Tim Lewis, "'I Look for the Good in All Situations': The Power's Toheeb Jimoh," *Guardian*, April 9, 2023.

Quotes from Nick Mohammed: Devon Ivie, "'Poor, Odd Nate,'" *Vulture*, June 2, 2023.

INDEX

Hunt, Brendan (*cont.*)
 on season two, 185, 186, 193
 on season three, 247, 248–249, 256
 on "The Signal," 223–224
 soccer and, 18, 70, 127, 128,
 132–133, 141
 on soccer in *TL*, 125–126
 on "Strange," 122
 Sudeikis and, 15, 16, 30, 37, 83, 214
 on "Sunflowers," 259
 on Zava, 254

I
Ibrahimović, Zlatan, 252, 253, 254, 255
improvisational comedy
 development of characters and, 81, 82
 during filming, 258
 Hunt and, 212–213, 214
 soccer-as-life metaphor and, 38–39
 Sudeikis's ability in, 21–22
 writing and, 83
Independent, 161
IndieWire, 70
Intelligence (TV program), 55–56, 273
"International Break" episode, 268–270,
 273–274, 276–278
"Inverting the Pyramid of Success"
 episode, 234–238, 239–240,
 241–244
Islam, Yusuf, 207
Iverson, Allen, 70, 71

J
Jade (*TL* character), 274–275
Jamieson, Cory, 134–136, 138
Jamie Tartt (*TL* character). *See also*
 Dunster, Phil
 auditions for, 61–63
 development of, 256–257
 Jones and, 37, 116–117, 257–258,
 282–283
 Kent and, 257

Lasso's narrative and, 283–284
last appearance of, 217–218, 220
in "Man City," 224, 225
original name for, 61
season one, 155
in "The Signal," 222
in "So Long, Farewell," 298
Jan Maas (*TL* character). *See*
 Elsendoorn, David
*The Jess Cagle Podcast with Julia
 Cunningham*, 96
Jeudy-Lamour, Moe, 197, 222
Jimoh, Toheeb
 about, 58, 60, 149
 during Akufo's tantrum, 243
 audition of, 59–60
 on being character in *TL*, 172
 on continuation of *TL*, 315
 on *FIFA 23* and script, 143
 on filming during COVID, 188
 Henry and, 139–140
 on "Man City," 225, 226–227
 on messages in *TL*, 195–196
 on niceness of cast, 88
 on "No Weddings and a Funeral," 229
 on potential of *TL*, 103
 on Rashford, 195
 on reaction to *TL*, 166–167,
 172, 313
 on season three, 250, 280, 281
 on "The Signal," 223
 singing by, 124
 on soccer in *TL*, 126

K
karaoke bar scene, 120–121
Keane, Roy, 153
Keeley Jones (*TL* character). *See also*
 Temple, Juno
 about, 51, 55, 236–237
 auditions for, 49–51
 development of, 81
 at end of season two, 241
 importance of, 100

INDEX

ABOUT THE AUTHOR

Jeremy Egner is a veteran pop-culture journalist in New York City. He is currently the television editor at *The New York Times*, where over the years he was written about era-defining series like *The Sopranos, The Wire, Breaking Bad, Mad Men, Game of Thrones,* and, of course, *Ted Lasso.*

Born and raised in the Dallas area, he graduated from the University of Texas and began writing about music and culture at the *Austin American-Statesman* in Austin, Texas. He lives in Brooklyn with his wife and daughter.

He's no soccer expert but does understand the offside rule. It's actually not that complicated.